DESIGNER'S BREAKING BLOCK

ROCKPORT

BREAKING DESIGNER'S BLOCK

501 graphic design solutions
for type, color, and materials

GLOUCESTER MASSACHUSETTS

ROCKPORT PUBLISHERS

First published in the United States of America by
Rockport Publishers, Inc.
33 Commercial Street
Gloucester, Massachusetts 01930-5089
Telephone: (978) 282-9590
Fax: (978) 283-2742
www.rockpub.com

Library of Congress Cataloging-in-Publication data available

ISBN 1-59253-042-7

10 9 8 7 6 5 4 3 2 1

Cover Design: Art and Anthropology

Grateful acknowledgement is given to Cheryl Dangel Cullen for her work from *Then Is Now: Sampling the Past for Today's Graphics* (Rockport Publishers 2001) on pages 10–27 and 126–141, and also for her work with Karen Triedman in *Color Graphics: The Power of Color in Graphic Design* (Rockport Publishers 2002) on pages 28–123; to Margaret E. Richardson for her work from *Type Graphics: The Power of Type in Graphic Design* (Rockport Publishers 2000) on pages 142–185; and to Rita Street and Ferdinand Lewis for their work from *Touch Graphics: The Power of Tactile Design* (Rockport Publishers 2003) on pages 234–349.

Typefaces featured as indicative and characteristic of a decade in the Type Tracker section of this book are owned and licensed by Agfa Monotype and have been loaned to Rockport Publishers for inclusion in this book.

PANTONE® Color references are protected by copyright and are reproduced herein by permission of Pantone, Inc.

PANTONE-identified Color reproduction information has been provided for the guidance of the reader. The colors have not been checked by Pantone, Inc. for accuracy. Consult current PANTONE Color Publications for accurate color.

PANTONE® is the property of Pantone, Inc.

Printed in China

CONTENTS

INTRODUCTION

Designer's block is something every designer has faced and when it sets in, it's usually at the most inopportune time. A deadline is looming and your mind is devoid of that critical flowing of creativity. Sometimes the answer to breaking the silence is to magnify the elements of a design and approach the design brief in parts (color, typography, and materials). By focusing on the separate elements, it can be easier to begin defining the feel and start building a basic structure. *Breaking Designer's Block* is broken down into three sections, each of which highlights work whose use of color, typography, or materials is outstanding and memorable, so sit back and be prepared to be inspired!

COLOR

Communication strategy—the essence of graphic design—can be jeopardized by poor color choice. Because written words register in the viewer's brain after it responds to color, strong choices are intrinsic to a great design. Although on a functional level it creates visibility and contrast, and enhances legibility, color can and should be used to entice people, promote a concept, twist a message, or convey a feeling or emotion.

As designers, we have been exposed to color theory, but we may find it difficult to expand our theoretical understanding into the realm of practical use. Although we may understand that a composition based on a pair of complements will create harmony, we may not understand which pair will increase the communicative powers of the design. In the same fashion, proportional balance between colors is obvious, but it is the way we manipulate the relationship to create the balance or imbalance that adds to or takes away from the design.

Although choosing simple color palettes might be second nature, correctly choosing a color scheme that will evoke calmness or anxiety may be more difficult to ascertain. Because color communicates, we must be concerned with what our choices are communicating. An increased understanding of people's response to certain colors, both nationally and abroad, will help us to convey our message on a psychological or emotional level.

A sophisticated designer can use color to his or her advantage by understanding the implications that it has, beyond attractiveness, that supports a design strategy such as its ability to evoke a specific period of time. A fondness for nostalgia and the desire to surround ourselves with things that remind of us of simpler times has made retro style popular. However, when re-creating the past, exactly where do you start? What makes a design harken back to an earlier era? The Color Cues feature, which begins our section on color, outlines the colors that dominated each decade during the 1900s and Leatrice Eiseman, director of the Pantone Color Institute and color consultant, graciously lent her expertise. Color is an incredibly powerful and universal design element whose possibilities are endless, so harness its strength and push its abilities to the wall.

TYPE

What makes good design great? The answer is an impeccable use of type. The choice of type, and how it is used, is the crucial element for effective design in any media from print in award-winning magazines to memorable book jackets and book design, from edgy websites to flashy snowboards. Contemporary typography—the effective use of digital fonts—has the ability to transform design into high art.

The designers featured here have redefined typographic design. Each is a stylist and interpreter, and, often, also a type designer. This section takes you into the studios and the minds of twelve of the most influential designers of our time. These stylists and practitioners of typographic virtuosity provide a range of work, with individuality, attitude, and graphic flair. Collectively they demonstrate the power of type in contemporary design.

Typefaces, as with color, get the same analysis with the Type Tracker feature beginning this section. Allan Haley, director of creative projects at Agfa Monotype, contributed his insight into type history, which is provided in a decade-by-decade overview of the typefaces that were invented and used during the 1900s, as well as those indigenous to the era that are particularly evocative of its style.

TOUCH

The power of tactile graphics goes way back. Visual artists are tactile people. We see and experience the physical world and never cease to be fascinated by it. No doubt, this fascination dates back to Neolithic times when early man began to understand the impact he could have on the physical world. At some unmarked moment around 10,000 years ago, someone placed a hand against a cave wall and blew pigment over it, using the mouth as an airbrush. The mark left still bears witness to his existence—the ultimate personalized trademark applied to a most permanent location.

Artists and designers love physical objects, especially if they have had a hand in making them. When people experience an art object tactilely and actually hold it in their hand, they understand something of what the artist was thinking when they created it. When

designers have the time and budget to experiment with materials, truly exceptional artifacts are created.

Most graphic designers receive countless promotional items in the mail from paper companies, design organizations, and other designers. The things we keep are often the most tactile: the strange little box sent years ago containing all the designers named Michael in San Francisco, the marvelous catalogs produced for Takashimaya in New York, or the wonderful "House of Cards" by Charles and Ray Eames. These are not simply beautiful things; they carry the imprint of their originators. They refuse to be thrown away with the junk mail and paper cups. They resonate with the excitement that we all feel when carefully selected materials are pulled together into an object charged with artistic inspiration and eloquent thinking. The resulting visual event continues to hold our attention, to demand our contemplation, and to leave us with a little mystery and magic, not unlike the image of the hand in that cave left long ago.

We hope this outstanding collection of work from numerous fields and award-winning designers helps you to break any designer's block you may, or may not, be suffering from.

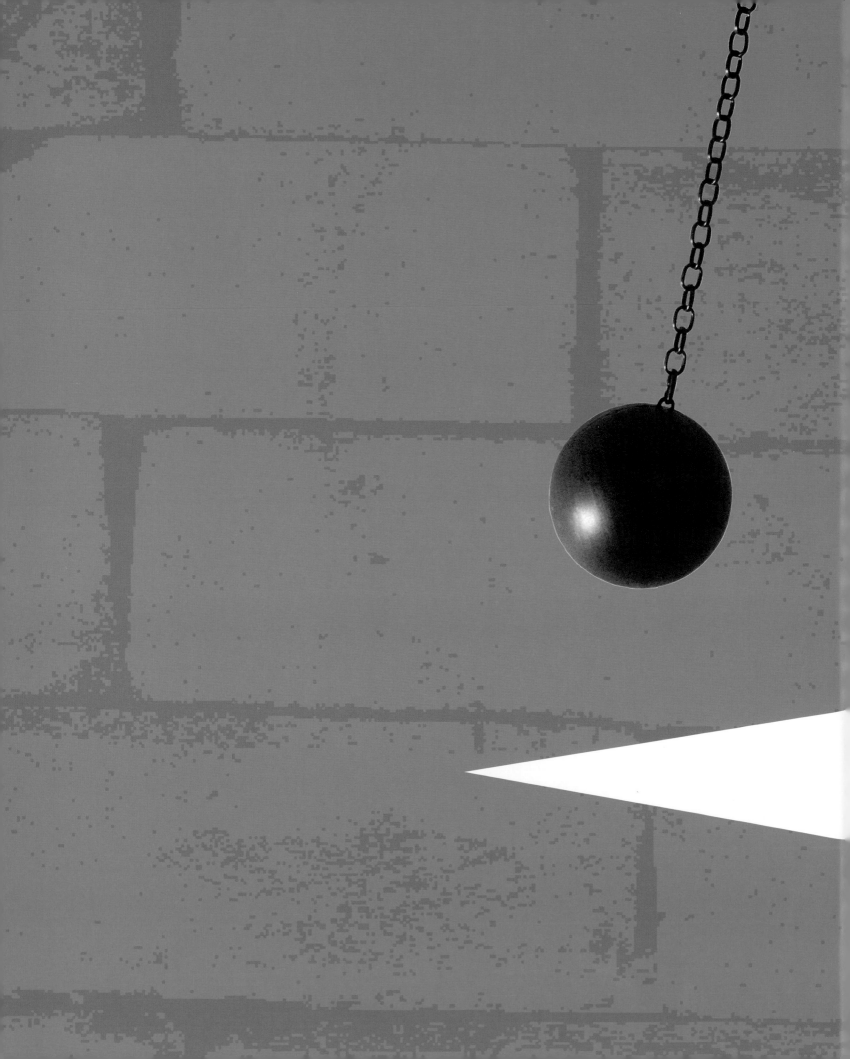

COLOR

In the early part of the century, women were getting their first taste of emancipation, and though it didn't last long, it did have an influence on color—primarily as evidenced by female undergarments. Lingerie began showing up in opalized pinks (PANTONE 5035) and pale pinky-beige tones (PANTONE 4675), marking the beginning of romantic, sexy colors used in underwear fashions, which had previously been seen as purely utilitarian. Women began using cosmetics, too, and the first blushes of rouge became popular. Face powders took on a tint for the first time and were available in a variety of colors to match complexions.

Color Cues: 1900s

Until the beginning of World War I in 1914, light colors were popular—light green (PANTONE 454), pale blue (PANTONE 5445), and what was called "swooning" mauve (PANTONE 5015). During this time, colors were often differentiated as city colors and the more utilitarian country colors, which included a lot of brown and tan (PANTONE 465).

The Art Nouveau movement had a tremendous influence on color and iridescence, as did the invention of the electric light bulb. Simply put, color usage changed because electric lights illuminated color and one could see it better than under gas light.

There was a bright explosion of color brought on by the popularity of the Ballet Russe. Similarly, the Fauvists—using shades of scarlet (PANTONE 199) and apple green (PANTONE 584) caused a color explosion of their own. The Impressionists and Neo-Impressionists indulged in floral hues of yellow (PANTONE 128), orange (PANTONE 143), teal (PANTONE 321), periwinkle (PANTONE 660), violet (PANTONE 512), rust (PANTONE 704), and of course, green (PANTONE 575), which ultimately influenced the colors of interior design and clothing for the wealthy.

During the war, color all but disappeared. Colorful clothing still existed, but it was difficult to obtain and was available only if one was willing to pay the hefty prices.

The lingering effects of the war could be felt in the early 1920s as evidenced by the prevalence of subdued colors—partly due to the high cost of dyes and colorful clothing during the late-1910s and partly a reaction against all the bright colors that were so popular in the mid-1910s.

Color 1920s
Cues:

In the 1920s, women enjoyed more freedom than ever before and the timing couldn't be more perfect for French fashion designer Coco Chanel to debut on the fashion scene. Her designs influenced fashion, notable for her unique blend of minimal, modern thinking. Colors in the Chanel palette, which spread throughout the world in all facets of design, defines the minimalist palette and includes beige (PANTONE 488), taupe (PANTONE 4645), gray (PANTONE WARM GRAY), and black.

An entire range of pale colors was also dominant including celery (PANTONE 614), pale pink (PANTONE 691), lavender (PANTONE 664), powder blue (PANTONE 650), and light green (PANTONE 622).

Simultaneously, a lot of glitter came into play and the Art Deco movement, which had a huge influence on color, ushered in a lot of bronze (PANTONE 8960), chrome, steel (PANTONE 8002), and glass.

Despite the popularity of minimalist colors and metallic shades, bright color didn't totally disappear in the 1920s. Color was used, but used sparingly and typically softer shades prevailed. Bright color took on the Japanese-born tradition of being used occasionally as a spot or accent color.

When we think of the 1930s, the colors of the Great Depression come to mind—somber gray (PANTONE 432) black, and brown (PANTONE 4625). But this palette was really only prominent in the early part of the decade—1930 to 1931—when bleak colors reflected the impact of the economic reality. Between 1932 and 1933, the pendulum swung back and the opposite of dark colors, which was a total absence of color—white—became popular because of its association with sunshine.

Color 1930s
Cues:

In fact, it was during this time that people began pursuing suntans in order to get that "healthy" look. White was the color that best showed off a good tan. The trend carried into interior decorating, too. Suddenly, against popular convention, trendsetters decorated interiors with all white, white-on-white themes.

White cars—prominent among the wealthy—debuted in the decade in startling contrast to the black automobiles, which were the norm.

White also evolved into the popularity of off-whites, ivories, and soft pastels (PANTONE 9042, PANTONE 9061, PANTONE 9060, PANTONE 9021, PANTONE 9023, PANTONE 9381, PANTONE 9041), never more evident than in the movies of the era that boasted platinum blond bombshell Jean Harlow undulating in satin sinuous gowns of these colors.

Gilding, seen on furniture legs and figurines, was also started in the '30s.

Ultimately, however, one can only experience so much white before the need for color began creeping back into the palette. By the mid-30s, lots of colors were used, most notably in unusual and complex combinations. For instance, periwinkle blues (PANTONE 2725) were shown with taupe or brown (PANTONE 264) and Dijon yellows (PANTONE 110) were combined with charcoal gray (PANTONE 426). Many of the color palettes were borrowed from the great ocean liners of the era with their sumptuous décor, which was notable for its complex color palettes.

The era saw the first suggestion of a cocktail dress with the introduction of the chic little black dress. The 1930s is also known for the debut of shocking pink (PANTONE 211).

In all, it was an era of bountiful color use and experimentation. "In these compressed ten years, a lot happened with color. It is the decade between two very important events—the Depression and World War II," says Leatrice Eiseman, director, Pantone Color Institute. Had it not been for the war, the decade "would have sparked a lot more color invention."

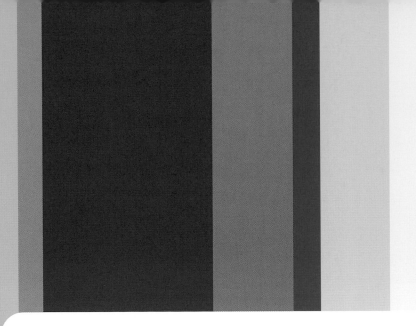

For the most part, colors in the 1940s took on a dusted quality, as dyestuffs were increasingly hard to get during the war years and the dyes that were available were largely composed of gray. Gray, itself, was prevalent in light (PANTONE 422) and dark shades (PANTONE 436), while colors like yellow (PANTONE 458), orange (PANTONE 472), mauve (PANTONE 500), navy (PANTONE 534), and green (PANTONE 5555) appeared chalky, muted, and unsaturated. However, the decade didn't start out this way.

Color Cues: 1940s

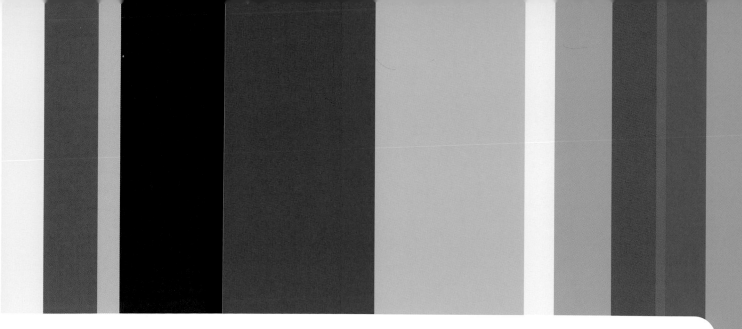

Going into the forties, colors were bright; cherry red lipsticks (PANTONE 1925) accented lively colors of hues of pink (PANTONE 196) and yellow (PANTONE 127). But, as the war escalated, colors began to lose their vitality since the bulk of dyes, which were manufactured in Germany, were not available. Ultimately, French fashion designers came to the rescue, making fashion statements out of the colors that were abundant—olive (PANTONE 455), khaki (PANTONE 4515), navy (PANTONE 539), and black.

Moreover, because dyestuffs were rationed and the availability of textiles was limited, the style and lines of clothing changed, too. Skirts became shorter and clothing became slimmer and more tailored—out of necessity—to minimize the fabric required.

As the war dragged on, the only place one would see color was in the hand knit caps, gloves, and sweaters that were made on the home front from leftover clothing. Drab military uniforms and civilian fashions were often accented with spots of "homemade" color. Of course, throughout the war, cosmetics were considered a morale booster, and shades of pink and red, the latter for lips and nails, continued to be popular throughout the decade.

Naturally, throughout the war, a country's colors signaled patriotism and the brighter, the better. In the U.S., shades of vibrant red (PANTONE RED 032), white, and blue (PANTONE 286) were prevalent.

By the latter part of the decade, color made a comeback in—of all things—"resort" clothing. The thinking was that summertime clothing was less expensive, so wild, vibrant colors were less of a fashion and investment risk. Popular tropical colors ranged from tangerine (PANTONE 123) and yellow (PANTONE 120) to vibrant teal (PANTONE 3265), fuchsia (PANTONE 2385), and purple (PANTONE 2582) to true blue (PANTONE 2727) and turquoise (PANTONE 306). The advent of these colors paved the way for the color palette of the 1950s.

Men went back to work after the war years and women returned to the home, bringing about an onslaught of femininity in all things as increasingly more products and services were marketed to women as homemakers: home appliances, cars, and fashion. Pink, almost universally regarded as the epitome of femininity was a popular color, but its significance went much deeper than aesthetics after the war weary, rationed, and subdued decade of the forties. After so much deprivation in everything, including color, pink's bright liveliness signified optimism and came to represent what the decade of the 1950s was all about.

Color 1950s
Cues:

Pink appeared in numerous variations-from peachy-pink (PANTONE 1765) to pale pink (PANTONE 183), medium pink (PANTONE 190), powder pink (PANTONE 196), and cool pink (PANTONE 203). Shocking pink, popular in the 1930s, made a comeback in a new incarnation: hot pink (PANTONE 212), and cosmetics companies like Revlon ran advertising featuring the entire product range in hot pink.

"Think pink" became a catch phrase and even Hollywood turned pink, featuring an entire scene in the motion picture *Funny Face*, starring Fred Astaire and Audrey Hepburn, in that shade. When pink (PANTONE 196) needed a partner, turquoise blue (PANTONE 304) rose to the occasion as its perfect complement—the colors were all part of a trend toward pastelling, and appeared on everything including two-toned cars such as Studebakers and Nash Ramblers. Other light cheery shades gaining momentum in the 1950s color palette include pistachio (PANTONE 365) and bright yellow (PANTONE 1345).

Amid a rainbow of pastels, black re-emerged as an influential color; it became chic to wear black and it appeared once again as the black cocktail dress and as skinny Capri slacks that looked great when accented with brightly colored tops. Technology was making more and more vibrantly colored dyes possible, and the decade saw the beginnings of fluorescent colors. Lime green (PANTONE 375) was introduced in the 1950s. This introduction was followed by other bright colors—born out of the beginnings of Rock n' Roll —yellow (PANTONE 109), raspberry (PANTONE 213), fuchsia (PANTONE 245), purple (PANTONE 266), teal (PANTONE 3272), and Kelly green (PANTONE 368).

Orange (PANTONE ORANGE 021) was also seen for the first time—and marked the first indication of the psychedelic era that was to come in the 1960s.

There was an explosion of color in the 1960s due to new technology that made a range of dyestuffs available to the masses. This innovation, coupled with an entire new range of synthetic fabrics and a renewed interest in cotton fabrics that took dye well, fueled the public's fascination with color that went beyond textiles and finishes to creating unique color combinations in everything from snow boots to raincoats.

Color 1960s
Cues:

Colored pantyhose debuted to complement mini-skirts, and the two appeared in a variety of combinations. Fashion designers Pucci and Mary Quant led this trend, and the result was that color appeared everywhere; items that had previously been black, khaki, or nude, burst onto the scene in never-before seen shades of red (PANTONE 1788), blue (PANTONE 299), yellow (PANTONE YELLOW), and green (PANTONE GREEN).

During the late-1960s, the popularity of the ethnic look inspired color combinations in all walks of life. Blue jeans were paired with Indian tops that sported a riot of colors.

Colorful peasant jewelry, beadwork, and macramé plant hangers and belts were popular. Women started lining their eyes with kohl pencils. The ethnic look gave the masses permission to do things that were widely innovative, and the trend took its color cues from native African, Oriental, and Indian clothing, arts, and crafts.

Meanwhile, the music scene and drug culture brought about the psychedelic era with a fluorescent explosion of color: blue (PANTONE 801 AND PANTONE PROCESS BLUE), lime green (PANTONE 802 AND PANTONE 375), vibrant yellow (PANTONE 803 AND PANTONE PROCESS YELLOW), fluorescent orange (PANTONE 804), fluorescent red (PANTONE 805), fluorescent pink (PANTONE 806), and violet and magenta (PANTONE 807 AND PANTONE PROCESS MAGENTA).

Late in the decade, orange and varying shades of golden yellow generated a stir after appearing on the cover of the Beatles' album *Yellow Submarine*. These warm shades ranged from goldenrod (PANTONE 130) and orange (PANTONE 186) to golden yellow (PANTONE 116) and varying hues of pumpkin (PANTONE 137). This seldom seen color palette rapidly became popular with interior designers. By the early 1970s, these shades could be seen in the very best homes with the latest décor.

The seventies introduced the ecology movement and the populace turned to earth tones—partly out of their concern for the environment and partly because people were visually exhausted by the frenetic color usage that marked the sixties.

Color Cues: 1970s

At the same time, technological advancements made even more pigments and dyestuffs available, opening the arena to even more color possibilities. This time, the advances impacted men as much as previous innovations had influenced women. Men gave up their white business shirts and for the first time started wearing colored shirts with coordinating ties. Soft, earthy, desert-inspired colors, inspired by the California lifestyle and climate were also prominent.

However, if one color palette marked the decade, it was that of earth tones, which are remembered today mostly for their use in kitchens, where small and large appliances were given industry-standard names that seventies homeowners shudder at today: avocado (PANTONE 119), harvest gold (PANTONE 129), and burnt orange (PANTONE 152).

As the decade wore on, the colors got deeper, and included bronze as well as various shades of brown (PANTONE 1395, PANTONE 140, PANTONE 4625, and PANTONE 1535), russet (PANTONE 1595), deep red (PANTONE 1797), and dark blue (PANTONE 2955 AND PANTONE 302).

By the 1980s, the buying public had had their fill of earth tones and the colors were no longer selling—in anything—clothing or appliances. New color palettes emerged, but splintered into two groups: Those favoring mauve (PANTONE 500), teal (PANTONE 563), and gray (PANTONE 429), which quickly became the principal neutral color of the decade; and those who leaned toward the Nordic influence, a palette featuring an array of cool blues (PANTONE 279, PANTONE 291) and blue-greens (PANTONE 313, PANTONE 319, PANTONE 3272).

Color
Cues:

1980s

These colors remained popular until the mid-eighties—when people had been mauved, tealed and grayed to death and demanded new colors. It seems that the lifecycle of color palettes was decreasing.

During this time, the women's movement was on the rise and fashion was all over the place—skirts were long and short; women stopped following fashion edicts and wore what looked best on them. The trend carried into color as well and people thought of color palettes in terms of what they liked. The result was a backlash on the idea of a person being color-printed, a trend that gained prominence in the seventies and pigeonholed a person as a particular "season," which in turn, determined the colors they should wear. Instead, consumers began recognizing the psychological aspects of color.

There was less dogma and more freedom and color choices were now based on the question: How does it make you feel?

Arising out of this trend was the popularity of colors born of the American West (also called Santa Fe colors) and those inspired by the film *Out of Africa*—namely peach (PANTONE 1565), pink and coral (PANTONE 176), turquoise (PANTONE 2975), sand (PANTONE 727), ivory (PANTONE 9140), and lavender (PANTONE 263). These colors, previously thought to be exclusively feminine, permeated into men's fashion and accessories as well, a trend that was globalized in such television shows as *Miami Vice*, which popularized the Florida look. During the mid- to late-1980s, men could be seen sporting colors they had never worn before.

Amid all the pastels, black made a resurgence (PANTONE PROCESS BLACK). In the U.S., the Reagans were in the White House, and due in part of Nancy Reagan's influence, the pair brought back the glamour of black. Black limousines and black taffeta defined grandeur and luxury. Black's new caché translated to interior design as well, where it came to be associated with the high-tech look. Chrome, steel (PANTONE 8002) and gray (PANTONE WARM GRAY) were accented with black to capture the newest look in modern, up-to-date kitchen technology. It became elegant to have a black phone again, which had not been popular since color invaded home appliances in the 1950s and 1960s.

The popularity of *Star Wars*' Darth Vader also had a lot to do with making black elegant and sexy and a new descriptive for black was born: tough chic.

Black (PANTONE PROCESS BLACK) was popular in the late-1980s and continued to be so into the nineties, but for other reasons. Now it was popular because the economy took a nosedive, and in such times, black tends to rise above other colors as the shade of preference. Bright colors also went away, while environmentalism was popularized. Beige, off-white, and ivory (PANTONE 454, PANTONE 9161, PANTONE 4685, AND PANTONE 9061) gained favor for their no-color look and perfectly showed-off natural cottons and showed up as white, almond, and stainless steel appliances.

Color Cues: 1990s

But the decade was not without its hallmark color. If one color had to be chosen to define the decade it would be hunter green (PANTONE 3305). Green was symbolic of nature and even the word green entered into our speech patterns—in phraseology that harkened to the environment and ecology as a whole.

By the middle part of the decade, the economy started to spike, so color came back into public life in full-force. While colors had never disappeared entirely, they had become less saturated, and now they re-emerged with a different hue. Between 1995 and 1997, yellow-green, chartreuse, and lime green (PANTONE 389) debuted in plastics and in clothing. Brights came back in every color form from yellow (PANTONE 107), orange (PANTONE 170), and red (PANTONE RED 032) to violet (PANTONE 2592), periwinkle (PANTONE 2725), and pink (PANTONE 211). During this time, green (PANTONE GREEN) appeared in numerous incarnations and remained popular, as did black, which never lost its power and showed no signs of disappearing.

As the turn-of-the-century approached, a new color appeared on the scene that was to become associated with the year 2000. It was a shade aptly named, millennium blue, a hue, which was forecasted to be *the* color that would define the early twenty-first century.

Color That Persuades

In our visually boisterous world, color is the key element that can be used to catch the viewer's attention. Whether bright or dull, singular or complex, physiological or psychological, theoretical or experiential, the persuasive power of color attracts and motivates a sale.

Although some colors produce an intrinsic physiological response—such as the way red increases your heart rate—most color response is due to experience and association. Persuasive color distinguishes one product from another, identifies the product, or associates the product with a similar brand name or category. Often, positive color associations increase the comfort level of the buyer. In the case of Cici's Pizza, designed by Design Forum, red and green are intentionally used to create an association with Italy and convey the idea of good Italian food.

There are palette associations for industries, product types, and geographical areas that can be used to support or authenticate a product or service. You might be persuaded to trust a bank that

uses blue in its logo and collateral materials because sound financial institutions often rely on blue to communicate stability and trust. The same approach is used for the Ellipsis catering menu designed by Dinnick and Howells. A natural color palette is supportive and consistent in that it suggests "homey and pleasant healthy food."

In addition to association, color can be used to identify a product. In the case of the Soho Spice restaurant in London, designed by Lewis Allen of Fitch, regional colors of India are used to identify the restaurant with its country of origin. The colors of Indian spices are also incorporated into the design. The spice colors create a taste–smell–visual association. The color allows people to see the taste and smell of Indian food.

A persuasive color palette can distinguish a product from its peers. Mires, in the piece Packaging System for Qualcomm, distinguishes its telephones by the use of fashion models and intense color. The high contrast "techno slick" colors against the monochromatic models and black

background increase overall image clarity. The boxes, when stacked together, make a strong visual statement causing the buyer to stop, look, and purchase.

Whether it's used in a product or an environment, persuasive color creates an association or identification, and it is the color that raises the comfort level for the purchaser of a product or service. As a result, it's the way color is used that distinguishes a product from comparable products and makes it sell better and faster.

FRANKFURTER SCHULTHEATERTAGE POSTERS

Client	Kuenstlerhaus Mousonturm, Frankfurt am Main
Design Firm	Büro für Gestaltung
Art Directors	Christoph Burkardt / Albrecht Hotz
Palette	Lime Green and Blue / Yellow and Turquoise / Blue and Pink

PROJECT DESCRIPTION

The client sponsors a two-week program of theater performances geared to children and needed lively posters to promote the event.

PROJECT CONCEPT

Because there were to be several different plays presented over the two-week period, using visuals that would attract the young audience could be confusing because they wouldn't necessarily relate to all the performances. Moreover, the posters were simply lists of the plays and dates presented. Instead of using graphics, color had to be the primary communicator to grab the attention of the young audience.

COLOR DESIGN

The design firm opted for a simple palette that would attract children with its lively, playful colors. The format remains consistent every year; only the color palette changes.

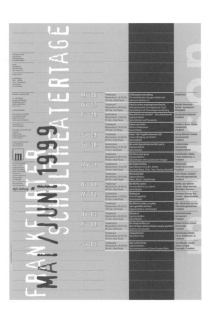

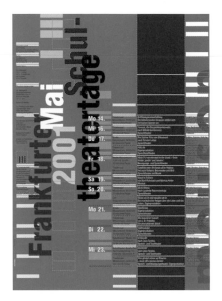

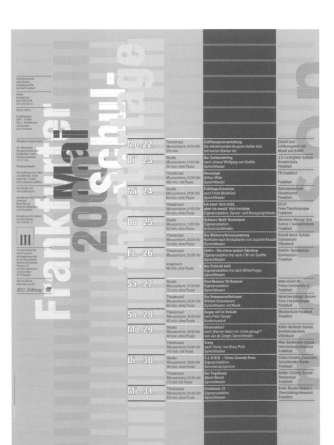

CREATIVE BLOC: 2001

Advertising Club of Dubuque	Client
Get Smart Design Co.	Design Firm
Jeff MacFarlane	Graphic Designer
Tom Culbertson	Illustrator
Orange / Green / Blue / Black / White	Palette

PROJECT DESCRIPTION

The Advertising Club of Dubuque tapped Get Smart Design Co. to develop the promotional materials for its 2001 creative conferences—which would be mailed directly to prospects in the hopes of getting them to sign up.

PROJECT CONCEPT

The design challenge was to find a way to cut through the mail clutter. Once it garnered the recipient's attention, the mailing needed to be strong enough to galvanize the recipient to complete the entry form and sign a check or fill in his or her credit card information. "With a limited number of mailings, we needed to attract a wide cross-section of attendees, [so] we selected powerful primary colors that could fight their way through stacks of direct-mail clutter," says Jeff MacFarlane.

COLOR DESIGN

"We attempted to brand the one-day conference through the use of color on mailings, signage, name badges, and the Web," MacFarlane explains. The result is a very simple series of direct mail pieces—here a postcard and a brochure—that are startlingly forthright. Simple icons and bold colors do all the talking.

Designers constructed the job with process colors in high percentages to stimulate action but never used more than two in any build.

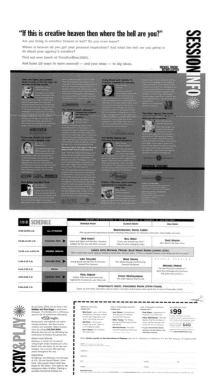

cinder bloc

engine bloc

creative bloc

PRO BEAUTY PROMOTIONAL IMAGE FOLDER

Client — Pro Beauty GmbH
Design Firm — Braue Branding & Corporate Design
Art Directors — Kai Braue / Marcel Robbers
Designer — Marcel Robbers
Palette — Orange / Silver-Green

PROJECT DESCRIPTION

Pro Beauty, a cosmetic-surgery center, sought Braue Branding & Corporate Design's help in developing a marketing piece that would help dispel patient fears about surgical procedures.

PROJECT CONCEPT

Designers opted to use a warm orange color to help reach their goal. A warm orange, they reasoned, would create a warm and cozy feeling and, when incorporated into the unique design of the brochure, would emphasize the emotional component of how plastic surgery can help unfold a person's beauty. The slogan "We unfold your beauty" reinforced the physical aspects of the brochure, which "unfolds its wings like a butterfly."

COLOR DESIGN

The folder was laminated to give it longevity and add feeling. The secondary color palette—a silver-green—was carefully placed in a nondominant position to represent the medical aspect of the procedures, whereas the bulk of the brochure addresses emotional and psychological aspects of undergoing surgery. Together, the color palette and unique way that the brochure reveals itself work hard at persuading patients that plastic surgery is nothing to fear.

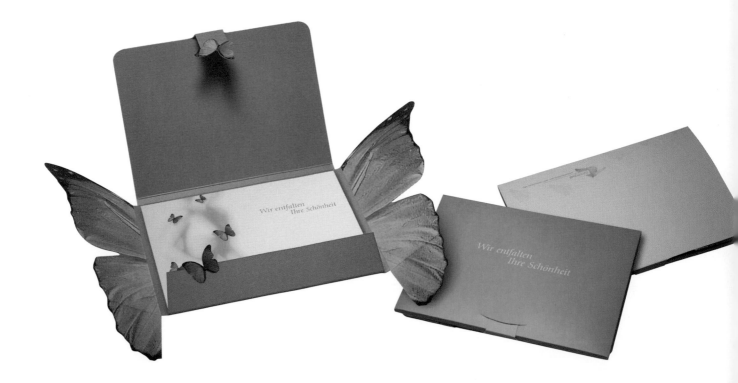

AIGA Washington, DC, Chapter	Client
Mek-Aroonreung / Lefebure	Design Firm
Pum Mek-Aroonreung / Jake Lefebure	Art Directors
Pum Mek-Aroonreung / Jake Lefebure	Designers
Cheryl Dorsett	Copywriter
John Consoli	Photographer
Red / Lime Green / Bright Cyan / Hot Orange / Tangerine Yellow	Palette

PROJECT DESCRIPTION

The Washington, D.C. Chapter of AIGA (American Institute of Graphic Arts) wanted to hold a breakfast seminar series. That meant finding a way to persuade designers that these seminars were different enough to warrant setting their alarm clocks extra early.

PROJECT CONCEPT

"The event was to be in the morning so we combined breakfast items and rise-and-shine colors to really grab the audience's attention and to let them know that this event was not going to be a typical morning lecture event," says Pum Mek-Aroonreung.

COLOR DESIGN

Designers decided to use a familiar breakfast item for each of four different postcards included in the mailing. Next, they searched for fonts that would match the familiar type on each item, altered the type in Adobe Illustrator, and then re-created the individual letters as needed. The type, combined with the familiar color palettes, associated with each item made the re-created images dead ringers for the real things.

If anyone doubts the power of color to persuade and ring the bell of name recognition, consider the familiar red *K* on a certain breakfast cereal or the hot pink and orange packaging that holds donuts just perfect for dunking.

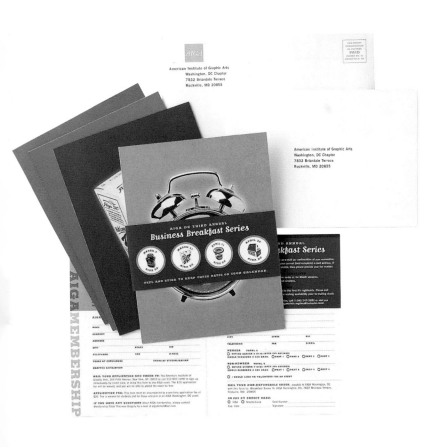

STOP HATE AT PENN STATE POSTER

Client	Penn State Institute for Arts and Humanistic Studies
Design Firm	Sommese Design
Art Director	Lanny Sommese
Designer	Lanny Sommese
Illustrator	Lanny Sommese
Palette	Black / White

PROJECT DESCRIPTION

"This poster was created in response to racial tension on the Penn State campus," says Lanny Sommese, designer. "The unrest was brought on by incidents that included threatening letters sent to a number of African-American students and faculty."

PROJECT CONCEPT

"A black-and-white palette was obvious," Sommese explains. "Black and white creates a sense of urgency. It gives the poster a 'hot off the press' newspaper look, which I enhanced by enlarging the dot pattern and awkwardly cropping the high-contrast photo of the hands and by the pasted-up quality I gave to the overall composition."

COLOR DESIGN

Adding to the feeling of urgency is the type, which Sommese cut out of paper by hand. "The hand-cut type is intended to add to the spontaneous appearance of the image and create a feeling of anarchy that I thought was appropriate," he says.

Posters were printed on a computer plotter printer, which allowed the university to print copies of the poster one at a time as needed, eliminating the expense of a large print run at the outset.

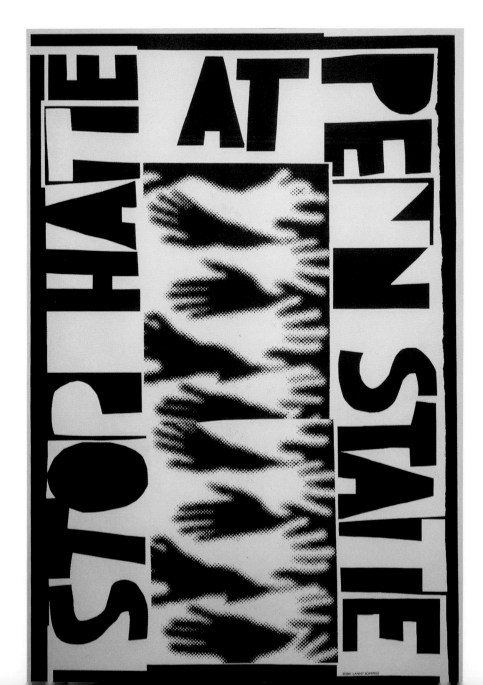

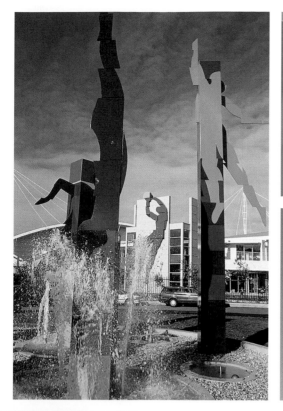

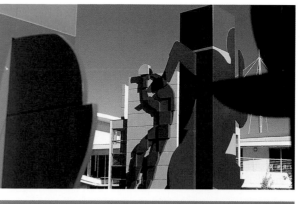

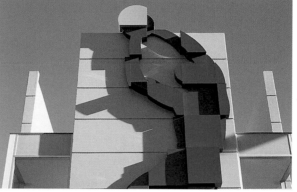

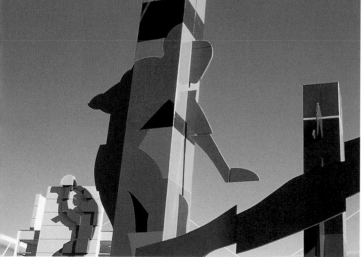

MELBOURNE SPORTS & AQUATIC CENTRE FOUNTAIN AND SCULPTURES

Melbourne Sports & Aquatic Centre Client

Cato Purnell Partners Pty. Limited Design Firm

Blue / Yellow / Red / Green / Orange Palette

PROJECT DESCRIPTION

The Melbourne Sports & Aquatic Centre, a large sporting venue, needed exterior graphics that indicated an atmosphere of fun, yet the organization was very budget-conscious.

PROJECT CONCEPT

Cato Purnell Partners developed a series of three-dimensional graphics as sculptures, even one including a fountain, in a palette of lively colors that leaves little doubt that this venue is for fun.

COLOR DESIGN

Clean, primary colors were used to create an atmosphere of vitality. Geometric patterns of color allow one-color sports figures in action to stand out, whereas the three-dimensional aspect of the sculpture gives the figures movement and persuades passersby that this place offers plenty of action.

Color Forecasts— Where Do They Come from?

by Leatrice Eiseman

From international runways to America's own designer collections, the march of models in the latest trend of colors will ultimately wend its way into and greatly influence the color of interior furnishings, automobiles, and all other manner of consumer goods, including product packaging, advertising, Web sites, and point-of-purchase appeal.

The designers themselves are the real stars of the shows. They are very much attuned to and inspired by the hues they choose for any given season; they literally mold and manage color so that it attracts or titillates the consumer's eye.

Obviously, fashion designers feel that color is an integral element of their work and recognize its emotional tug at the consumer level. The colors that appear first in fashion will trickle down inevitably to other design sensibilities, including graphic design.

In this modern age of instantaneous global communication, the pecking order is not as rigid as in the past, when new colors were first embraced by fashion where they remained firmly entrenched for several seasons (or years) before designers and manufacturers adopted and adapted them for other design areas. Today the crossover of colors can happen within a matter of days as graphic designers access and adapt to the latest trends.

In the late 1980s, environmentalism was gaining ground as a sociological issue that encouraged the use of recycled paper and discouraged the use of toxic chemical inks that were used in the bolder colors. As a result, nonbleached hues like beige and off-white became the colors of the moment in consumer goods, including clothing, home furnishings, packaging, and paper.

More recently, the graphic arts industry has spawned some of the most creative and unique color combinations and outrageous images that are constantly flashing on www.whatever.com. Colors bombard the public from a vast variety of other venues as well—from point of purchase to slick magazines, newspapers, catalogs, and billboards to the ubiquitous fashion reports on MTV, E! (Entertainment) Channel, and CNN. As a result of all of this exposure to color, the consumer is more savvy than ever; he or she expects to see new color offerings in all products, so it behooves the smart designer to stay ahead of the curve.

To stay on the cutting edge of what's happening in color, it is imperative to understand the events that brought them to the forefront. From a purely psychological and sociological perspective, forecasted colors are inspired by many aspects of lifestyle. For example, when designer coffee became the rage in the mid 1990s, coffee browns came forward in every area of design.

It is the attitudes and interests of the public at large — not only through entertainment and fashion icons — and their important social concerns, needs, desires, fears, and fantasies that may spawn the newest color trends.

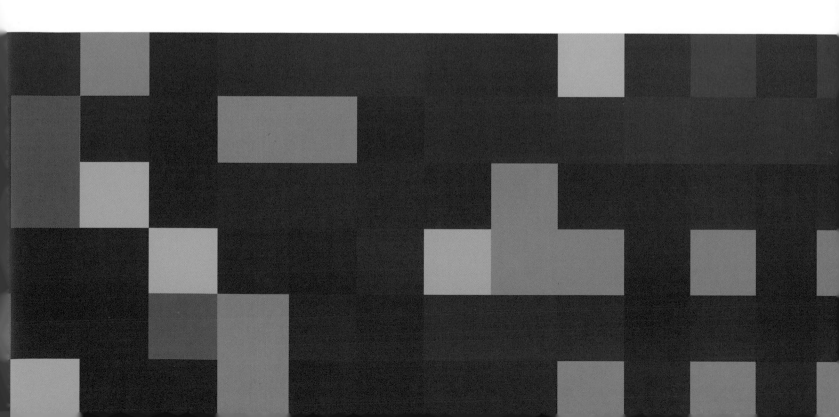

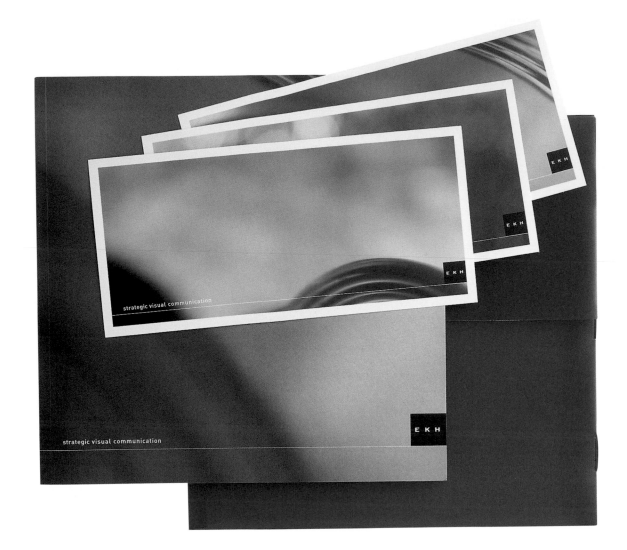

EKH CORPORATE PROFILE

Client EKH Design
Design Firm EKH Design
Art Director Anna Eymont
Designer Rebecca Lloyd
Photographer Greg Havemza
Palette Blue / Silver

PROJECT DESCRIPTION
EKH Design, an Australian design firm, tackled the job of creating its own corporate profile—never an easy task when a firm must evaluate its own products and services.

PROJECT CONCEPT
Designers photographed tin cans to symbolize different forms of communication and placed these images on the cover and introductory pages of the brochure. The abstract images "convey the creative nature of our business and the blue feel gives us a point of difference among other design businesses," says Anna Eymont.

COLOR DESIGN
Blue was chosen for the corporate profile because it communicates calmness, professionalism, and creativity, according to designers. Everything from the blue plastic envelope to the interior brochure carries the blue theme, which uses a variety of hues.

SEGA TRADE SHOW GRAPHICS PROMOTION

Sega	Client
Mires	Design Firm
John Ball	Designer
Cyan / Black / Red / Blue / White	Palette

PROJECT DESCRIPTION

Mires was asked to create an identifying graphic image to be used at a gaming industry trade show to promote Internet playing products. The image was to appear on everything from binders to banners.

PROJECT CONCEPT

Mires wanted to utilize Sega's previous success with its prime target market, twelve to twenty four, and employ graphics and color that were aggressive, mysterious, and borderline ghoulish. Using mystery and intrigue, these graphic features would entice Sega players to play online.

COLOR DESIGN

Although they wanted to keep within the color families of blue, red, and white, Mires adjusted and intensified the color, replacing royal blue and primary red with an intense cyan blue and hot orange. In addition to the evocative choices, color placement was crucial to the design. The unexpected blue field on the faces made them mysterious, whereas the hot orange on the type added a reference to computerized game playing.

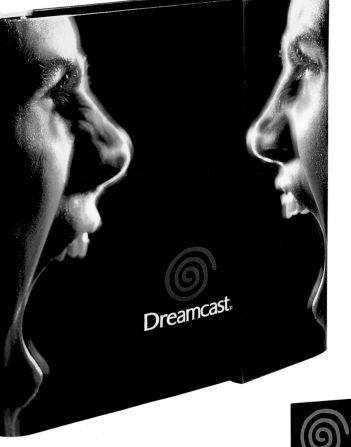

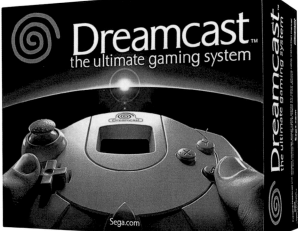

PACKAGING SYSTEM FOR QUALCOMM'S TELEPHONE

Design Firm	Mires
Creative Director	Jose Serrano
Graphic Designer	Deborah Hon
Palette	Warm Yellows / Greens / Warm Reds / Oranges / Cool Blues

PROJECT DESCRIPTION

Qualcomm worked with a design team headed by creative director Jose Serrano of Mires Design Inc., San Diego, California, to come up with a concept for marketing their telephone product.

PROJECT CONCEPT

The Mires concept involved changing the nature of how a telephone is marketed from a commodity to an attractive, impulse product. Rather than using corporate design and colors that presented the product as an accessory to a larger product system, Mires created packaging that had shelf impact. They achieved this by using models with an international flair with assertive poses and by using contrasting, high-intensity color.

COLOR DESIGN

By intention, Mires uses colors that are not corporate but are consistent with the international look of the graphics. On the sides of the box, the highly intense and somewhat techno-slick colors work to create contrast with the models that appear monochromatic. However, on the box top, the color submerges the ear and mouth body parts. Different palette groupings accompany different models. The visual variety gives the stacked items a colored blocklike appearance. Together they serve as a vivid point-of-purchase display creating a product that sells itself.

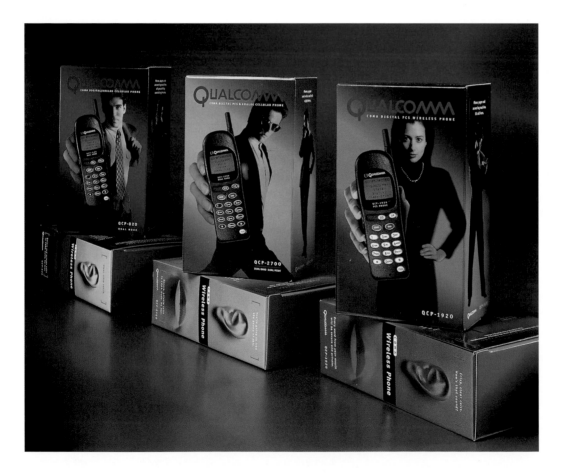

ESPN	Client
Cross Colours	Design Firm
Joanina Pastoll / Janine Rech	Creative Directors
Justin Wright	Designer
David Pastoll	Photographer
Red / Black	Palette

PROJECT DESCRIPTION

ESPN, the cable sports network, wanted a print campaign to promote the 2000 Summer X-Games, the *X* standing for extreme sports.

PROJECT CONCEPT

To demonstrate the extreme nature of ESPN's X-Games, "which sometimes verge on shocking, red and black were used aggressively," says Joanina Pastoll.

COLOR DESIGN

Dramatic, mood photography sets the stage for this print campaign, which was then colored in red and black—aggressive colors that played to the extreme headline "You're gonna die. So die trying." The color palette only seems to heighten the details in the vivid photography, which contributes equally to the message. The aggressive players don't seem to mind their battle scars, which drip black blood, so intent are they on their goal. This is not a print campaign that the casual reader glosses over.

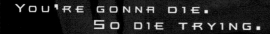

GENESIS, A STUDY IN MEANS, FRASER PAPER

Design Firm	The VIA Group
Art Director	Oscar Fernandez
Designers	Oscar Fernandez / Andreas Kranz / M. Christopher Jones
Copywriter	Wendie Wulf
Production	Shelly Pomponio
Palette	Browns / Tans / Greens / White / Gray-Blue

PROJECT DESCRIPTION

Fraser asked VIA to create a promotional piece that would increase awareness and, thus, reinvigorate the Genesis uncoated recycled product line. The target audience was senior management designers making essential paper selections for pieces such as annual reports, brochures, and fine books.

PROJECT CONCEPT

Working with the original product name Genesis, VIA used the nautilus shell as a symbol of balance, proportion, beauty, and visual order. The shell and the piece itself were representative of the continual transformation of natural materials according to the system of visual organization drawn from nature and man. The swatch book was also a demonstration piece for high-end printing techniques. In order to portray flexibility, the beautifully narrated book was created in a four-color process and was filled with many different printing techniques.

COLOR DESIGN

The theme of natural color is prevalent throughout the book. Type colors often matched the colors of the paper, and there is a list of paper colors in color-appropriate type on the last page. In addition to the use of neutral colors, primary color is used for visual excitement on the cover and throughout the book.

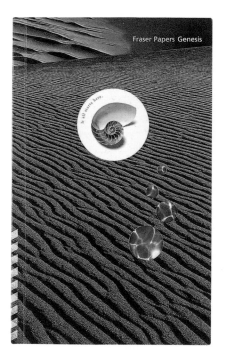

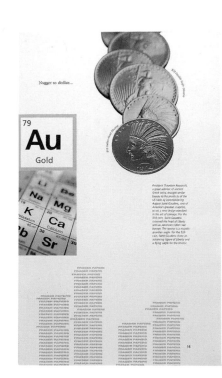

Copper

Fossil

Blue

Rain

Smoke

Tallow

Tortoise

Green

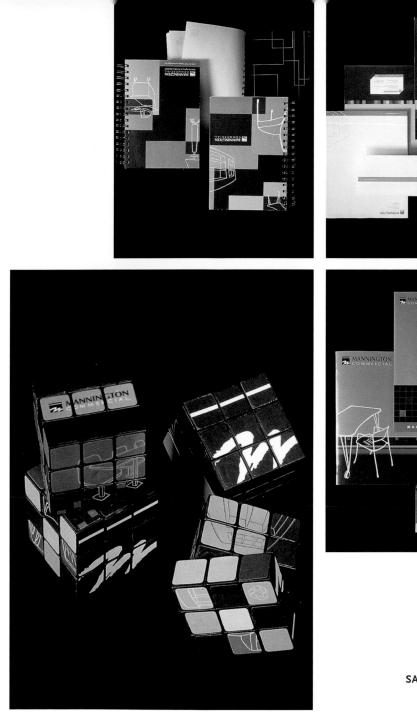

SAMPLE BOOKS FOR MANNINGTON COMMERCIAL

Mannington Commercial	Client
Supon Design Group	Design Firm
Supon Phornirunlit	Creative Director
Pum Mek-Aroonreung	Art Director
Todd Lyda, Jennifer Higgins, Todd Metrokin	Designers
Jae Wee	Illustrator
Dusty Purples / Blues / Orange / Green / Primary Red / Yellow	Palette

PROJECT DESCRIPTION

Mannington Commercial asked Supon Design Group, a Washington, DC, design firm, to redefine Mannington's product through swatch books and collateral material. Rather than being solely dependent on a consumer-based client, they wanted to expand their target market to include a more sophisticated group of architects and interior designers. Their primary purpose was to attract a more upscale clientele.

PROJECT CONCEPT

Supon Design Group used a series of line drawings of interior furnishings that were then superimposed on top of gridlike graphics. They created eight to ten designs that identified with a modern upscale target market. The idea was to create sample books that took color and design trends into consideration while creating pieces that would last up to ten years. The clean architectural renderings combined with the color graphics created a modern, timeless look.

COLOR DESIGN

The color and design served as a device to attract designers and architects to explore the Mannington product. Color worked integrally with the line drawings to create visual movement across the sample covers and within the architectural renderings. Toned-down colors are combined with a layering design technique to give the books a more corporate and professional look.

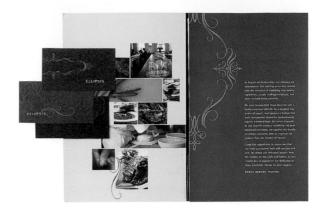

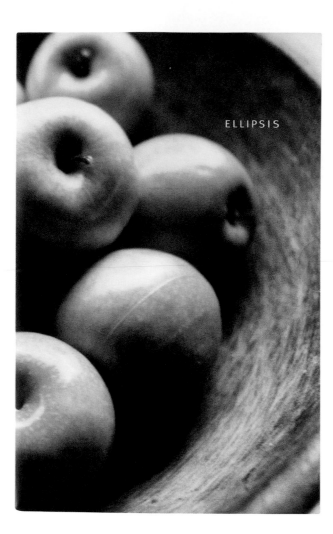

CATERING MENU FOR ELLIPSIS RESTAURANT

Client Ellipsis
Design Firm Dinnick and Howells
Graphic Designers Sarah Dinnick and Jonathan Howells
Palette Greens / Eggplants / Creams

PROJECT DESCRIPTION

Nancy Barone, proprietor of Ellipsis restaurant in Toronto, Canada, asked Dinnick and Howells to design a catering menu and business cards for their restaurant, which serves hearty and healthy foods. A neighborhood favorite, the eatery was designed in rich brown, earth tones, and white woods with a cream bar.

PROJECT CONCEPT

Using the menus and other collateral materials, Dinnick and Howells wanted to communicate the idea that "food and pleasure are synonymous. "Because they wanted to support the feeling of the restaurant, "which was created with the intention of combining high quality, classic cooking techniques and down to earth comforts," Dinnick and Howells came up with the idea of using warm, earthy food colors and antique dingbats from the restaurants as a pattern for the back of the menus and the business cards.

COLOR DESIGN

Soft, natural imagery and color supported the leaning toward health organic food. Rich eggplants and apple greens were used for the cover and business cards, whereas toned-down values of greens, blues, and creams were used for the back of the menu. Green-apple greens and grays were dominant colors in the photographic images on the back and front.

Yosemite National Park	Client
MOD/Michael Osborne Design	Design Firm
Paul Kagiwada	Creative Director
Purples / Blues / Deep Reds / Oranges / Greens / Brown	Palette

PROJECT DESCRIPTION

Because Yosemite National Park workers were concerned with public behavior toward the bear population, they hired Michael Osborne Design to create a wild bear awareness campaign. The primary concern was warning people about the dangers of feeding bears and leaving food in their cars. T-shirts and posters were to be manufactured as part of the campaign.

PROJECT CONCEPT

The park wanted people to leave the bears alone, thereby keeping them wild, so Michael Osborne Design created a concept that revolved around the idea that bears are not friendly. Although the T-shirts and posters needed to be consumer-friendly, the image had to give the feeling of standoffishness. Graphics and color had to be used to distance people from the bears.

COLOR DESIGN

The color supports the seriousness of the bear issue. While the six colors are rich, dark, and muted, combined their discordancy creates an unsettled feeling. Because these discordant colors create a jarring, uncomfortable sentiment, the design succeeds in conveying a sense of danger.

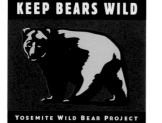
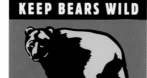
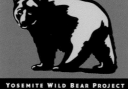
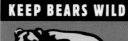

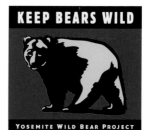

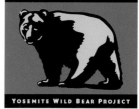

PEARL JAM CONCERT POSTER

Client Pearl Jam
Design Firm Ames Design
Designer Coby Schultz
Palette Hot Red / Lime Green / Blue

PROJECT DESCRIPTION

Pearl Jam hired Seattle-based Ames Design to create a series of concert posters for their last tour. Ames Design created a limited-edition silkscreen poster for each venue and the band sold them during the concert.

PROJECT CONCEPT

Coby Schultz used the concept of bold and prehistoric images placed in an unconventional setting to create a cool, avant-garde feeling. He wanted to enhance a feeling of spontaneity and excitement. The image was reinforced by using fluorescent inks and futuristic type. Schultz cropped the drawing so that it would take a minute for the viewer to see what was going on.

COLOR DESIGN

Schultz chose the fluorescent inks to intensify an already bold image and give the overall piece a futuristic feel.

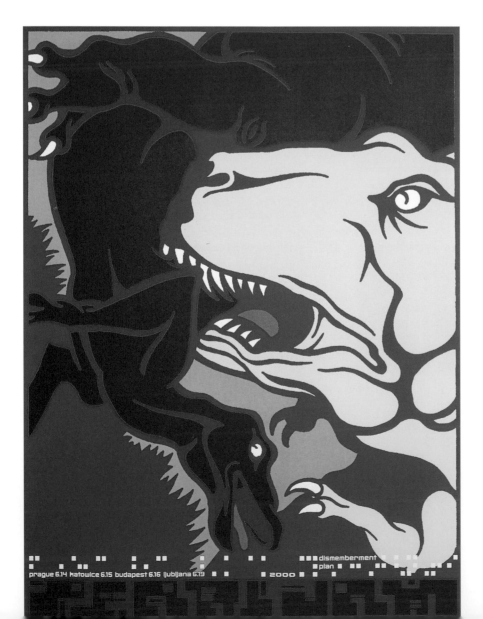

Face à Face	Client
Metzler and Associates	Design Firm
Mark Antoine Herrmann	Creative Director
Mark Antoine Herrmann, Fabienne Grosslerner	Graphic Designers
Greens / Purples / Pinks / Oranges / Turquoise	Palette

PROJECT DESCRIPTION

Face à Face, a French designer eyewear company with markets in Europe, Japan, and the United States, asked Metzler to create a new identity that included packaging and collateral literature. The product development reflected both the designer's attitude toward the clean and functional, while the product was perceived as part of the luxury business.

PROJECT CONCEPT

Metzler and Associates wanted to create a two-sided identity: one side with a clean, simple, and elegant logo and the other side with a bright and colorful look. The patterns stemmed from a lively interpretation of the former logo design.

COLOR DESIGN

Metzler chose a vivid fashion-based color palette that will change and evolve in a timely way with fashion trends. The stationery was created to provide great color contrast between the front and back and to inject an element of surprise into the product.

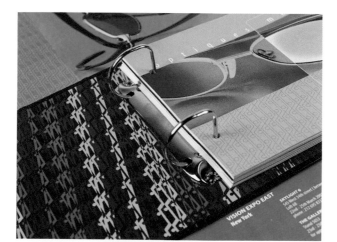

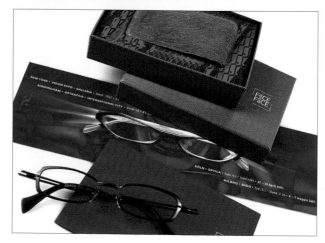

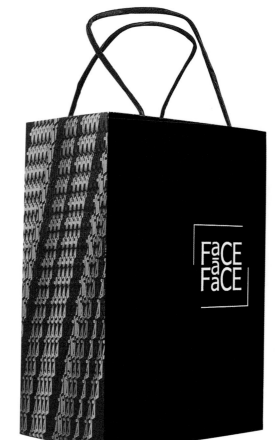

Color That Changes Your Perspective

Because the designer wants to alter the viewer's perception, color that changes a person's perspective is perhaps the most difficult and creative use of color in graphic design. It is difficult because the color acts as the antagonist for the change in perception and is integral to the strategy of the piece. It is the relationship between what is expected and what is actually presented that creates interest and excitement.

Color that changes your perspective can be at the basis of the design strategy. For example, VIA uses gray in the gofish.com logo to suggest a mixing and a union—rather than a transaction—between the buyer and the seller. KBDA creates a fun promotional piece that portrays the idea that clients and designers don't always agree on color selection or meaning. The relationship between the words and the colors are integral to the piece.

Color can also support and enhance an unusual design concept. In the Lee direct-mail piece designed by Fitch, a tribal tattoo design uses cutouts to reveal bright shirt colors beneath. It is the only bright color in the mailing. The Molecular Bio-systems

annual report by Cahan and Associates uses color to show a loose affiliation between subject matter and visual design. Although the color pink suggests human flesh, thereby giving the medical technology a human quality, it supports the design strategy by creating a low-intensity and low-contrast image.

Another way in which color can be used to change a person's perspective is to employ color that is intentionally different from the norm. In the Christmas CD mailed out for Albertsen and Hvidt, re:public used orange instead of red to represent a "controllable wild." "Incorrect color" was also used by Cahan and Associates in the Consolidated Paper book on annual reports in which green chapter heads replace corporate blue. The book itself has a chapter on corporate blueness, showing the intended choice of green. It is through that intentional manipulation of color that color changes a person's perspective.

FRANKFURT—STADT POSTERS AND FLYER

Client	City of Frankfurt am Main
Design Firm	Büro für Gestaltung
Art Directors	Christoph Burkardt / Albrecht Hotz
Palette	Pink / Teal / Blue / Green / Yellow

PROJECT DESCRIPTION

Frankfurt—Stadt der Wissenschaften is an annual exhibition that features a wide variety of scientific institutions in Frankfurt, Germany, ranging from humane organizations to those in natural science. With so many organizations represented, the exhibition needed promotional materials that would build attendance.

PROJECT CONCEPT

Designers chose a color palette that would demand attention for these organizations that are often thought of as boring and staid. No tranquil palettes would do for this group; instead, designers took the opposite approach and went for a palette that screamed "Wow!"

COLOR DESIGN

"The colors attract attention to these often overlooked institutions as well as showing the wide spectrum in contrasting colors," says Albrecht Hotz.

Team 7 International	Client
Julia Tam Design	Design Firm
Julia Chong Tam	Art Director
Julia Chong Tam	Designer
Julia Chong Tam	Illustrator
Green / Yellow / Fuchsia / Purple / Black / Gold	Palette

PROJECT DESCRIPTION

For Team 7 International's annual New Year's card, Julia Tam Design set to work on the Year of the Dragon design. She wanted to avoid depicting a black-and-white or gold dragon as is seen on most commonly used cards.

PROJECT CONCEPT

Not wanting the card to appear commonplace, Julia Tam decided to transform her dragon into a bright colorful one that intertwines with the numbers 2000. "Adding pattern in the numbers, checkers, stripes, dots, wiggles in bright, primary colors makes it not only colorful but interesting," says Tam. Gold foil adds an additional point of interest and panache.

COLOR DESIGN

The vibrant, rainbow-colored dragon with its interesting die-cuts and accordion folds stands apart from most Year of the Dragon visuals, which tend to stick to a palette of red, black, white, and gold. This card's differences make it memorable.

BROWN JORDAN CATALOG, PRESS KIT, AND MARKETING MATERIAL

Client Brown Jordan
Design Firm 5D Studio
Art Director Jane Kobayashi
Designer Jane Kobayashi
Palette Silver

PROJECT DESCRIPTION

Brown Jordan, manufacturer of outdoor furniture, was introducing a new category of furniture—stainless steel—and needed a high-end catalog that would provide the entry into this market.

PROJECT CONCEPT

"We designed the catalog to highlight stainless [steel] by using metallic silver," says Jane Kobayashi. The trick was that Kobayashi didn't just use silver as an accent color, but also as the background to four-color images printed on clear polyester to carry the stainless steel theme throughout the catalog and all the marketing materials.

COLOR DESIGN

The catalog's cover and divider pages are printed with four-color images on transparent polyester. The pages underneath have metallic silver gradations, which become the background for the polyester images. The facing pages to the dividers feature silver halftones that work with the polyester divider page when it is turned and laid on top.

Similar techniques are also carried through the press kit folder, advertising campaign, and other marketing materials.

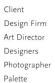

Holden Color Inc.	Client
Barbara Brown Marketing & Design	Design Firm
Barbara Brown	Art Director
Barbara Brown / Jon Leslie	Designers
Z Studios	Photographer
Metallic Gold / Silver / Cyan / Red / Yellow	Palette

PROJECT DESCRIPTION

"When Barbara Brown Marketing & Design was given the opportunity to create a direct mail program for a large printer, we knew we might be pioneering a new way of printing," says Barbara Brown.

PROJECT CONCEPT

Instead of using regular cyan, magenta, yellow, and black inks, the designers used the metallic equivalents. "The result is a unique, complex palette full of depth and almost three-dimensional effects that provides an antique tone complementing the brochures' melodramatic, silver screen theme," states Brown.

COLOR DESIGN

One challenge to using this technique of replacing the traditional four-color process inks with their metallic equivalents meant that designers were not able to obtain a true proof before the matchprint.

To capture the movie theme, designers placed die-cuts on the cover of each brochure to mimic the look of a film strip that reveal just enough of the images below to pique reader's interest and get them to open the brochure.

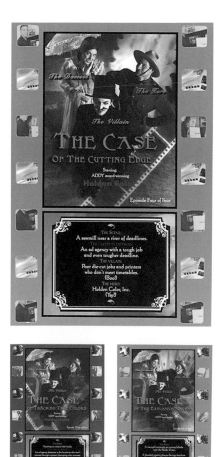

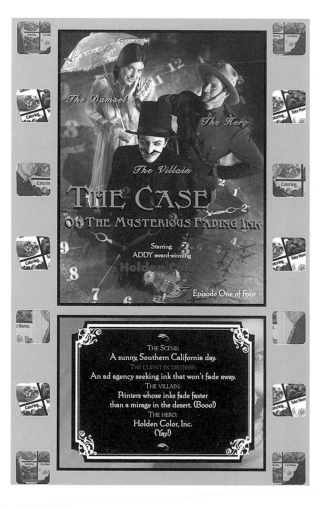

"ALL SIDES CONSIDERED" BOX SHOW

Client	Grand Rapids Public Art Museum
Design Firm	Palazzolo Design Studio
Art Director	Gregg Palazzolo
Designer	Mark Siciliano
Palette	Yellow / Purple / Black / Green / Orange

PROJECT DESCRIPTION

To promote a box show where area artists created all boxes, the Grand Rapids Public Art Museum tapped Palazzolo Design Studio for ideas.

PROJECT CONCEPT

Playing off the title of the public broadcasting program, "All Things Considered," Palazzolo Design Studio developed a box with the theme, "All Sides Considered," to promote the event. "Highlighting a primary palette on different sides of the three-dimensional illustrated boxes conceptually relates to the show," says Gregg Palazzolo.

COLOR DESIGN

The color palette is striking, eye-catching, fresh, and contemporary, which seems to make the geometric shapes stand out even more than they ordinarily would. "Having a strong field of yellow in the background only gave more emphasis on the box itself," adds Palazzolo.

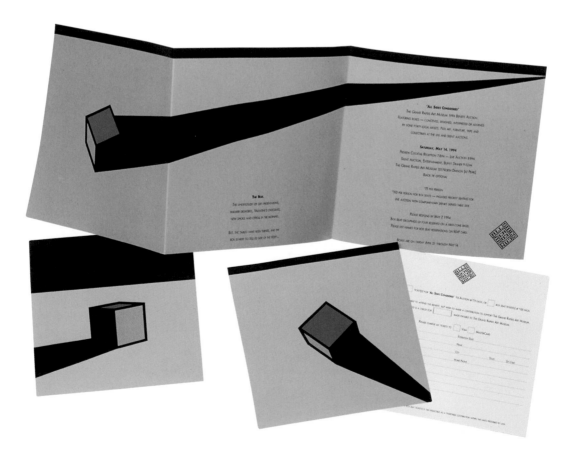

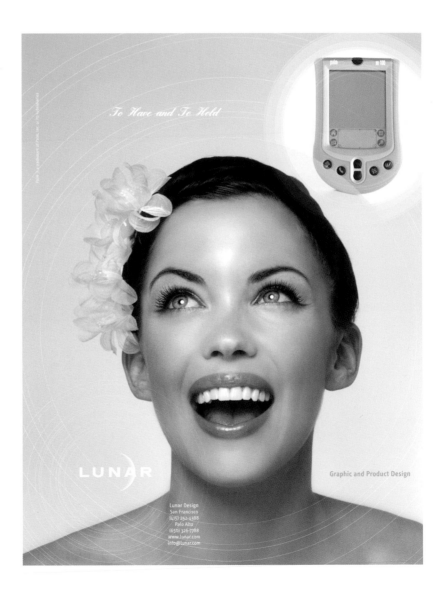

TO HAVE AND TO HOLD BRIDE AD

Lunar Design	Client
Lunar Design	Design Firm
Kristen Bailey	Art Director
Florence Bautista	Designer
Sam Yocum	Photographer
Pink	Palette

PROJECT DESCRIPTION

Lunar Design needed a self-promotional ad to appear in key graphic design publications including *ID* magazine, *Design Report* from Germany, and *Axis* from Japan. No ordinary ad would do. "Lunar wanted its ad to stand apart from the typical product-design magazine ads, which tend to feature contextless images of products," says Kristen Bailey.

PROJECT CONCEPT

Designers created the ad by selecting type and designing the layout to be reminiscent of a wedding invitation. "The pinkness of the bride ad communicates not only to the target audience—we designed this product for a nonbusiness user—but shows the personalization aspects of the product," says Bailey.

COLOR DESIGN

Using a palette of pink, pink, and more pink, according to Bailey, the ad stands out. "Overall, the ad visually and subtly conveys Lunar's ability to turn people's needs into beautiful and functional products."

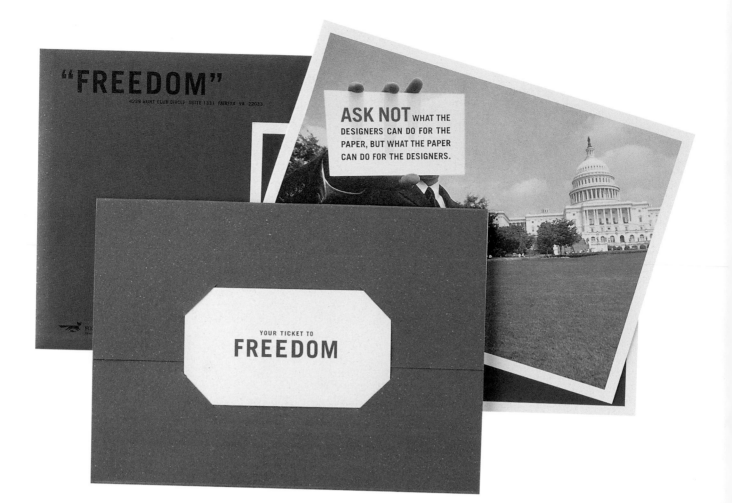

FREEDOM OF DC PARTY INVITATION

Client	Fox River Paper Company
Design Firm	Mek-Aroonreung / Lefebure
Art Directors	Pum Mek-Aroonreung / Jake Lefebure
Designers	Pum Mek-Aroonreung / Jake Lefebure
Copywriter	Steve Smith
Photographer	John Consoli
Palette	Red / White / Blue

PROJECT DESCRIPTION
Fox River Paper Company was hosting a party for Washington, D.C.–area designers and needed a party invitation that would generate a turnout for the event that kicked off at 9:00 P.M.

PROJECT CONCEPT
"The freedom concept took historic quotes and used them in the invitation for designers to come to the paper company party," says Jake Lefebure. "We selected the [Fox River] Sparkles paper to create a retro look and feel. Also, the red envelope, blue wrap, and white mini ticket make the piece fit together by reinforcing the freedom theme."

COLOR DESIGN
Designers heavily saturated the CMYK images to draw out the sparkles in the paper stock. "The muted tones and oversaturated color photos make the piece have a unique look and feel," adds Lefebure.

SMPV / SSPM LOGOTYPE

Swiss Musicpedagogic Association (SMPV)	Client
Niklaus Troxler Design	Design Firm
Erich Brechbühl	Art Director
Erich Brechbühl	Designer
Green / Rhodamine Red	Palette

PROJECT DESCRIPTION

The assignment: create a logo for the Swiss Musicpedagogic Association.

PROJECT CONCEPT

Erich Brechbühl tackled the job with two colors—a vibrant green and hot pink—and only used the acronym from the client's name—SMPV/SSPM.

COLOR DESIGN

He colored the letters, set in the typeface Globus, in each of the two hues of the palette and seemingly sliced the letters apart and interlinked them. Thanks to the expert use of color and placement, the finished logotype actually seems to show the vibration of music, which is what the association is all about.

Consumer Reaction to Color

by Leatrice Eiseman

Word-association studies that ask respondents for their reactions to color often show a marked similarity across the population. The dominant colors in the following list will generally elicit similar responses. These colors and consumer responses are taken in part from *The Pantone Guide to Communicating with Color*, published by Grafix Press. Note that for most colors, the positive responses are far more prevalent that those that might be thought of as negtive.

DOMINANT COLORS AND RESPONSES

Bright Red:
Exciting, energizing, sexy, hot, dynamic, stimulating, provocative, dramatic, aggressive, powerful

Light Pink:
Romantic, soft, sweet, tender, cute, babyish, delicate

Burgundy:
Rich, elegant, refined, tasty, expensive, mature

Fuchsia:
Bright, exciting, fun, hot, energetic, sensual

Orange:
Fun, whimsical, childlike, happy, glowing, vital, sunset, harvest, hot, juicy, tangy, energizing, gregarious, friendly, loud

Bright Yellow:
Enlightening, sunshine, cheerful, friendly, hot, luminous, energetic

Greenish Yellow:
Lemony, tart, fruity, acidic

Beige:
Classic, sandy, earthy, neutral, soft, warm, bland

Coffee or Chocolate:
Rich, delicious

Deep Plum:
Expensive, regal, classic, powerful, elegant

Lavender:
Nostalgic, delicate, sweet, scented, floral, sweet-tasting

Orchid:
Exotic, flowers, fragrant, tropical

Sky Blue:
Calming, cool, heavenly, constant, faithful, true, dependable, happy, restful, tranquil

Bright Blue:
Electric, energetic, vibrant, flags, stirring, happy, dramatic

Navy:
Credible, authoritative, basic, classic, conservative, strong, dependable, traditional, uniforms, service, nautical, confident, professional, serene, quiet

Aqua:
Cool, fresh, liquid, ocean, refreshing, healing

Dark Green:
Nature, trustworthy, refreshing, cool, restful, stately, forest, quiet, woodsy, traditional, money

Bright Yellow-Green:
Artsy, sharp, bold, gaudy, trendy, tacky, slimy, sickening

Black:
Powerful, elegant, mysterious, heavy, basic, bold, classic, strong, expensive, magical, nighttime, invulnerable, prestigious, sober

Taupe:
Classic, neutral, practical, timeless, quality, basic

Gold:
Warm, opulent, expensive, radiant, valuable, prestigious

PRECIS BROCHURE

Client	Millward Brown
Design Firm	Lewis Moberly
Art Director	Mary Lewis
Designers	David Jones / Bryan Clark
Illustrators	Bryan Clark / Steven Sayers
Palette	Red / Yellow

PROJECT DESCRIPTION

Client Millward Brown needed a brochure to market Precis, a software brand in the media analysis sector that explains its services in simple terms.

PROJECT CONCEPT

"Color is used in a literal way to change perspective and to explain the key attributes, services, and benefits that Precis can offer," says Mary Lewis. Red, aside from being an attention-getting color that communicates vibrancy and strength, is used here to create visual trickery that helps keep reader interest high.

COLOR DESIGN

The red brochure includes interleaved color film that renders part of each printed line illustration invisible until the film page is turned. "The revealed remainder of the illustration changes the viewer's perception of what he thought he was seeing," says Lewis.

The red film demands attention and the yellow pages signal caution—you can't always trust what you see.

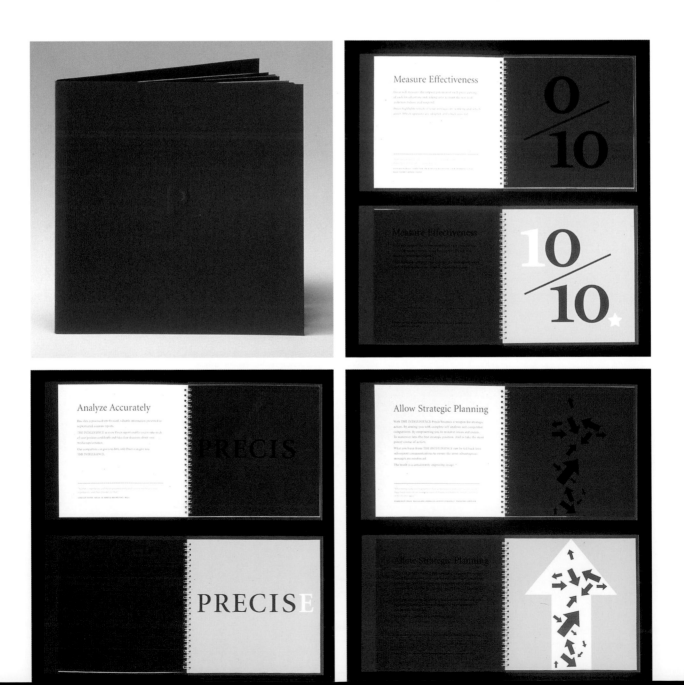

COMMISSION FOR WOMEN 20 YEARS POSTER

Pennsylvania State University Commission for Women	Client
Sommese Design	Design Firm
Kristin Sommese	Designer
Lanny Sommese	Illustrator
Hot Pink / Orange / Green / Purple / Blue / Black	Palette

PROJECT DESCRIPTION

Penn State's Commission for Women was celebrating its twentieth anniversary and wanted Sommese Design to create a poster to commemorate the event.

PROJECT CONCEPT

In an effort to show the organization's growth over twenty years, Sommese Design created a simple illustration of flowers and trees reaching for the sky but, although these images are what we might expect to see, the color palette is not. Color placement is unexpected; the sky is green and the grass is blue.

COLOR DESIGN

Originally, a bright red was specified to appear where hot pink and orange is currently. "I had intended for the flower centers and the sun to be connected visually through color that was bright and vibrating," says Kristin Sommese, who reviewed the proof and didn't think the colors were as intense as they needed to be. "I determined that if we printed a fluorescent spot color instead of the red generated through a full-color separation, I would get the intensity I was looking for. This was something I could never have considered but I liked the quirkiness of it in relation to the other colors."

THE BLACK DOG FOUNDATION

THE BLACK DOG FOUNDATION LOGO

Client The Black Dog Foundation
Design Firm Cato Purnell Partners Pty. Limited
Palette Red Orange / Black

PROJECT DESCRIPTION

The Black Dog Foundation, an organization that counsels for depression, tapped Cato Purnell Partners for a logo that avoided a clinical appearance, yet spoke to the organization's mission.

PROJECT CONCEPT

The symbol for the foundation took its inspiration from Winston Churchill on two counts. First, it incorporates his *V* for victory salute as well as the fact that he always likened depression, from which he suffered, to a black dog constantly lurking.

COLOR DESIGN

To portray these complex messages visually, designers incorporated the victory salute into a finger-puppet shadow display where the salute is prominent in the foreground, while a dog appears in the shadow... constantly lurking. Black was the obvious choice for the dog's shadow, which communicates depression and lack of warmth. More important, by using this technique, designers sidestepped the obvious black dog motifs of Labrador retrievers and other black breeds, which are now commonplace on logos ranging from beer to clothing.

AURORA / LIGHT FANTASTIC

Darling Harbour Authority Client
Cato Purnell Partners Pty. Limited Design Firm
Primary colors Palette

PROJECT DESCRIPTION

Australia's Darling Harbour Authority retained Cato Purnell Partners to promote its summer "light festivals" in a nighttime party environment.

PROJECT CONCEPT

The concept was inspired by the "painting with light" technique that is used during the light festivals. However, Cato Purnell Partners recorded this light show on film and then transformed these nighttime images into abstract pieces of art.

COLOR DESIGN

"The film images were translated into raw primary colors to give an abstract interpretation of the intent of the festivals," say the designers. The result is almost like a negative piece of film, only here, the colors are vibrant and designers exchange them and mix and match them at will. By using a primary color palette, they achieve an energy against the dark background that is closely akin to the show of light on night sky, despite the obvious limitations of being reproduced as ink on paper.

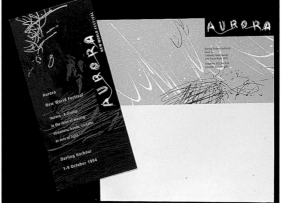

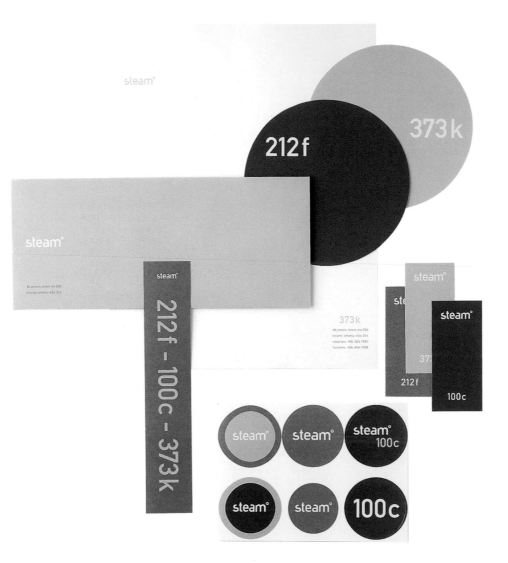

STEAM FILMS STATIONERY SYSTEM

Client	Steam Films
Design Firm	Blok Design Inc.
Art Director	Vanessa Eckstein
Designers	Vanessa Eckstein / Frances Chen / Stephanie Yung
Palette	Dark Blue / Medium Blue / Light Blue

PROJECT DESCRIPTION

Steam Films, an innovative film company, needed a stationery system that reflected its unique creativity. Blok Design Inc. came on board to deliver the identity.

PROJECT CONCEPT

"The entire concept behind Steam was to express that unique creative moment—as if a boiling point—in which one state is transformed into another," says Vanessa Eckstein. The idea that steam is a changing thing—occurring only after water is heated—called for an equally fluid and changing identity. Hence, designers chose to use a palette based on three shades of blue—blue because of its association with water and three shades to graphically illustrate the changing state of steam.

COLOR DESIGN

"We chose three colors of blue from light to dark and three numbers that reflect that moment in three different measurements to enhance the concept," says Eckstein. "These visual elements flow in and out of the system building a dynamic of its own."

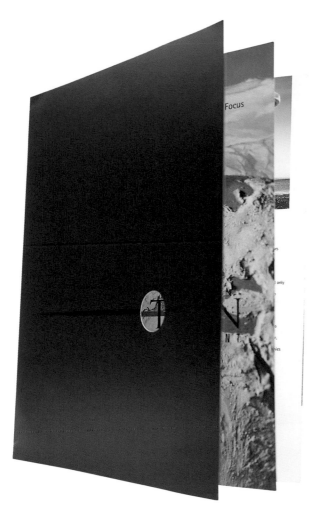

LAKETON INVESTMENT MANAGEMENT PROMOTIONAL BROCHURE

Laketon Investment Management	Client
The Works Design Communications Ltd.	Design Firm
Scott Mcfarland	Creative Director
Royal Blue / Gold	Palette

PROJECT DESCRIPTION

The Works Design Communication Ltd. was asked by Laketon Investment Management to create a promotional piece that would reflect its new expansion. The newly created workforce combined fifties conservatives with a young, thirties, up-and-coming group.

PROJECT CONCEPT

The idea for the brochure was to develop a promotional piece that would reflect experience and stability combined with creativity and freshness.

COLOR DESIGN

The brochure design revolved around a key phrase: "Laketon—bringing the world into focus." The new logo, which was the dominant cover done as a circular cutout from the underlying page, was designed to reflect an abstraction of that global view. Pushing a design-forward concept, Scott Mcfarland created an unusual inverted design in which pure color with an integrated logo is on the cover whereas photographic images and corporate name are within. He then stabilizes the inverted design with the choice of rich but traditional colors: royal blue and gold.

441-4 COLORS FOR THE PRICE OF 1

Client Fraser Papers, Inc
Design Firm The VIA Group
Designers Oscar Fernandez / Andrea Kranz
Copywriters Wendie Wulf / Kari Lowery ·
Production Shelly Pomponio
Palette Spectrum Colors

PROJECT DESCRIPTION
VIA was asked by Fraser Paper, a paper manufacturer of uncoated cover and commercial papers, to create a print piece for the Fraser Brights/Torchglow Opaque product line. The object was to increase sales and to increase awareness that colored paper was a reasonable way to create design without the expense of four-color processing.

PROJECT CONCEPT
The idea was to challenge designers on a limited budget to create dramatic and interesting impact with one color. The theme "4 colors for the price of 1," in addition to being a promotional piece, could also be used as an instruction book that showed designers a variety of ways to use colored paper in their designs.

COLOR DESIGN
Design and color were promoted as the key ingredients in communication as an alternative to the use of expensive printing techniques. Each color of paper was treated as an individual graphic work that explored the use of halftones, line art, illustrations, blurred images, hand-drawn elements, and other design options. The materials explored various design possibilities and promoted the idea of the strength and flexibility of a singe color choice. In addition, on each page there were descriptive color associations and an ongoing poetic text.

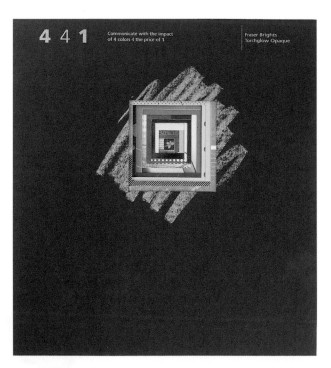

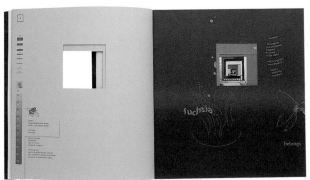

KBDA PROMOTIONAL PIECE

KBDA	Client
KBDA	Design Firm
Barbara Cooper	Creative Director
Barbara Cooper	Designer
Black / Blue / Mango / Blue-Green / Peony / Burgundy / Yellow-Green / Brown	Palette

PROJECT DESCRIPTION

The purpose of the promotional piece was to look at the difference in response between the client and the designer.

PROJECT CONCEPT

The concept behind the piece was to show awareness on the part of the designer that the client's response to color is often very different from that of the design team. The multi-colored strip shows a designer's understanding of the client's interpretation of color. The client's and the designer's color feeling is represented in each color square.

COLOR DESIGN

The color design identifies two different types of responses to individual colors. The color strip says "How do you see it" and suggests that designers and clients don't always agree on color interpretation. Not only does it portray meanings for each color, but it shows that there is more than one interpretation. It acts as an educational piece in that it describes color meanings from the more sophisticated designer's point of view.

ANNUAL REPORT FOR MOLECULAR BIOSYSTEMS

Client Molecular Biosystems
Design Firm Cahan and Associates
Creative Director Bill Cahan
Designer Kevin Roberson
Palette Warm Pinks / Magenta / Cyan

PROJECT DESCRIPTION

Molecular Biosystems (MB)asked Cahan and Associates to create an annual report highlighting Optison, an advanced-generation ultrasound contrast agent. Developed and manufactured by MB, the low-dose agent offers doctors a clearer ultrasound image by increasing contrast.

PROJECT CONCEPT

Bill Cahan's conceptual strategy visually portrayed the difference between the low-contrast, fuzzy image provided by regular agents and the high contrast, clear image that the contrast agent provides. By creating fuzzy images that could be interpreted in several ways, Cahan shows the importance of the dye. Using a play on words and images he implies, "Let's show what the world would be without contrast."

COLOR DESIGN

The color design stemmed from a picture of color microspheres given to Cahan. Pink was highlighted because it was a very human, fleshy color, and its pastel nature enhanced the fuzziness of the image, making it harder to decipher. In an image in which clarity had been resolved using the drug, a very intense magenta was used along with a cyan background to show contrast.

WITHOUT CONTRAST, INTERPRETING IMAGES CAN BE A LOT OF GUESSWORK.

WELCOME TO THE NEW AGE OF ULTRASOUND IMAGING. DEVELOPED BY MOLECULAR BIOSYSTEMS, OPTISON™ CONTRAST ECHO HELPS CARDIOLOGISTS DIAGNOSE WITH CONFIDENCE. NO MORE FUZZ-O-GRAMS.

Valentis	Client
Cahan and Associates	Design Firm
Bill Cahan	Creative Director
Sharrie Brooks	Designer
Pink / Rust / Lime Green / Black / Reds / Muted Yellow	Palette

PROJECT DESCRIPTION

Valentis, a high-tech medical firm involved in the development of a broad array of products, technologies, and intellectual property for the delivery of biopharmaceuticals, asked Cahan and Associates to create an annual report.

PROJECT CONCEPT

Cahan and Associates took what was a very abstract medical concept in research stages and tried to create an abstract visual concept. Influenced by art and modern and postmodern architectural theory, they were able to create a visual image. Over the past few years, the medical concept has evolved into products being clinically tested so the design has become more concrete. The arrows on the cover of the 2000 annual report suggest the forward movement into clinical trials of the products.

COLOR DESIGN

The designers at Cahan worked with abstract, fine arts-based color palettes and intentionally added the pink, which is somewhat unusual and jarring, to support the idea of a new and revolutionary concept. The color placement is also used to support the idea of progression.

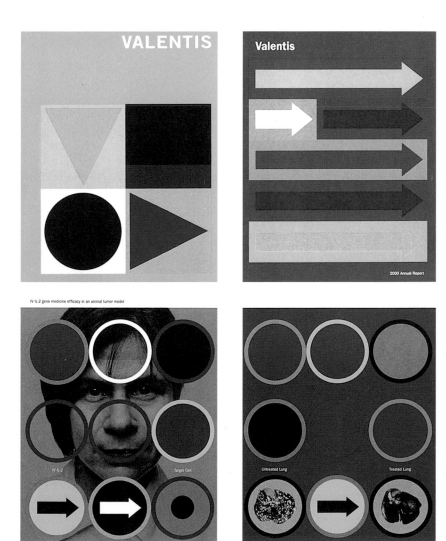

CHRISTMAS CD

Client	Albertsen and Hvidt
Design Firm	re:public
Creative Directors	Athena Windelev / Morton Windelev
Art Director	Athena Windelev
Palette	Orange

PROJECT DESCRIPTION
Re:public was asked by Albertsen and Hvidt, a young consultancy, to create packaging for their Christmas card gift.

PROJECT CONCEPT
The main idea behind the project was to create a new and refreshing image for the consultancy. To create an edge for the piece, the image on the cover is a lamp created by designer Ann Jacobsen, done in a warm orange color.

COLOR DESIGN
The orange is used for aesthetic purposes and sends the powerful message of "a controllable wild." It is interesting that although it is Christmas, orange is used instead of red.

Act AB Client
2GD Design Firm
Jan Nielson / Ole Lung Creative Directors
Silver Gray / Orange Skin Tones Palette

PROJECT DESCRIPTION
Act AB, a Swedish company, asked 2GD to create a strategy for the launching of Boblbee, a unique backpack.

PROJECT CONCEPT
In order to appeal to young urbanites, 2GD composed a strategy which incorporated images of city life for the launch of the Boblbee urban backpack.

COLOR DESIGN
The color scheme for the campaign is dynamic, smooth, and metallic to reflect the identity. The logo remains achromatic to contrast with the intensity of the figures and the silver background color.

Color with a Primary Message

The bold, graphic appearance of color used to convey a primary message clarifies, enhances, and defines images to get the point across fast. More often than not, these strong color choices are easily readable and identifiable and seem to be based on experiential knowledge. Although not as sophisticated or unique, these colors that we view quite frequently generate an immediate response.

Often these colors imply a functional message—as red, green, or yellow traffic lights and signs—or have an everyday, natural association—such as grass green or sky blue. In his promotional piece, 110 Years of Ljubljana Waterworks, Edi Berk used blue to identify and create a common association that people make with water. Green was also used as identification with land.

Primary message color can also be a color affiliated with a strong brand identity. Large corporations such as Coca-Cola and Dunkin' Donuts use red and pink respectively to identify themselves and other products under their domain. The use of a corporate color will give the product a stronger market presence. This was the case for the Levi's invitation—when they talk about true blue, they're talking about the Levi's brand.

In addition to specific corporations, types of industries, groups of people, or age groups can be identified through certain color choices. Primary colors or pastels are used quite successfully when it comes to children's and related industries. Metzler and Associates used primary colors in a logo for Smobey's—a manufacturer of children's toys—to create an association with children.

Primary message color can also be used as a reinforcement of an idea. In the member's journal of the Toronto Art Gallery, designed by Dinnick and Howells, background color is taken directly from the central image on the cover or the artistic period of the artwork. It reinforces the concept and theme of the issue. Primary color can be used to reinforce the strength or meaning of a piece. In the design of the B/Stop Poster by KROG, the familiar red is a universal symbol to halt. Due to cultural experience, these responses are almost innate and, thus, influence our attitude toward them.

Primary message color is the color that "beats its chest." This "here I am and this is my point" type of color is the color of choice to sell merchandise, create a direct link, or make a point clearly and expediently.

UCLA IN LA

Client UCLA—Vice Chancellor/External Affairs
Design Firm Gregory Thomas Associates
Art Director Gregory Thomas
Designers Gregory Thomas / Julie Chan / David LaCava
Illustrator Julie Chan
Palette Red / Blue / Yellow / Orange / Purple / Green

PROJECT DESCRIPTION

UCLA plays an incredibly influential role in Los Angeles County. "Despite its many projects ranging from health care to K–12 education, the university was concerned that its message was not being distributed to its many constituents," says Gregory Thomas of the map/brochure project that was to be titled "UCLA in LA."

PROJECT CONCEPT

To drive home the point that UCLA is accessible throughout the county, designers decided to create a snapshot of UCLA in LA. Using bright colors and geometric shapes to define UCLA's involvement, the poster met all the objectives and more. Color was the prime instrument in illustrating the diverse areas of involvement.

COLOR DESIGN

Color-coding has long been a way to cleanly organize lots of information for easy reference. Here, traditional color-coding goes one step further. A blue cross is used to denote health services programs and their locations and a red house stands for K–12 educational programs, all of which makes for easy reference. But more importantly, when all these symbols are scattered across the map, the color symbols reinforce the message that UCLA is not only in LA,

DUTCH GRAPHIC DESIGN: 1918–1945 EXHIBITION POSTER

Massachusetts College of Art—Boston	Client
Elizabeth Resnick Design	Design Firm
Elizabeth Resnick	Art Director
Elizabeth Resnick	Designer
Elizabeth Resnick	Photographer
Red / Yellow / Blue	Palette

PROJECT DESCRIPTION

Elizabeth Resnick's firm was retained to create a poster to promote an exhibition of Dutch graphic design during the time period between World War I and World War II.

PROJECT CONCEPT

The idea was to develop a poster with a contemporary flair to promote a period of graphic design that was popular more than sixty years ago.

COLOR DESIGN

Resnick used colors popular with the De Stijl aesthetic—a palette of the primaries and the clean lines of Futura—to emphasize the period between 1917 and 1939, which is the same period in which the De Stijl Movement was in full gear. De Stijl, which originated among a group of Dutch artists in Amsterdam, is characterized by its clean type, primary colors, and geometric images.

EDUCATING ARTISTS FOR A MULTICULTURAL WORLD POSTER

Client — Professional Arts Consortium
Design Firm — Elizabeth Resnick Design
Art Director — Elizabeth Resnick
Designer — Elizabeth Resnick
Palette — Red / Yellow / Orange / Blue / Green / Purple

PROJECT DESCRIPTION

The Professional Arts Consortium, which offers educational programming for a consortium of six area colleges dedicated to the visual and performing arts, needed a poster to announce an upcoming seminar.

PROJECT CONCEPT

The seminar, which discussed the benefits of fostering racial and cultural diversity in curricula and on campuses, needed to communicate that diversity is a good thing—something to be promoted.

COLOR DESIGN

Elizabeth Resnick opted to use a rainbow palette as a metaphor for diversity as she built the design. Using all the colors of the rainbow—red, yellow, orange, blue, green, and purple—as a process job, she aptly communicated both visually and metaphorically that racial and cultural diversity can be beautiful.

CONQUEROR—COLOUR SOLUTIONS

Arjo Wiggins	Client
HGV	Design Firm
Pierre Vermeir	Art Director
Damian Nowell / Christian Eves	Designers
Black / Cyan / Magenta / Yellow	Palette

PROJECT DESCRIPTION

Arjo Wiggins, a manufacturer of fine printing papers, needed packaging that would communicate that its new ultrawhite paper, Conqueror—Colour Solutions—was ideal for printing with a color laser printer, inkjet printer, and color photocopier.

PROJECT CONCEPT

The triangular icon that is used universally to signify toner appears traditionally in black. Designers at HGV decided it was time to infuse some color into this familiar icon to symbolize that their client's product can be used in laser printers, inkjets, and photocopiers.

COLOR DESIGN

Designers colored the icon with a palette that comprises four-color process printing—black, cyan, magenta, and yellow (with two secondary hues). The result is a clean package with an unmistakable message.

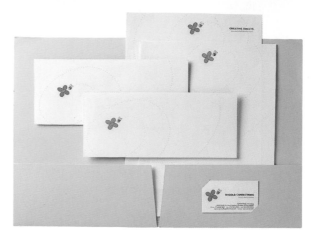

RAGOLD CONFECTIONS STATIONERY PROGRAM

Client	Ragold Confections Inc.
Design Firm	JOED Design Inc.
Art Director	Edward Rebek
Designer	Edward Rebek
Palette	Black / Yellow / Orange / Blue / Purple / Green

PROJECT DESCRIPTION

Ragold Confections Inc., a candy manufacturer that also imports and exports products, manufactures private-label goods, and develops new products, needed an identity system that united the company while distinguishing the different divisions.

PROJECT CONCEPT

JOED Design Inc. developed the bee and flower design, along with the tagline "making sweet things happen" to suggest Ragold Confections' involvement in the process. Rather than creating different color-coded folders for each division, the design team took a more subtle approach.

COLOR DESIGN

Different colored flowers were used to represent each of the company's four divisions. The pocket folder is the only piece that incorporates all the colors in one place—which cut expenses tremendously. Business cards and the folder were printed on the same form as well, resulting in an additional savings. Likewise, the letterhead and envelopes were printed on the same form.

AGT	Client
Grafik Marketing Communications	Design Firm
David Collins / Gregg Glaviano / Judy Kirpich	Designers
AGT	Photographer
Red / Gold / Black / Green	Palette

PROJECT DESCRIPTION

AGT's Retail Solutions brochure is all about color. AGT is a digital-media management company that assigned designers the task of showing the importance of color reproduction for retail clients.

PROJECT CONCEPT

Although the entire brochure was devoted to the message of accurate color reproduction, two interior spreads were of utmost importance. "When retail companies produce catalogs, it is important for the photos of the products to match the color of the original," says David Collins. "In these spreads, we found and photographed a number of pieces of red apparel that were similar in hue, but different. The headline asked, 'When is red not red?'"

COLOR DESIGN

The brochure was printed in eight over eight colors, including both process and match colors in its twelve pages plus cover. The brochure accurately communicates its message—and the reader is reassured that, in fact, AGT knows color. The next time a retailer is producing a color catalog and wants accurate reproduction, AGT is the company to turn to.

TRINET REBRANDING PLAN

Client	TriNet
Design Firm	Kirshenbaum Communications
Creative Director	Susan Kirshenbaum
Designer	Jim Neczypor
Illustrator	Doug Ross
Copywriter	Lessley Berry
Palette	Orange / Periwinkle Blue / Green

PROJECT DESCRIPTION

TriNet outsources comprehensive Human Resources (HR) services to growing businesses. The company wanted an updated brand identity to reflect their new integration of Internet tools and technology into their products and services.

PROJECT CONCEPT

To distinguish TriNet from its competitors, Kirshenbaum Communications created an entirely new marketing program to reflect an organization that is technology-based, yet has a strong human element. Along with rebranding the company, recreating its identity, and redesigning its logo, they developed a tagline, brand standards manual, business system marketing kit (folders, inserts, and templates), and corporate brochure.

COLOR DESIGN

Three colors are used to represent the three different areas of the business. Kirshenbaum suggested that TriNet leave the old turquoise for a more current, Web-friendly color system that is more youthful and energetic. Colors were designed for the Web, process, and print.

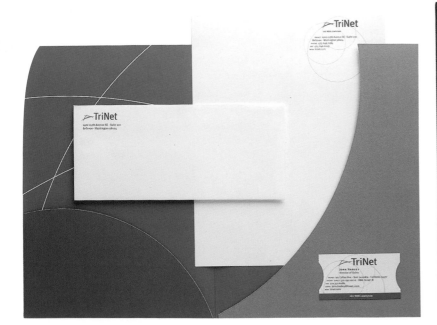

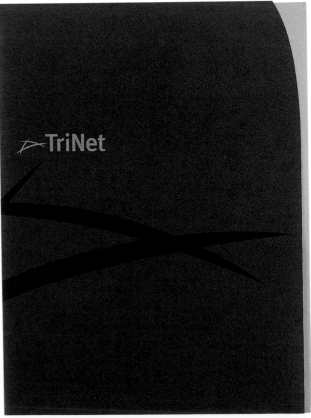

MOD BUSINESS SYSTEM

MOD/Michael Osborne Design	Client
MOD/Michael Osborne Design	Design Firm
Michael Osborne	Art Director
Michelle Regenbogen / Paul Kagiwada	Designers
Lime / Plum / Cherry / Mango / Periwinkle	Palette

PROJECT DESCRIPTION

Michael Osborne Design was changing its branding to MOD and needed a look that was in keeping with its new name.

PROJECT CONCEPT

The change in branding was enhanced through the use of some modern, fresh colors—lime, plum, cherry, mango, and periwinkle—which rotate in different combinations on each element of the identity system. In fact, Michael Osborne's business card sports several variations and the colors used on the letterhead differ from the mailing envelope.

COLOR DESIGN

The colors were lithographed, whereas the text was letterpressed for added distinction. The MOD wordmark was created by digitally manipulating a variety of fonts to come up with a proprietary hybrid. Ganging up on large press sheets and then cutting down the sheets for the letterpress run gave designers the flexibility of using the wide-ranging color palette.

SPICERS PAPER MOVING ANNOUNCEMENT

Client Spicers Paper
Design Firm Giorgio Davanzo Design
Designer Giorgio Davanzo
Palette Apple Green / Warm Gray

PROJECT DESCRIPTION
Paper merchant Spicers Paper had
expanded and needed a larger facility.
Once settled in, they needed a way to
announce their new location.

PROJECT CONCEPT
Incrementally larger die-cut squares
combine to convey the message of growth
in this direct-mail piece.

COLOR DESIGN
"The die-cut squares are positioned so that
only a part of the copy—the word larger—
can be seen when the card is folded,"
explains Giorgio Davanzo, designer. Green
is the prominent color to designate the
firm's growth that necessitated the move to
a larger facility.

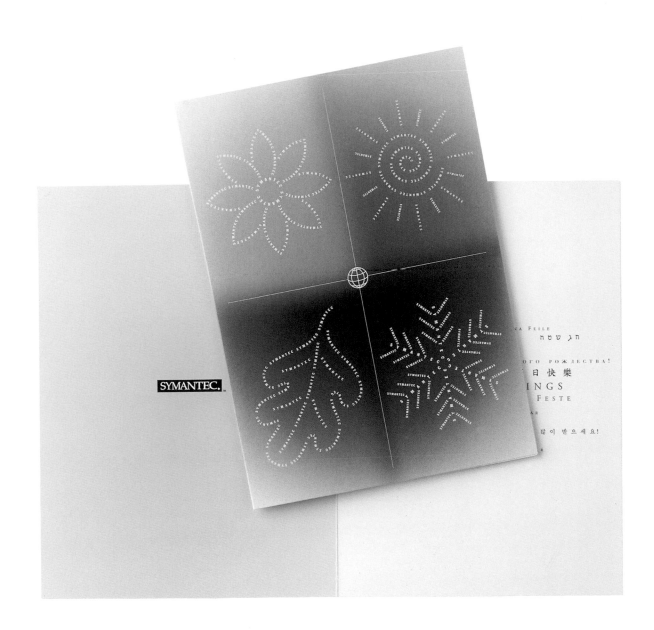

Symantec Corporation	Client
Gee + Chung Design	Design Firm
Earl Gee	Art Director
Earl Gee / Fani Chung	Designers
Earl Gee	Illustrator
Green / Yellow / Brown / Blue	Palette

PROJECT DESCRIPTION

"Symantec Corporation, a global leader in computer software, sought a season's greetings card that would respect the seasons in both northern and southern hemispheres," says Earl Gee.

PROJECT CONCEPT

Color was used to symbolize the four seasons—green for spring, yellow for summer, brown for fall, and blue for winter—each with an appropriate icon of the season composed of the letters SYMANTEC.

COLOR DESIGN

The job was printed in five colors—process and yellow. "Soft process color gradations blend into each other as a metaphor for the blending of seasons throughout the year," adds Gee. The type treatment on the cover was set in Meta Plus Normal and was used on a path to draw symbols of the season.

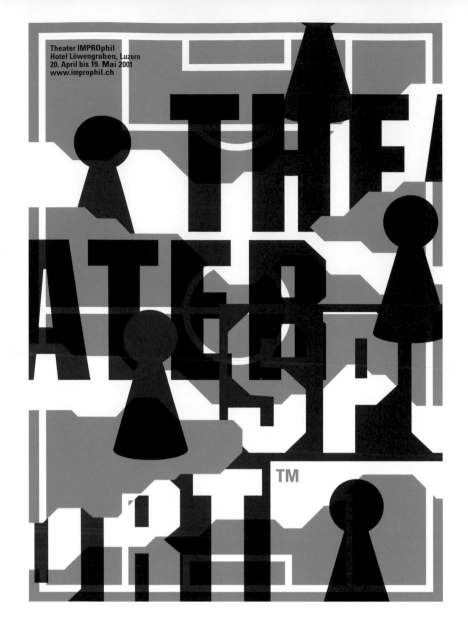

THEATERSPORT POSTER

Client	Theater IMPROphil
Design Firm	Mix Pictures Grafik
Art Director	Erich Brechbühl
Designer	Erich Brechbühl
Palette	Green / Red

PROJECT DESCRIPTION
Theater IMPROphil, an improvisational theater group, tapped Mix Pictures Grafik to develop a poster promoting their performance running April 20 through May 19, 2001.

PROJECT CONCEPT
Designer Erich Brechbühl decided to use an abstract art design in two complementary colors—red and green. By colorizing some of the letters in the design that spell out the word "theater" in red and laying them on top of the green, the colors mix to form a third color, which is a visual metaphor that communicates what this theatrical organization is all about—improvisation.

COLOR DESIGN
Brechbühl created the artwork in Freehand and printed it on poster paper in just two colors, yet the result appears to be four colors as a result of the ink overlapping to form a third hue and the generous use of white, unprinted paper.

Omni Media — Client
After Hours Creative — Design Firm
Russ Haan — Graphic Designer
Red — Palette

PROJECT DESCRIPTION

Omni Media wanted an ad to promote a new CD-ROM that told the story of the incident at Roswell, New Mexico, where the government purportedly covered up the crash of a UFO.

PROJECT CONCEPT

The ad used a simple tactic—using a flood of red with only minimal type and a tiny photo. "The impact of the huge amount of red brings the magazine reader to a halt," says Russ Haan. "The tiny image of the alien is almost voyeuristic, so you feel like you're peeking into a place where you're not allowed, and the little bit of copy is humorous, so you know this piece takes itself lightly."

COLOR DESIGN

"The ad uses the color red to do a number of things," adds Haan. "First, red is the color of warning, the product is all about the secrecy of information pertaining to UFOs, particularly the incident at Roswell, New Mexico. It also grabs attention and stops the reader in mid-browse. Finally, it works like an exclamation point, conveying excitement."

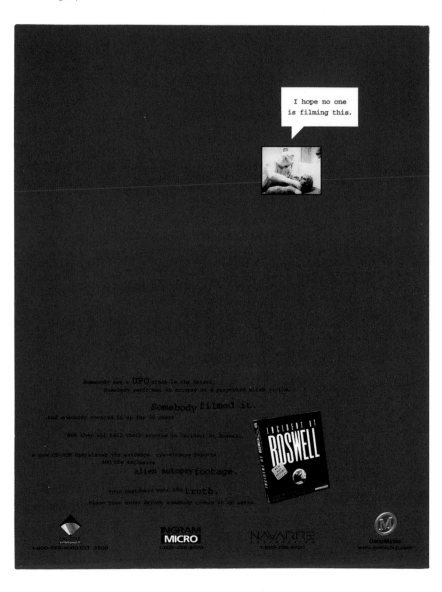

HERMAN MILLER 2001 ANNUAL REPORT INNOVATION

Client Herman Miller
Design Firm BBK Studio
Art Directors Yang Kim / Steve Frykholm (Herman Miller)
Designers Yang Kim / Michele Chartier
Illustrator Michele Chartier
Palette Black / Blue / Orange / Magenta / Gray

PROJECT DESCRIPTION

Herman Miller, maker of contract furniture, dubbed its 2001 annual report *Innovation* and called upon BBK Studio to give it form.

PROJECT CONCEPT

In a drastic turn from previous years' annual reports, designers reasoned that a lack of color—or just using black—provided enough innovation design-wise to measure up to the title of the report. "How often do you see an annual report that's just black?" asks Yang Kim, BBK Studio. "Color wasn't important to this concept so black was the logical choice."

COLOR DESIGN

The report isn't just black type; it includes a secondary palette of blue, orange, magenta, and gray along with four-color process, which was used for the internal photography. However, giving the black its sophistication, single-mindedness, and unique character is the use of Glamma stock. As readers flip through the pages, they see only a few words of copy at a time. This slow, timed-released display of black text sends a precise, unadorned message that cuts through the clutter. There is no frivolous copy here; this back-to-basics messaging gets noticed because it indicates importance.

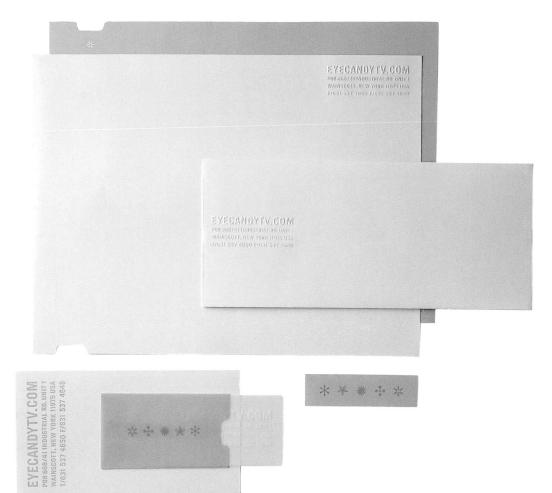

EYECANDYTV.COM IDENTITY

eyecandytv.com	Client
Blok Design Inc.	Design Firm
Vanessa Eckstein	Art Director
Vanessa Eckstein / Frances Chen / Tony DeFrenza	Graphic Designers
White / Yellow / Silver	Palette

PROJECT DESCRIPTION

Eyecandytv.com tapped Canada's Blok Design to develop an identity that would be as leading edge and unique as the company, which is pioneering Internet television programming.

PROJECT CONCEPT

Nothing staid and traditional would do for this venture; Blok Design had to come up with something different. The designers' solution was to develop a white-on-white letterhead system featuring blind embossing with an eye-popping, show-stopping splash of sunny yellow on the reverse of the letterhead and inside the envelope. The yellow—seen as fresh and innovative— makes one stop and take notice because it is so unexpected.

COLOR DESIGN

"The design had to both differentiate itself from the existing market—very virtual/high-tech—and distinguish itself as a young, unique proposition in television," says Vanessa Eckstein. "From a bold yellow color, as the only color through the entire identity to subtle uses of white on plastic and white on white, it invites the audience to question and be intrigued by the many forms and materials this identity presents."

"Surprise was a fundamental part of the challenge, as well as a no-nonsense stylistic approach," Eckstein adds.

Color—
True or False?

by Leatrice Eiseman

Blue is always associated with serenity and dependability.
FALSE.

Beware the overgeneralized color concepts in any color family. Light, midtone, and deeper blues are associated with certain constants in our environment, such as the sky, the sea, and the outer limits. However, just as the name implies, bright electric blue evokes greater energy and excitement.

The use of orange in print, packaging, advertising, or the product itself cheapens the value of the product.
FALSE.

Although the advent of "fast-food orange" lent a tacky connotation to the color, the 1990s brought about a new recognition and fascination for orange as it was used in more exotic contexts by diverse cultures. Couture fashion designers introduced orange into their collections and currently the color is more widespread at every level of the marketplace.

Brown is the embodiment of all things organic, natural, wholesome, and earthy.
TRUE.

Although it is true that brown has traditionally been thought of as a "Mother Earth" kind of color and can still be used within that context, it is a shade that has seen some changing consumer responses. Largely because of the designer coffee phenomena, the shade has taken on a whole new dimension with many consumers now perceiving the brown family as rich and robust.

Kids best accept vibrant yellow-greens.
TRUE.

Although it is true that kids love bright, eye-popping chartreuse yellow-greens, they are not amongst adults' favorite colors. It is a color that intermittently explodes on the scene and then periodically disappears, but it is a powerful, albeit youthful or trendy, presence on the printed page or a Web site. As the yellow green is lowered in intensity, the acceptance level rises for adults.

Red is the most visible of all colors.
FALSE.

Although red may aggressively demand attention, it is not the most visible of all colors, particularly at twilight when the light is starting to wane. Yellow is actually the most visible, especially when combined with black.

COVER DESIGN FOR MEMBERS' JOURNAL

Client	Art Gallery of Ontario
Design Firm	Dinnick and Howells
Graphic Designers	Sarah Dinnick / Jonathan Howells
Palette	Spectrum Colors

PROJECT DESCRIPTION

The Art Gallery of Ontario asked Toronto-based Dinnick and Howells to create a cover design for their members' journals.

PROJECT CONCEPT

The idea revolved around the need to create a standard design with flexibility that could change monthly in accordance with the featured artwork.

COLOR DESIGN

The type, logo, and graphic design remain constant, whereas the color changes with respect to the artistic image. The color never overpowers the image; rather, it identifies with the piece in terms of period and style.

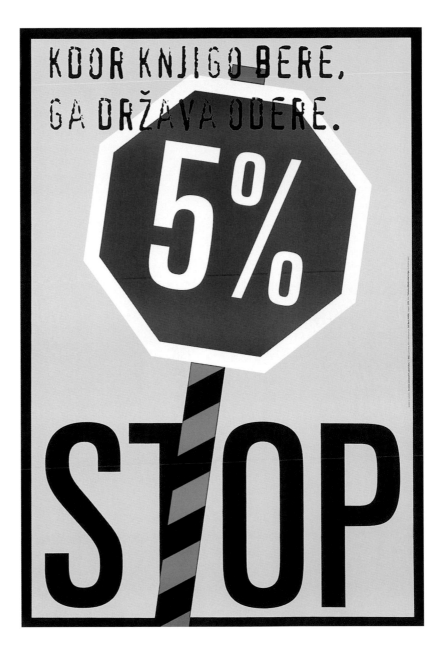

B/ STOP POSTER

Drutvo zaloænikov Slovenije — Publishers Society of Slovenia, Ljubljana — Client

KROG — Design Firm

Edi Berk — Creative Director

Intense Red / Yellow / Green / Black — Palette

PROJECT DESCRIPTION

Edi Berk was asked by Drutvo zaloænikov Slovenije — Publishers Society of Slovenia, Ljubljana, to create a poster designed for a campaign to help publishers achieve the lowest possible taxes on books.

PROJECT CONCEPT

The idea for the piece was based on the incongruous nature of making someone who reads a book pay a tax to the state treasury, thus making the attainment of knowledge more costly. The piece points out that this is contrary to the idea of wanting an increasingly educated public.

COLOR DESIGN

Berk used bright colors purely as an attention-getting device. The red of the stop sign reinforces the commonly understood meaning of "stop!"

BOOK AND PROMOTIONAL POSTER FOR GAUDEAMUS IGITUR

Client	Dræavni Izpitni Center–Examination Centre of the Republic of Slovenia
Design Firm	KROG
Creative Director	Edi Berk
Palette	Yellow / Red / White / Green / Lavender

PROJECT DESCRIPTION
Berk was asked by the Dræavni Izpitni Center–Examination Centre of the Republic of Slovenia, Ljubljana, to develop a book that explains the graduate celebration known as "matura," and acts as a guideline for recent graduates who might want to incorporate customs into their own "matura" rituals.

PROJECT CONCEPT
The design concept stemmed from the target audience of eighteen-to nineteen-year-olds that Berk considered to be a young and energetic, computer-oriented generation that loves to experience life.

COLOR DESIGN
Berk created a mood with the color that he thought would appeal to an active, youthful age group. The poster used bright colors and unusual typography to catch a person's attention and enhance and clarify the image.

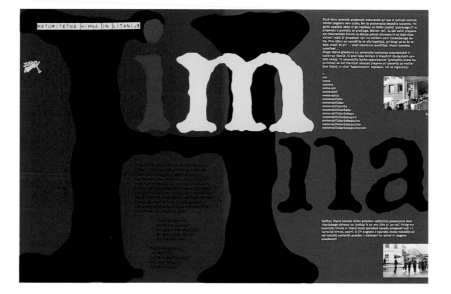

Silly Goose Company	Client
Fellers Marketing and Advertising	Design Firm
Bryan Pudder	Art Director
Bryan Pudder	Creative Director
Bryan Pudder	Illustrator
Bright Yellow	Palette

PROJECT DESCRIPTION

The project was The Potty, a promotional poster designed for Piddlers Toilet Targets manufactured by the Silly Goose Company. The piece was to be included in a response to inquiry about Piddlers Toilet Targets, biodegradable devices in funny shapes that allow for easier potty training. It was also considered as a point-of-purchase piece for retailers.

PROJECT CONCEPT

The objective of the piece was to very clearly convey the selling point of "pee goes where it belongs." Since the product affects both parent and child, Fellers wanted to create a childlike way to simply communicate the selling point. The result was a kid's drawing for an adult's benefit. The drawing was colored to push the childlike quality.

COLOR DESIGN

They chose yellow because "yellow is the color that communicates urine."

Piddlers Toilet Targets They're simple and fun. Just drop one in the toilet, and start tinkling. They melt away on contact. A great way to make potty training easy on everybody.

www.piddlers.com

Color That Evokes Emotion

Color that evokes emotion is by far the broadest type of color usage. We do not live in the black-and-white world of the film *Pleasantville*. Rather, we live in an increasingly colorful world that is filled with emotions, feelings, and associations. Everything from curtains on the wall to our toothbrushes has become a color statement. It has led us to have to define and redefine our response to color. To strengthen our design we must carefully understand the target market and find out what their response might be.

This response is determined by color culture—the response that the viewer has to color because of sociological, historical, political, geographical, and psychological reasons. Color that evokes emotion is not a direct response to obvious associations as in primary message color, or intuitive as it is in color that persuades, but comes from the depth of personal experience and may vary by individual or culture. Purple is viewed quite differently around the world—in some Asian cultures, purple is affiliated with royalty, whereas in the United States, there is no such affiliation.

Color can be used to evoke the pleasantness of an environment or a region. For example, blue-green and a warm yellow may evoke the feeling of the tropics whereas desert red and browns might suggest the New Mexico desert. Blue, white, and chrome are repeatedly used in Design Forum's prototype for the West Marine chain because the palette evokes a feeling of boating and the sea. Metzler and Associates used the color of provincial France for the French airline Air Littoral to create an identity and tie the airline's services to the region.

Evocative color can be drawn from a smell or a musical piece. The Soho Spice restaurant in London used the color of spices to enrich its Indian decor. Troxler's Jazz Blvd book cover and poster use images stemming from the sound of the music, the motions of the musicians, the style of the instruments, and are supported by his strong color visualization.

Nostalgia for a different time period is often important in a design. 1960s colors were intrinsic to the design of the play poster for *New Patagonia* by Ames Design. The green prevalent in the electronic world of the 1980s was used in the Jester's *Digitalia*

CD cover designed by F3. Pink was used on the auction poster for Marilyn Monroe to identify her and her bright clothing and was also reference to the "pop-ish" colors of the 1950s and 1960s.

Emotive color can have symbolic meaning. In the Chela Financial Corporate report by Kirshenbaum Communications, yellow represented gold (money), the process of education (school buses and pencils), and a path toward a better future (the yellow brick road). Red has great symbolic meaning. Lanny Sommese used red to represent blood, death, and fear in his Stop poster.

Emotive color may be used in the broadest fashion but it is the type of color that is by far the most complex. While difficult to control because people's responses will vary, understanding and utilizing color meaning will lend great impact to your design.

KONFETIE JEWELRY POSTCARD CATALOG

Client Konfetie Jewelry—Jenn Fenton
Design Firm The Riordon Design Group
Creative Director Ric Riordon
Designers Amy Montgomery / Shirley Riordon
Photograper David Graham White
Palette Purple / Fuchsia / Lime / Turquoise / Orange

PROJECT DESCRIPTION

Jenn Fenton is an upbeat jewelry designer, whose firm, Konfetie is known for its handmade beaded jewelry. Fenton needed a catalog that reflected her products and, in particular, her influence and unique design style.

PROJECT CONCEPT

Fenton's jewelry plays to seasonal colors and current trends, but the real key to Konfetie's success is Fenton herself. Her vibrant personality is as much a part of the company as the jewelry she creates. When the Riordon Design Group entered the picture, designers felt that any product catalog should reflect Fenton's personality as much as the design.

COLOR DESIGN

To communicate Fenton's captivating nature and penchant for the unusual, the Riordon Design Group chose a palette that imitated her personality—uplifting colors of purple, fuchsia, lime, turquoise, and orange—and which perfectly complemented her colorful beaded creations. Designers developed a series of six postcards—primarily to eliminate the need for any binding—that allows for new cards to be easily integrated into the system as needed. The postcard catalog arrives in a confetti-speckled vellum envelope, which further keeps the tone light, fun, and whimsical—just like the creator and her creations.

Format Design	Client
Format Design	Design Firm
Knut Ettling	Designer
Knut Ettling	Illustrator
Blue	Palette

PROJECT DESCRIPTION

Format Design's self-promotional mailer and leave-behind highlights the firm's graphic design work for print, corporate, and Web-based projects.

PROJECT CONCEPT

Knut Ettling chose blue as the corporate color for Format Design, primarily because it is simple, memorable, and easy to associate with his firm.

COLOR DESIGN

"Format Design is the blue company," says Ettling. Why blue and not another color? "I like it; it fits me. It is fresh and positive, like the sky." Moreover, he adds, "There is no other design company in this area using a similar color." The resulting brochure is compact and cleanly designed. The plastic translucent itself is eye-catching; the brochure tucked inside is streamlined and expertly designed with an embossed cover and round corner die-cuts. Examples of Ettling's work are sprinkled throughout the inside four-color process pages, which contrast nicely with the blue cover.

INTERNATIONALES JAHRBUCH KOMMUNIKATIONS—DESIGN 1996/97 BOOK

Client	Verlag Form, Frankfurt am Main
Design Firm	Büro für Gestaltung
Art Directors	Christoph Burkardt / Albrecht Hotz
Palette	Violet / Lavender / Blue / Orange / Pink / Teal / Yellow / Green

PROJECT DESCRIPTION

Design the cover of a graphic design annual—that was the task set before designers at Büro für Gestaltung, who tackle the project annually and always strive to do something different to keep the book's appeal fresh.

PROJECT CONCEPT

Every year when the book comes out, designers try to find a different abstract picture that will work as the lead cover image—after all, it is the cover image on any book that motivates a potential buyer to make an actual purchase. In the case of a design annual, even more importance is placed on the cover image because it must attract the toughest audience of all— skeptical graphic designers.

COLOR DESIGN

They opted to base this cover image on color and no two colors are alike. The job was printed in four-color process and each color is different—if only by about 10 percent. All these different colors, together with the unique layout, result in a three-dimensional effect.

Stephan Touristik Client
Büro für Gestaltung Design Firm
Christoph Burkardt / Albrecht Hotz Art Directors
Aqua / Yellow Palette

PROJECT DESCRIPTION

Stephan Touristik, a German travel agency that deals exclusively in trips to Latin America, needed some eye-catching promotional materials that would convey the mood and feel of the getaways they offer.

PROJECT CONCEPT

Because the agency deals exclusively in trips to South America and environs, they needed a look that communicated warm, sunny destinations—and conveyed a sense of carefree abandon that makes a person who is dragged down by daily life want to get away from it all.

COLOR DESIGN

To accomplish their goal, the design team knew they needed colors that were fresh and uplifting. By choosing such a palette, the posters would look like a departure from everyday life and visually appear to lift some of the burdens from travelers' shoulders even before the holiday begins.

Specifically, they wanted the palette to reflect a hot side—or the sun—as desig nated by yellow and a cool side to represent the sea as denoted by a shade of teal. Designers digitally manipulated existing typefaces to create two of their own, which further enhance the feeling of whimsy generated by these posters.

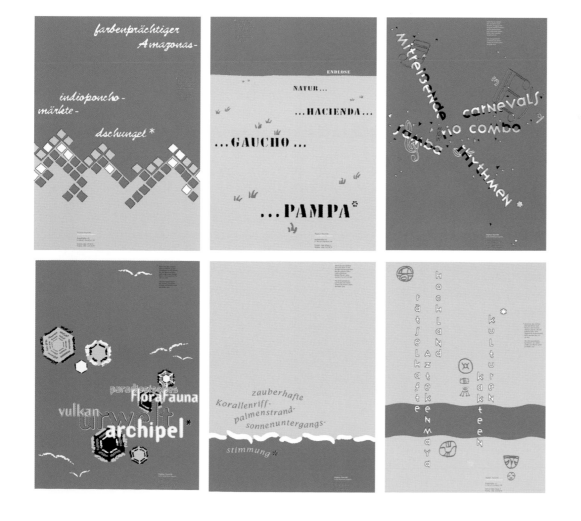

Client	*Time* magazine
Design Firm	Mirko Ilić Corp.
Designer	Deborah Hon
Palette	Black on Black

PROJECT DESCRIPTION

Time magazine retained Mirko Ilić Corp. to illustrate its cover for an issue featuring an article about evil.

PROJECT CONCEPT

The colors chosen to answer this question were simply black on black.

COLOR DESIGN

Working with black is tricky, so the cover was executed two different ways for the domestic and international editions. The domestic cover was printed in two spot colors, whereas the international edition was printed in four-color process because it provided more consistency over multiple presses.

So powerful are the glossy black letters spelling *evil* on the matte black background that from newsstands the cover makes a powerful, emotional statement. Using black to represent evil is so timeless that even with a cursory glance this ominous cover can't help but evoke a gut-wrenching response. One immediately thinks the magazine cover is dated September 11, 2001, but it is not; the date on this cover is June 10, 1991.

Christie's	Client
Parham Santana	Design Firm
Maruchi Santana	Creative Director
Julia Chong Tam	Designer
Deep Pink / Purple / Yellow / Red	Palette

PROJECT DESCRIPTION
Parham Santana was asked by American Movie Classics to create promotion materials for an auction to be aired exclusively on cable channels entitled "AMC Live from Christie's. The Personal Property of Marilyn Monroe."

PROJECT CONCEPT
Parham Santana wanted to create a poster that reflected the personality of Marilyn, her complexity, her timeless sexuality, and her ultimate, untimely death. It became a celebration of a woman who intrigues and inspires us to this day.

COLOR DESIGN
The color choice was based on a shocking pink Pucci dress that was owned by Marilyn. It was chosen because it was so full of life and intense color, just like the woman she was. The deep pink was very cosmetic, very female, and very sexy. The color, in addition, referenced the pop-ish, artificial colors of the 1950s and 1960s.

NOVELL 2001 BRAND CAMPAIGN

Client	Novell, Inc.
Design Firm	Hornall Anderson Design Works
Art Director	Jack Anderson / Larry Anderson
Designers	Jack Anderson / Larry Anderson / James Tee / Holly Craven / Michael Brugman / Kaye Farmer / Taka Suzuki / Jay Hilburn / Belinda Bowling
Photographer	David Emmite
Palette	Red / White

PROJECT DESCRIPTION

Novell, Inc., a networking software provider, called upon Hornall Anderson Design Works to help them elevate the Novell brand.

PROJECT CONCEPT

Designers accomplished this goal by taking ownership of the color red and the initial N from the pre-existing Novell wordmark.

COLOR DESIGN

"A generous use of white as a design element and red as a branding element was applied, as well as the contrasting use of bold colors," says Jack Anderson. "The red signifies power and strength, as well as longevity—all elements reflecting the client and their position in the software industry."

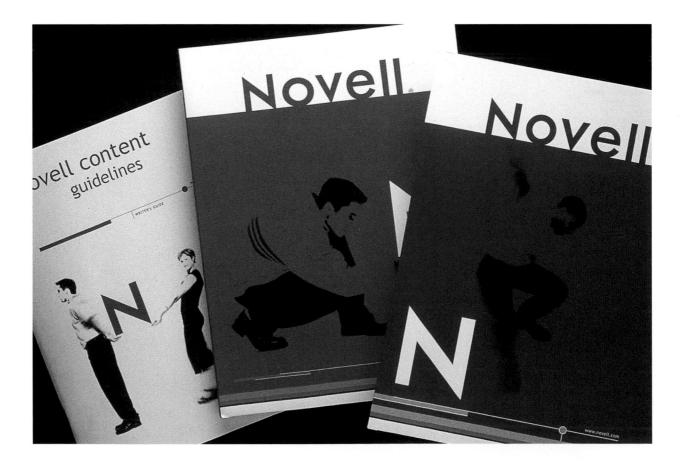

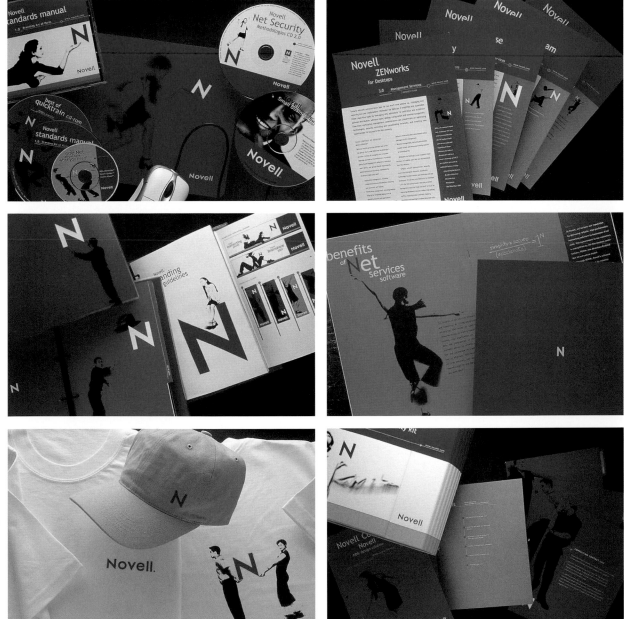

T26 ANYTIME NEWSPAPER

Client	T26
Design Firm	Segura Inc.
Art Director	Carlos Segura
Designer	Amisa Suthayalai
Illustrator	Amisa Suthayalai
Palette	Pink / Blue

PROJECT DESCRIPTION

Segura Inc. was given the job of developing a promotion for a new line of typefaces introduced by T26, a digital type foundry.

PROJECT CONCEPT

"For this piece, the colors blue and pink were chosen for their inherent connection with youth and gender," explains Carlos Segura. "The youthfulness of the colors helps to emphasize the newness of the fonts being introduced in the piece."

COLOR DESIGN

It's true. Blue and pink immediately conjure up images of new life and freshness. Here, they work well to introduce brand new typefaces. "The gender reference works with the title 'Anytime' and indicates that the fonts are for anytime and anyone," adds Segura.

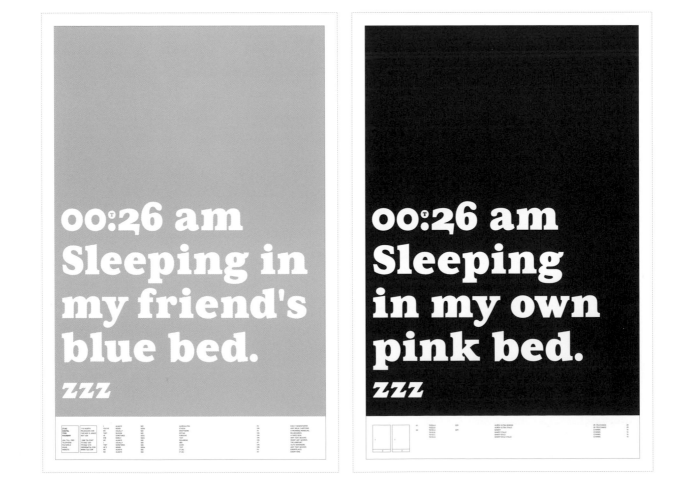

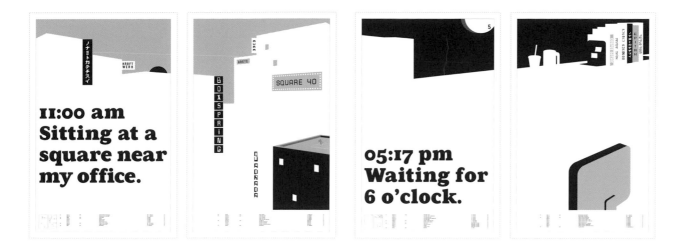

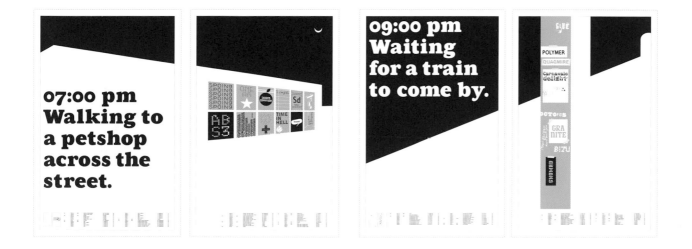

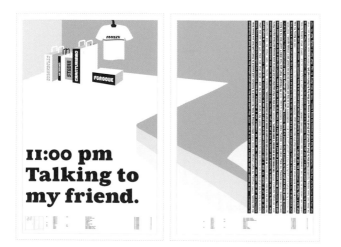

KATHOLISCHE KIRCHGEMEINDE SEMPACH

Client	Katholische Kirchgemeinde Sempach
Design Firm	Mix Pictures Grafik
Art Director	Erich Brechbühl
Designer	Erich Brechbühl
Palette	Yellow / Black

PROJECT DESCRIPTION

A Catholic church in Switzerland was in need of a letterhead system that aptly reflected its ministry.

PROJECT CONCEPT

Designer Erich Brechbühl used die-cutting and color to set this identity system apart. Printing on the front of the identity is kept minimal—only the church's name appears in black. This is augmented with six die-cuts to simulate church windows.

COLOR DESIGN

The reverse of the letterhead is flood printed with yellow so that when the letter is folded, the yellow shows through the die-cuts—like the "warm light inside the church," says Brechbühl.

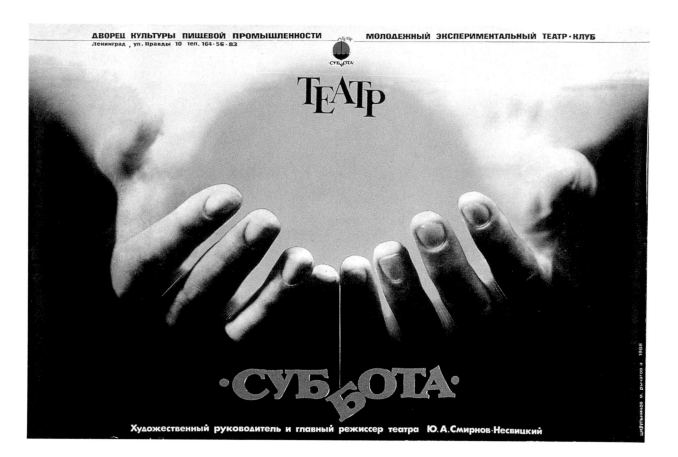

RUSSIAN THEATER SATURDAY

Theater Saturday	Client
Misha Design Studio	Design Firm
Misha Lenn	Art Director
Misha Lenn	Designer
Anatoly Richagov	Photographer
Yellow / Black	Palette

PROJECT DESCRIPTION

Theater Saturday, a semiofficial theater in communist-dominated St. Petersburg, Russia, asked designer Misha Lenn to create a logo that spoke to the community and communicated that entertainment is something to be enjoyed.

PROJECT CONCEPT

Using a minimalist palette of yellow and black, Lenn integrated a photo of hands into the foreground of the design and rendered this element in black. The hands hold what looks to be sunshine, which emanates from the burst of yellow he placed in the center of the artwork.

COLOR DESIGN

"The color emphasized the creation of hope and joy from the black-and-white daily background," says Lenn, citing how the logo, like the theater itself, works to bring some lightheartedness, joy, and diversion to the challenges of daily life.

Color and Kids

Although most adults see pastels as appropriate choices for infants, studies show that tiny tots are most drawn to vibrant primaries of red, blue, and yellow. Between the ages of three to six, their attention is drawn to the secondary shades of green, purple, and especially orange. This age group is also drawn to sparkling, shimmery finishes and if it sparkles in bright colors, all the better.

There is a new phenomenon that started in the 1990s. Beginning at the toddler stage was the introduction of black and deepened Euro colors, which was always verboten in kid's markets. And these sophisticated colors are even more prevalent in the tween market of ages six to twelve.

This is not to suggest that brights have lost their appeal for kids. They are still powerful attractors in all graphic applications such as ads, Web sites, packaging, TV commercials, and video games.

Of course, the operative word is cool. Kids at this tween stage want desperately to fit in—to look like their peers and to wear and carry the colors that their friends do. They study very closely what they see on display in malls. As part of this need to look just like their friends, brand image becomes very important because they can then be sure they will fit in.

This is also the age when they want things that seem disgusting to their parents. Sickly yellow green (the color of squished caterpillar) is especially appealing. If there was a green hot dog available to kids, that's the one they'd want to eat! For these younger age groups, the color of food is actually more important than the taste. Kids also have great visual acuity and will notice subtle differences in color more rapidly than adults.

There are less hard and fast gender identification rules about color today. At one point, all pinks were strictly for girls. Currently, the brighter hot pinks work

across both genders and are often used to denote active sports. Another color that was considered strictly feminine was purple. But as a result of its use in active sports, especially in sports logos, purple is now well accepted by male tweens and teens.

Tweens are rehearsing for their teenage years. At ages ten to twelve, they study teenagers very closely for the next big trend. For example, if black is the hot teen color, that's what the older tweens want, so it behooves the graphic designer working with these youth markets to stay on top of the trends.

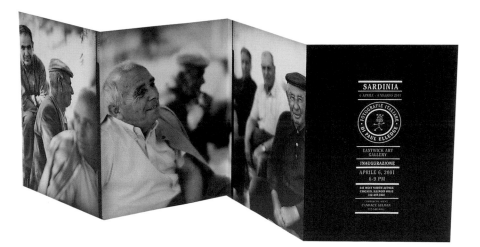

SARDINIA POSTER AND INVITATION

Client	Paul Elledge Photography
Design Firm	Lowercase, Inc.
Art Director	Tim Bruce
Designer	Tim Bruce
Photographer	Paul Elledge
Palette	Black / Dark Orange

PROJECT DESCRIPTION

Photographer Paul Elledge sought the expertise of Lowercase, Inc. when he needed an invitation and poster to promote an exhibition of his works.

PROJECT CONCEPT

Elledge's work—as shown here—is part of his Fotografie Italiane collection called Sardinia. The photos were all taken recently, but rendered in sepia tones to make them look like oft-thumbed vintage photographs of the locals from an Italian village.

COLOR DESIGN

"The use of color in the photo tritones is meant to invoke a sense of classic Italian photography," says Tim Bruce, art director and designer on the project. As a whole, the package does more than that; the color palette lends a richness and elegance to the pieces, along with a certain reverence for the past.

EKH Design	Client
EKH Design	Design Firm
Myriam Kin-Yell	Art Director
Sandra Marta	Designer
Sinead Doyle	Photographer
Lime Green / Fuchsia / Orange / Black / Turquoise	Palette

PROJECT DESCRIPTION

Like most graphic design firms, EKH Design wanted to create its own Christmas card for the upcoming holidays but, unlike a majority of design firms, it is located in Sydney, Australia, where Christmas occurs in the summertime, necessitating a different color palette than is considered traditional.

PROJECT CONCEPT

"As Christmas in Australia is in summer, bright colors have been selected to enhance this summer festive season," says Anna Eymout of EKH Design. As a result, instead of a palette of cool wintry whites and icy blues or traditional pine green and red, the card takes a completely different tact.

COLOR DESIGN

"Designers took to the beaches and streets of Sydney with a digital camera and a determination to capture their own experience of Christmas in the beautiful city," says Eymount. The result is an eclectic mix of traditional holiday icons—Rudolph the Red-Nosed Reindeer—alongside "Aussie Snow," which is a shimmering ocean beach.

The promotion drives home more than a holiday message; it proves that the adage "know your audience" should never be shrugged off—the power of color to evoke a response will vary from market to market.

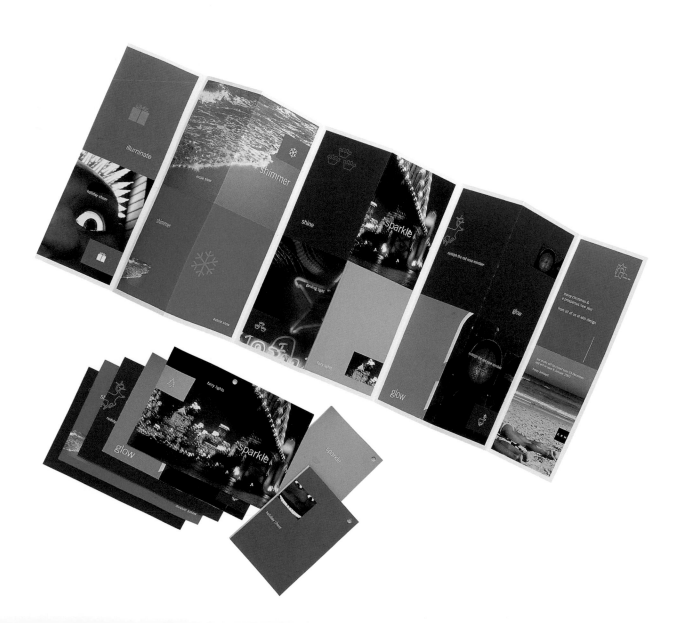

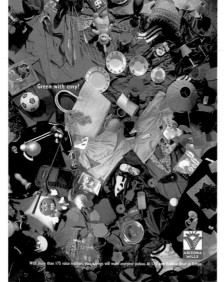 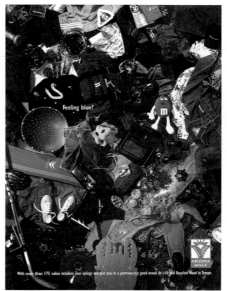 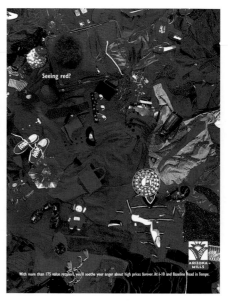

ARIZONA MILLS ADVERTISING SERIES

Client Arizona Mills
Design Firm After Hours Creative
Palette Red / Blue / Green

PROJECT DESCRIPTION
Arizona Mills, a shopping mall with more than 175 retailers, needed an ad campaign that adequately represented all of its stores and their diversity.

PROJECT CONCEPT
After Hours Creative developed an idea based around a series of three ads—each of which would be created in a single color, since colors are often associated with moods—especially moods that tend to spur shopping sprees.

COLOR DESIGN
"Once we found a way to unite a certain kind of mood with a reason to shop at Arizona Mills, we went to all the retailers, asked for products in that color, assembled them into a giant collection, and took the shot," says Russ Haan. "The result was a striking and simple series of ads that conveyed the breadth of the items available at the mall and reinforced their value, shopping, and entertainment positioning."

Vent | Client
After Hours Creative | Design Firm
Red / Green | Palette

PROJECT DESCRIPTION

Unsettling is an understatement to describe this series of three posters that extend Season's Greetings, wish Happy Holidays, and promote Peace on Earth, while using old Marine training handbooks along with traditional holiday colors to provoke a response.

PROJECT CONCEPT

"Holiday colors are red and green. But when you use really bright versions, contrast them with black illustrations from military manuals, you get a troubling contrast," says Russ Haan, After Hours Creative.

COLOR DESIGN

"We took the irony of holidays based on religion with the fact that most wars are caused because of religious differences. The contrast of the happy greetings with the violent images summarizes the global predicament we're in now," adds Haan. "The in-your-face colors grab your attention even before you read the message."

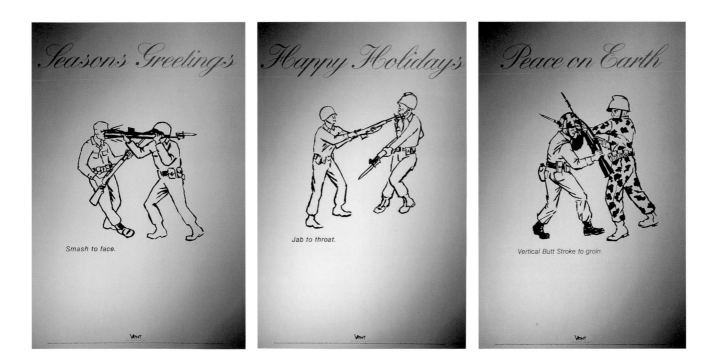

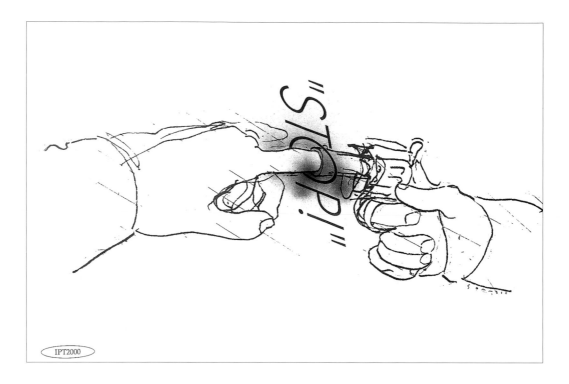

IPT2000

STOP POSTER

Client Penn State Institute for Arts and Humanistic Studies
Design Firm Sommese Design
Art Director Lanny Sommese
Designer Lanny Sommese
Illustrator Lanny Sommese
Palette Black / Red

PROJECT DESCRIPTION
Sommese Design was brought aboard to create a poster to promote gun control. Subsequently, what had originally been an idea Lanny Sommese created as a contest entry was finessed and re-created as a poster that is startling in its simplicity.

PROJECT CONCEPT
Lanny Sommese used red, which metaphorically calls to mind fire, stop signs, danger, and blood in the design as a subtle spot color. "Because of the topic, it was a no-brainer to use red," Sommese says.

COLOR DESIGN
He added the red with spray paint. Then, he scanned the artwork into the computer. "The sprayed effect enhanced the message by giving a raw human look to the image. The spray painted look also added to the image emotionally and added another level of metaphor," says Sommese.

Herman Miller	Client
BBK Studio	Design Firm
Yang Kim, Steve Frykholm (Herman Miller)	Art Directors
Yang Kim	Designer
Steven Joswick / Yang Kim	Illustrator
Orange / Red / Green / Blue / Yellow / Pink	Palette

PROJECT DESCRIPTION

Furniture manufacturer Herman Miller was commemorating its 75th anniversary, so when the time came for its annual report, designers decided to dub the event a birthday and followed through on the theme from there.

PROJECT CONCEPT

"We wanted to have a party with the book," remembers Yang Kim, art director and designer on the project. "We chose primary colors and had fun with party favors like confetti, pop-ups, a party hat, megaphone, balloon, and a button."

When used on their own, primary colors have their own unique personalities. When combined, as they are here, they generate a lighthearted, party atmosphere. They communicate a fun, playful, boisterous, and carefree attitude.

COLOR DESIGN

The art for the party hat was created with all the names of Herman Miller's employees—about six thousand at the time—with multicolored stars separating each name. This particular aspect of the project was tedious and time-consuming, but by making the star into a font keying in the names became a much more efficient process.

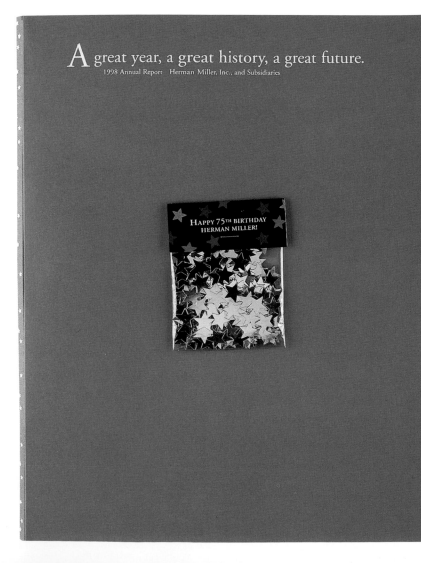

NEOCON COLORS WEB SITE

Client	Herman Miller
Design Firm	BBK Studio
Art Director	Kevin Budelmann
Designer	Mike Carnevale
Palette	Black / Red / Blue / White / Green

PROJECT DESCRIPTION

In conjunction with the launch of a NeoCon (a contract furniture trade show) promotional site for Herman Miller, BBK Studio developed an online version of the company's "Things That Matter" campaign.

PROJECT CONCEPT

The digital version of the campaign was created in a sophisticated, gamelike format where DHTML layers and JavaScript are used to allow users to reveal marketing messages with an element of surprise.

COLOR DESIGN

The game is presented in a color palette that plays off thematic statements and serves as the site's navigation. Squares of black, red, blue, white, and green act as the navigational bar, but there's more. Each color gets its own screen that makes a statement about the color, which then leads into statements about Herman Miller. For instance, the green screen states, "After 75 years, we're still green," then goes on to tout Herman Miller's commitment to environmentally sensitive products and business practices.

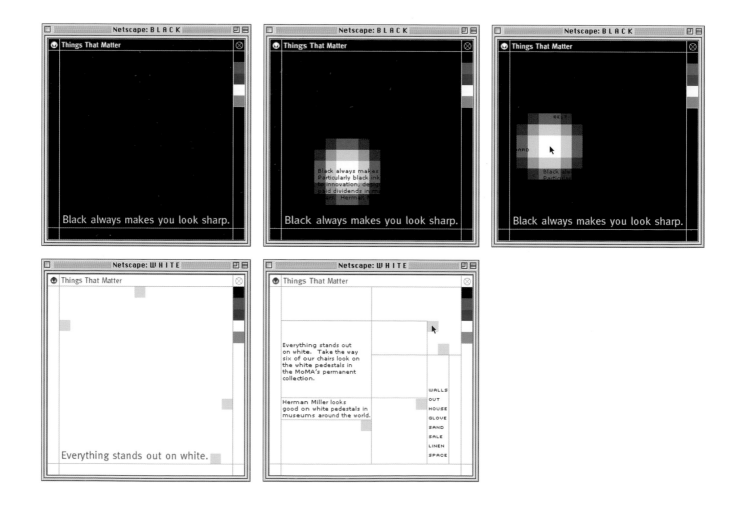

INDUSTRY FILMS HOLIDAY CARD

Client Industry Films
Design Firm Blok Design
art director Vanessa Eckstein
Designer Stephanie Yung
Palette White / Orange

PROJECT DESCRIPTION
"Create a holiday greeting card for us," was the dictate from Industry Films. Blok Design gladly took on the project and opted to do something nontraditional.

PROJECT CONCEPT
Holiday cards are traditionally dressed in red and green but not this one. There are no embellishments here. This card is simply white on white blind-embossed; the only color is just a touch (a small touch) of orange—which signifies hope. "This holiday card was about giving and caring," says Vanessa Eckstein, art director. "We felt that blind-embossing the type was a way of connecting to the text—of actually feeling the message."

COLOR DESIGN
"There is a honest and simple approach about simple white-on-white typography," says Eckstein of the blind embossing, which does give the recipient a way to feel the message and be touched by its content. Its understatement is due largely to the white-on-white palette, which aptly demonstrates the power of color or lack thereof.

IT'S ABOUT A CURE. ON YOUR BEHALF WE MADE A DONATION TO THE AIDS COMMITTEE OF TORONTO AND TO THE BREAST CANCER SOCIETY OF CANADA. HAPPY HOLIDAYS + OUR BEST WISHES FOR 2001. FROM ALL OF US AT INDUSTRY FILMS.

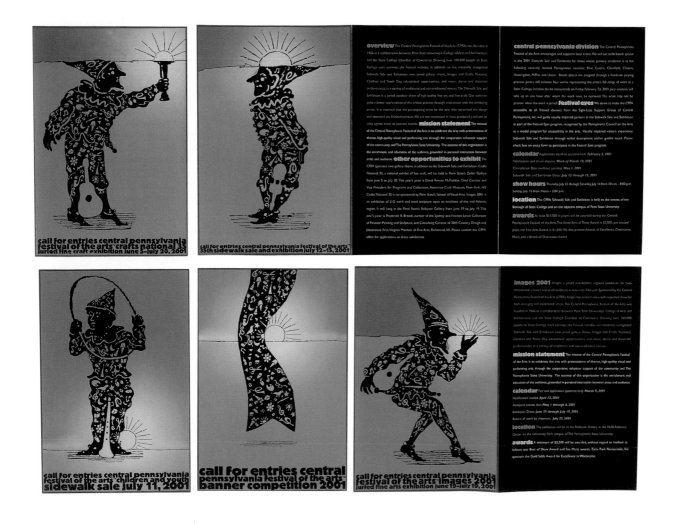

CENTRAL PENNSYLVANIA FESTIVAL OF THE ARTS CALL FOR ENTRIES

Central Pennsylvania Festival of the Arts	Client
Sommese Design	Design Firm
Lanny Sommese	Art Directors
Erik Boissonneault / Marc Elias	Designers
Lanny Sommese	Illustrator
Orange / Yellow / Green / Black	Palette

PROJECT DESCRIPTION

Sommese Design has created the promotions for the Central Pennsylvania Festival of the Arts, an annual midsummer celebration of the visual and performing arts, for thirty years. The campaign begins with a poster that captures the look and feel of the event, which is followed by a series of call for entry brochures, T-shirts, and more.

PROJECT CONCEPT

Since the festival is held on the Penn State University campus and in State College, a city nestled in the mountains of central Pennsylvania, Lanny Sommese decided to replicate the landscape in an abstract fashion on the call for entries brochures. Green was chosen for the natural setting and bright yellow for the summer sun. The colors were kept bright to reflect the party atmosphere of the event. Black was added to make the colors appear even more intense and vivacious.

COLOR DESIGN

Sommese used an airbrush effect to feather and blend colors to create a glow. "Color is important as well to enhance the collectibility of the poster," says Sommese. "The festival goers seem to like colorful and are more likely to take a colorful poster home."

Jazz Blvd. Niklaus Troxler Posters / Lars Müller Publishers

JAZZ BLVD BOOK COVER AND POSTER

Client — Niklaus Troxler Design
Design Firm — Niklaus Troxler Design
Creative Director — Niklaus Troxler
Palette — Lime Green / Magenta / Purple

PROJECT DESCRIPTION
The project involved the creation of a book cover for a book of jazz posters designed by Troxler himself. The original design was a poster, of which various parts were used to create eight different versions for the book. The poster was also for sale.

PROJECT CONCEPT
Niklaus Troxler's passion for both jazz and design resulted in the creation of a jazz festival in his hometown of Willesau, Switzerland. Consistent with the underlying theme of the book, Troxler created the piece as a response to the colorfulness of sound. He used color line and shape to express jazz music.

COLOR DESIGN
Troxler's images stemmed from the sound of the music, the motions of the musicians, and the style of the instruments. Active lines and shapes are supported by his strong color visualization. In Jazz Blvd he has used his intuitive color sensibility to evoke excitement, create contrast, and heighten the activity of the piece. "Color," he says, "brings the design to a point."

Sensurround Staging	Client
Ames Design	Design Firm
Barry Ament	Creative Director
Red / Neon Orange / Black	Palette

PROJECT DESCRIPTION

Ames design was asked to create a play poster for the first theatrical production of *A Clockwork Orange*.

PROJECT CONCEPT

Although the director/producer didn't want associations to be made with the movie or its imagery, they did want an ultraviolent approach to the design of the piece. As a response to this, Barry Ament of Ames Design created a very subtle, violent character as a focal point. A pencil sketch was used for final art to enhance the rawness of the piece.

COLOR DESIGN

To keep the "underground effect," Ament used two colors that he considered to be a bold and somewhat dissonant color combination. Neon orange and black created almost a nauseating effect, but he still kept black and red, a historically violent color combination.

POSTER FOR *NEW PATAGONIA*

Client	Seattle Repertory Theatre
Design Firm	Ames Design
Creative Director	Barry Ament
Palette	Lime Yellow / Black / White / Green / Blues / Pinks / Oranges

PROJECT DESCRIPTION

Ames Design was asked by Seattle Repertory Theatre to create a poster for a production of *New Patagonia*.

PROJECT CONCEPT

The play was a one-man show that told the story of a Timothy Leary–type character looking back on his days of sex, drugs, and rock 'n' roll. For the poster, Ament used a Fillmore style (1960s poster designed for rock shows at a venue called the Fillmore) to create an instant association with the summer of love. By graphically placing the type and images inside of the character's head, Ament created an image that portrayed a man looking back on his life.

COLOR DESIGN

The colors were chosen to strengthen the 1960s imagery. He used the split fountain technique, common in the 1960s, in which several colors are pulled at the same time, rather than individually causing the colors to bleed together in a rainbow type effect.

Chela	Client
Kirshenbaum Communications	Design Firm
Susan Kirshenbaum	Creative Director
Jim Neczypor	Designer
Doug Ross	Illustrator
Lessley Berry	Copywriter
Yellow / Gold	Palette

PROJECT DESCRIPTION

Chela, the United States' largest nonprofit institution focused solely on education finance, asked Kirshenbaum Communications to create a financial and corporate report that would be targeted at financial institutions, government agencies, and financial aid administrators.

PROJECT CONCEPT

The report is based on the idea of connections. The mission statement for the nonprofit is to finance lifelong education while strengthening the bonds between the learner, the school, and the lenders. The cover illustration was based on literally connecting the dots from school to financial institutions with the money in between.

COLOR DESIGN

The key color for the report was yellow, which represents the pencils students use, the color of a school bus, and the gold connecting students and their financing. In addition, the yellow brick road is used to show a path of growth and exploration. Because they are targeting an older age group, Kirshenbaum decided against other primaries in favor of a more sophisticated and subdued, but lively and colorful, color scheme.

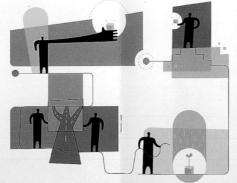

TYPE

Type Tracker:

1900s

Influences

Aside from the Arts & Crafts move-
ment, many fonts were influenced by
hand-lettered creations that printers
brought to type foundries in the
hopes that they could be replicated
as new typestyles. Sheet music of
the period included a lot of hand-
lettering that influenced type design
considerably and is a great source of
inspiration for mimicking the faces
that were popular during the time, as
in vintage advertising.

Characteristics

During the late 1800s, typefaces
were known for their circus-like
appearance. They were very
elaborate and ornate, which was
perfect for the Big Top. The first
designs released after the turn-of-
the-century were distinctive for
their simplicity, which had a calm-
ing effect on type. These faces were
influenced somewhat by the Arts &
Crafts movement and had a hand-
hewn appearance, in fact, many
were designed to look as if they had
been lettered by hand.

Fonts of the early 1900s

Unfortunately, many of the distinc-
tive display faces of this period are
not available in digital type, but can
be found in old type books for
reference. (One good source to try is
*American Metal Typefaces of the
Twentieth Century* by Mac McGrew
and published by Oak Knoll Books,
New Castle, Delaware, 1993.) The
most characteristic fonts of the
period include Clearface Gothic
(ITC revitalized this face as ITC
Clearface, but it isn't an exact replica
of the original typeface), Florentine,
Roycroft, Pabst, Bullfinch, Della
Robbia, and Globe Gothic.

The fonts created during this
time that are still widely used today
have become almost generic in
their appearance, and while born
in the early twentieth century, they
do not necessarily evoke that era.
Nevertheless, these text and dis-
play fonts, such as News Gothic,
Franklin Gothic, and others, along
with their familial variations, are
historically accurate to the time
and are considered by many to be
the bread and butter fonts of today.

*Typefaces owned and provided by
Agfa Monotype.*

Fonts you probably own that evoke the era:

T Franklin Gothic
abcdefghijklmnopqrstuvwxyz1234567890
ABCDEFGHIJKLMNOPQRSTUVWXYZ

T Franklin Gothic Extra Condensed
abcdefghijklmnopqrstuvwxyz1234567890
ABCDEFGHIJKLMNOPQRSTUVWXYZ

T Franklin Gothic No. 2
abcdefghijklmnopqrstuvwxyz1234567890
ABCDEFGHIJKLMNOPQRSTUVWXYZ

T Bodoni
abcdefghijklmnopqrstuvwxyz1234567890
ABCDEFGHIJKLMNOPQRSTUVWXYZ

T Bodoni Poster Italic
abcdefghijklmnopqrstuvwxyz1234567890
ABCDEFGHIJKLMNOPQRSTUVWXYZ

T Caslon
abcdefghijklmnopqrstuvwxyz1234567890
ABCDEFGHIJKLMNOPQRSTUVWXYZ

T Caslon Italic
abcdefghijklmnopqrstuvwxyz1234567890
ABCDEFGHIJKLMNOPQRSTUVWXYZ

Type Tracker: 1920s

Influences

When Morris Fuller Benton took over as the director of typeface development for the American Type Founders, a conglomerate of about twenty-three type foundries established in the late 1800s, he built a library of typefaces based on his vision. The typefaces developed during his tenure carry his unique thumbprint and are noted for the humanistic feelings they evoke and their craftsman-like appearance, such as Parsons and Cheltanham.

Characteristics

Fonts of this period possess an eclectic blend of various characteristics. Many fonts originating during the twenties were designed to appear purposefully rugged such as Parsons and Packard. Simultaneously, typefaces developed during this time were influenced by the turn-of-the-century Victorians and, at the opposite end of the spectrum, the modern turns of the Art Deco movement.

Fonts of the 1920s

Perhaps the quintessential typeface of the 1920s is Broadway, seen by many as among the much-overused typefaces that illustrate the Roaring 20s. Ozwald, and today's version, ITC Ozwald, is another font evocative of the era, while Coronet typifies a 1920s script typeface.

Sans serif designs developed in the late 1920s were based on geometric forms. Sans serif fonts from the late 1920s that are still used today include German designs, Futura and Kabel, and their United States counterpart, Erbar. Franklin Gothic and News Gothic are sans serif designs that were also popular in the twenties, but they don't necessarily evoke an atmosphere of the era in graphic design pieces created today the same way that some of the others, such as Kabel. Gill Sans is also a 1920s typeface, but it did not really become popular until the 1930s and 1940s.

Typefaces owned and provided by Agfa Monotype.

Fonts you probably own that evoke the era:

EAGLE BOLD
ABCDEFGHIJKLMNOPQRSTUVWXYZ1234567890

Cheltenham Bold
abcdefghijklmnopqrstuvwxyz1234567890
ABCDEFGHIJKLMNOPQRSTUVWXYZ

Cheltenham
abcdefghijklmnopqrstuvwxyz1234567890
ABCDEFGHIJKLMNOPQRSTUVWXYZ

Kabel Black
abcdefghijklmnopqrstuvwxyz1234567890
ABCDEFGHIJKLMNOPQRSTUVWXYZ

Kabel Book
abcdefghijklmnopqrstuvwxyz1234567890
ABCDEFGHIJKLMNOPQRSTUVWXYZ

Kabel Heavy
abcdefghijklmnopqrstuvwxyz1234567890
ABCDEFGHIJKLMNOPQRSTUVWXYZ

Kabel Light
abcdefghijklmnopqrstuvwxyz1234567890
ABCDEFGHIJKLMNOPQRSTUVWXYZ

Monotype Broadway
abcdefghijklmnopqrstuvwxyz1234567890
ABCDEFGHIJKLMNOPQRSTUVWXYZ

MONOTYPE BROADWAY
ABCDEFGHIJKLMNOPQRSTUVWXYZ1234567890

Ozwald
abcdefghijklmnopqrstuvwxyz1234567890
ABCDEFGHIJKLMNOPQRSTUVWXYZ

Type Tracker:

Characteristics

Typefaces in the 1930s ranged from very conservative text designs to elaborate display fonts. Typefaces with art deco influences are also characteristic of the period. Art deco-inspired fonts are generally mannered designs with strong thick and thin contrasts to the strokes such as Radiant, Piranes Script. They have a small x height and tall ascenders. Examples of fonts with tall ascenders include Stymie Elongated and Radiant. Many fonts are notable for their heavy, dark designs such as Goudy Stout. Conversely, another '30s font, Huxley Vertical, is quite light by contrast, which proves that designers in the '30s worked in both extremes.

Influences

Art deco, both in art and architecture influenced type design in the 1930s. European design, which was a trend-setter for design in the early part of the century, was another influence. Many designers created hand-lettered art deco forms; those that became popular would be taken to type foundries and turned into cost-effective typefaces for printers and publishers.

Fonts of the 1930s

Times Roman was developed in 1932, as were other text fonts. Though not typical of the thirties, the decade saw the first wave of geometric sans serif fonts including Futura, Gill, Granby, and Metro. Out of the Bauhaus movement were fonts more indicative of the period such as Egyptian slab serif fonts Memphis, Stymie, and Karnac—all of which were available in the 1800s as display fonts, but were not introduced as font families until the '30s. Popular script typefaces included Kaufman Script and Keynote Script.

Typefaces owned and provided by Agfa Monotype.

Fonts you probably own that evoke the era:

GRECO SOLID
ABCDEFGHIJKLMNOPQRSTUVWXYZ1234567890

Hollywood Deco
abcdefghijklmnopqrstuvwxyz 1234567890
ABCDEFGHIJKLMNOPQRSTUVWXYZ

Dynamo
abcdefghijklmnopqrstuvwxyz1234567890
ABCDEFGHIJKLMNOPQRSTUVWXYZ

Bernhardt Bold
abcdefghijklmnopqrstuvwxyz1234567890
ABCDEFGHIJKLMNOPQRSTUVWXYZ

Bernhardt Medium
abcdefghijklmnopqrstuvwxyz1234567890
ABCDEFGHIJKLMNOPQRSTUVWXYZ

Bernhardt Light
abcdefghijklmnopqrstuvwxyz1234567890
ABCDEFGHIJKLMNOPQRSTUVWXYZ

Type

Characteristics

Slab serif typefaces were popular in the forties and were a primary focus. Fonts such as Beton, Cairo, Stymie, and Karnac were popular as both text and display faces and also quite distinctive. Meanwhile, many of the fonts from the 1930s remained popular. There was a holdover of elegance in typefaces, but the forties now considered many of the faces with the 1930s Art Deco influence passé.

Influences

Because of the war, very few new fonts debuted in the 1940s. Type foundries were turned into ammunition factories, making bullets or small arms.

Fonts of the 1940s

Among the typefaces true to the era, but not necessarily illustrative of the period include: Fairfield, a text font, which is fairly non-descript, Bernhard Tango, and Cartoon Light, many of which are no longer available—at least in a digital format. Anyone looking to find and research these older fonts can do so by picking up a copy of *American Metal Typefaces of the Twentieth Century* by Mac McGrew and published by Oak Knoll Books, New Castle, Delaware, 1993.

Typefaces owned and provided by Agfa Monotype.

Fonts you probably own that evoke the era:

T

Monotype Lydian
abcdefghijklmnopqrstuvwxyz1234567890
ABCDEFGHIJKLMNOPQRSTUVWXYZ

T

Monotype Lydian Cursive
abcdefghijklmnopqrstuvwxyz1234567890
ABCDEFGHIJKLMNOPQRSTUVWXYZ

T

Bernhard Modern
abcdefghijklmnopqrstuvwxyz1234567890
ABCDEFGHIJKLMNOPQRSTUVWXYZ

T

Park Avenue
abcdefghijklmnopqrstuvwxyz1234567890
ABCDEFGHIJKLMNOPQRSTUVWXYZ

T

PL Radiant
abcdefghijklmnopqrstuvwxyz1234567890
ABCDEFGHIJKLMNOPQRSTUVWXYZ

1950s

Type Tracker:

Influences

With the war over, more typesetting was being done. European typefaces that were popular in the 1930s, were discovered during the war, and once the type foundries started up production again, the U.S., in particular, started importing many fonts from overseas. Consequently, several of the faces that debuted in the U.S. in the fifties, had actually been in use throughout the 1930s and 1940s in Europe.

Characteristics

In contrast to the flamboyant colors and sprightly atmosphere of the 1950s, typefaces of the era were pretty austere. In the 1960s and 1970s, fonts livened up as part of an Art Nouveau and Art Deco revival and there was a surge in display type when phototypesetting came into being, but in the meantime, typefaces were pretty bland.

Fonts of the 1950s

Among the popular faces were Caledonia, a text typeface; Spartan and Tempo, neither of which are available today in digital form, were created to imitate Futura, a German font used widely in the twenties and thirties; Comstock was used a lot but isn't available today as was Times New Roman, which was designed in the 1930s in the United Kingdom and was imported by the U.S. in the fifties.

Typefaces owned and provided by Agfa Monotype.

Fonts you probably own that evoke the era:

Times New Roman
abcdefghijklmnopqrstuvwxyz1234567890
ABCDEFGHIJKLMNOPQRSTUVWXYZ

Corvinus Skyline
abcdefghijklmnopqrstuvwxyz1234567890
ABCDEFGHIJKLMNOPQRSTUVWXYZ

PL Latin Bold
abcdefghijklmnopqrstuvwxyz1234567890
ABCDEFGHIJKLMNOPQRSTUVWXYZ

Bodoni
abcdefghijklmnopqrstuvwxyz1234567890
ABCDEFGHIJKLMNOPQRSTUVWXYZ

Futura
abcdefghijklmnopqrstuvwxyz1234567890
ABCDEFGHIJKLMNOPQRSTUVWXYZ

Futura Light
abcdefghijklmnopqrstuvwxyz1234567890
ABCDEFGHIJKLMNOPQRSTUVWXYZ

Type
Tracker:

1960s (background)

Influences

The period was marked by two distinctive styles: a lot of revivals, including Art Nouveau and to a lesser degree, Art Deco period influences. Meanwhile, the whole psychedelic movement generated its own style of typefaces, many of which took their inspiration from Art Nouveau posters and similar graphic type treatments of the Art Nouveau artists.

Characteristics

Typefaces of the 1960s are easy for designers to emulate because there were some very distinctive typefaces used during this period.

Fonts of the 1960s

By far the most popular text typefaces of the period were Helvetica and Times Roman. However, other, more distinctive faces were also used. Unfortunately, while many of the original sixties faces are not available today in digital form, there are some that are revivals of sixties typeface design including display fonts such as Peace, Love, Ray Cruz's Swinger, Pump, Black Boton, Eccentric, plus Art Nouveau revival faces like Skjald, Windsor (which was from the late 1800s that became available in phototype), and M.N. Ortem.

Typefaces owned and provided by Agfa Monotype.

Fonts considered groovy in the sixties include:

PEACE OPEN
ABCDEFGHIJKLMNOPQRSTUVWXYZ1234567890

PEACE OUTLINE
ABCDEFGHIJKLMNOPQRSTUVWXYZ1234567890

PEACE SOLID
ABCDEFGHIJKLMNOPQRSTUVWXYZ1234567890

LOVE OPEN
ABCDEFGHIJKLMNOPQRSTUVWXYZ1234562890

LOVE SOLID
ABCDEFGHIJKLMNOPQRSTUVWXYZ1234562890

LOVE STONED
ABCDEFGHIJKLMNOPQRSTUVWXYZ1234562890

T URTEM
ABCDEFGHIJKLMNOPQRSTUVWXYZ1234567890

T Cruz Swinger
abcdefghijklmnopqrstuvwxyz1234567890
ABCDEFGHIJKLMNOPQRSTUVWXYZ

T Windsor
abcdefghijklmnopqrstuvwxyz1234567890
ABCDEFGHIJKLMNOPQRSTUVWXYZ

T Windsor Elongated
abcdefghijklmnopqrstuvwxyz1234567890
ABCDEFGHIJKLMNOPQRSTUVWXYZ

Type Tracker:

1970s

Characteristics

Swash letters, fancy characters that loop under other characters, were popular in the seventies. This trend was prompted by the famous United Airlines advertising campaign — Fly the Friendly Skies—which used Bookman with a twist by incorporating fancy letters in it.

Influences

Trends were established during the 1970s by International Typeface Corporation (ITC), which was formed during the decade and enjoyed its strongest influence in the seventies and early eighties. ITC issued new fonts on a quarterly basis and designers turned to ITC and its magazine, *U&lc*, to see what the newest faces were. All in all, the seventies were a very innovative time with a lot of new typeface designs.

Fonts of the 1970s

The quintessential fonts of the period were ITC Souvenir and ITC Avant Garde Gothic—which were so popular sophisticated designers shunned them for years afterward because they were so associated with the 1970s to the point of overuse. Also popular were ITC Benguiat, ITC Souvenir, ITC Bookman, ITC Tiffany, and Antique Olive.

Typefaces owned and provided by Agfa Monotype.

Fonts you probably own that evoke the era:

T **Bookman**
abcdefghijklmnopqrstuvwxyz1234567890
ABCDEFGHIJKLMNOPQRSTUVWXYZ

T **Benguiat**
abcdefghijklmnopqrstuvwxyz1234567890
ABCDEFGHIJKLMNOPQRSTUVWXYZ

T *Benguiat Book Italic*
abcdefghijklmnopqrstuvwxyz1234567890
ABCDEFGHIJKLMNOPQRSTUVWXYZ

T Avant Garde
abcdefghijklmnopqrstuvwxyz1234567890
ABCDEFGHIJKLMNOPQRSTUVWXYZ

Type Tracker:

Influences

Prior to 1985 and the advent of desktop publishing, the control of how typefaces looked and were fashioned was held in a few hands, primarily the large foundries, a couple of influential designers, and companies like International Typeface Corporation (ITC).

When desktop publishing boomed, boutique type foundries popped up and all different styles of fonts became available and there was a lot of experimentation, as well as a lot of revivals. Companies like T26, Adobe, Font Bureau, and many individual designers influenced typeface design during the latter part of the twentieth century. There was really no single influence on type during this period.

Characteristics

Because of the proliferation of type houses during the last twenty years of the 1900s, it is difficult to pin down one or two characteristics that exemplify type of that period. Wildly experimental, alternative designs were created and competed successfully with retro faces and revivals of old standbys. Three trends emerged during the twenty-year span between 1980 and 1999. First, as mentioned, there were a lot of alternative typestyles and experimental type treatments as evidenced by such fonts as Space Kid, Synchro, and Handwrite Inkblot. Calligraphic typefaces were also popular as evidenced by the wide use of ITC Humana and the light-handed Papyrus. Finally, retro typefaces that allowed designers to use new, cutting edge fonts to replicate another time also boomed. Some of the more popular fonts of this style include Mojo, which conjures up images of the 1970s, Martini at Joe's, replicating the 1950's modern style, and Bertram, which is a throwback to the 1940s.

Typefaces owned and provided by Agfa Monotype.

A few fonts showing the diverse trends of the 1980s and 1990s include:

BERTRAM
ABCDEFGHIJKLMNOPQRSTUVWXYZ1234567890

Handwrite Inkblot
abcdefghijklmnopqrstuvwxyz1234567890
ABCDEFGHIJKLMNOPQRSTUVWXYZ

Humana Serif Bold
abcdefghijklmnopqrstuvwxyz1234567890
ABCDEFGHIJKLMNOPQRSTUVWXYZ

Humana Serif Light
abcdefghijklmnopqrstuvwxyz1234567890
ABCDEFGHIJKLMNOPQRSTUVWXYZ

MARTINI AT JOES
ABCDEFGHIJKLMNOPQRSTUVWXYZ1234567890

Papyrus
abcdefghijklmnopqrstuvwxyz1234567890
ABCDEFGHIJKLMNOPQRSTUVWXYZ

Handel Gothic
(stylized/decorative characters)

SYNCHRO
ABCDEFGHIJKLMNOPQRSTUVWXYZ1234567890

SYNCHRO REVERSED
ABCDEFGHIJKLMNOPQRSTUVWXYZ1234567890

Plazm

Above: *Plazm 21* "LawnScapes" cover explores issues of livability and growth

ART DIRECTION: JOSHUA BERGER, NIKO COURTELIS, PETE McCRACKEN. DESIGN: PETE McCRACKEN. PHOTOGRAPHY: MARK EBSEN. LETTERPRESS OVERLEAF: CRACK PRESS

Opposite: The design of the "Against Livability" spread for *Plazm 21* was a result of a two-day student workshop given by Plazm at Oregon State University.

ART DIRECTION: JOSHUA BERGER, NIKO COURTELIS, PETE McCRACKEN. DESIGN: GARRETT ANDRES, MATT BALDWIN, LAUREN McKENNA

PLAZM MEDIA COLLECTIVE is based in a spacious office surrounded by artists' studios near the Willamette River in Portland, Oregon. Here, the collective runs a design studio, Plazmfonts, and *Plazm* magazine, published quarterly.

The most visible Plazm entity is the magazine. This publication is eclectic, intelligent, and edgy with typocentric, quirky design. It is also the calling-card and portfolio for the interrelated talents of the art directors Joshua Berger, Pete McCracken, and Niko Courtelis (now based along with Riq Mosqueda in New York at Lintas Lowe & Partners, embodying Plazm East).

"Although the magazine has evolved since we started it in 1991," according to Berger, it remains "our printed laboratory, our ongoing experiment. It still is a forum for our varying interests. The fonts grew out of the magazine and the Plazm design group as well."

Berger says that from its inception, Plazm was dedicated to merging multiple visions and voices. "We started as a cooperative and non-profit enterprise. Eventually we needed to run the business of the magazine properly, so Pete and I started working here full time. And with Niko (who then worked at Wieden & Kennedy), we've remained dedicated to experimentation through discourse. We value everyone's contribution here from managing editor Jon Raymond to the intern. The magazine is the product of whoever is involved at the time. We begin with this internal critique, by listening first." McCracken adds that "the results are much better when you let this process work. It's like having everyone's input in my band—the music then becomes much more interesting both to listen to and to play." According to Courtelis, this interplay of personalities "speeds up the process. Each person brings his or her particular interest, be it film, music, photography, to the table. The group thinking and talking gives each project parameters. From the ideas generated comes a vision, a direction, and we agree on a brief. This approach has evolved, but it allows us to explore what something is or isn't, to deconstruct on paper."

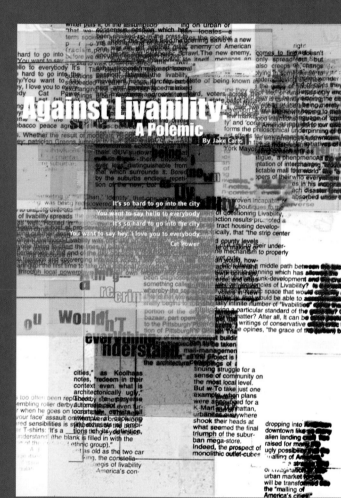

Against Livability:
A Polemic

By Jake Caroll

It's so hard to go into the city
You want to say hello to everybody
It's so hard to go into the city
You want to say hey, I love you to everybody

— Cat Power

Last fall, not long after their attorneys general returned home with the Big Tobacco peace agreement, the States fired the opening salvo in a new war on yet another great enemy of American health and prosperity: Sprawl. The new enemy, rather than threatening life itself, menaces an even more ephemeral state of being known as Livability.

On November third, voters across the country faced a mixed bag of state ballot initiatives and constitutional amendments, over two hundred of them at final count, aimed at somehow curbing the relentless expansion of the suburbs. A surprisingly large majority of these measures passed, often by comfortable margins, and within a week big-city dailies were declaring the birth of a national livability movement. Suddenly Al Gore, known for his inhuman enthusiasm for land-use, planning and other tedious "soft-green" issues, went from laborious wonk to political bellwether and was being quoted from coast to coast, possibly for the first time in his career. And while Gore busied himself formulating the administration's new "Livability Agenda," a host of pro-development politicians defeated at the city and county levels began clearing out their desks. Growth-control had been definitively proven capable of making or breaking political livelihoods. Livability was officially on the map.

Anyone trying to chart the lines of battle tentatively drawn in the fall election would, however, find themselves at the end of the day gripping a hopelessly confused cartographic remnant. The political filiations and converging interests which have driven the latest anti-growth uprisings, while appearing for the first time to take on a national character, are frequently perverse, and often channeled through local powerplays with their own arcane and case-sensitive sets of ground rules. Whether the result of patrician Greens jumping in bed with NIMBY suburbanites in Ventura County or mega corporations hijacking Sierra Club legislation in Arizona, the defense of livability continually defies the balding liberal/conservative dichotomy that once purported to organize the nation's political life.

Moreover, in addition to draping over old political paradigms, the cloak of livability spreads across geographic borders as well. Rooted in both disenchantment with the suburban condition—its failure of public transportation, dearth of affordable housing, and engulfment of open space—as well as a strange nostalgia for urban life—its density, variety, and texture—the fight against sprawl, perhaps by definition, renders the boundaries between city and suburb somewhat blurry. For sprawl, one comes to find, doesn't only spread out, but also creeps in, hangs on, and bubbles up, applying in some sense to almost any example of underachieving architecture. But whether taking the guise of suburban "livability," urban "quality of life," or even rural "way of life," the anti-sprawl movement is currently offering a national referendum on public space and how it works, and moreso, on life and how to live it.

Waxing discontent with America's architecture and infrastructure has most recently been diagnosed by marketing consultants as "mall fatigue," the phenomenon whereby the serial presentation of interchangeable outlet stores in predictable mall formats finally begins to rob shoppers of their enthusiasm, of their sense of shopping as event. In focus groups, the petri-dishes of marketing's gay science, the epidemiologists of mall fatigue have learned that consumers crave a more unique shopping environment, one which offers both commercial variety and the patina of city living excitement. As marketing consultant Robert Gibbs puts it in his article, "Urbanizing: A Primer on How Downtowns Can Compete with Retail Malls," "(Americans) long for the community consensus and sense of place which once ruled our commercial and civic lives." In other words, the bustle and clang of the old city, cleaned up and encoded in the very blueprints of the new.

Consider an extreme case, that of Pittsburgh, where Mayor Tom Murphy and the city government have set in motion an unprecedented redevelopment plan to transform a portion of the city's downtown into a new cyborg mall-district, "part bazaar, part open-air street mall and part big-city promenade" according to the Pittsburgh Post-Gazette. Murphy's plan calls for a seven-block portion of Pittsburgh's Golden Triangle, encompassing a total of more than eighty of the city's oldest buildings (including more than a few "architectural masterpieces"), to be taken over by eminent domain and turned over to a single mall-management company, Urban Retail Properties. "Marketplace," as the project is known, will exist within and retain most of the architectural trappings

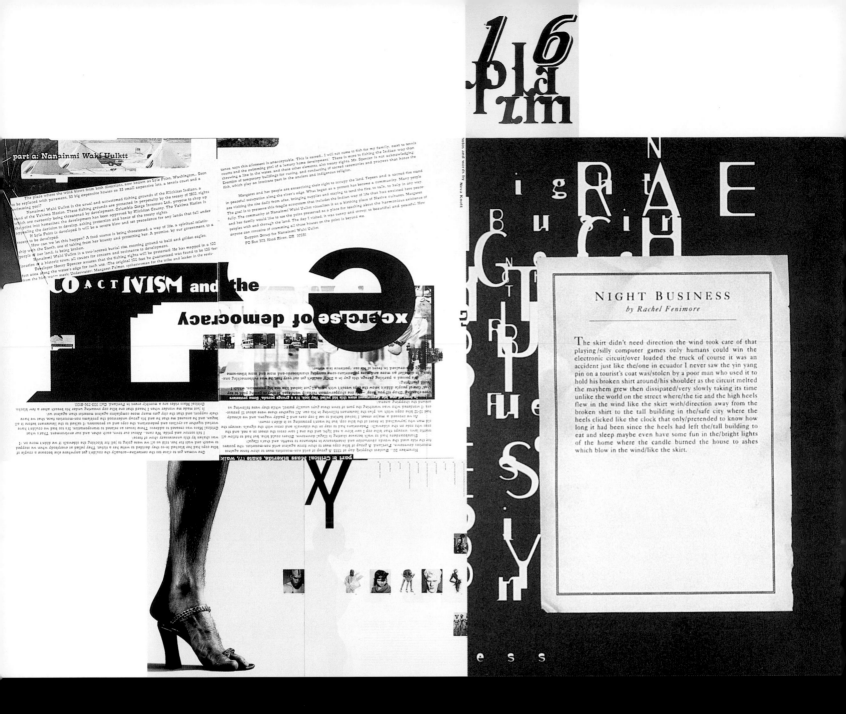

part a: Nanainmi Wakł Uulktt

ACTIVISM and the exercise of democracy

NIGHT BUSINESS
by Rachel Fenimore

The skirt didn't need direction the wind took care of that playing/silly computer games only humans could win the electronic circuit/over loaded the truck of course it was an accident just like the/one in ecuador I never saw the yin yang pin on a tourist's coat was/stolen by a poor man who used it to hold his broken shirt around/his shoulder as the circuit melted the mayhem grew then dissipated/very slowly taking its time unlike the world on the street where/the tie and the high heels flew in the wind like the skirt with/direction away from the broken shirt to the tall building in the/safe city where the heels clicked like the clock that only/pretended to know how long it had been since the heels had left the/tall building to eat and sleep maybe even have some fun in the/bright lights of the home where the candle burned the house to ashes which blow in the wind/like the skirt.

PLAZM MAGAZINE
The magazine has allowed Berger, McCracken, and Courtelis to art direct designer/collaborators for the covers and within its pages, including Ed Fella, The Attik, David Carson, and Why Not Associates. Although *Plazm* is deliberately intended to never look the same

twice, to evolve with each issue, the magazine can be characterized as being filled with innovative design treatments of its editorial subjects, with an emphasis on typographic virtuosity. *Plazm*'s commitment to type diversity is reflected in their varying treatments of the *Plazm* logo for each issue. Berger characterizes

the magazine as a "well-produced 'zine."

The content of *Plazm*, with themes like "Identity" or "Architecture," is often esoteric, and the design matches the intensity of the content. Admitting that there was a period when the typography in *Plazm* was based on "experimenting with type as type," so that "*Plazm* became

known for deteriorated type and messing things up," that phase has ended, says Berger. "We're not dedicated to sameness," he reiterates.

PLAZMFONTS AND TYPOGRAPHY
A spin-off generated by the magazine includes a range of Plazmfonts. "We

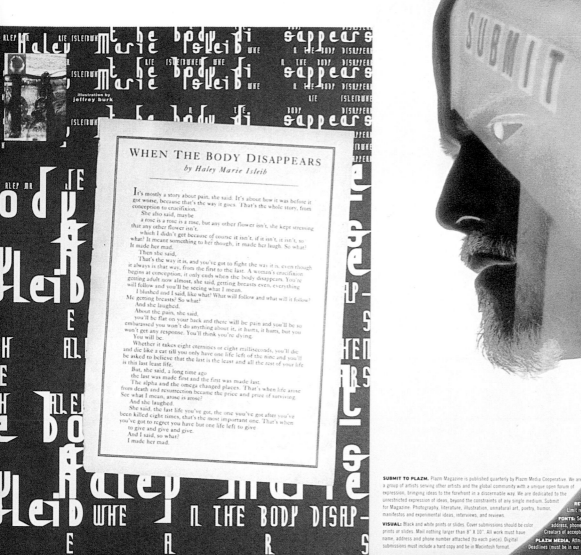

Plazm Ecoactivism spread
ART DIRECTION: JOSHUA BERGER,
NIKO COURTELIS. DESIGN: KAT SATO

Plazm XY spread
ART DIRECTION: JOSHUA BERGER, NIKO
COURTELIS, PETE McCRACKEN. DESIGN:
JOSHUA BERGER. STYLE EDITOR: STORM
THARP. TEXT: JON RAYMOND

Plazm 16 announcement poster
DESIGN: DAVID CARSON

Plazm poetry spread
ART DIRECTION: JOSHUA BERGER, NIKO
COURTELIS. DESIGN: NIKO COURTELIS

Plazm Submit poster
ART DIRECTION/DESIGN: NIKO COURTELIS
PHOTOGRAPHY: BOB WALDMAN

Plazm 22 Identity cover
ART DIRECTION: JOSHUA BERGER, NIKO
COURTELIS, PETE McCRACKEN. DESIGN:
JOSHUA BERGER, ANDRÉ THIJSEEN
PHOTOGRAPHY: ANDRÉ THIJSEEN

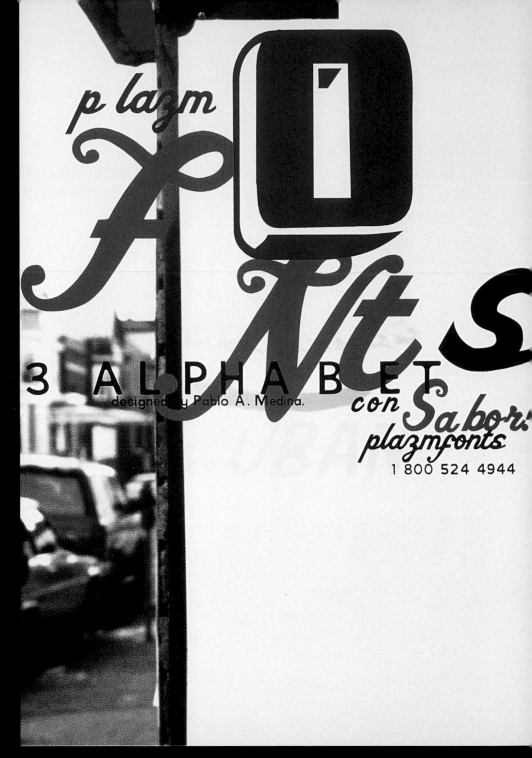

p lazm

FONTS

3 ALPHABET

designed by Pablo A. Medina.

con Sabor

plazmfonts

1 800 524 4944

bored with the options we had available in type choices, so I started creating my own things to have something new to play with," says Pete McCracken, who also has his own letterpress and silk-screening studio, Crack Press. His Inky Black font is used frequently in the

magazine. McCracken expounds on the many talents of type designers discovered by and now distributed by Plazm-fonts. Designers like Marcus Burlile, Angus R. Shamal, Christian Küsters, and Pablo Medina have created outstanding typefaces. McCracken points out, "We

promote the individual who creates the font for Plazmfonts, rather than promoting ourselves as the foundry," he says.

Although the Plazm designers do use Plazmfonts in the publication, their typographic rationale is conceptually driven. "We don't use new fonts for the sake of

using them," Berger says. Courtelis reiterates, "Our typographic approach stays on the conceptual level. We choose the flavor of type appropriate to the idea, rather than a typographic style for style's sake. We avoid the temptation to just look cool." And as Berger points

Opposite, clockwise from upper-left:

Plazmfonts Subluxation poster

ART DIRECTION: JOSHUA BERGER, NIKO COURTELIS,
PETE McCRACKEN. DESIGN: NIKO COURTELIS
PHOTOGRAPHY: PETE McCRACKEN

Plazmfonts: Con Sabor!

ART DIRECTION: JOSHUA BERGER, NIKO COURTELIS,
PETE McCRACKEN. DESIGN: PABLO MEDINA

Seybold Type Gallery poster

DESIGN/PRINTING: PETE McCRACKEN

Right: Mtvpe. Plazm was commissioned
to create a new typeface for MTV for use
as the channel's primary on-air presence.
MTV asked Plazm to "challenge the no-
tions of what a typeface can and should
be." Plazm responded by creating a type-
face that was not only readable on screen
but that suggested an entire aesthetic.
Rather than creating a typeface within
a restricted framework, Plazm built the
framework around the typeface.

Mtvpe is a post-Helvetica typeface
based on a simple geometric architec-
ture in which smooth edges contrast
right angles. Its varying stroke width
and unconventional x-height suggest
a modern style tempered by tradition.

ART DIRECTION: JOSHUA BERGER, NIKO COURTELIS,
PETE McCRACKEN. DESIGN: JOSHUA BERGER, NIKO
COURTELIS, PETE McCRACKEN, RIQ MOSQUEDA
PRINCIPAL TYPE DESIGN: PETE McCRACKEN. TYPE-
FACES SHOWN: MTVPE, MTVPE SLANT, MTVPE BOLD,
MTVPE BOLD SLANT. CLIENT: MTV NETWORKS

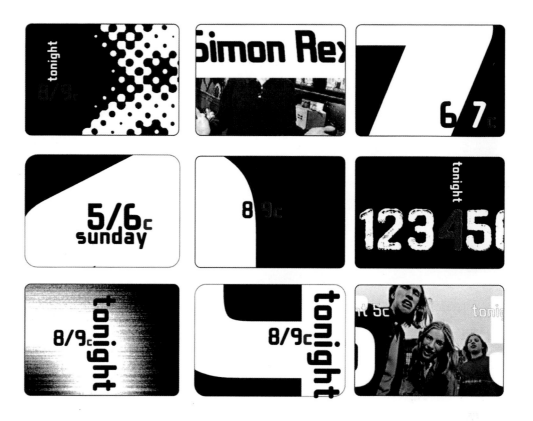

Mtvpe WAS DESIGNED EXCLUSIVELY FOR MTV NETWORKS
ABCDEFGHIJKLMNOPQ
RSTUVWXYZabcdefghi
jklmnopqrstuvwxyz
1234567890

out, producing a hand-crafted feeling
for *Plazm* work is important to the art
directors, although they will opt to use
Univers or Helvetica when the editorial
direction of an issue demands it.

PLAZM DESIGN
Plazm Design works for outside clients
including Nike, PICA (the Portland Insti-
tute for Contemporary Arts), and MTV
(for which Plazm designed the Mtvpe
typeface). The Plazm process of inter-
nally brainstorming is again the start-

ing point. "We view ourselves as prob-
lem solving the concepts aesthetically,"
Berger says. "Our approach ends up being
a creative solution rather than a style,"
McCracken adds. Again the Plazm work
responds to client needs with careful
and considered type treatments.

THE FUTURE
With Niko Courtelis and Riq Mosqueda
(formerly a Plazm intern and one of the
collective) now both in New York, Plazm
East is launched. Berger says that this
allows more access to the contributing
designers based there, which adds even

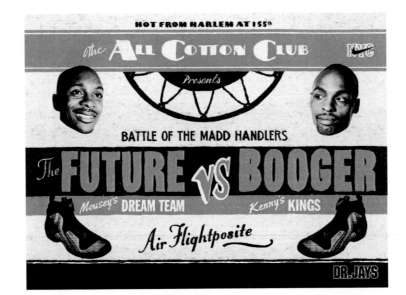

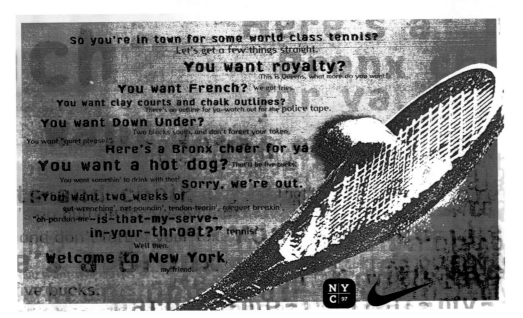

From bottom left:

Nike US Open Limited Edition poster. This poster is a component of Nike's overall graphic presence at the US Open tennis tournament. The assignment was to evoke "tennis with a unique New York attitude," and included design of 38' walls, product displays, banners, etcetera.
ART DIRECTION: JOSHUA BERGER, NIKO COURTELIS, PETE McCRACKEN DESIGN: JOSHUA BERGER, PETE McCRACKEN. CLIENT: NIKE

All Cotton Club/NYC City Attack. Outdoor advertising promoting basketball shoes employs both street and professional New York players. Hand lettering was utilized to reflect Cotton Club posters from the 1920s.
DESIGN FIRM: PLAZM DESIGN. AD AGENCY: WIEDEN & KENNEDY. ART DIRECTION: DANIELLE FLAGG. DESIGN: JOSHUA BERGER, PETE McCRACKEN, LOTUS CHILD, JON STEINHORST. WRITER: JIMMY SMITH. CLIENT: NIKE

more voices to the publication. Courtelis adds that he and Mosqueda are art directing upcoming issues and recruiting Graham Wood of Tomato as one of their contributors. Also from Plazm East, Courtelis will pursue Plazm book projects, including one on "the design of

'zines." Also scheduled for distribution is Plazm Video, a new venture for the magazine.

Although more clients are lining up for Plazm design, the linchpin of this complex, contemporary collective is the publication. Berger sums up, "*Plazm*

magazine is passionately presented, and it is personal. We don't really do it for anyone but ourselves."

muslimgauze
hussein mahmood jeeb tehar gass

muslimgauze
hussein mahmood jeeb tehar gass

CD packaging and promotional poster
for Muslimgauze: self-described as
"fake Arab ethnic industrial music
with political overtones"

ART DIRECTION: JOSHUA BERGER, NIKO COURTELIS,
PETE McCRACKEN, RIQ MOSQUEDA. DESIGN: RIQ
MOSQUEDA. PHOTOGRAPHY: SHIRIN NESHAT
CLIENT: SOLEILMOON RECORDINGS

Leonardo Sonnoli

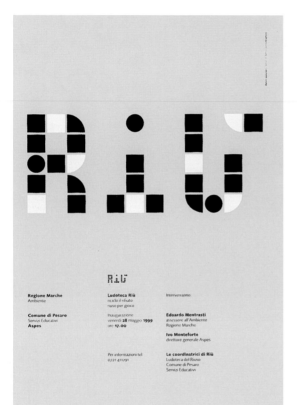

FOR THE LAST TEN YEARS Leonardo Sonnoli has been art director of Dolcini Associati in Pesaro, Italy. The firm's founder, Massimo Dolcini, manages the firm, and Sonnoli is the designated "creative leader." Dolcini Associati has a diverse list of clients and produces work ranging from corporate identity and signage systems to books and magazines, but Sonnoli is best known for "cultural communication," work done on behalf of municipalities (like Pesaro), museums, and non-profit foundations.

On behalf of these clients, Leonardo Sonnoli has managed to create a range of posters that are stark, complex, typographically acute, and brain teasing. He provokes and challenges his audience to delve into a poster's meaning, rather than explicitly conveying it.

Above: RIU poster with the collaboration of Monica Zaffini. Opposite: Poster for City of Pesaro announcing an exhibition of women's textile work
DESIGN: LEONARDO SONNOLI

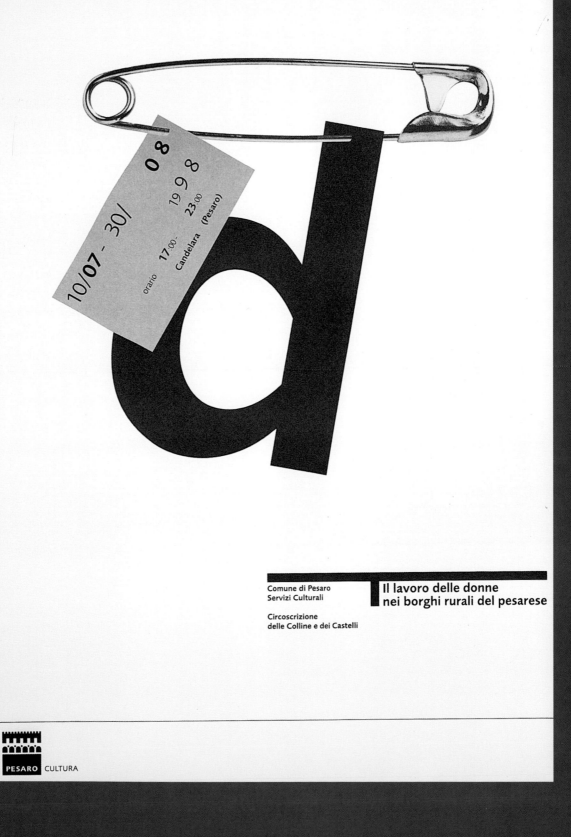

10/07 - 30/ 0 8
1998

orario 17.00 - 19 9 8
Candelara (Pesaro) 23.00

Comune di Pesaro
Servizi Culturali

Circoscrizione
delle Colline e dei Castelli

Il lavoro delle donne
nei borghi rurali del pesarese

PESARO CULTURA

prosa

Comune di Pesaro/Amat
Teatro Rossini Stagione Teatrale 1999 - 2000

Abbonamento a 7 spettacoli (Turni A/B/C/D)

Posto di platea e posto di palco di I e II ordine sett. cent.	L.308.000
ridotto per anziani oltre 65 anni e giovani fino a 24 anni	L.266.000
Posto di palco di I e II ordine sett. lat. e posto di palco di III ordine sett. cent.	L.259.000
Posto di palco di III ordine sett. lat. e posto di 1a fila di galleria	L.203.000
Posto di palco di IV ordine e posto di 2a e 3a fila di galleria	L.161.000
Attenzione: il programma può subire variazioni per cause di forza maggiore	

Biglietti

Posto di platea e posto di palco di I e II ordine sett. cent.	L.45.000
ridotto per anziani oltre 65 anni e giovani fino a 24 anni	L.40.000
Posto di palco di I e II ordine sett. lat. e posto di palco di III ordine sett. cent.	L.38.000
Posto di palco di III ordine sett. lat. e posto di 1a fila di galleria	L.30.000
Posto di palco di IV ordine e posto di 2a e 3a fila di galleria	L.25.000
Loggione	L.12.000

Biglietteria:
nel corso della stagione la biglietteria del Teatro Rossini (Piazzale Lazzarini, 29 - Tel. 0721 33184) sarà aperta dal giorno precedente la prima rappresentazione con orario 10-12, 16-19. Dalle ore 16 alle ore 19 è possibile effettuare prenotazioni telefoniche.

Orario degli spettacoli:
salvo diversa indicazione gli spettacoli avranno inizio alle ore 21.00 nei giorni feriali e alle ore 17.00 la domenica e i giorni festivi. A spettacolo iniziato è vietato l'ingresso in platea e ai posti numerati di galleria.

de filippo
molière
shakespeare
pirandello
ionesco
ibsen
baricco

21/22/23/24 ottobre 1999 Diana Or.I.s presenta NATALE IN CASA CUPIELLO di Eduardo De Filippo con Carlo Giuffré e Angela Pagano regia Carlo Giuffré

4/5/6/7 novembre 1999 Teatro de gli Incamminati presenta IL MALATO IMMAGINARIO di Molière con Franco Branciaroli regia Lamberto Puggelli

25/26/27/28/29 novembre 1999 Teatro Stabile del Friuli-Venezia Giulia presenta AMLETO di William Shakespeare con Kim Rossi Stuart regia Antonio Calenda

10/11/12 dicembre 1999 (fuori abbonamento) Fondazione "Le Città del Teatro" Teatro Stabile delle Marche presenta

SCENE D'AMOR PERDUTO da William Shakespeare regia Massimo Navone - Giampiero Solari

13/14/15/16 gennaio 2000 Plexus T. - Teatro Stabile di Catania presentano PENSACI, GIACOMINO! di Luigi Pirandello con Turi Ferro regia Guglielmo Ferro

10/11/12/13 febbraio 2000 Compagnia Glauco Mauri presenta IL RINOCERONTE di Eugène Ionesco con Glauco Mauri, Roberto Sturno regia Glauco Mauri

24/25/26/27 febbraio 2000 Teatro Stabile di Firenze presenta HEDDA GABLER di Henrik Ibsen con Anna Bonaiuto regia Carlo Cecchi

6/7/8/9 aprile 2000 Teatro Laboratorio Settimo presenta NOVECENTO di Alessandro Baricco con Eugenio Allegri regia Gabriele Vacis

PESARO TEATRI

Anonimo (sec. XIX).
Nudo maschile di schiena.
Matita nera lumeggiata
a biacca su carta preparata
nocciola, mm 484x381.
Pinacoteca civica di Pesaro

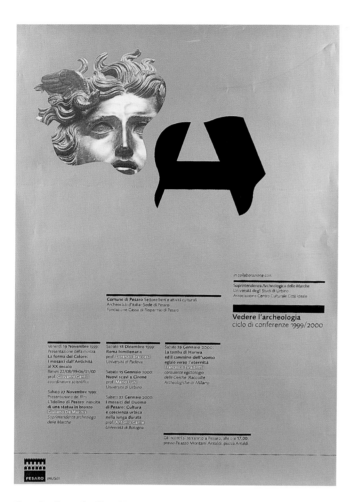

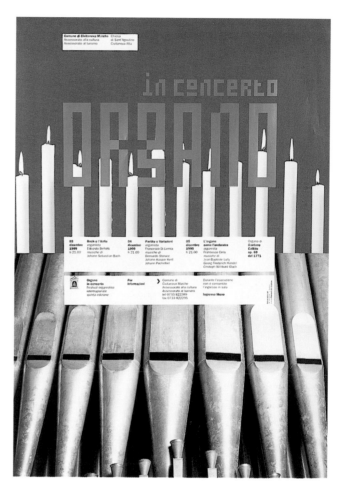

Opposite: Poster for City of Pesaro Theater
Above left: Poster for City of Pesaro archeo-
logical exhibition and lectures. Above right:
Poster for organ concert designed with the
collaboration of Massimiliano Patrignani

DESIGN: LEONARDO SONNOLI

DESIGN PHILOSOPHY

Although dismissing a philosophy of
design as "pretentious," Sonnoli does
relate to his work in very definite terms.
He elaborates, saying "I consider my job
as a profession, and I regard myself as
a professional. This means I try to solve
each problem of communication as
effectively as possible. Definitely I
have my own ideas on how to design.
Mainly I base my creative skills on
a knowledge of the past, especially
gleaning techniques and methods
from the masters, and interpreting

these, like using collage, digitally."

For Sonnoli, the masters are the
European Avant Garde. He says, "I
grew up loving the 20th century de-
signers like Piet Zwart, El Lissitzky,
Jan Tschichold, Laszlo Moholy-Nagy,
and also the Italian Futurists. I have

based my creative skills on this knowl-
edge of the past."

To explain how he works, Sonnoli
uses this analogy: "You can compare
designing to driving a car. To go safely
ahead, you have to check the rear-view
mirror, in this case to glance to the

Right, clockwise from upper left:
Poster for Conference on Sister Town
(three circles form a "g" standing for
"gemellaggio," Italian for "sister town."
The alphabet designed for the poster
is composed by "sister shapes": circles
and its modules and squares); Poster
for Conference for Hope (Speranza), a
lecture by the philosopher Massimo
Cacciari; Easy Cooker poster for a de-
sign competition for new pots and
frying-pans; and Alphabet poster for
the opening of the academic year of
the architectural university of Venice

Opposite: Poster for the City of Pesaro
announcing a kitchenware design
competition to benefit the disabled

DESIGN: LEONARDO SONNOLI

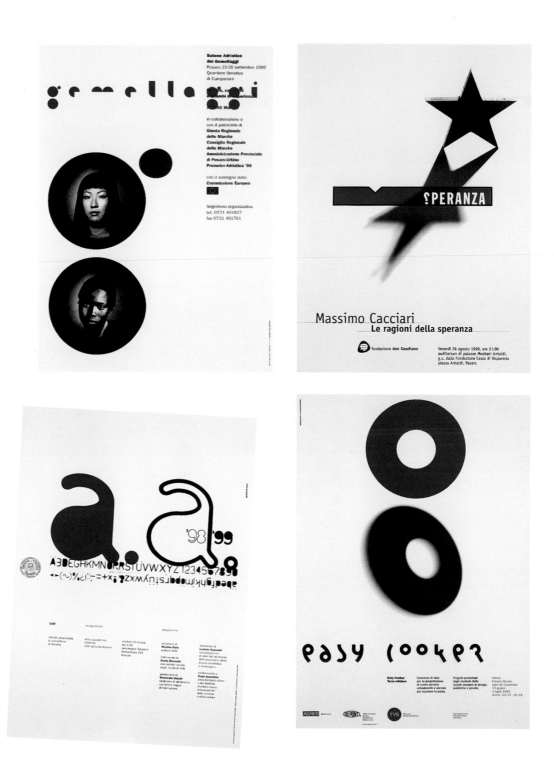

past. Then I use these aesthetics and
remix the past with our own 'zeitgeist'
and our new technology."

He further compares what he does as
a designer to what a disc jockey does
with music, saying, "The way a DJ works
as a mixer of music, I am working with
my keyboard and my mouse and mixing
bits of text with bits of pictures." Sonnoli
calls this approach "neue remix" with ref-
erence to the title of the Jan Tschichold
classic, *Die Neue Typographie.*

Although this may describe the
Sonnoli process of design, it doesn't
fully reflect the effectiveness of the
results. His work not only displays
these formidable influences, but it also
brings them into a contemporary con-
text. His posters are large not only in
terms of size, but in terms of ideas.
Sonnoli produces eye-catching, mind-
provoking posters with intriguing type
treatments and suggestive imagery.
Sonnoli has moved from avant garde
to a heightened minimalism while cre-
ating a sense of shock with sheer scale.
His use of balance, negative space, and
illustrative text put the viewer in awe.
(Imagine Pesaro festooned with posters
by Sonnoli.)

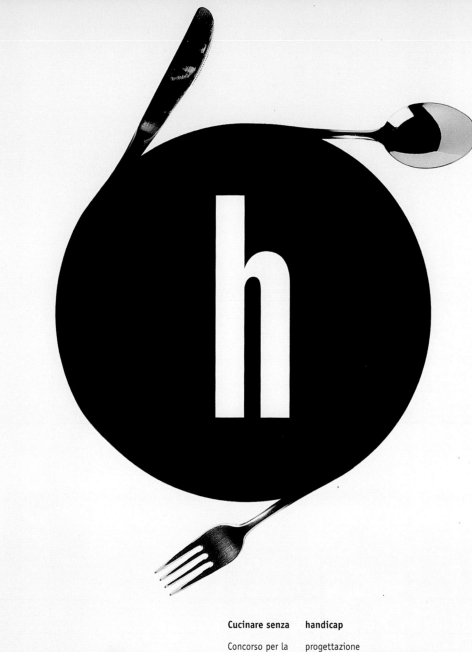

Cucinare senza handicap

Concorso per la progettazione
di pentole per ipovedenti
e cucine per disabili
Pesaro, sala Laurana

fondazione **don gaudiano**

6 > 21 giugno 1998
orario 18.00 - 22.00

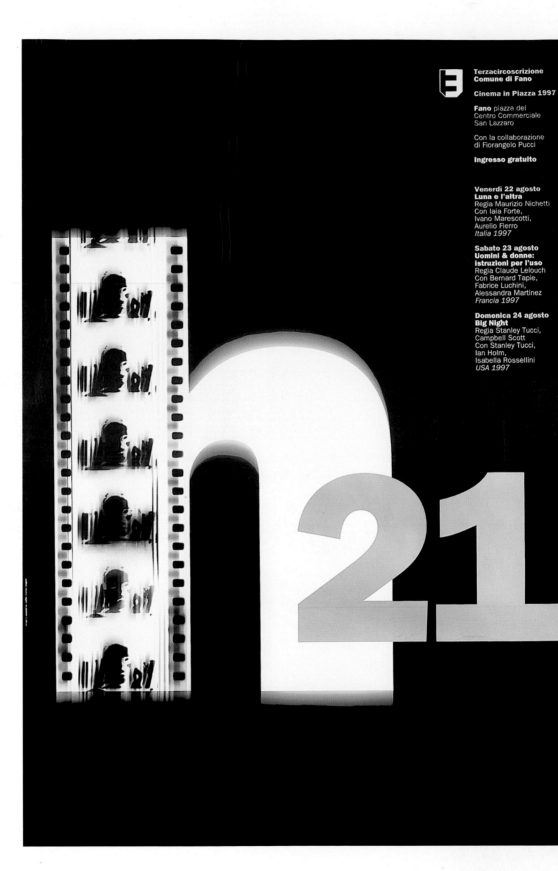

Posters for film festival 1997, 1998
designed with the collaboration of
Monica Zaffini

DESIGN: LEONARDO SONNOLI

**Terzacircoscrizione
Comune di Fano**

Cinema in Piazza 1997

Fano piazza del
Centro Commerciale
San Lazzaro

Con la collaborazione
di Fiorangelo Pucci

Ingresso gratuito

**Venerdì 22 agosto
Luna e l'altra**
Regia Maurizio Nichetti
Con Iaia Forte,
Ivano Marescotti,
Aurelio Fierro
Italia 1997

**Sabato 23 agosto
Uomini & donne:
istruzioni per l'uso**
Regia Claude Lelouch
Con Bernard Tapie,
Fabrice Luchini,
Alessandra Martinez
Francia 1997

**Domenica 24 agosto
Big Night**
Regia Stanley Tucci,
Campbell Scott
Con Stanley Tucci,
Ian Holm,
Isabella Rossellini
USA 1997

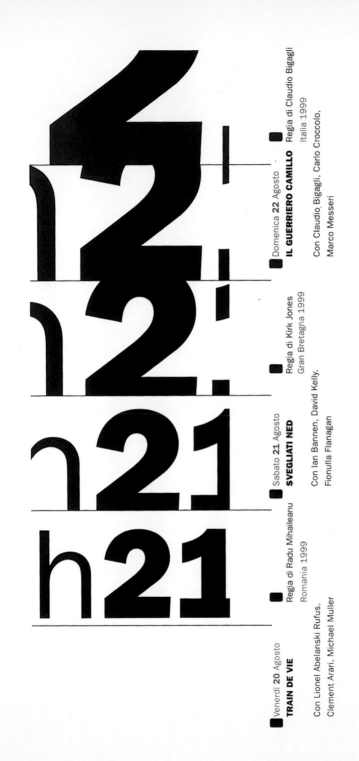

Venerdì **20** Agosto
TRAIN DE VIE

Con Lionel Abelanski Rufus,
Clement Arari, Michael Muller

Regia di Radu Mihaileanu
Romania 1999

Sabato **21** Agosto
SVEGLIATI NED

Con Ian Bannen, David Kelly,
Fionulla Flanagan

Regia di Kirk Jones
Gran Bretagna 1999

Domenica **22** Agosto
IL GUERRIERO CAMILLO

Con Claudio Bigagli, Carlo Croccolo,
Marco Messeri

Regia di Claudio Bigagli
Italia 1999

**Terza
circoscrizione
Comune
di Fano**

**Cinema
in Piazza '99**

Fano
piazza
del Centro
Commerciale
San Lazzaro

Proiezioni alle
ore 21:00

Con la
collaborazione
di Fiorangelo
Pucci

**Ingresso
gratuito**

design L. Leonelli / m. zaffini stampa magma

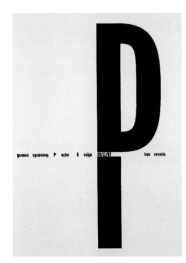
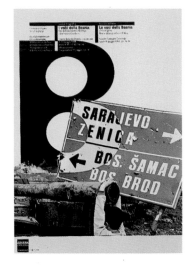

TYPE AND TYPOGRAPHY

Sonnoli says the unique use of type in his designs originates in "taking away rather than adding. It's really a challenge to communicate with as little information as possible without being boring or not expressing ideas," he says. In part, this minimalist vision is enhanced by his choice of sans serif, no-frills type.

He hearkens to the Bauhaus experiment and typographic aesthetic, saying, "Moholy-Nagy wrote that type contains a visual element so strong that it communicates more than just intellectual meaning, and photography when used as a typographical element is efficient, so you substitute text on its own as phototext." In other words, text works effectively as illustration.

Sonnoli invented the term "wri-thing" to elaborate on the theme of type as an object in its own right. This was the subject of a lecture he gave at the university of Venice. And Sonnoli designed the "Wri-Thing" poster, which defines the term as "the displacement of type into things and things into words." In further explaining this concept, he adds,

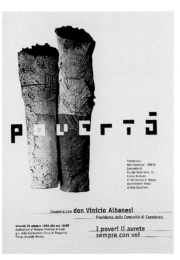

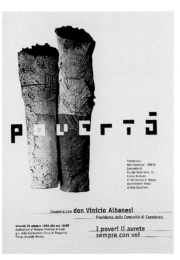

Massimo Cacciari

Gerusalemme e Atene:
Giovedì 26 agosto ore 18:00 alle radici dell'Europa
auditorium di Palazzo Montani Antaldi
g.c. dalla Fondazione Cassa di Risparmio
Piazza Antaldi, Pesaro

fondazione **don Gaudiano**

"Essentially I am saying that text is type-based and that you show the shape of an idea through the use of type."

Although Sonnoli has designed type that he says is primarily display type, he doesn't claim to be a type designer. What he feels he does best is design with type. Although Sonnoli is known for his typographical experiments, he says that when choosing a typeface, he often falls back on a "comforting" sans serif like ITC Franklin Gothic.

Although there is a definite style evident in Sonnoli's work, he claims that "it is not my goal to have a style but to visibly express an idea. With my work, I'd like to stimulate people to think and not just 'receive' a message. Furthermore I think good graphic design has to help people to enlarge their visual aesthetic and (maybe artistic) knowledge. In this sense I believe in good visual communication as an important cultural tool."

DJ Stout

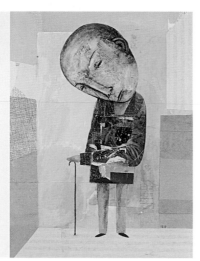

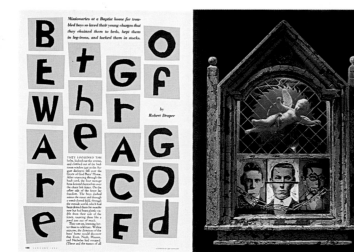

IN JANUARY, DJ Stout left his position as art director of the news and cultural monthly, *Texas Monthly*, to join Lowell Williams in Austin as a partner of Pentagram. Stout will be specializing in magazine and book design for the prestigious design firm, extending the legacy he has created in the pages of *Texas Monthly*. In many ways, joining the hallowed group of Pentagram partners was a hard decision for Stout, since he had been so involved with the magazine. He is proud to remain on the *Texas Monthly* masthead as a contributing editor.

For this art director, the magazine became a forum for working with content that he describes as "outstanding." His relationship with the magazine's long-time editor Greg Curtis allowed him the leeway to create effective and memorable designs responsive to the magazine's subject matter, which Stout interpreted in a myriad of ways. Stout says, "This was a really great job for an editorial art director. I respect the entire staff and was considered part of the editorial team. I had wonderful copy to work with—well-researched, investigative reporting from great writers. *Texas Monthly* is a bastion for well-done, independent journalism. And Texas is a great state to write about. It is steeped in myth and legend. And currently there is so much going on here."

Stout's contributions to this magazine's success are his astute editorial sense and a keen sensitivity to the text. Each cover and editorial spread he designed is a case study in interpreting content.

Above: Spread for *Texas Monthly* article on a nursing home
ART DIRECTION: DJ STOUT
ILLUSTRATION: JORDIN ISIP

Spread for *Texas Monthly* article "Beware the Grace of God," a story on an abusive Baptist boys' home
ART DIRECTION: DJ STOUT
ILLUSTRATION: GARY TANHAUSER

Opposite: Spread for *Texas Monthly* feature on bank robber
ART DIRECTION: DJ STOUT
ILLUSTRATION/LETTERING: MELINDA BECK

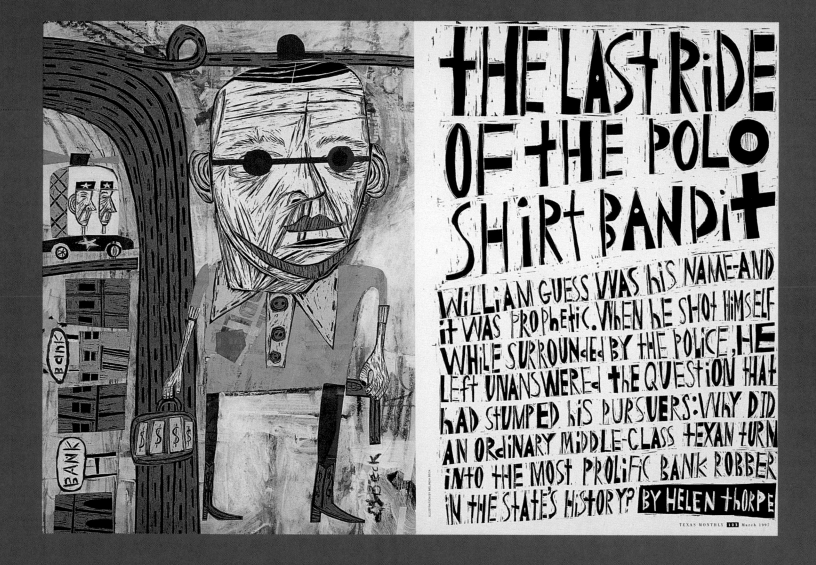

THE LAST RIDE OF THE POLO SHIRT BANDIT

WILLIAM GUESS WAS HIS NAME—AND IT WAS PROPHETIC. WHEN HE SHOT HIMSELF WHILE SURROUNDED BY THE POLICE, HE LEFT UNANSWERED THE QUESTION THAT HAD STUMPED HIS PURSUERS: WHY DID AN ORDINARY MIDDLE-CLASS TEXAN TURN INTO THE MOST PROLIFIC BANK ROBBER IN THE STATE'S HISTORY? BY HELEN THORPE

Above: *Texas Monthly* cover and spreads on Lyle Lovett
ART DIRECTION: DJ STOUT
PHOTOGRAPHY: ALBERT WATSON

Right: Opening spread for *Texas Monthly* article on a contemporary posse
ART DIRECTION: DJ STOUT
PHOTOGRAPHY: LAURA WILSON

Opposite page: Opening spread from *Texas Monthly* feature on Willie Nelson at 65
ART DIRECTION: DJ STOUT
PHOTOGRAPHY: DAN WINTERS

DESIGN PHILOSOPHY

DJ Stout designed editorially for *Texas Monthly*. He used the magazine articles as the media for the canvases he created. He did not gloss over words, but made them come alive on the page. He knows the writers, the editorial direction, and the audience of *Texas Monthly*, and all these factors contributed to his art direction. As Stout would have it, he designed as part of the editorial team. "I was more into the journalistic function of the magazine, more interested in what the magazine was doing rather than creating pure design. The art direction of this magazine is part of the team mission, the editorial driving force of this publication," he says.

It is hard to imagine any of these stories without these designs. Using the words as his inspiration, Stout managed to combine text, image, and type treatments into exquisitely crafted editorial design that is universally understood, but steeped in the visual lore of Texas.

For example, the spread that Stout did for trial of the murderer of the

TEXAS MONTHLY

STEVE
FROMHOLZ

GUY CLARK

LOVETT LEARNED A
THING OR TWO ABOUT
SINGING SONGS AND
TELLING STORIES FROM
ONE OF THE ORIGINAL
COSMIC COWBOYS

MICHAEL
MARTIN
MURPHEY

★ ONE OF LOVETT'S
★ BIGGEST INFLUENCES
★ AS A SINGER WAS THE
★ MAN WHO WROTE
★ "MUSKRAT LOVE,"
★ NOTED ICONOCLAST

WILLIS ALAN RAMSEY

WHAT DO THE YEARS DO
TO A REBEL? SOMETIMES
THEY MAKE HIM EVEN
WILDER. THE RED HEADED
STRANGER LONG AGO
WENT GRAY, BUT HIS
PASSION—FOR MUSIC, THE
ROAD, AND ADVENTURE—
HASN'T GONE COLD.

BY GARY CARTWRIGHT

at 65

PHOTOGRAPHS BY DAN WINTERS

The SWEET SONG of JUSTICE

It took the jury less than three hours to find Yolanda Saldivar guilty of murdering Selena. But for two weeks in October, all of Texas followed the most sensational trial in years. A behind-the-scenes look at what happened inside the courtroom. by Joe Nick Patoski

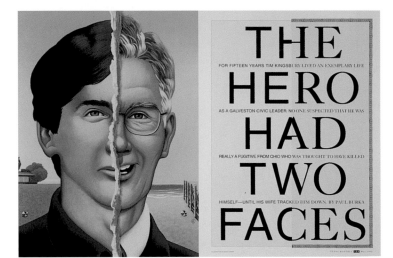

This page and opposite from above left:

Opening spread on the trial of Selena's murderer

ART DIRECTION: DJ STOUT
ILLUSTRATION: OWEN SMITH

Texas Monthly spreads on Texas folk art

ART DIRECTION: DJ STOUT
PHOTOGRAPHY: BRIAN SMALE

Texas Monthly spread on Ross Perot

ART DIRECTION: DJ STOUT
ILLUSTRATION: HANOCH PIVEN

Texas Monthly spread on George Foreman

ART DIRECTION: DJ STOUT
ILLUSTRATION: DAVID COWLES

Texas Monthly spread "The Hero Had Two Faces"

This is the opening spread for a feature about a man who had a double life. He abandoned his family in Ohio where he faked a suicide note before fleeing town and then was discovered years later in Galveston, Texas where he had become a prominent and respected civic leader.

ART DIRECTION: DJ STOUT
ILLUSTRATION: STEVE CARVER

Texas Monthly opening spread for feature on two champion bridge players

ART DIRECTION: DJ STOUT
ILLUSTRATION: KEITH GRAVES

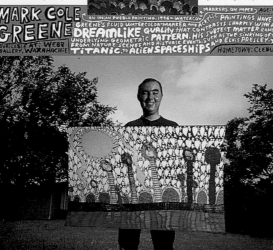

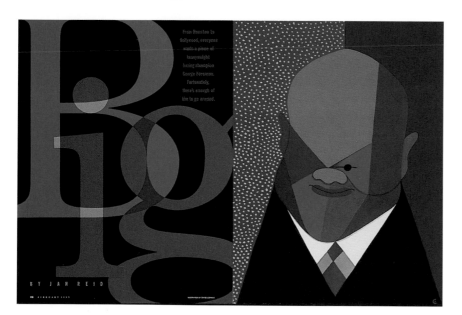

singer, Selena, illustrated the singer as a religious icon, while the type treatment was in the style of an old-fashioned Mexican bible. Stout had acquired one of these bibles and for three days, he photocopied, cut, and pasted type to simulate that biblical feeling. This spread won a gold award from the Society of Publication Designers for Stout.

TYPE AND TYPOGRAPHY

It is not unusual for Stout to hand-render a type treatment, as in "The Horse Killers," where he used a child-like scrawl that added a sense of menace. This worked in conjunction with a searing illustration done by Matt Mahurin.

For a feature on Willie Nelson (whom Stout describes as "the best-known person in Texas"), at age 65, the photographer Dan Winters shot this musical legend from behind (with Nelson's guitar slung over his shoulder), while Stout created a letterform montage to simulate the guitar to render the singer's name in this title.

And for interpreting another Texas favorite son, singer Lyle Lovett (for the

Left: *Texas Monthly* spread on "Amateur Skull Boilers," a group of amateur detectives in San Antonio
ART DIRECTION: DJ STOUT

Opposite: *Texas Monthly* spread on children who killed a horse
ART DIRECTION: DJ STOUT
ILLUSTRATION: MATT MAHURIN

release of a CD featuring Texas music of the 1970s), Stout set the cover lines in the style of music posters of the 1970s. He repeated this look throughout the editorial spreads with photographs of Lovett by photographer Albert Watson.

Stout collects old type books so that he can find references that capture the mood of the editorial pieces, as he did with "The Last Posse." Here, the type is reminiscent of that used on "wanted" posters and conveys the Wild West ethic of these contemporary Texas law men.

There is a distinctive, handcrafted quality to Stout's headline treatments, along with his coherent blending of title, image, and text. This is the designing forte that he takes with him into his new role at Pentagram.

As the 17th Pentagram partner, Stout relishes the support of other partners, like Paula Scher and Woody Pirtle in the New York office, as well as all of the resources and opportunities Pentagram can offer. He travels frequently to work with clients, but is happiest in the Austin Pentagram office. Texas is home, and although Stout may now design for every corner of the world, this is where he is content to stay.

THE HORSE KILLERS

by ROBERT DRAPER

Bored and angry, a group of kids in a small East Texas town took out their hostility on a HORSE, whose violent death shocked the world.

Don Zinzell

ZINZELL IS BASED in a loft at the far edge of SoHo in Manhattan. Don Zinzell is its creative force, and when necessary, he draws from a network of highly talented collaborators. Beginning in 1987 as a "designer for hire," as he describes himself, Zinzell decided in 1995 to establish the studio as it is today. Recently, his wife Manon, with a background in architecture and branding, joined in as studio manager and project director. The studio space is large, airy, open, and filled with bustling energy. In many ways, Zinzell has set up a prototype for design of the future, a model for working that is unencumbered and fast and with design that transmits what Zinzell calls "the vernacular of modern culture."

With clients such as Sony, Prescriptives, Tommy Hilfiger, and Tourneau, and prospective clients lining up, Zinzell is always busy. He provides original concepts and his skills as a photographer, type designer, and art director. What Zinzell offers is a "360-degree attack on the senses: a three-pronged approach to design that is visual, cerebral, and emotional," he says. He lists his favorite tools of the trade as "metaphors, negative space, found objects, and chance."

His style of photography, which he refers to as "utilitarian," is often seen in his design work, and his photographs have been acquired by the Nonstøck agency, which specializes in alternative, non-traditional photography. (Zinzell has created ads for Nonstøck as well.)

His type designs, now available for sale, have often evolved from the custom logo designed for clients. He designs not only for print, but the Web, branding, identity, signage, video, motion graphics, multimedia projects, and packaging.

Don Zinzell relates to design as an experience of total involvement. His clients look to him for a "different" take on designing, an expanded and exhaustive response to any brief. So Zinzell tends to give them just that, often starting with creating an identity—a logo treatment—and then developing that concept into anything from an advertising campaign to a Web site. His designs merge his photographs with his type treatments to create what he calls "design as a total environment."

Top right: Interpretation of "T" for Boston ATypI incorporating photographs of images of found type
DESIGN/PHOTOGRAPHY: DON ZINZELL

Above: Poster for Devilish typeface
DESIGN/PHOTOGRAPHY/TYPE DESIGN: DON ZINZELL

Opposite: Spreads from book, *How to Be Happy Damn It*
DESIGN/PHOTOGRAPHY/TYPE DESIGN: DON ZINZELL
WRITER: KAREN SALMANSOHN

nonstøck.

7iN73LL

1_800_673_6222
www.nonstock.com

DESIGN PHILOSOPHY

In explaining his design philosophy, Zinzell refers to "cultural relevance," which he explains this way: "If I create a piece that lacks cultural relevance, a total sense of resounding to what is important at this time, the design is dead, it has no life. So that thinking and context always has to be there." Zinzell feels that his design is based on looking at things from unexpected sources. He explains, "I am greatly influenced by new discoveries in science. I would like to think of design in terms of quantum theory or chaos theory. For example, if you as a designer can open yourself up to a project, discoveries will just materialize. A sort of 'super luminal' connection will occur. This is where an idea or concept almost exists before the event. It is as if you are developing something from the inside out, working in reverse, tapping into your inner self, like traveling 'into' a typeface rather than designing it only on the surface. I find that the most rewarding aspect of design is 'discoherence' when several contradicting conditions exist simultaneously, but

Opposite left: Promotional piece for Zinzell
photography for NonStøck. Opposite right:
Page from Zinzell brochure

DESIGN/PHOTOGRAPHY: DON ZINZELL

Above: Spread for *Addict* magazine
Below: Logo and label for Kogos

DESIGN/PHOTOGRAPHY/TYPE DESIGN: DON ZINZELL

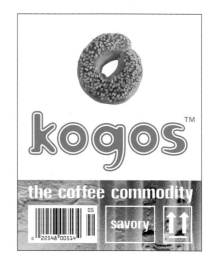

contribute to singularity. It is the equivalent of stripping something down to its basic elements while maintaining multiple layers of meaning. Working within these concepts means embracing change when you get an unpredictable result. This allows you to work with rather than

fight with the unexpected. It can make what you do very special and very honest. Design 'accidents' always make the work more interesting if you incorporate them."

Zinzell wants the designs that he produces to have a "clean, generic, almost

pharmaceutical look. I like to strip things down to basics, to challenge that memory overload with which we are constantly bombarded," he says.

He credits his growing up in a punk rock/new wave environment for much of his current thinking. He is a musician

and had until recently been involved with a techno band that also included colleagues and collaborators like Michael Uman, a broadcast director, and Gavin Wilson, photographer and illustrator. These two, as well as a coterie of other like-minded photographers, artists,

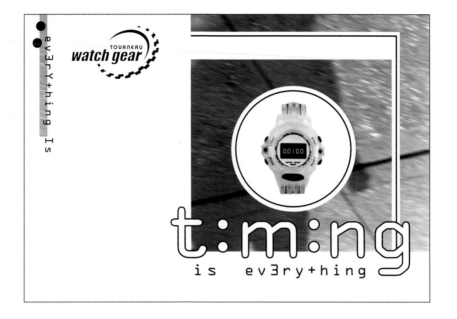

designers, writers and guests, meet
every Tuesday to keep in touch, but also
to keep a fresh perspective on the work
they are doing.

Zinzell is also involved in think-tank
collaborations that cross disciplines. He
works with architects, writers, musicians,

visual artists, and fashion and furniture
designers, and he finds these interactions
essential. "It is a continuing education,"
he says, adding that these alliances keep
ideas flowing and lead to new areas of
work opening up.

TYPE AND TYPOGRAPHY
What also distinguishes Zinzell's work
is finely honed type treatments with
typefaces he designs for each project.
Because Zinzell creates specific type-
faces for clients, he transforms these or
his logo designs into the beginnings of

a typeface and then continues to round
out the character sets into whole type
families. Recently, because of requests
to make his faces available for sale, he
has become his own "type foundry."
Undaunted by the number and range
of typefaces now in the marketplace,

t

⠀ 0 36694 69355 0

technology

Zinzell feels that there can never be too many type choices, and he continues to design new ones. His own type designs he describes as being based on "a relationship with contemporary elements, both planned and accidental. In other words, any experience, visual inspiration

from any source, things in everyday life, can lead to a type design. So, too, can a botched design where what results is far better than what I had planned." Zinzell's fonts include Devilish, Vixa, Amp, and Int'l Runway.

For Don Zinzell, designing everything

and anything is not a profession, or a career, or merely work. It is his forum for his obsession. It is a way of life .

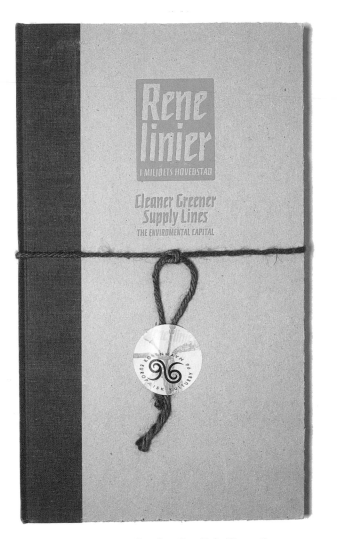

Cover from *Rene Linier* (Cleaner, Greener
Supply Lines) book

Opposite: Spread from *Rene Linier* book

Torben Wilhelmsen

AT HIS DEN BLAA TROMPET (The Blue Trumpet) studio in
Copenhagen, Torben Wilhelmsen works on graphic design, multi-
media, and Web production. He aspired to be an illustrator, but
found that graphic design "offered more jobs," he says. "I taught
myself graphic design, and whenever new opportunities in
graphic design came up, I jumped at them. These were mostly
magazines, leaflets, and posters," he adds. This work eventually
brought Wilhelmsen awards, including one for magazine and one
for book design. Wilhelmsen reports that in 1994 he also turned
to multimedia (creating two CD-ROMs). Then he joined the grow-
ing league of Web designers and eventually wrote *Hjemme.sider*
(translated as *Home.pages*), which was designated as "a selected
book of the year" in 1998. He continues to experiment with de-
signing for the Web, apparent at his own Web site as well as in
work for clients. Wilhelmsen also teaches at The Graphic Arts
Institute of Denmark.

Wilhelmsen's designs are very illustrative. As exemplified by
his business card, he manages to present information in a series of
colorful, flowing, soft images combined with fluid type treatments.
This is also reflected in other type treatments in which Wilhelmsen
presents playful, layered, and yet entirely legible type.

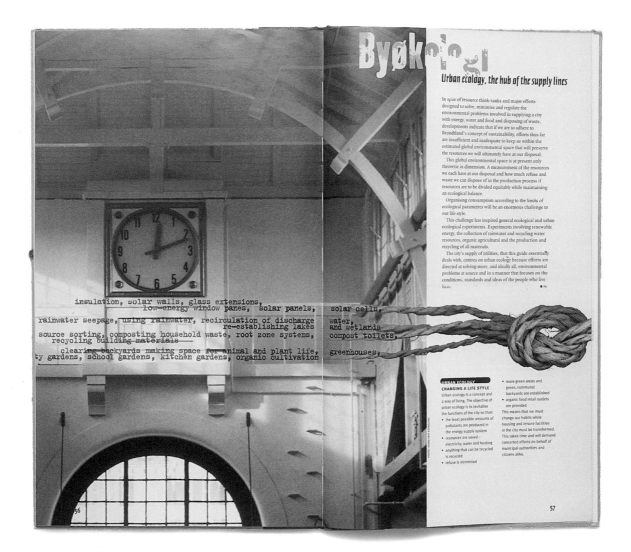

Byøkologi

Urban ecology, the hub of the supply lines

In spite of resource think-tanks and major efforts designed to solve, minimise and regulate the environmental problems involved in supplying a city with energy, water and food and disposing of waste, developments indicate that if we are to adhere to Brundtland's concept of sustainability, efforts thus far are insufficient and inadequate to keep us within the estimated global environmental space that will preserve the resources we will ultimately have at our disposal.

This global environmental space is at present only theoretic in dimension. A measurement of the resources we each have at our disposal and how much refuse and waste we can dispose of in the production process if resources are to be divided equitably while maintaining an ecological balance.

Organising consumption according to the limits of ecological parametres will be an enormous challenge to our life style.

This challenge has inspired general ecological and urban ecological experiments. Experiments involving renewable energy, the collection of rainwater and recycling water resources, organic agricultural and the production and recycling of all materials.

The city's supply of utilities, that this guide essentially deals with, centres on urban ecology because efforts are directed at solving more, and ideally all, environmental problems at source and in a manner that focuses on the conditions, standards and ideas of the people who live here.

insulation, solar walls, glass extensions, low-energy window panes, solar panels, solar cells, rainwater seepage, using rainwater, recirculation of discharge water, re-establishing lakes and wetlands source sorting, composting household waste, root zone systems, compost toilets, recycling building materials — clearing backyards making space for animal and plant life, greenhouses, ty gardens, school gardens, kitchen gardens, organic cultivation

URBAN ECOLOGY

CHANGING A LIFE STYLE

Urban ecology is a concept and a way of living. The objective of urban ecology is to revitalise the functions of the city so that:

- the least possible amounts of pollutants are produced in the energy supply system
- resources are saved – electricity, water and heating
- anything that can be recycled is recycled
- refuse is minimised

- more green areas and green, communal backyards are established
- organic food retail outlets are provided

This means that we must change our habits while housing and leisure facilities in the city must be transformed. This takes time and will demand concerted efforts on behalf of municipal authorities and citizens alike.

DESIGN PHILOSOPHY

Wilhelmsen relates design to finding parameters within which to work and then making a creative leap. He says, "I have always been experimenting and combining techniques and materials in various ways. But I also always search for restrictions when I work. That is how

I taught myself, and that is how creativity works. I ask myself how do I pass the limits, the restrictions of a certain task. The tighter these binds are, the more creativity flows. And the more fun it is to actually pass the limits."

Wilhelmsen also states that "the big leap in my creative process came when

I started to work on a Mac in 1989-90. Back then the computer offered wonderful restrictions (disk space, speed, PostScript errors, etc.), but I could actually make very organic design that wasn't possible without the computer."

As for inspiration, Wilhelmsen says you have to search within yourself. In

his case, he wrote a short story called "The Blue Trumpet" (hence the name of his studio), which is essentially a fairy tale about a boy and his attempts to play a blue trumpet. The more the boy plays, the more his playing provokes an explosion of color. This is Wilhelmsen's metaphor for the creative act. "You have to

Below: Torben Wilhelmsen business card
DESIGN: TORBEN WILHELMSEN

Opposite: New Year Greeting poster from
Den Blau Trompet
DESIGN/ILLUSTRATION: TORBEN WILHELMSEN

search within—creativity and inspiration come from somewhere deep in yourself and in your mind. And anything, even an old nursery rhyme, can inspire it," he says.

TYPE AND TYPOGRAPHY
Wilhelmsen experiments with type, quite aware of its challenge and restrictions.

He says, "Typography is the basic discipline in graphic design, although it is often disregarded. You may be able to create beautiful images without any typography, but in order to make graphic design work as an integrated part of communication, you have to take special care of how you present the typography.

To put it simply: you can make a beautiful graphic design solely by means of a typographic treatment, but with bad typography, even if you have nice images, it is likely these will just impede the communication rather than convey it." Wilhelmsen also points out that good typography is not just about what type-

face to use. He says, "Almost any typeface (and 'hurrah' for all the experimental typefaces) will work if the typography is well done."

GENVEJ

JO DET ER DA NOK USUNDT - MEN DET VARER HELLER IKKE LÆNGE...

IL LUS INNOVA TRATION

ILLUSTRATION

introduktion

inspiration

INTEGRATION

And they even blew it at night!

integration

INTEGRATION

Den Blå trompet

Da han først havde set trompeten i vinduet, kunne han ikke slippe den. Han var i den tvivl - s

– så måtte råd komme siden. Men da han skubbede døren op til den lille kælderbutik, var han stadi

han stadig tom....

computation

penge kommer ikke gratis. ¶ En lille blåtonet kvinde passede med halvblind sirlighed det li

det lille lokales frodighed og opfattede ikke hans slet skjulte forargelse over et let støvl-

le lokales frodighed og opfattede ikke hans slet skjulte forargelse over et let støvlag. Ha

ag. Han prøvede forsigtigt at puste det væk og tog derefter hårdere fat med et hjørne

prøvede forsigtigt at puste det væk og tog derefter hårdere fat med et hjørne af sin trøj

af sin trøje. Uden held, støvet var på det nærmeste groet fast, og kvinden interessere

Uden held, støvet var på det nærmeste gro

smykker, som hun arrangerede i for

fast, og kvinden interesserede sig kun for nog

skellige mønstre i blå fløjlsforede bak

Stephen Farrell/Slipstudios

Above right: Contents page for *The Pannus Index*
(Vol. 2 No. 1)
VISUAL CONCEPT/DESIGN: STEPHEN FARRELL/SLIPSTUDIOS
SENIOR EDITOR: VINCENT BATOR

Above: Two spreads from "Farewell to Kilimanjaro"
in *The Pannus Index*
DESIGN: STEPHEN FARRELL/SLIPSTUDIOS. WRITER: STEVE TOMASULA

Opposite: Book jacket for *The Pannus Index*
VISUAL CONCEPT/DESIGN: STEPHEN FARRELL/SLIPSTUDIOS

STEPHEN FARRELL could be described as a type designer, a typographer, and a graphic designer, but these descriptions in no way capture the full extent of his impact on typographic design. Farrell is a virtuoso, with type as his instrument. He has managed through his close collaboration with writers and poets (most notably Steve Tomasula and Daniel X. O'Neill) to inspire and to expand a new genre that could be called literary typography. He talks about type as if it were a living presence: the "dramatis personae" on the page. For Farrell, working with type is like working with an actor developing a role, or a musician interpreting a new composition.

Working in collaboration to develop what Farrell calls "image-fictions, visual essays and language investigations" constitutes the chief focus of Farrell's Slipstudios, founded in 1992 and based in his bungalow in Chicago. Farrell describes the studio as "a multi-disciplinary design environment which fosters the creative interaction of writers and visual artists…. We treat the two main components of the studio—graphic literature and digital typography—as inseparable and essential for the creation and distribution of each."

This may sound esoteric, and it is. Many of Farrell's self-funded collaborations appear in literary journals, design journals, or exhibition catalogs, all of which are forums for critical discourse on language, image, and storytelling. Although this often means a brief appearance for each piece of work, Farrell, who takes no clients at Slipstudios, is committed to this arena of design. And it has brought him recognition and acknowledgment from his peers. In fact, he was one of the designers whose work was chosen for the recent Cooper-Hewitt, National Design Museum inaugural Triennial, "Design Culture Now." He explains, "I focused on tangent points between my most recent digital typeface, Volgare, and the unconscious event of handwriting." The exhibition work featured a "series of handmade books and wall texts which provided a 'font travelogue,' where individual letterforms can be inspected as constructed islands and sentences are fluid archipelagos," he says.

VOL. 2 *No.* 1

THE **PANNUS** INDEX

8US$

3 EASY PIECES
Voices of the Pre-millennium

STEVEN TOMASULA · KEN G. YOUNG · HUGH FOX

Spreads and pages from "Visible Citizens" in *Emigre*
WRITER/DESIGN: STEPHEN FARRELL/SLIPSTUDIOS

COLLOQUIAL FOR **CLASSICAL FORM**

signature, inside cover
Safe Methods of Business, 1895. *Top shelf.*

INHABITING FORMS
VISIBLE CITIZENS

STEPHEN FARRELL & JIWON SON

ESSAY BY *STEVE TOMASULA*

with "Cities and Names 2" from *Invisible Cities* by Italo Calvino

Gauge fire damaged. For display only.

Temperature unknown, but no doubt hot. *One hundred thousand years ago, as few as 50 people walked out of Africa and began to populate the world. Presumably, they were looking for a home.* **Outside 47°/ Inside 72°.** *One hundred and eighty-six thousand generations later, I am living in America and writing about the house Stephen Farrell and Jiwon Son have just moved into—a form of home. A form of I.*

CZECHOSLOVAKIA

ITALY *KOREA

Site 1 Enter the kitchen.

XLI **TONE OF SUBLIMITY.**
[The tone of Sublimity manifests an extreme admiration which almost overwhelms. The speaker seems uplifted by the majesty and the grandeur. While akin to Awe, Sublimity has in it less of Fear and more of Joy.]
Natural Drills in Expression, 1909. *Top shelf.*

XXXII.1 *HOOKS THAT SEPARATE INSIDE FROM OUTSIDE*

CLASS XXXII *HOOKS*

DESIGN PHILOSOPHY
For Farrell, his philosophy of design and his approach to aesthetics are the crucial rationales for everything he does. Admitting to what he calls "an obsessive methodology of cross-referencing, splicing, and grafting," Farrell explores type and language as "relay systems."

For example, Farrell's typographic "realization" of Steve Tomasula's "Farewell to Kilimanjaro" in the literary publication *The Pannus Index* incorporates what he describes as "indeterminacy of position, avant-garde Modern typography, and layout techniques."

TYPE AND TYPOGRAPHY
Farrell's theories on typography are well documented, including speeches and presentations he has given across the United States and abroad and his teaching at both The School of the Art Institute of Chicago and the Illinois Institute of Art. He bolsters his prem-

ises with examples from science, philosophy, cultural anthropology, history, and literature, as well as design theory, pop culture, and advertising. "My interest," he says, "is translating across disciplines, which both acknowledges and challenges the impulse to classify and establish boundaries."

CLASSICAL FORMS

COLLOQUIAL FORMS

The Universal Self Instructor: The Epitome of Forms (of) Reference Manual, 1886. Bottom shelf.

TONE OF MEDITATION.
[The tone of Meditation is always linked with some other (usually Argument) and indicates to the listener self-communion. The speaker is subjective. He is thinking aloud.]
Natural Drills in Expression, 1929. Top shelf.

CLASS III *FLOOR BROOMS*

Have you ever had the experience of going through a stranger's old photos, maybe found in an attic, and seeing yourself in them? The familiar patterns are inherently recognizable: rituals of holidays; the group-shot to document, "We were here. Together." Yet at the same time there is something deflating in the commonness of our collective togetherness. We like to think of ourselves as radically unique, even if finite form—two legs, one head—means this can only be true with qualification. Our own family photos underscore how radically un-unique we are. There on Uncle Billy's face is my nose. Aunt Dodo has my hair. Skin color, surname, genetic tithes. The real surprise is in discovering that a form that is so intimate can be so invisible, even as it directs what we think, what we do—almost to the point of being destiny. As a male, for example, I will never be a mother, while two thirds of you who are reading this will die because of some genetic legacy you carry within, working its way to conclusion. Old homes are like that. Or as Italo Calvino puts it:

Gods of two species protect the city of Leandra. Both are too tiny to be seen and too numerous to be counted. One species stands at the doors of the houses, inside, next to the coatrack and the umbrella stand; in moves, they follow the families and install themselves in the new home at the consignment of the keys. The others stay in the kitchen, hiding by preference under pots or in the chimney flue or broom closet: they belong to the house, and when the family that has lived there goes away, they remain with the new tenants; perhaps they were already there before the house existed, among the weeds of the vacant lot, concealed in a rusty can; if the house is torn down and a huge block of fifty families is built in its place, they will be found, multiplied, in the kitchens of that many apartments. To distinguish the two species we will call the first one Penates and the other Lares.

Safe Methods of Business, 1896. Top shelf.

CLASSICAL FORMS

COLLOQUIAL FORMS

Forms and General Reference Manual, 1884. Bottom shelf.

Safe Methods of Business, 1896. Top shelf.

KEROLIN HOOKS TO HANG HATS, HATS LIKE ROOFS, BEING USED TO KEE

Safe Methods of Business, 1896.
Top shelf.

CLASSICAL FORMS
Lincoln Library of Essential Information, 1924. Middle shelf.

COLLOQUIAL FORMS

Tracts CD. Opposite below: Front and back
sleeve designs for 2 Multimedia Tracts CD
WRITER/DESIGN: STEPHEN FARRELL/SLIPSTUDIOS

Following spread: Timeline wall for Cooper
Hewitt's National Design Triennial, "Design
Culture Now"
DESIGN: STEPHEN FARRELL/SLIPSTUDIOS

Those who may not have seen Farrell's work in literary journals or *Emigre* magazine or at the "Design Culture Now" exhibition, may know him best as a type designer. Since 1994, Farrell has been scrutinizing handwriting from historical periods. Farrell says

that he became interested in the warmth and humanity of what had been produced by an actual person's hand. From this he says, "I cautiously pursued its translation into a digital medium. I was interested in answering these questions: 'What does it mean to place handwrit-

ing outside the act of creation?' Suddenly, the living hand embedded in the marks of handwriting is unlinked from a particular body and a particular event of writing. Might the digital medium offer to a handwriting performance its eternal return?"

One of the most striking examples he found was "an original Florentine death record dated 1601, which I discovered at the Newberry Library in Chicago." This manuscript, "penned by an anonymous clerk," inspired Farrell to "start working on a typeface based on that 'hand.'"

To write *my body*

A reader's plunge into the siren surface is not without risk.
Shipwrecks in a surface too shallow or too impenetrable are
dangers of heeding the call, of spending time with a work whose
worth has only a sketchy physiognomy. But with these potential
losses come the gains of a qualitative discourse at the visceral
level, a subjective edge with language. Adrienne Rich says:
"When I write 'THE BODY' I see nothing in particular. To write 'MY
BODY' plunges me into lived experience, particularity: I see scars,
disfigurements, discolorations, damages, losses, as well as what
pleases me."

SLIP STUDIOS
CDO 2 MULTIMEDIA TRACTS 1997-1999

4421 NORTH FRANCISCO AVENUE CHICAGO, USA 60625 SlipStudios@compuserve.com

CDO

WHY IS IT WORSE TO SAY AN ANGLE IS COLD : BODY LANGUAGE IN THE PAPER THEATER
AND A CURVE WARM ?

Macintosh/PC platforms.
Requires 152MHz PowerPC or Pentium,
Mac OS 7.5 or Windows 95/98, or later, 32mb free ram,
x8 speed cd-rom drive and monitor set to millions of colors.
Preferred monitor resolution: 1024 x 768 pixels.
Minimum: 632 x 624 pixels.

000007

© 1999. Slip Studios.

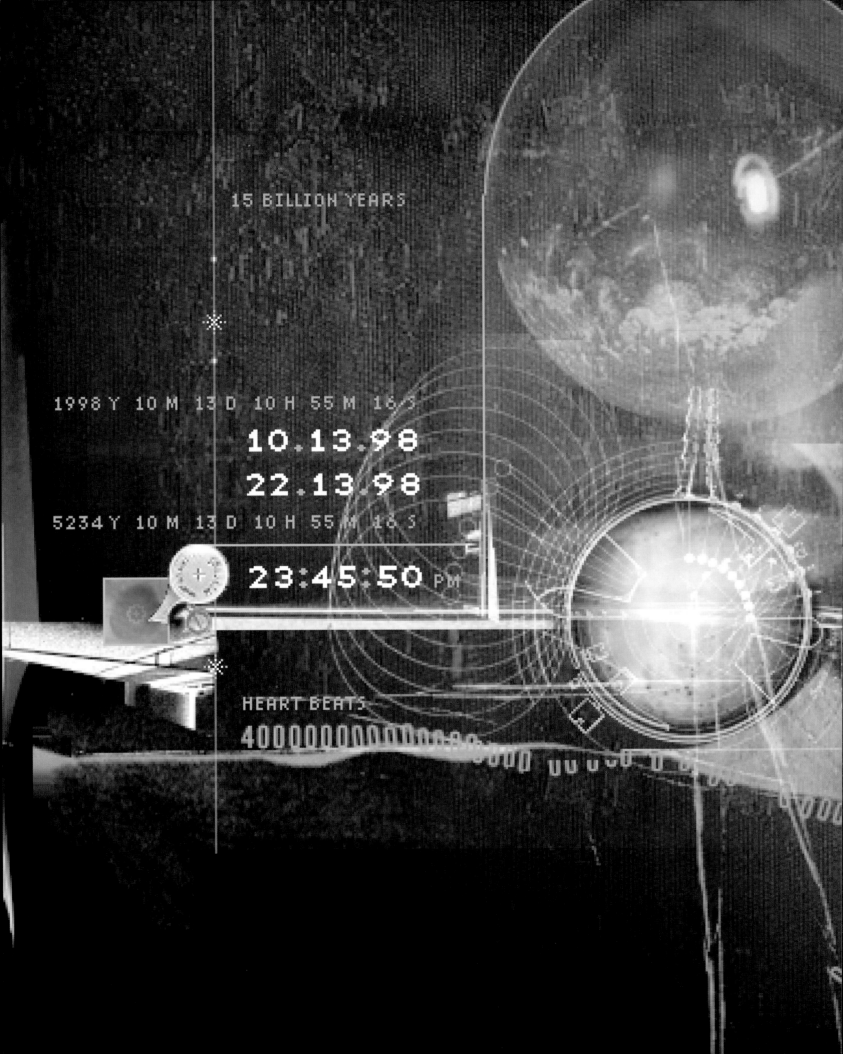

Betelguese 520

Eventually Farrell had over 500 characters, including variations of each letterform, ligature, and terminal, all of which, he says, "allowed for a more convincing simulation of the varied marks of actual handwriting." The resulting typeface, Volgare, has elegance, fluidity, and a historical flavor, as well as a sensitivity of interpretation based on the original handwriting. Since its release, Volgare has become a collector's item. What Farrell says he most enjoys is "seeing Volgare employed by a wide variety of typographers for a wide variety of uses."

Farrell also adds the context that this typeface keeps that original penman alive: "We are commonally reconstituting the identity of that anonymous individual, making him say things he never dreamed in languages he never knew."

Some of Farrell's other type designs include Flexure and Indelible Victorian.

Volgare Proclamation

I Here lie Volgare,
 wrought from the hand of ✗,
 birthed inside a type designer's studio,
 and being only the latest product
 in a long line of American things
 fashioned from the raw material of Europe.

II Thinkers and writers:
 Take and patch these marks onto your own speech.
 Receive and place this set of characters,
 forever re-written,
 living as endless words-in-waiting,
 an infinite event yanked from a
 hundred unconscious moments in the life of a skeletal clerk.
 May the automatic feeling of Diction be with you always.

SLIP—— , 773.989.0460 DXO

Fred Woodward / Rolling Stone

**Above: Spread for *Rolling Stone*
interview with Leonardo DiCaprio**

ART DIRECTION: FRED WOODWARD. DESIGN:
FRED WOODWARD, SIUNG TJIA. PHOTOGRAPHY:
MARK SELIGER

**Spread for *Rolling Stone* interview
with Ricky Martin**

ART DIRECTION: FRED WOODWARD. DESIGN:
FRED WOODWARD, GAIL ANDERSON. PHOTOG-
RAPHY: DAVID LACHAPELLE

**Opposite: Spread for *Rolling Stone*
feature on Sarah Michelle Gellar**

ART DIRECTION: FRED WOODWARD. DESIGN:
FRED WOODWARD, GAIL ANDERSON. PHOTOG-
RAPHY: MARK SELIGER

ROLLING STONE is a magazine with roots in 1970s counterculture that grew up to be the establishment entertainment magazine. Noted for its music-insider editorial perspective and its street-smarts in matching writer with subject (novelist David Foster Wallace writes on then-presidential candidate John McCain, for example), what also sets *Rolling Stone* apart is its design bravado.

To most designers, *Rolling Stone* art director Fred Woodward is a hero. For 13 years, Woodward has risen to the challenge of creating savvy, insightful editorial interpretations of every star on the planet. Although these are the same celebs who appear in every magazine, in *Rolling Stone,* they get the stellar treatment they deserve.

Working closely with exceptional photographers (such as Mark Seliger, Albert Watson, David LaChapelle) and a host of remarkable illustrators, Fred Woodward and his design team combine image, headline treatment, and text ingeniously. Especially notable in the *Rolling Stone* interviews, the designs project a persona rather than a personality. The synergy of subject and presentation is seamless. In design terms, Woodward and his collaborators have forged contemporary editorial design classics.

For example, the design for an interview with Leonardo DiCaprio has a Bauhaus flavor, with brightly colored blocks spelling out "Leo." The design transforms the teen idol into a pop icon. For Al Pacino, the actor's name spelled out in a bowl of alphabet soup contrasts with a moody photograph of the actor on the opposite page, thus capturing both familiarity and mystery. If there is a secret to the Woodward success, it is the sheer joy of finding the right gestalt for each subject.

BY JANCEE DUNN It's all well and good that the Getty Museum, in Los Angeles, has paintings by Degas and stuff, but today there is a much more exciting exhibit: Sarah Michelle Gellar is here! Where the hell's the camera?

Love At First Bite

SARAH Michelle Gellar

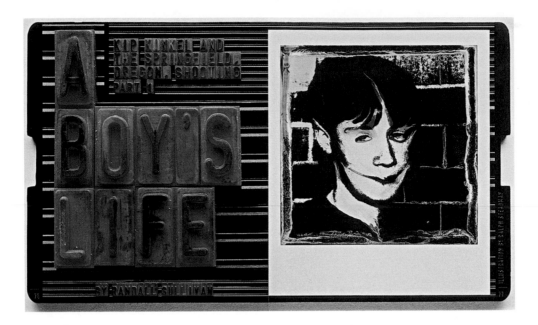

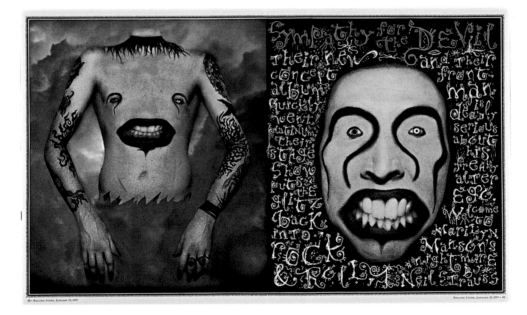

Acknowledged as typographically brilliant by every major design and typographic organization, Woodward conceives type treatments that capture mood as well as personality. In his working of Eddie van Halen's name, he creates a pyramid of type. For Ricky Martin, the name is imbedded in a type puzzle. For a feature on Crosby, Stills, Nash, and (sometimes) Young, the individuality of each, as well as their collaboration, is captured in poster-like pages. (For this layout, a *Rolling Stone* reader wrote, "I loved the photo intro—a very powerful graphic to those of us who were there when it all began.")

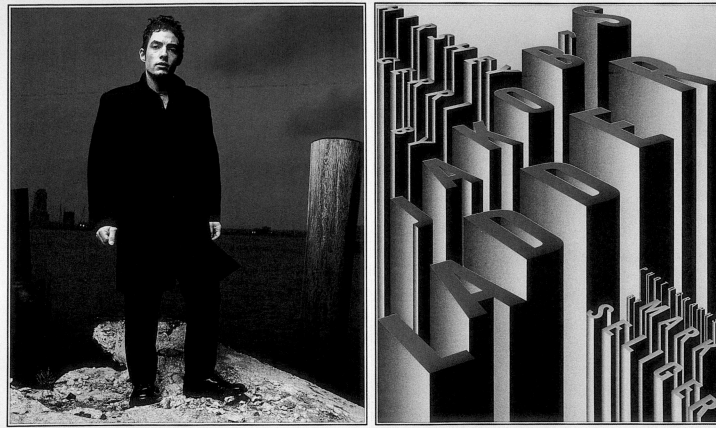

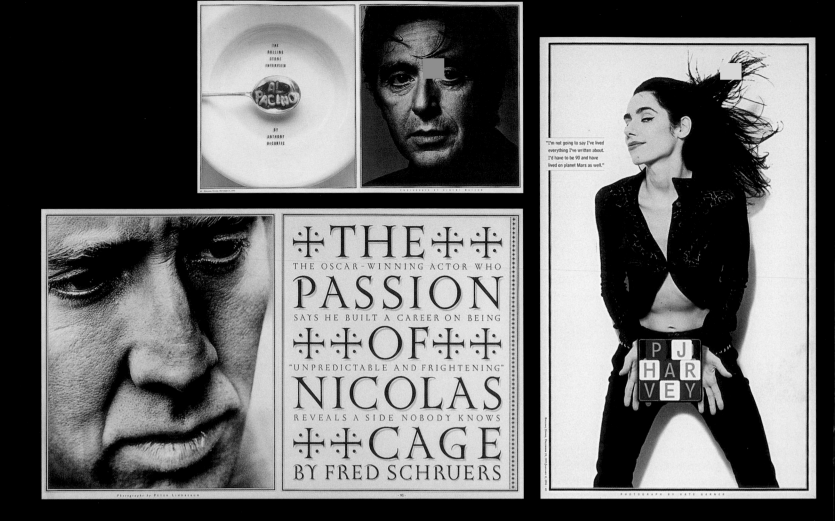

Above, clockwise from left to right:
Spread for *Rolling Stone* interview
with Al Pacino

ART DIRECTION: FRED WOODWARD. DESIGN:
FRED WOODWARD, GAIL ANDERSON. PHOTOG-
RAPHY: ALBERT WATSON

Page for *Rolling Stone* interview
with PJ Harvey

ART DIRECTION: FRED WOODWARD. DESIGN:
FRED WOODWARD, GAIL ANDERSON. PHOTOG-
RAPHY: KATE GARNER

Spread for *Rolling Stone* interview
with Nicholas Cage

ART DIRECTION: FRED WOODWARD. DESIGN:
FRED WOODWARD, GAIL ANDERSON. PHOTOG-
RAPHY: PETER LINDBERGH

Opposite top: Spread for *Rolling
Stone* feature on REM

ART DIRECTION: FRED WOODWARD. DESIGN:
FRED WOODWARD, GERALDINE HESSLER
PHOTOGRAPHY: ANTON CORBIJN

Below: Spread for *Rolling Stone*
interview with Jack Nicholson

ART DIRECTION: FRED WOODWARD
DESIGN: GAIL ANDERSON. PHOTOGRAPHY:
ALBERT WATSON

®EM

MORE SONGS about DEATH and ANXIETY...REMARKS Concerning BiLL CLINTON, psychedelic DRUGS And the SAD DECLINE oF the '60s GENERATION...the MYSTERIOUS CASE of the DISAPPEARING manager... and SOMe PERTINENT FACTS about TODAY'S R.e.M. | by CHRIS HEATH |

[ROLLING STONE · 52 · October 17,1996]

34

THE ROLLING STONE INTERVIEW + BY FRED SCHRUERS

Photograph by Albert Watson

50 · ROLLING STONE, NOVEMBER 12, 1998

ROLLING STONE, NOVEMBER 12, 1998 · 51

Although Woodward also directs music videos and is feverishly designing books, these are extensions of his key role at *Rolling Stone.*

Fred Woodward is genuinely shy and eschews being in the spotlight himself.

Along the way, Woodward has accrued more national and international design awards for the magazine than any other publication. He seems quietly surprised at the consistent attention and kudos he has received.

As Woodward expressed it in a rare interview with Peter Hall, art directing *Rolling Stone* "is a blue collar job. It burns up ideas and you just have to keep feeding it." Many see the talents of Fred Woodward in terms of innova-

tive genius, but Woodward is more likely to pass these talents off as coming with the job. And that job has allowed him to create editorial displays that are instinctive, intuitive, and visually intelligent.

HIS JOURNEY

FROM NERDY NEW YORK KID

TO HIP HOLLYWOOD ROYALTY PROVES

THERE'S SOMETHING ABOUT BEN STILLER

by Chris Mundy

BEN STILLER'S LOS ANGELES apartment is striking for a number of reasons (the penthouse deck with a view of the Wilshire Country Club springs to mind), but what stands out most is why he feels at home there. "What I really like," says Stiller as he shows you around, "is that it feels like a New York apartment."

He's right. Much like Stiller himself, the home seems slightly out of place in the high glare of Hollywood, more subdued, the kind of space as likely to have the curtains drawn as it is to have the sun pouring in.

Stiller points out the hardwood floors, the Twenties-style kitchen, the original moldings. In the large main room of the duplex's bottom floor, there is a collection of black-and-white photographs, nothing else – like a SoHo gallery space.

As he gives the tour, Stiller is warm; yet, for someone who has made his mark in comedy, he does not strike you as the casual sort. He is unfailingly polite; he is friendly; but there is also a quiet intensity and a nervousness that seeps into the air around him. You like him. You just wouldn't call him to entertain at a child's birthday party.

"I've never really felt like a funny, funny guy," says Stiller as we make our way to the deck. "I've never really felt like Mr. Life of the Party. People who know me know that I'm not the most gregarious person. I'm trying to open myself up more. I've realized in the last few years that my state of mind affects how I live my life."

Stiller's mind these days must be in a dizzy state – a career high induced by the sheer goofiness and phenomenal success of There's Something About Mary. Stiller has always been one of the most versatile talents of his generation: an Emmy-winning writer (for The Ben Stiller Show); a director of major stars in major motion pictures (Winona Ryder in Reality Bites, Jim Carrey in The Cable Guy); and a steadily em-

ployed actor drawn to small, intriguing comedies such as Flirting With Disaster, Zero Effect and the controversial Your Friends and Neighbors. But rarely have the heavens been better aligned for a performer than they are now for Stiller. First comes There's Something About Mary, the summer comedy that won't quit even deep into the fall and the kind of colossal hit that every star needs. At the same time, Stiller nails a performance at a junkie TV writer in Permanent Midnight that most serious actors wait a lifetime to deliver. After a career spent working diligently, Stiller has finally hit

their parents out of town, the two would fill the void with show business. Not surprisingly, both are now actors. From the moment Ben began to look at the world around him, he has been building his body of work.

"Ben and Amy and a lot of films together," says Anne Meara. "They would do show-false. He works harder than anyone I know. He never, ever, ever is not working. It's actually bizarre."

"But we didn't want to go to L.A.," says Jerry. "We thought a bigger danger was growing up in a community where the neighbors were all stars and the kids were in competition with their parents' roles."

> ## "I've never really felt like a funny, funny guy,
> *like Mr. Life of the Party," says Stiller.*
> ### HE IS UNFAILINGLY POLITE; HE IS FRIENDLY;
> BUT THERE IS ALSO A QUIET INTENSITY AND A NERVOUSNESS
> *that seeps into the air around him.*

the big time by shooting dope, donning braces and getting his penis caught in his zipper.

But then, the map of Stiller's world has always been drawn with blurry borders between reality and pop-culture fantasy. As a child, he was taught to swim, in Las Vegas, by the Pips; he watched home movies of Rodney Dangerfield holding him when he was an infant; Stiller even had the Swami Satchidananda borrow his skateboard outside the Stillers' apartment building, on Riverside Drive in New York. When one of the Beatles' tinted gurus of choice borrows your skateboard, it's tough to talk about a normal childhood with a straight face.

Stiller's parents, Jerry Stiller and Anne Meara, are a veteran comedy duo and were thirty-two-time guests on The Ed Sullivan Show. (Today, Dad is best known as Frank Costanza on Seinfeld, and Mom from movies like The Daytrippers.) The pair often traveled for work, leaving Ben and his older sister, Amy, alone. Upset that show business had taken

The irony is that while his parents agonized over whether to live in New York or Los Angeles, Stiller was learning to exist in the entertainment industry. Today, at thirty-two, Stiller lives comfortably in all three.

SCENE 2 – AS STILLER lounges on his deck in L.A., he tips back in his chair and tries to make some sense of it all. He has spent a great deal of time in therapy – "I haven't been going for about a year, but I actually really like it," he says – and his approach to answers often seems rooted in those sessions.

"I'm working on that whole happiness-balance issue in life," says Stiller. "I think you're always working on that. I tend to lean more toward the work side of life. It's important to find happiness outside of your work."

Yet, if you listen to the people who know him best, you wonder how precarious that balance really is.

His friend (and Permanent Midnight memoirist) Jerry Stahl: "I've never seen anybody put in the sheer man-

hours Ben does. Being a forty-five-year-old guy with a liver that lives in an adjoining county, I sure as hell can't keep up. It's amazing."

His father: "He works much too hard, for my money. I just wish he would take a rest."

His friend and frequent collaborator Janeane Garo-film was his source of pleasure as a child, his work and life have morphed into one. Still, it's difficult to understand what drives him.

"As a kid, I was just fascinated by the mechanics of filmmaking," says Stiller. "I thought I was going to be a cinematographer for a while. The idea of making movies was so much fun. Then, as I got older, acting and writing and the content became more important."

The question is rephrased. His fascination with film is a well-known fact, but what drives Stiller personally?

"In terms of what I've kept on doing," he says, "I've rarely stopped and stepped back."

SCENE 3 – STILLER'S FIRST films were highly derivative. Based mostly on his favorite television shows and on movies like Airport 975, they articulated his obsession with popular culture yet displayed little vision of his own. Of course, he was barely a teenager. But still. His seminal work had actually blossomed earlier – when he was able to locate his demons.

He found them on Eighty-fourth Street in Manhattan.

Stiller's apartment was on Riverside Drive; his best friend lived on Central Park West; in between was Brandeis High School. "Those four or five blocks were like a gantlet," remembers Stiller. "I used to live in fear of those Brandeis kids."

"One day he was mugged twice, once on the East Side and once on the West Side," says Jerry Stiller. He laughs. "And once they came back and said, 'We don't like this watch.'"

All this helped young Ben evolve a personal style of film. "One guy would get mugged and then we'd run after them through Riverside Park," recalls Stiller of his earliest works. "They all had names like They Called It Murder and Murder in the Park."

As Stiller's adult career blossomed, it followed a similar path – the Ben Stiller Show showcased his ability to ape his favorite movies before homing in on his darker depths. Yet Stiller's range almost never came to light. Perhaps having missed his dramatic turn in They Called It Murder, the producers of Permanent Midnight first offered Stiller's role to David Duchovny and (no, this is not a typo) Jon Bon Jovi. Even Stiller had his doubts.

"The biggest challenge was convincing myself that I was allowed to play that part," Stiller says. "I was fascinated by it. There were a lot of similarities as far as Jerry Stahl as a person – this Jewish comedy writer in L.A."

Based on Stahl's autobiography of his descent into the hells of heroin and Hollywood, the film is as relentless as any in recent memory, and Stiller who barely ate during the course of filming – is convincing.

"Meeting Jerry and talking about this role really changed me as a person," says Stiller. "The key for me was that he showed me I didn't have to be a drug addict to understand why addicts take drugs – it's about not wanting to feel pain. I figured out what I did in my

Louise Fili

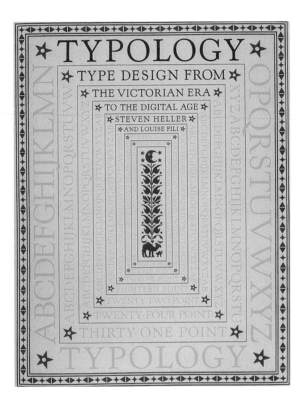

Above: Book jacket for *Typology:
Type Design from the Victorian
Era to the Digital Age*
ART DIRECTION/DESIGN: LOUISE FILI
WRITERS: STEVEN HELLER/LOUISE FILI

Opposite: Cover for *Belles Lettres:
an Arts and Crafts Writing Tablet*
ART DIRECTION/DESIGN: LOUISE FILI

Book jacket for *Streamline*
ART DIRECTION/DESIGN: LOUISE FILI
WRITERS: STEVEN HELLER/LOUISE FILI

THE WORK of distinguished designer Louise Fili is characterized by its elegance. Fili brings an ethereal quality to her designs based on an inherent sensitivity to the subject and exquisite type treatments. Fili began honing her craft with her work as a senior designer with the legendary typographer/designer Herb Lubalin. She then went to Pantheon Books, where she designed over 2000 book jackets. The most instantly familiar Fili design for Pantheon was the jacket for *The Lover,* the novel by Marguerite Duras, which, with its softened image, subtle color, and evocative type, has become a classic of contemporary design. The recipient of awards from every major design competition, and with work in the permanent collections of the Library of Congress, The Cooper Hewitt Museum, and the Musee des Arts Decoratifs, Fili opened her own studio in 1989.

Her firm, Louise Fili Ltd., specializes in logo, package, restaurant, type, book, and book jacket design. Fili says, "I have two assistants in the studio, and would never want to get any bigger. Since I am very much a hands-on designer, keeping it this size allows me creative control and limits my work to what I am interested in: food, type, or Italy." She adds, "I do not, and probably never will, design on a computer (although, of course, I rely on my staff to be more current)."

From her office in an area filled with design studios on Fifth Avenue, Fili reports that her windows face the Empire State Building. "I love to watch the play of light and color during the day, which inspired me to set up a tripod to document it." She also says, "Manhattan for me is a small town. My home is four blocks away from my office, and many of my clients (mostly restaurants) are in the neighborhood, so I always have a table."

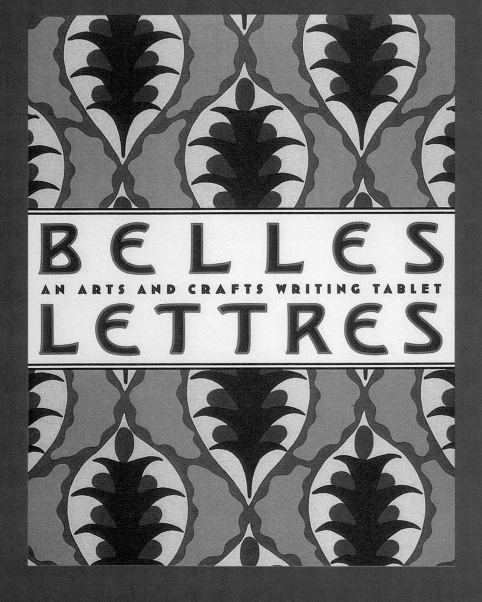

BELLES
AN ARTS AND CRAFTS WRITING TABLET
LETTRES

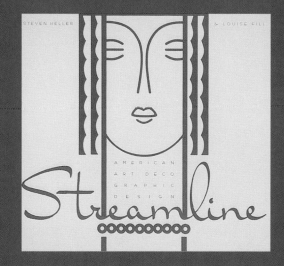

STEVEN HELLER & LOUISE FILI

AMERICAN
ART DECO
GRAPHIC
DESIGN

Streamline

Te xt
copy right
© 1998 by J. Patrick
Lewis. Illustrations
copyright © 1998
by Gary Kelley. All
rights reserved. No
part of this publication
may be reproduced or trans-
mitted in any form or by any
means, electronic or mechanical,
including photocopy, recording,
or any information storage and
retrieval system, without
permission in writing from the
publisher. Requests for permission
to make copies of any part of the
work should be mailed to: Permissions
Department, Harcourt Brace & Co.,
6277 Sea Harbor Drive, Orlando, FL
32887-6777. *Creative Editions* is an
imprint of The Creative Company,
123 South Broad Street,
Mankato, Minnesota.
56001.
Library
of Congress
Catalog
Card
Number:
98-8-
4158.
First
Edition
A C E
F D B

With co-author (and husband) Steven Heller, Fili has collaborated on a series of books on periods and styles of designs that are invaluable interpretive references to historical milestones in design. Since Fili and Heller have vast collections of design memorabilia, these books are both homage to what has gone before and labors of love. The series, published by Chronicle Books, includes *Italian Art Deco, Dutch Moderne, Streamline, Cover Story, British Modern, Deco Espana, German Modern, French Modern,* and *Typology.* The book jackets designed for the series by Fili capture each style, mood, and nuance and embody the historical knowledge and passionate interests of the collaborators.

DESIGN PHILOSOPHY
Reverence for the subject and an enlightened sensitivity in response to each project's unique character are evident in Fili's work. Fili's designs resound with her vast insights and perfection of technique. These qualities make Fili designs seamless and timeless. Fili seems to design from the inside out. Her designs

have character and depth, so that when she is creating an identity for a new restaurant, for example, her work conveys a definite individuality, a sense of the ambiance of the place, and an inherent stability. Fili's designs are never ephemeral, but are designed to last. Much of this has to do with the intense process of creating logos and type treatments that gives each project its raison d'être.

TYPE AND TYPOGRAPHY

Fili says, "Type is of the utmost importance. When we do a logo, for example, the type we use is either scanned in from old type books and reworked, or completely made from scratch, or else we start with a computer font and manipulate it. In any case, once the type is settled, it still needs to be taken to another level. For example, for the Metro Grill, which is in the Garment District of Manhattan, we designed the logo and then had it made into stitched labels to be used on the menus, chefs' hats, and servers' shirts."

Parallel to Fili's work for clients is

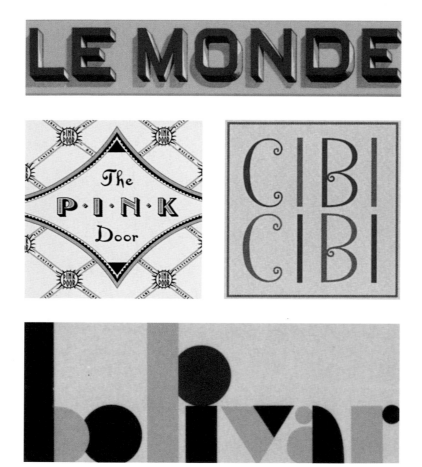

her personal work, which gives her the freedom to explore and interpret her own obsessions. She explains, "Although I am very happy to do the work that comes my way, I always make a point of pursuing my own personal projects. And once a year or so, we do a limited edition letterpress promotional book for the studio." These, including her *Copyright Pages* and her *More Logos A to Z,* are indicative of her commitment to and passion for type.

Fili is now at work on another labor of love. She is writing and designing a designer's guide to Italy, which will be a promotional series for a printer.

Louise Fili's work is more than design: it is inspired art that designers respect, covet, and collect.

Smay Vision

Above: Smay Vision business card for Phil Yarnall

Opposite: Promotional postcard for Smay Vision.

Phil Yarnall comments on the elements used in both: "The business card incorporates type borrowed from old blues posters and street signs in Belize. The images in both incorporate everything from photo booth photos and digital photos to a three-dimensional clay devil in the postcard, and a vintage men's magazine of the blood-and-guts variety showing a man wrestling with a giant squid."

DESIGN: STAN STANSKI, PHIL YARNALL/SMAY VISION

SMAY VISION is the meaningless but memorable name (cribbed from "greeking" copy appearing in an old Letraset catalog) for the design team of Stan Stanski and Phil Yarnall. The two met at Tyler School of Art (part of Temple University in Philadelphia) where, as Stanski recalls, "We attended every class together, graduated together, and moved to New York at the same time." They had also been in a band together, the Slim Guys, which was probable cause for their launch into designing for the music business.

After three years of working for *Guitar* magazine (Stanski) and PolyGram Records (Yarnall), the two joined forces and launched Smay Vision six years ago. "We started with a go-get-them attitude, which we pursued aggressively, including designing our own fonts for every project," Stanski recalls.

Smay Vision, and the client list, evolved so that now the studio may be involved in 50 or 60 projects a month. The "Smayboys'" way of working has also changed, although many of their stylistic signatures, especially notable in idiosyncratic type treatments, remain. "We used to literally work together on the one computer we had. We had two rolling chairs and we would swap places and work on the same piece," Yarnall recalls. Now, Stanski and Yarnall often have to work separately because of the volume of work, but they still collaborate. "We're like a tag-team, and we add to what each of us is doing. We are always meshing our thought processes," Yarnall adds.

Below: Comps for Splendid Blend
CD packaging for Musicblitz.com
 Yarnall says type interpretation
came from "Spanish comic books
and bad 1970s Italian type."
DESIGN: STAN STANSKI,
PHIL YARNALL/SMAY VISION

Opposite clockwise from left to right:
CD for Funky Divas, Client: Polygram
Records. CD for Floodgate "Penalty,"
Client: Roadrunner Records. CD for
Old School compilation, Client: Poly-
gram. CD for Boiled Borscht, Alex
Rostotsky Trio, Client: Pope Music.
CD for Meat Puppets "No Joke," Client:
Island Records. CD for Jimi Hendrix
"South Saturn Delta," CD for Jimi

Hendrix "Experience," CD for Jimi
Hendrix "Live at Woodstock," Client:
MCA Records. CD for Janis Joplin with
Big Brother and the Holding Co. "Live
at Winterland '68," Client: Sony
Music/Legacy Recordings
DESIGN: STAN STANSKI,
PHIL YARNALL/SMAY VISION

TYPE AND TYPOGRAPHY
Since many of the Smay projects still
relate to music, they have acquired a
reputation for forging type treatments
which are either nouveau funky, Gen-X,
or contemporary retro. For boxed CD
releases of Janis Joplin and Jimi

Hendrix, for example, Stanski and Yarnall
had to pull off a '90s spin and attitude
for '60s reissues. "This is a tricky thing.
It had to be based on what had been done,
yet look like new releases," says Stanski.
Their type treatments look softly psy-
chedelic for Joplin and iconically saintly

for Hendrix. Stanski and Yarnall con-
tinue to develop type serendipitously,
claiming that they have collected an
archive of hand-done signs from all over
the world as references, from jaunts to
the Caribbean and South America, among
other places. And they can be inspired,

according to Yarnall, by "type that
started stretching as it came through
the fax machine" (actually it was a bad
fax of Hendrix's face) as the basis for a
new typeface.

...If you like yourself, you can never be alone...

Opposite: Christmas card and promotional postcard from Smay Vision. Below: Smay Vision promotional sticker

DESIGN: STAN STANSKI, PHIL YARNALL/SMAY VISION

DESIGN PHILOSOPHY

"As our projects get bigger and bigger," Stanski says, "our response to clients is to try to be appropriate for their needs, which can be more restrained and more real world than what we'd like to do. Within that framework, we want to be as cutting edge as possible." "We're not super-artsy," adds Yarnall. "We don't reject or turn down projects because we can't have complete creative control, but we do want to have the concept shine through." Both concur that the labor of love is working on "our own thing," where the experimentation can be overt or over-the-top.

THE WORK

Smay Vision's array of projects spans smaller clients to mass market block-busters. Within the range of jobs, the Smay look is most conveyed by a hand-crafted feeling, even if computer-pro-duced. Acknowledging that their college work (under the mentorship of Stan Zagarski) was cut-and-paste, they are reluctant to produce work that looks computer-generated and untouched by

Opposite: "Tips from the Trenches" special insert poster (front and back) for *Guitar* magazine. Editorial spread for *Guitar* magazine. Left: Call for Entries posters for the New York Underground Film Festival. Below: Smayboy editorial promotional brocure. Cover: Stan Stanski (standing), Phil Yarnall (on the leash)

DESIGN: STAN STANSKI, PHIL YARNALL/SMAY VISION

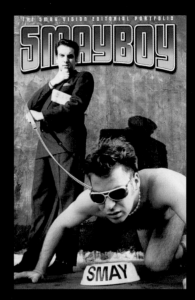

the human hand. "We like to do things that are made with a homemade look," says Stanski. The Smay Vision collection is characterized by editorial work that has in-your-face images and blasting type treatments (like type imbedded on the rubber sole of a shoe or food arranged in type forms); posters with distressed or elongated type and weird imagery; and CD covers packed with custom lettering. Essentially, Smay work looks like Smay—edgy, funny, and touched by the human hands of Stanski and Yarnall.

Typerware

Above: Spread from Garcia Fonts Library #3 devoted to gastronomic type design

The FontSoup type family was first featured within this library. ("FontSoup is a Typerware contribution to the literacy of culture" is stated on the right edge). According to Balius, "The controversial type project Garcia Fonts & Co. often used irony and sense of humor in order to introduce concepts, attitudes and the philosophy of the project itself. We were conscious that our approach to type design was not in the formal/traditional manner. So, we stated 'we do not design type,' (at least not in the usual formal way)."

DESIGN: ANDREU BALIUS

Opposite: Poster featuring Playtext. This typeface was used as the corporate text face for Garcia Fonts printed matter.

DESIGN: ANDREU BALIUS

FOR THE LAST SEVEN YEARS, Andreu Balius and Joan Carles P. Casasin have comprised the two-man team that runs the type foundry and (typo)graphic design company Typerware in Barcelona. The two met in 1993 and discovered mutual type interests. Both design type for pleasure as well as for use in design work they are commissioned to do. In their early days, this work was flyers, posters, and leaflets for Barcelona's night club and music scene. "We enjoyed these since we love graphic design, and we tried to experiment, to investigate, to simply learn as much as we could within our work," says Balius, who speaks for them both.

Typerware, Balius says, creates type designs "tied into our commissioned graphic design work. Sometimes we design typefaces for specific design projects, as in the work we did for the theater group La Fura del Baus. We did the graphic images for their production, "Manes." Then we designed a book based on the concept and ideas which originated from the theatrical production. We worked with a small budget, but we were happy with the results. For the book we designed two type families, FaxFont (a faxed four-weight typeface) and the NotTypewriterButPrinter type family (a four-weight type with the shapes scanned from old matrix printouts using varying amounts of ink). Both were used for the first time in the book" (and now are sold by Typerware).

Balius and Casasin have achieved an international reputation for their dynamic typographic experiments. The partners have produced graphic and type designs that capture a Catalan sensitivity and energy. Balius says, "We did not have formal (or even traditional) training in typography or type design. We both studied graphic design and so we had to work hard on our own to develop our type design. Most of this knowledge comes from our curiosity, our enthusiasm, and our self-training."

Garcia Fonts is a secondary project in which the two have been involved, a not-for-profit type exchange where type designers submit work and receive other designers' fonts for free. This commitment to expanding the availability and use of new typefaces has been a labor of love.

The two have also created commercial fonts sold by International Typeface Corporation and FontShop International.

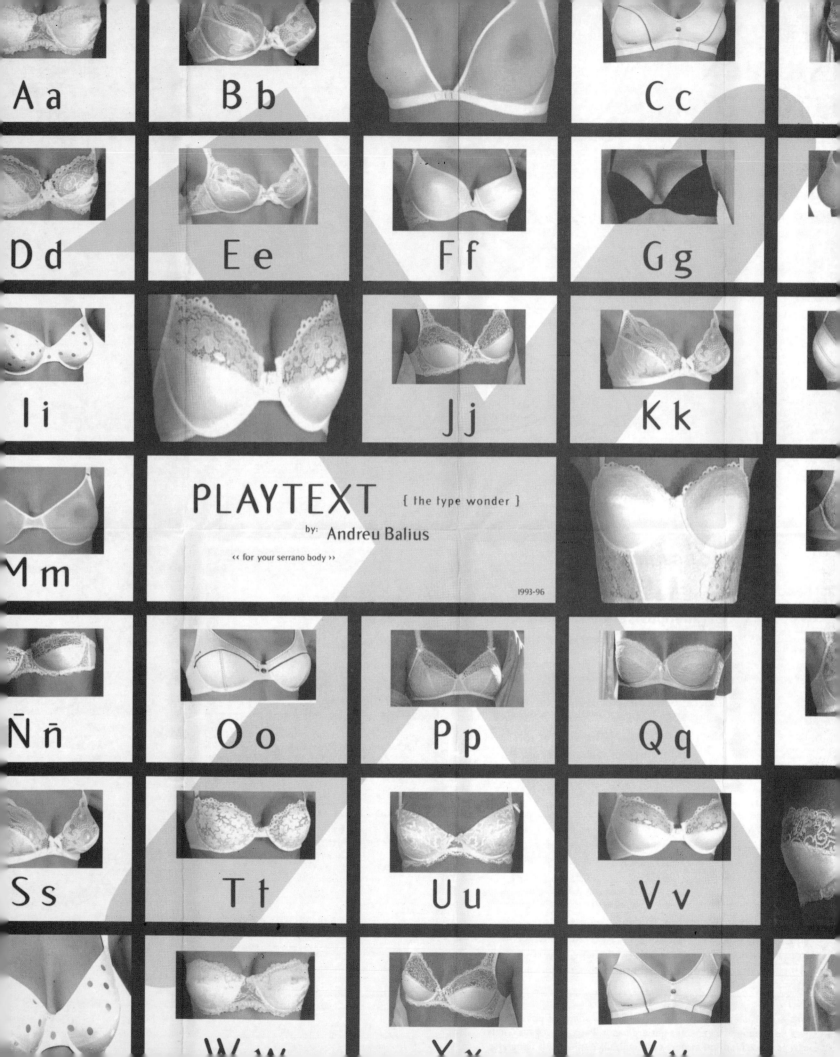

PLAYTEXT { the type wonder }

by: Andreu Balius

‹‹ for your serrano body ››

1993-96

Legibility keeps your mind clean & tidy

Opposite: Center spread from Garcia Fonts Library #4 stating, "Legibility keeps your mind clean & tidy"

Balius comments, "We used an ironic picture introducing Ozo (Ozone) typeface, with an overlapping of designer Massimo Vignelli's recommended basic types since Vignelli had been adamant that 'the proliferation of typefaces and type manipulations represents a new level of visual pollution threatening our culture. Out of thousands of typefaces, all we need are a few basic ones, and trash the rest.' Ozo type, therefore, is a Typerware contribution to the ecology of communication. We used type as a way to react, as a way to say things visually."

DESIGN: ANDREU BALIUS

Below: Covers from Garcia Fonts Library #4 and #6 in which the new fonts from the Garcia Fonts catalog are featured

DESIGN: ANDREU BALIUS

DESIGN PHILOSOPHY

According to Balius, "The important thing in designing is to try to be honest in your work and to communicate in the best way possible, since communicating visually is not an easy thing. It has to do with manipulation combined with conveying knowledge. A designer cannot be outside of the things he is communicating through design. We feel that we are taking part in the content in some way. We are also part of the society in which the design will be seen. Although making things work properly in a design is the main goal, you can't forget that you are part of a bigger context and that taking a position on how your design affects society is, in most cases, inevitable."

TYPE AND TYPOGRAPHY

Balius compares type with music. He says, "With music you have words and melody which you hear at the same time. With type, it is as if you 'listen' visually; i.e. the words and the type function simultaneously. Type helps the ideas you are presenting to be 'heard' in the best way. Type is like a

10a

MOSTRA d'ART

CONTEMPORANI

CATA

5 - 28 DE

centre cultural **CAN MULÀ**

PARC DE CAN MULÀ
08100 MOLLET DEL VALLÈS
BARCELONA
TEL. (93) 570 16 17
FAX (93) 570 72 39

HORARIS
Dilluns, dimarts, dimecres i divendres: de 5 a 9 del vespre
Dijous: de 10 a 2 del migdia
Dissabtes: de 10 a 2 del migdia i de 5 a 9 del vespre
Diumenges i festius: de 12 a 2 del migdia

Ajuntament de
Mollet del Vallès

INAUG

centre cultural **CAN MULÀ**

Poster for a young Contemporary Art
Exhibition at Centre Cultural Can Mulà,
Mollet del Vallès in Barcelona
 "The concept suggests really fresh
juice in the contemporary Catalan art
scene," says Balius.
DESIGN: ANDREU BALIUS, JOAN CARLES P. CASASIN
TYPERWARE

JLIOL 1996

š

ndres 5 de juliol
a les 20 h

Below, clockwise, left: Poster for a
(Poli) Poetry recitation. "The illustra-
tion defines the kind of surrealistic
performance that is behind this poet's
recital. This serigraph poster on grey
fish-wrapping paper is one of our first
works as Typerware," says Balius.

One of a series of Flyers for the NITSA
Club in Barcelona; Primavera Sound
Poster for an indie (independent)
young pop festival in Barcelona; Flyer
for a DJ programme at the NITSA
Club in Barcelona

DESIGN: ANDREU BALIUS, JOAN
CARLES P. CASASIN/TYPERWARE

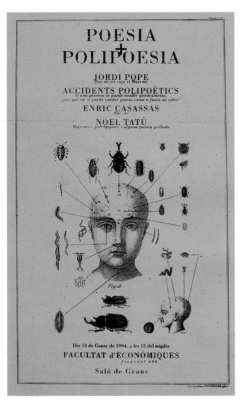

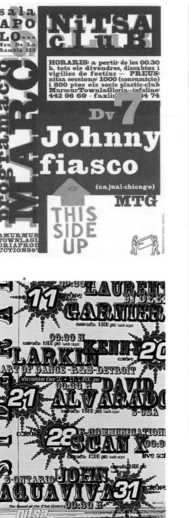

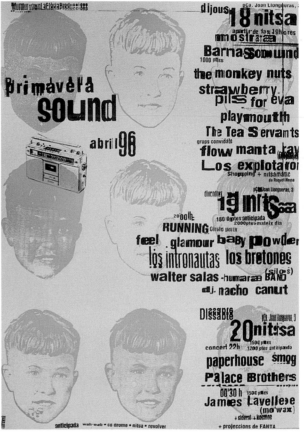

nice sound that gives sense to the silence of text."

When choosing a typeface, he adds, "Context is the important thing. This includes designing a typeface, when necessary, for a certain design project. We think of type and its context like a great meal. (We are Mediterranean, after all.) Choosing the right typeface is similar to ordering the right wine, which complements the meal. The relationship among the combined tastes of certain dishes with specific wines is important to becoming a gourmet. This is not unlike choosing the right type for the right project or specific context. This is the reason why we need as many typefaces as possible, in order to have a wide range of good choices. We think of the same appropriateness and specific relationship to the concept when we have to design a typeface. We relate to the context of the design commission, the motivation for the project, before starting the first sketches for a new type."

Balius and Casasin concur that "type conveys ideas. We use type in order provide messages that are intended to be

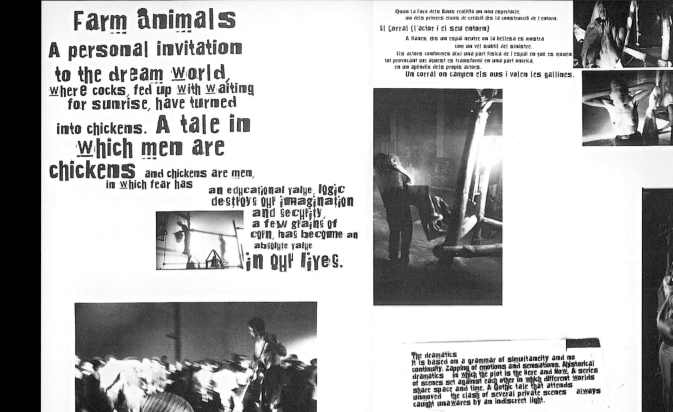

Farm animals
A personal invitation
to the dream world,
where cocks, fed up with waiting
for sunrise, have turned
into chickens. A tale in
which men are
chickens and chickens are men,
in which fear has
an educational value, logic
destroys our imagination
and security,
a few grains of
corn, has become an
absolute value
in our lives.

Quan La Fura dels Baus realitza un nou espectacle,
un dels primers eixos de creació és la construcció de l'entorn.
El Corral (l'actor i el seu entorn)
A Manes, és un espai neutre on la bellesa es mostra
com un vel subtil del sinistre.
Els actors conformen així una part física de l'espai en què es mouen,
tot provocant que aquest es transformi en una part onírica,
en un apèndix dels propis actors.
Un corral on campen els ous i volen les gallines.

The dramatics
It is based on a grammar of simultaneity and no
continuity. Zapping of emotions and sensations. Ahistorical
dramatics in which the plot is the Here and Now. A series
of scenes set against each other in which different worlds
share space and time. A Gothic tale that attends
unmoved the clash of several private scenes always
caught unawares by an indiscreet light.

read in a certain way. But we also consider that ideas are conveyed in type. You can express ideas through type. You can design a typeface (a whole font, alphabet, a family, whatever …) in order to say things, make people think about something, express a feel-

ing, a personal view of the world. You can say all of these things in a type design."

Balius comments on the Typerware partnership: "We were lucky to meet each other one day at the BAU School in Barcelona, because it is difficult to

find someone who can share the same thoughts and have the same motivation about design and typography. And so here we are with the energy and joy to challenge our work and to find our place in the tiny Spanish market for type design and typography."

Laurie Haycock Makela

Above: T-shirt front (Shock) and back (Disorderly)
from *Whereishere* book, 1999

DESIGN FIRM: WORDS + PICTURES FOR BUSINESS + CULTURE
ART DIRECTION: P. SCOTT MAKELA, LAURIE HAYCOCK MAKELA
DESIGN: WARREN CORBITT

Opposite: Concept proposal for advertising
campaign, 1999

DESIGN FIRM: WORDS + PICTURES FOR BUSINESS + CULTURE
DESIGN/PHOTOGRAPHY: P. SCOTT MAKELA
CLIENT: ROSSIGNOL SKI + SNOWBOARD

IN 1996, P. Scott Makela and Laurie Haycock Makela went to Cranbrook Academy of Art in Bloomfield Hills, Michigan, to become co-chairs of the 2-D design department there. They also merged their talents by creating a new studio, Words + Pictures for Business + Culture. Scott's studio had been primarily known for creating dynamic videos, experimental fonts, and daring designs. Laurie had been the design director of the Walker Art Center in Minneapolis, where her design innovations graphically transformed the identity and the publications of that institution. She had commissioned Matthew Carter, for example, to create a font specifically for the art center.

Together, P. Scott Makela and Laurie Haycock Makela forged a dynamic and multi-faceted program for Cranbrook students. At the same time, they pursued a range of interests including film titles, video, Web and editorial design, as well as broadcast advertising, through their studio. For most designers, the Makelas' work captured the energy, technical savvy, and graphic experimentation of the last decade. In 1998, their landmark book (co-authored with Lewis Blackwell), *Whereishere: impounded at the borders of mass communications: ideas, materials, images, narrative, toxins* was published (along with a corresponding Web site) and the Makelas achieved yet another triumph of expression and ideology, with many more expected.

In May, 1999, P. Scott Makela died unexpectedly from an undiagnosed virus. In one day, Laurie Haycock Makela found herself a widow, a single parent to their two children, and the sole head of the Cranbrook department, as well as the studio.

The work featured here is from the Rossignol campaign. It displays many traits of the Makelas' collaborative signature: dramatic images, expressive, interpretive type treatments, energy that vibrates on the page in a synergy of image and text.

This is how this work came to be documented in Laurie Haycock Makela's own words:

"These works represent the end of Words + Pictures for Business + Culture — the uncanny result of atomic loss. Scott's last works — "Faith and Action," "God is Close to Ya," and "Vertigo is Fun" — were created to pitch the Rossignol ski and snowboard print campaign and Web account. Scott, a passionate and strong snowboarder, possessed a graphic voice perfectly suited and eager to seduce his audience.

"The day after he died, a shocked but oddly inspired team of Cranbrook Academy of Art graduate students joined me to create dozens of new directions for our clients. Press deadlines knifed us, and the client-relationship became tense. The real issue, of course,

BACKING STARS NOT BUYING THEM

THE TEAM
Nita Arpiainen
Ron Chiodi
Andrew Crawford
Dionne Delesalle
Jonas Emery
Jeremy Jones
Pascal Imhof
Gaku Nagata
JF Pelchat
Pauline Richon
Tony Raos
Paavo Tikkanen
Doriane Vidal

ROSSIGNOL
rossignolsnowboards.com
YOU MUST RIDE.

was that Rossignol had fallen in love with Scott's passion for the project. What was Words + Pictures without the wind tunnel effect of Scott's 200 mph energy and talent?

"The team, particularly Paul Schneider, Warren Corbitt, Kurt Miller, and Brigid

Cadbry, lived in the forest-like vortex of his absence, subsisting on vibrant memories and holograms of the remarkable graphic voice of P. Scott Makela. The work you see here reflects our respect for that joyful, noisy, wicked voice."

Laurie also reports that "Following

the Rossignol project, Words + Pictures just had to shut down."

In recognition of the last ten years of their contribution to the design field, The America Institute of Graphic Arts awarded the Makelas the Gold Medal for Innovation 2000.

In 1999, Laurie (with Skooby Laposky) made a CD, *Wide Open: Music for P. Scott Makela*, since creating music as well as videos had also been a facet of the Makela oeuvre. She has continued her work at Cranbrook, as well as lecturing and performing at the Tate Gallery

WAS THAT
DROP 50
OR 80 FT.
WHO CARES.

THE TEAM
Nita Arpiainen Ron Chiodi Andrew Crawford Dionne Delesalle Jonas Emery
Pascal Imhof Gaku Nagata JF Pelchat Pauline Richon Tony Roos Paavo Tikkanen Doriane Vidal

ROSSIGNOL
rossignolsnowboards.com

in London and in New York, Osaka, Lausanne, and Argentina.

Laurie Haycock Makela shares the thinking behind her new venture: "As I slowly unravel the collaborative voice I shared with Scott, I'm doing new vocal and video work under the name of AudioAfterLife. New typography takes cues from the sonic culture, as its context and technologies mutate once again. I've experienced the exasperating differences between the virtues of 'time-based' typography and those of book design. I'll call the next phase 'audiographics,' where fonts come with sound, the book is wired, the auditorium is full, and the voice is real."

As a startling human being and as a designing voice, no one could be more real than Laurie Haycock Makela.

Jonathan Barnbrook

Above: Book jacket for Damien Hirst book *I WANT TO SPEND THE REST OF MY LIFE EVERY-WHERE, WITH EVERYONE, ONE TO ONE, ALWAYS, FOREVER, NOW.* Booth-Clibborn Editions

Opposite: Cover and spread for *Why2K?,* Booth-Clibborn Editions. Subtitled "Anthology for a New Era," the book has a series of essays by notables such as poet Seamus Heaney, historian Eric Hobsbawm, and filmmaker Derek Jarman.

DESIGN: JONATHAN BARNBROOK

JONATHAN BARNBROOK has his studio in London, on Archer Street in Soho. Barnbrook Design, now in its tenth year, has a staff of two—Jonathan and Jason Beard—but the work that emanates from this enterprise belies its size. Barnbrook is a graphic designer, font designer, and advertising director. He may be best known for designing the book on the controversial contemporary artist, Damien Hirst, titled *I WANT TO SPEND THE REST OF MY LIFE EVERYWHERE, WITH EVERYONE, ONE TO ONE, ALWAYS, FOREVER, NOW.* The book's publisher, Edward Booth-Clibborn, has called Barnbrook a genius, and the book has won every major design award from New York to Tokyo.

In this collaboration with Damien Hirst, Barnbrook achieves an art book that redefines the genre. His design combined with the complex production surprise the reader at every spread. Not only does Barnbrook capture the essence of both Hirst's work and mind, he uses design to involve the reader with pull-outs, overlays, die-cuts, inserted posters, and puzzles. The book is not only a good read, but also an interactive experience. The first printing of this hefty tome sold out and the second printing continues to sell.

With this book, Barnbrook, who assiduously worked closely with Hirst for a year and a half, made a deliberate attempt to "redefine contemporary art book design."

A second Booth-Clibborn Book, *Why2K?,* has recently been released. In this book, Barnbrook typographically explores and illustrates essays that focus on this new century done by Britain's New Millennium Experience Commission. It, too, offers devices and surprises that move this book toward a new form. Barnbrook describes his design approach here as creating a "typographic wedding cake."

While working on yet another Booth-Clibborn book, he has continued his collaboration with Hirst by branching out into restaurant design. The resulting restaurant, Pharmacy, has won numerous design awards. Barnbrook also worked with Hirst to design a corresponding delicatessen called Outpatients. In addition, Barnbrook is designing textiles, products, and a Kanji font for Japan. In terms of which new areas he wishes to explore next, he sees his future as open-ended.

You Are Here

WHY 2K?

You Are Here

Below and opposite: Spreads from
Why2K?

Following spread: "Derek Jarman's
Garden" spread from *Why2K?*

DESIGN: JONATHAN BARNBROOK

"i didn't exist at creation
i didn't exist at the flood
and i won't be around for salvation
to sort out the sheep from the cud-

"or whatever the phrase is. the fact is
in soteriological terms
i'm a crude existential malpractice
and you are a diet of worms."
James Fenton

"history repeats itself. historians repeat each other."
Philip Guedalla

on the\move:

DESIGN PHILOSOPHY

For Barnbrook, design is his forum to "make a difference." He does approach each project with the intention of finding a solution to a design problem, but he does not attack this conventionally. Key to this approach is his aspiration to "add some value to the existing culture." He says that it is "important to have an emotional reaction to text," and the passionate response produced on the page is his hallmark. For Barnbrook, there is no doubt that design can be an art form in its own right, so his work conveys that intensity and concern with form. With the Hirst book, for instance, he did not merely display Hirst's work, but demonstrated it, made it resonate, and, in so doing, created a book which has itself become a collectible art piece. His interpretation of the essays in *Why2K?* is also a considered and text-based improvisational response that enhances the writers' theories, reflections, and opinions on the future through design.

TYPE AND TYPOGRAPHY

Barnbrook is known for his vast

THE **STEREOTYPE** IS THE ETERNAL
FEMININE. SHE IS THE SEXUAL OBJECT
SOUGHT BY ALL MEN, AND BY ALL WOMEN.

SHE is of neither sex, for she has herself no sex at all. Her val U R E
is solely attested by the demand she excites in others. All s H E
must contribute is her existence. She need achieve nothi N G ,
for she is the reward of achievement. She need never gi V E
positive evidence of her moral character because virtue I S
assumed from her loveliness, and her passivity. If any m A N
who has no right to her be found with her she will not be B E
punished, for she is morally neuter. The matter is sole L Y

one of male rivalry. Innocently she may drive men to madness and war. The more
trouble she can cause, the more her stocks go up, for possession of her means more
the more demand she excites. Nobody wants a girl whose beauty is imperceptible
to all but him; and so men welcome the stereotype because it directs their taste into
the most commonly recognised areas of value, although they may protest because

SOME ASPECTS OF
IT DO NOT TALLY
WITH THEIR FETISHES.

THE FEMALE
EUNUCH

Germaine Greer

MY EARLIEST MEMORIES

ARE OF THE OLD LAWN-MOWER WITH WHICH WE LABOURED TO CUT THE GRASS.

I am so glad there are no lawns in Dungeness. The worst lawns, and for that matter the ugliest gardens, are along the coast in Bexhill – in Close and Crescent. These are the 'gardens' that would give Gertrude Jekyll a heart attack or turn her in her grave.

On the 28th of June 1992 President Mitterrand of France made a sudden, unannounced and unexpected appearance in Sarajevo, already the centre of the Balkan War that was to cost perhaps 150,000 lives during the remainder of the year. His object was to remind world opinion of the seriousness of the Bosnian crisis Indeed, the presence of a distinguished, elderly and visibly frail statesman under small--arms and artillery fire was much remarked on and admired. However, one aspect of M. Mitterrand's visit passed virtually without comment, even though it was plainly central to it: the date. Why had the President of France chosen to go to Sarajevo on that particular day? Because the 28th June was the anniversary of the assassination, in Sarajevo, in 1914, of the Archduke Franz Ferdinand of Austria-Hungary, which led, within a matter of weeks, to the outbreak of the First World War. For any educated European of Mitterrand's age, the connection between date, place and the reminder of a historic catastrophe precipitated by political error and miscalculation leaped to the eye. How better to dramatize the potential implications of the Bosnian crisis than by choosing so symbolic a date? But hardly anyone caught the allusion except for a few professional historians and very senior citizens. The historical memory was no longer alive.

ERIC HOBSBAWM

typographical talents. He uses type as a medium to be worked onto a blank canvas. Beginning with his "interest in language," Barnbrook paces the pages he designs, creating a visual typographic rhythm in response to the text. Each design project he attacks becomes a

typographical metaphor for the thought processes of the writers. Typographically, what can be expected from Barnbrook is the unexpected.

Barnbrook also designs his own typefaces for his foundry, Virus. His font designs are equally edgy, esoteric, and

intelligent and include Drone, False Idol, and Nixon. These designs are a microcosm of his thinking process. Each has a rationale, an attitude, and an emotional resonance.

For Barnbrook, it is important that his graphic work is not only good design,

but relevant in many other ways. His approach to designing seeks not only a restatement of what design inherently is, but, more importantly, what it can be.

MATERIALS

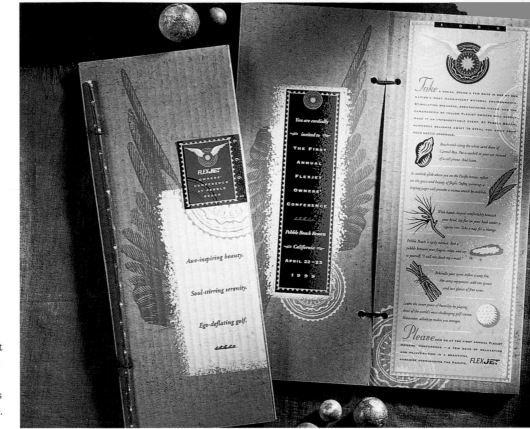

Flexjet Pebble Beach Invitations

Once a year, Flexjet—a company that offers fractional ownership of expensive jet aircraft—thanks its Fortune 500 clientele with an exclusive event in Pebble Beach, California. Sonia Greteman and her cohorts look forward to producing the annual invite.

This piece uses tactile materials to convey the beauty of the event's northern California site. The oversized, corrugated cardboard cover speaks of earth and soil, the bamboo stick and the elastic binding suggest flora and fauna, while the gold and off-white metallic inks anticipate the beauty of a coastal sunset. The feather image was silk-screened onto the cardboard, and the informational typography—which needed to be crisp and readable—was reserved for stickers that easily adhered to the final product.

Another year's invitation required a bit of research in aerodynamic physics. The Lift Your Spirit theme connotes the breezy mood of the party's locale and spirit.

Making a miniature kite that would actually fly took some testing on the part of Greteman's creatives, who were forced to spend an entire day conducting tests out in the parking lot. (Boo-hoo, creatives.)

There's a ball of string hidden inside the box, giving the invitation's recipients every reason to go fly a kite.

design firm
The Greteman Group

design/art direction
James Strange,
Sonia Greteman

client
Flexjet

materials
wood, corrugated cardboard, bamboo, paper, string, labels

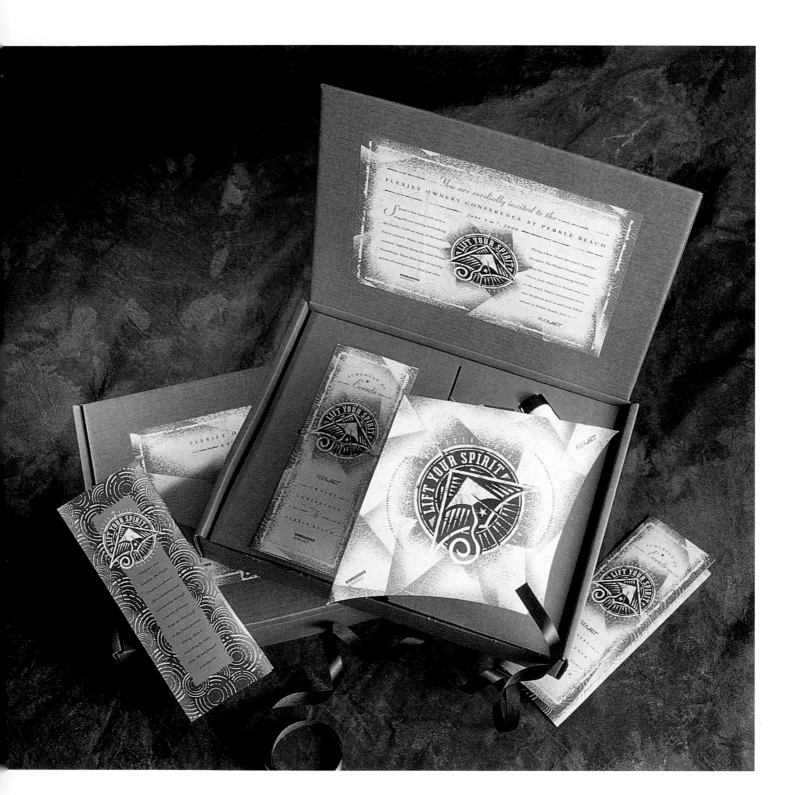

design firm
The Greteman Group

design/art direction
James Strange,
Sonia Greteman

client
Bombardier

material
die-cut cardstock

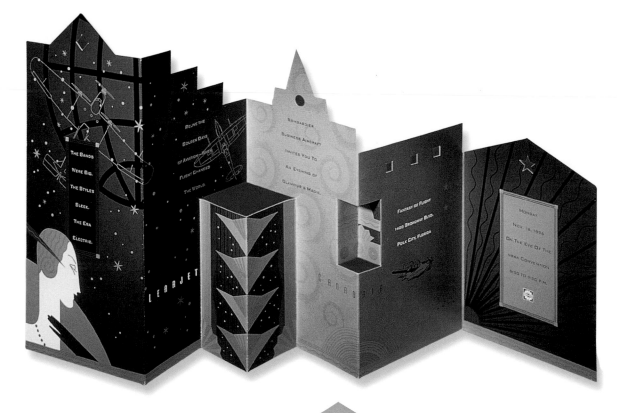

Learjet Party Invitation

When Bombardier, manufacturers of
Learjet and other business jets, decided
to throw a trade show party at Florida's
famous Fantasy of Flight Museum, they
needed an invitation as high-flying as
their aircraft. The Greteman Group, taken
with the assignment, got nostalgic about
the Golden Age of Flight and created a
pop-up skyline evoking the days when
passengers dressed up for the adventure
of air travel.

In addition to the intricate die-cuts
necessary to build three-dimensionality,
the combination of dull and gloss var-
nishes creates an almost magical sense
of depth.

design firm
Studio Guarnaccia

designer
Steven Guarnaccia

client
Kendall Square Research

materials
cardboard, vellum,
aluminum

 Kendall Square Research Invitation

Mind and matter converge in this design, which
confronts the recipient with a complex emblem of
interlinked icons that unfold through successive strata,
revealing the party information. Finally, the metal plate
is unearthed. "We wanted to give them an object," says
Guarnaccia, "Something that people would find appealing
in and of itself, a little gift."

**"The materials and the design developed together," Steven Guarnaccia
says of this outstanding tactile party invitation. "The client had seen
our "Al U. Minium"/self-promotion (p.286) and knew they wanted to
work with tin, and the entertainment at the event was a movement
artist whose work is powerful and abstract. We were looking for
something poetic and ancient. The graphite ink has a metallic sheen
to it, and I wanted to choose imagery that would work well with that."**

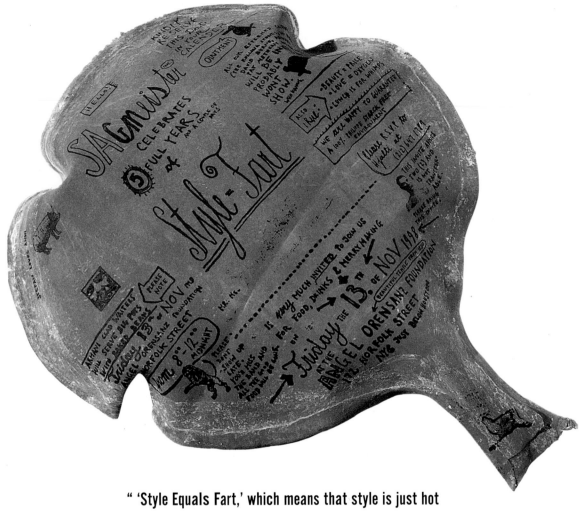

" 'Style Equals Fart,' which means that style is just hot air, that the work should be about concept."

—Stefan Sagmeister

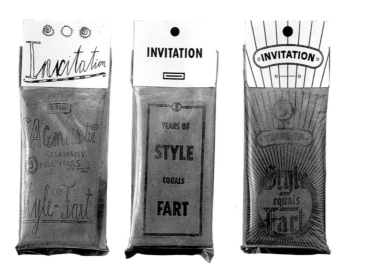

Invitation To Fifth-Year Celebration

There's no denying the whimsy of this whoopee cushion party invitation. It also illustrates why tactile graphics turn up in concept-driven designs more often than in designs based solely on style: The concept-first approach is about what a design *does* (function), rather than how it *seems* (style). Tactile elements, intruding as they do into 3-D space, imbue the message more with substance than appearance.

"At the design studio we are only secondarily interested in style and more in the content of the piece and the concept," says Stefan Sagmeister. "The style comes out of the concept. We come up with a concept first, then look at what kind of form it will take." A designer's approach should determine his client list, Sagmeister believes. "We look for clients who don't think that style is important. I don't mean that in a flippant way, I really mean it," he insists.

About the whoopee cushions, he says, "In the beginning we had a little slogan: 'Style Equals Fart,' which means that style is just hot air, that the work should be about concept."

After printing these simple party favor/invites, they were put back into their original bags for mailing.

design firm
Sagmeister, Inc.

designer
Stefan Sagmeister

client
self-promotion

material
whoopee cushion

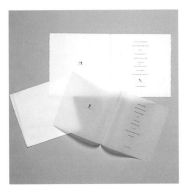

design firm
Sagmeister, Inc.

client
private client

materials
cardstock, silk, vellum

Dancing Wedding Invitation

"I am attracted to physics because it allows you to make something that involves the viewer," says Stefan Sagmeister. "When you can do that, as a designer, you have won." He is intrigued by children's science books—"They are much more applicable to graphic design [than physics books for adults] and have a lot of little experiments in them."

Sagmeister created this tactile invitation to celebrate the wedding of two close friends. A white card is bound together with a piece of white silk and a piece of vellum. On the card is an image of a dancing couple. Instructions tell users to put the silk on water, then place the vellum on the silk. "It's a strange effect," as Sagmeister describes it. "The paper disc really dances on the silk, quite a little ballet-like effect."

UCLA Department of Architecture and Urban Design/Lecture Series '97

Designer Rebeca Méndez drew her inspiration for this poster from the subjects covered in the lecture series for UCLA's Department of Architecture and Urban Design. "Some of the speakers focused on systems... particular to 'the city,' and other speakers touched on issues pertaining to 'the body,'" she says. "Ubiquitous to the city is garbage—an ever-changing and chaotic system." Méndez used flexography to print on garbage bags, which suggest formlessness and also "makes reference to skin and its simulation."

design firm
Rebeca Méndez
communication design

client
University of California
Los Angeles (UCLA)

material
garbage bags

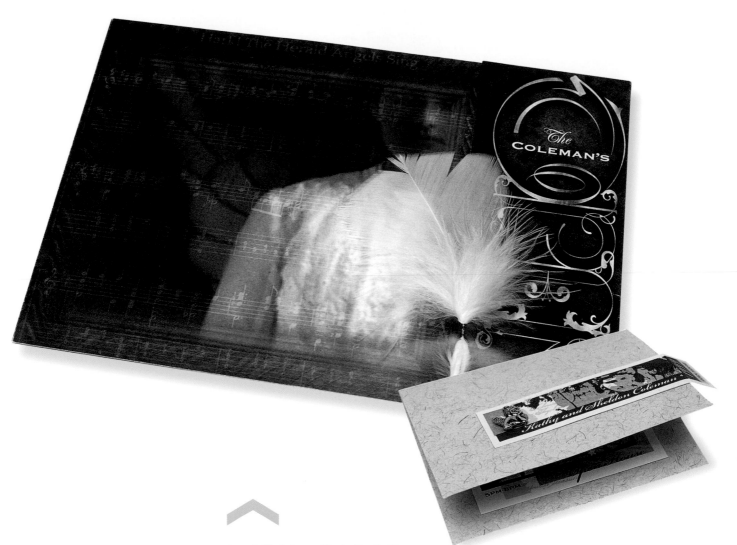

Angel Christmas Party Invitation

Karen and Jon Wippich had been working for a family-owned company for a while when they were asked to design an invitation for the family's annual Christmas party. The client's only request was that an angel somehow be part of the design.

> "My wife [and design partner] Karen and I collect old photos from auctions, and we scanned one of those and got wings from a stock CD. We scanned in sheet music for the background," says Jon Wippich. "We were looking for a way to keep the card closed, and we found this bag of feathers at a hobby shop." The feather's quill is inserted through the little notch to keep the card closed. "Having an extra element, like the angel feather on the first card set the tactile theme for all the cards we did over the years."

In keeping with the spirit of giving, one of the angel cards was itself a gift. "We wanted to make an invitation that you could also use as a frame for a photo of your own, once the party was over."

Though these holiday graphics are gentle and mild, the inclusion of a tactile element in each lends a zippiness that points to the humor and geniality of the season.

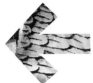

design firm
Dotzero Design

designers
Karen Wippich,
Jon Wippich

client
private client

materials
cardstock, feather, brass
charm, metal novelty ring

Eileen Boxer's invitations for New York's Ubu Gallery are legendary. Boxer gives her own concepts a back seat to the featured artists' whenever possible. "In cases when the artist is living, I insist upon working with them to some degree. I'm not interested in being the artist for these pieces, but in being the graphic designer," she says. Although their visual appeal is obvious, Boxer's designs also have an undeniable tactile power in the hand.

American Institute of Graphic Arts awards notwithstanding, if the real commercial design trophy is audience impact, then Boxer's Ubu invites have made the hall of fame.

design firm
Boxer Design

designer
Eileen Boxer

client
Ubu Gallery

materials
paper, box

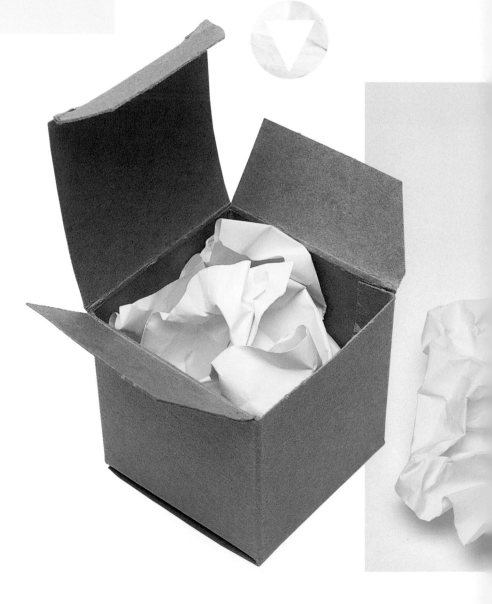

Sol LeWitt Opening Invitation

The artist's distance from the piece's final crafting is a critical element in the work of American conceptual artist Sol LeWitt. Starting in the late 1960s, LeWitt shattered the near-universal assumption that a fine artist must necessarily be a craftsperson. Although LeWitt's pieces were inspired and meticulously planned, he didn't execute the work himself. Instead, he armed his assistants with instructions and sent them out to create his pieces.

To begin the design process for Ubu's LeWitt show, Boxer spoke with the conceptualist. LeWitt described what he wanted for the invitation, and this singular, tactile design evolved out of that conversation. "The paper is off the shelf at Staples, a rubber stamp was made for the text, and the mailing house crumpled it. It ended up having such an object quality, and the effect is so simple that it was substantial," Boxer says.

Consider this: Since LeWitt's work is by definition created by others, and since he expressed his wishes for the invitation to Boxer, in a sense each recipient of the invitation received an original work of art!

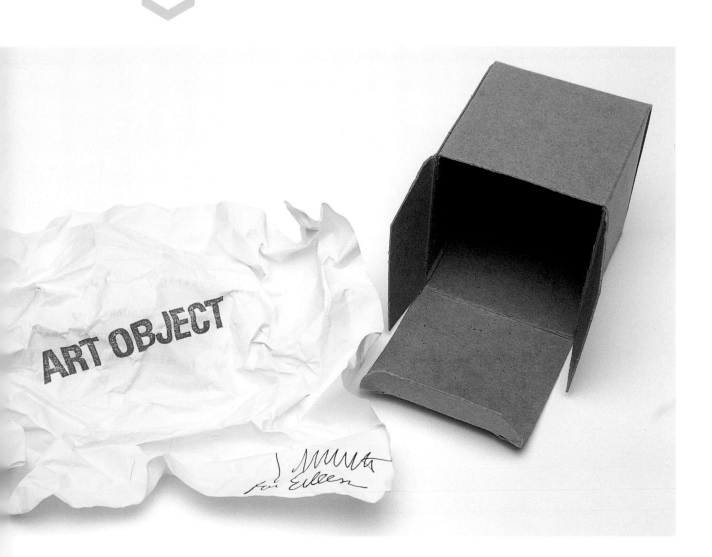

Villegle' Opening Invitation

design firm
Boxer Design

designer
Eileen Boxer

client
Ubu Gallery

material
laminated cardstock

Jaques Villegle' created his art from old posters and other material that the artist found pasted layer upon layer to the walls of the Paris Metro. Villegle' tore the material down, cropped it carefully, then framed it for display.

> "I wanted to involve the recipient with this idea of ripped paper," says Boxer. "The printer was so thrilled to work on this, and it was quite simple to do, just a solid black card with four-color on the other side, and it folded, and then the little die cut was put in to [guide] the rip. I wanted it to rip as though it were framed by the black."

Boxer adds, "I like things best where the message is simple and direct and visceral. It gets you involved in what the artist is doing, you're participating in it, receiving the messages that come from ripping paper."

In keeping with the Metro theme, the concept for this piece came to Boxer on the subway, in what she describes as "the Creative Moment, when an idea seems to fall from the sky."

design firm
Boxer Design

designer
Eileen Boxer

client
Ubu Gallery

material
paper shopping bag

The '60s in the Seventies Opening Invitation

For this themed show, Boxer discovered an unlikely surface for invitations: shopping bags. "Shopping bags were a big thing, a big means of expression in the '60s," she says. Boxer found this interesting version, ordered the smallest size she could get, then had them printed in Texas and assembled in Mexico. Every surface of the bag is printed. "We could have just done a foil stamp on a plain bag, but doing that wasn't any cheaper."

JINDRICH STYRSKY
"EMILIE COMES TO ME IN A DREAM"
COLLAGES & PHOTOMONTAGES
PRAGUE, 1933

E R O _ I C I S M

IN SURREALIS_ _OTOGRAPHY
& COLLAGE: 1_ _ – 1948

MARCH 6 — MAY 3, 199_
RECEPTION: APRIL 17, 1997, 6–8 PM

ubu

16 EAST 78TH STREET, NEW YORK, NY 10021
TEL: 212 794 4444 FAX: 212 794 4289

DISCRETION ADVISED! SEXUALLY EXPLICIT MATERIAL ENCLOSED
Edition Ubu #12 Printing / Boxer, German
Design: Eileen Boxer

design firm
Boxer Design

designer
Eileen Boxer

client
Ubu Gallery

materials
cardstock, plastic sleeve

Eroticism Opening Invitation

"In this country, you can buy pornography, you just can't mail it," Boxer says, describing a concern that guided the invitation design for this show of sexually explicit collages from the 1930s. "Also, children can open the mail or see it, and we wanted to be sensitive to that."

The muscle behind this tactile graphic is in what you can't see. As Boxer describes it, "You hold it, and your fingers are almost burning to know what's inside." What's inside the jet-black plastic wrapper is a standard postcard printed with imagery from the show.

Boxer's tried-and-true mailing house had a heat-sealing machine that sealed the little envelopes.

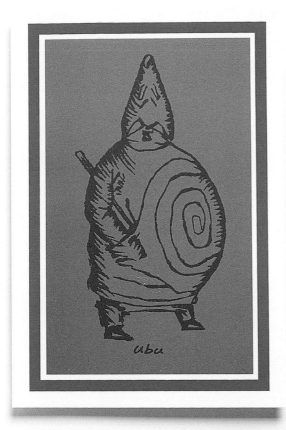

design firm
Boxer Design

designer
Eileen Boxer

client
Ubu Gallery

materials
cardstock, scratch-off
material

Destruction/Creation Show

"Most people on the Ubu mailing list know to expect something, that they'll need to be involved in the invitation in some way," Eileen Boxer says, chuckling. The Ubu gallery invited its fans to the opening of the show called "Destruction/Creation" by sending them this orange card...and a penny. "We thought that would be the clue to figuring out what to do."

Printing on scratch-offs can be a challenge. "The scratch-off material has to be sealed," Boxer explains, "But rather than doing it as a separate coating, we did it as a reverse, with the light part of the image sealed and the dark portion left unsealed. It's really just a two-color job."

As in all her work, Boxer kept the concept paramount here. "The most important thing was to create something that had to be destroyed or tampered with in some way, in order to get to the information," she says, adding, "We got that."

"It's so important to me to get people to think about things, it makes me enjoy doing this work. If you get people to ask questions, if you leave them with something in their minds, you've done something. It's like a good movie; Does it bring something into your life?": EILEEN BOXER

Richard Tipping Opening Invitation

Found objects, metal signage, and the influence of surrealism all turn up in the work of artist Richard Tipping. Boxer got the idea for this invitation from one of Tipping's found-object pieces—a souvenir license plate with the name "Art" preprinted on it. Tipping bought the little plate in a shop, signed it, and added it to his oeuvre. When Boxer saw it, she suggested using custom-made souvenir plates for the show's invitations.

"I have this great supplier, Electromark, and they did the metal stamping. The owner, Blair Brewster, is a great fan of conceptual art, and the two of them [Brewster and Tipping] have gone on to collaborate on other things.

design firm
Boxer Design

designer
Eileen Boxer

client
Richard Tipping

material
stamped metal

láször moholy–nagy
photograms, photographs, prints, drawings, collages, ephemera
october 27– december 22, 2000
reception: thursday, october 26, 6:00–8:00 pm

ubu
16 east 78th street, new york, ny 10021
tel: 212.794.4444 fax: 212.794.4289

edition ubu #22 design: eileen boxer

Moholy-Nagy Opening Invitation

Although Moholy-Nagy made very few actual photographs in his career, he nonetheless is a major figure in the history of modern photography. Much of his extant work is in the form of "photograms": shapes both familiar and abstract burned and dodged into photographic paper with a variety of instruments.

When this Ubu invitation is removed from its envelope, it filters ambient light, creating something akin to a photogram on whatever surface is beneath. "I like the way this one gets you involved in the process," Boxer says.

design firm
Boxer Design

designer
Eileen Boxer

client
Ubu Gallery

material
transparent plastic

design firm
Chen Design Associates

designers
Joshua Chen, Kathryn
Hoffman, Leon Yu,
Gary Blum

illustrators
Gary E. Blum, Elizabeth
Baldwin

photography
Joshua Chen, Leon Yu

client
Mohawk Paper Mills

materials
plastic CD case, paper

Mohawk Mills Party Favor CD Case

Oh, the horrors of business party-going. It's neither completely business nor completely fun, so many folks spend the evening either avoiding responsibility or each other. However, having something really interesting to talk about can be just the thing to break the ice.

Take this very functional and funky favor, presented to attendees of Mohawk Paper Mill's West Coast gala.

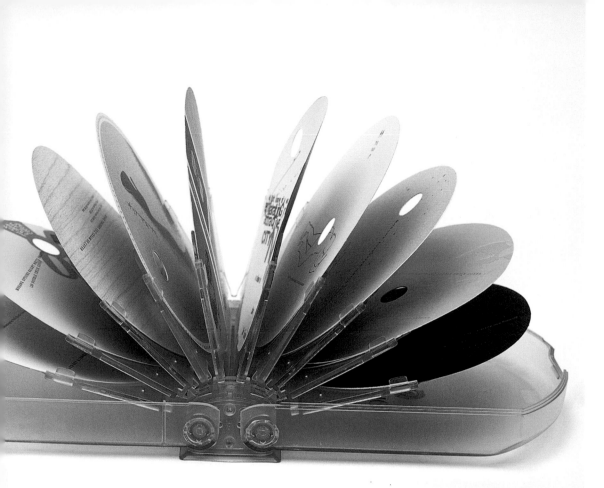

"The event was held at the Great American Music Hall in San Francisco," says designer Joshua Chen. "So Mohawk suggested giving away CD holders with paper CDs that would show off their papers. We were told we could design whatever we wanted, but the challenge was completing the project in only three and a half weeks."

As a thank you to Mohawk Paper, five area printers and two die-cut houses volunteered to help on this pro bono job, which featured wacky text researched and written by Chen's team to highlight the music scene in San Francisco. For example, attendees who pulled out the Mohawk Satin Blue White sample enjoyed reading that The Who kicked off their '73 tour at the Cow Palace. Next to a less-than-glamorous line drawing of a vertically challenged rocker, the text reads, "After drummer Keith Moon passes out on stage twice, a frustrated Pete Townsend calls out to the audience in search of anyone to take his place."

iron & candy

00206

SIX

1	2	3	4	5	6	7	8	9
10	11	12	13	14	15	16	17	18

design firm
Diesel Design

designer
Will Yarbrough

client
Diesel Design
self-promotion

materials
test tube and stopper, jaw-
breaker, ball bearing, tag

Sixth Anniversary Invitation

"When we're doing something for ourselves we can really blow it out design-wise, just so there's a solid concept behind it," says Diesel designer Shane Kendrick. For this invitation to Diesel's sixth anniversary party, the admittedly materials-oriented shop let concept take the lead.

"Candy and iron are the traditional gifts for the sixth anniversary," Kendrick explains. "The designers started researching things that would contain the little jawbreaker and the ball bearing perfectly, and they found this great test tube in a scientific supply catalog." The tag dangling from the tube invites recipients to RSVP on-line, which served the double function of driving eyeballs to Diesel's Web site.

design firm
Diesel Design

client
Diesel Design
self-promotion

material
paper

Fifth Anniversary Invitation

"If there's one thing that's a constant theme here, it's making work that's fun, cost-effective, and high-impact," declares Diesel Design founder Jeffrey Harkness. This simple invitation to the company's fifth anniversary party not only filled the bill, but did it with a tactile flourish.

"It's an invoice from a mechanic shop," says Harkness, "Just a one-color print job. But people loved the details like the greasy fingerprints and 'Please *play* this amount.' Also, they loved that you could tear off the second sheet and fax it to us to RSVP."

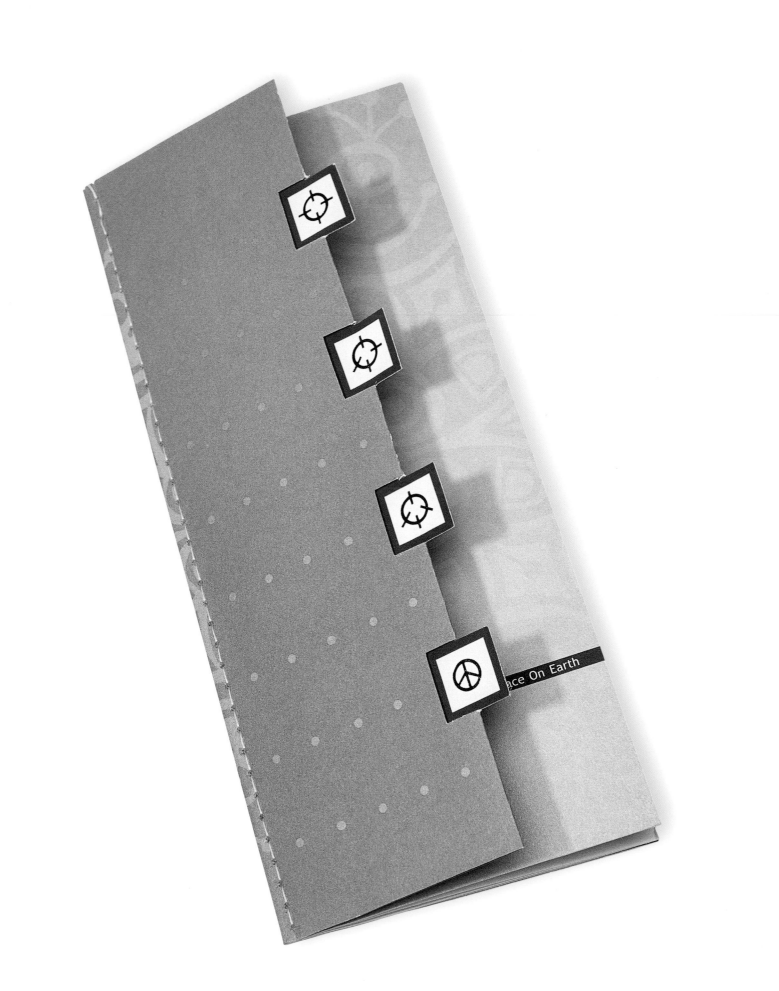

CJ Graphics Christmas Party Invitation

CJ Graphics is a hip Toronto print shop that has positioned itself to attract designers rather than deal directly with advertisers. The invitation for CJ's legendary annual Christmas party is designed by a different Toronto design firm each year, and the commission is coveted.

When Riordon Design Group was asked to create the invitation, they decided to skew toward the tactile as a way of showcasing what CJ Graphics can do. "We wanted it to be a keeper, more of an accessory rather than something you'd throw away," says Ric Riordon. "We chose [card]stocks that showcased a variety of textures and finishes. CJ Graphics is associated with a bookbinder, so we had the piece sewn together. In the mind of the user, the handwork says that you've taken care, that you've given the piece your attention."

design firm
The Riordon Design
Group, Inc.

designer
Shirley Riordon

client
CJ Graphics

materials
various papers,
stiched binding

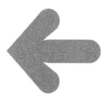

EVENTS ❮ INVITING ART

design firm
Mark Allen Design

client
Hip Hop Awards

materials
acetate, cardstock

Hip Hop Awards CD Invitation

There's a particular thrill to tactile designs that require breaking, ripping, and tearing. For this VIP invitation to the Hip Hop Awards, Mark Allen says, "I wanted to use the cover to play up the 'street' aspects of the music, the stuff in urban culture that you actually see and touch." Allen's solution was an invitation that reads like layer upon layer of graffiti, wrapped in an acetate sleeve that has to be broken to access the information—and free CD—inside.

Fashion Show Invitation

design firm
Wen Oliveri

art direction/design
Jamie Oliveri,
Cinthia Wen

client
Patrick Robinson

materials
watercolor paper,
fabric

Wen Oliveri recognized that Patrick Robinson was a unique fashion designer, a man driven by a personal mission of simplicity and integrity. For this invitation, Oliveri says, "We worked really closely with Patrick. He has a strong sense of material and the tactile, and this particular collection had a lot of hand treatments in the clothes.

"We wanted to carry that over into the invitation. It was cost-effective, but it also had less of a mass-produced feeling."

The watercolor paper was torn by hand, the message was stamped, then a sewing machine was used to stitch on the fabric swatch. "In fashion, it's easy to get too slick," Oliveri says. "We were after something more human."

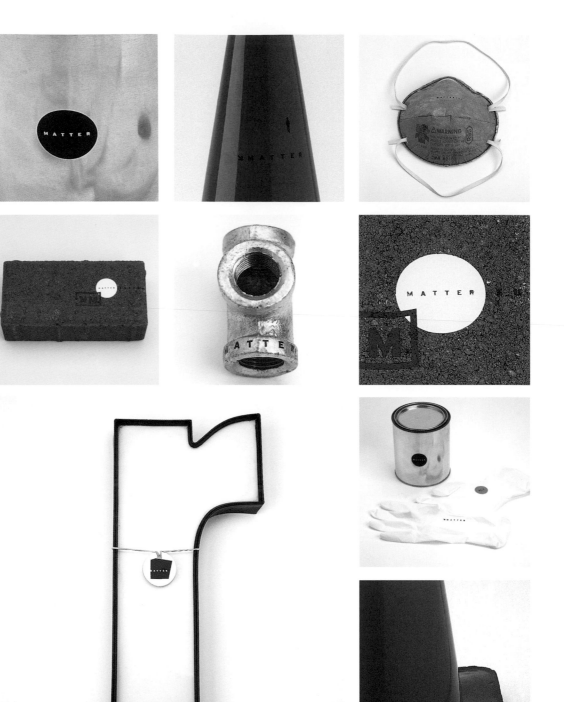

design firm
MATTER

designers
Jason C. Otero,
Rick Griffith

client
MATTER self-promotion

materials
Paint can, traffic cone,
particle mask, brick,
plumbing tee, brick, 3-D
signage lettering, paint
can with latex gloves,
traffic cone

Found Object Self-Promotions

"We solve design problems for a variety of media," says Jason Otero
of the Denver design studio MATTER. MATTER's slogan, "MATTER
surrounds us," reflects the studio's multidisciplinary scope,
which is given form in these found-object self-promotion pieces.

"The materials we use have to connect thematically to the piece
we're working on," says Otero.

design firm
Dotzero Design

designers
Karen Wippich,
Jon Wippich

client
Dotzero Design
self-promotion

materials
Formica, adhesive vinyl,
brass, rubber

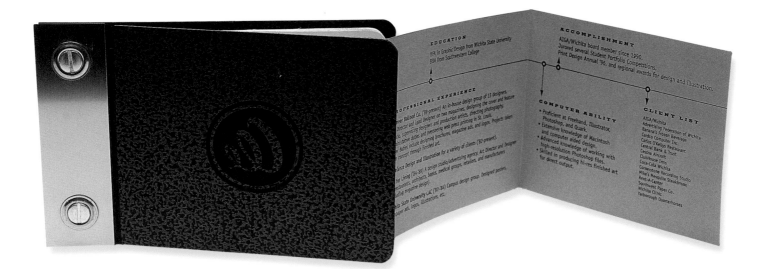

Formica Self-Promotion

Self-promotions often have a double burden: They must represent the creative spirit of the sender, and they are often produced with little or no budget. Fortunately, tactile graphics is the perfect medium to express high artistry on a slender pocketbook.

The cover of one of designer Jon Wippich's most successful self-promo pieces gets its expensive, finished look from Formica—a material usually associated with frugality. Out of its usual counter-top context, though, the Formica feels unexpectedly consequential. Wippich reports that, "When I leave the book behind for clients, they say, 'You mean I get to keep this?'"

Wippich decided on the rubber binding after realizing that Formica was too brittle to bind directly, and paper too fragile. "I remembered this company that sells rubber belting, and it was perfect, and they also gave me a special contact adhesive," he says. "Then I found the brass plaque at a trophy store and had them drill holes in it. A leather store crimped the grommets." A silk-screening vendor cut the logo out of vinyl, and Wippich burnished it on by hand.

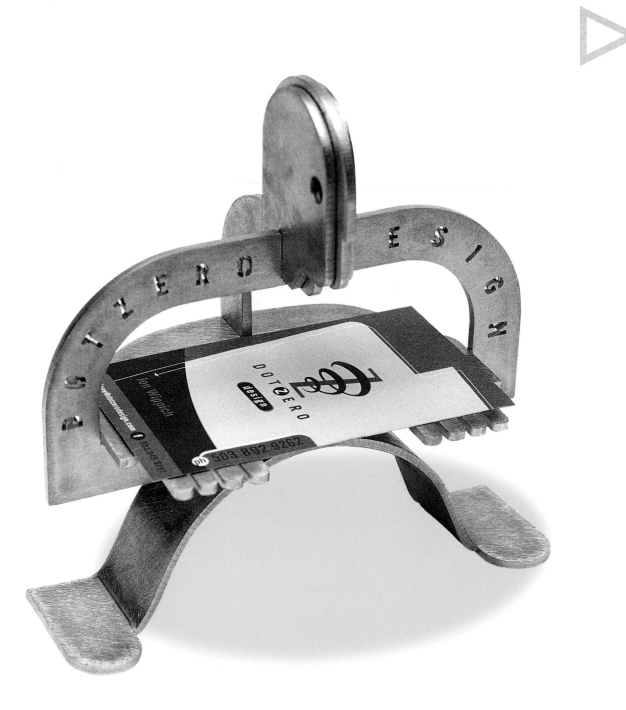

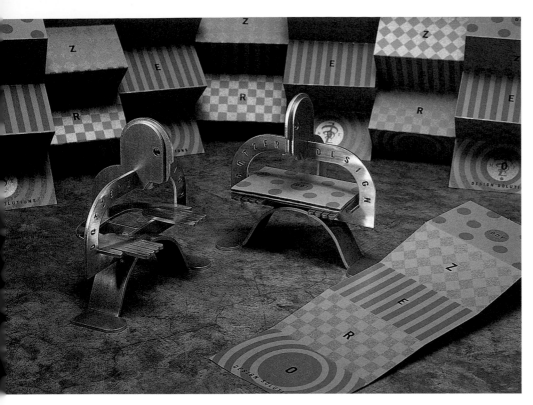

design firm
Dotzero Design

designers
Karen Wippich,
Jon Wippich

client
Dotzero Design
self-promotion

material
aluminum

Aluminum Man Card Holder

It is an ongoing challenge for designers to create a
self-promotion that will stay in clients' hands, rather than
in the circular file. This business card holder self-promo
for Dotzero uses a witty, tactile design to solve that problem.

Jon Wippich approached a metal-cutting shop with a
cardboard mockup of his burly little roustabout. "At first
I wanted it in steel, but I also wanted the legs bowed, and
the metal cutters showed me that it would be much easier
to bend aluminum." Wippich and the metal cutters refined
successive drafts until the design was not only delightful
to look at, but structurally integral: The limbs of the
aluminum laborer are designed to hold together without
soldering.

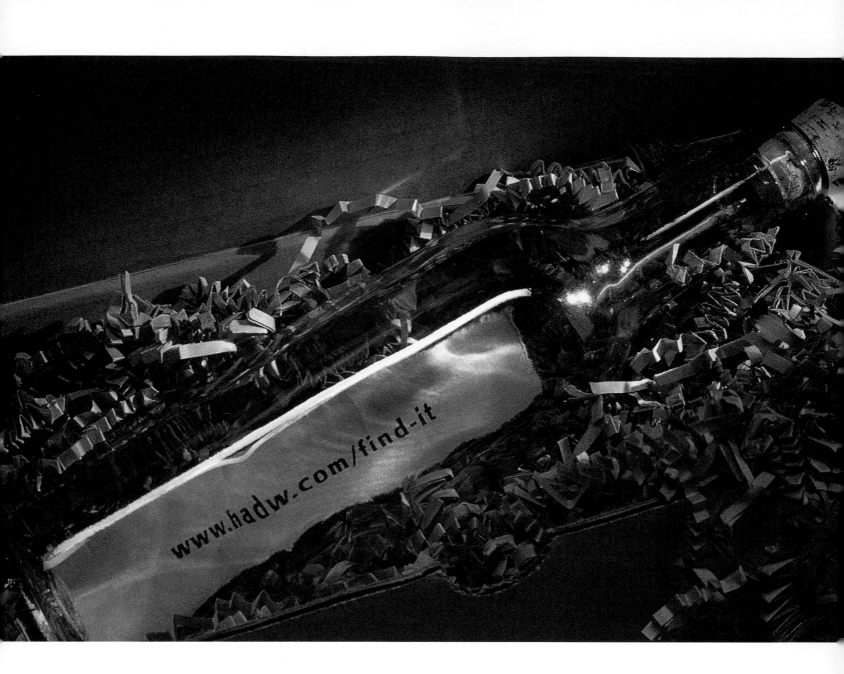

www.hadw.com/find-it

design firm
Hornall Anderson Design
Works, Inc.

client
Hornall Anderson Design
Works, Inc. self-promotion

materials
glass bottle, paper,
metal can, can opener

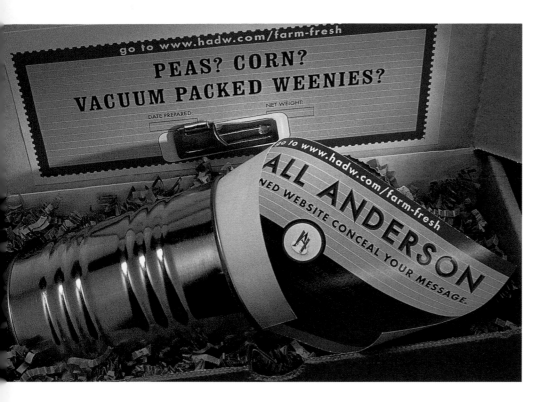

go to www.hadw.com/farm-fresh

PEAS? CORN?
VACUUM PACKED WEENIES?

DATE PREPARED: NET WEIGHT:

go to www.hadw.com/farm-fresh

ALL ANDERSON
NED WEBSITE CONCEAL YOUR MESSAGE.

Message-in-a-Bottle and Paint Can Self-Promotion

"People were given hands for a reason," says Chris Sallquist, partner in Hornall Anderson Design Works, Inc. "We like the sensation of picking things up. I still print articles out from my computer so I can hold the pieces of paper in my hand; it's just easier for me to comprehend that way. And that's why three-dimensional design enriches our experience. You just have to get more involved with it."

Running with this theory, Sallquist decided to create a promotional campaign for the launch of Hornall Anderson's on-line creative services division. By sending a message in a bottle and, later, a message inside a paint can (accompanied by a can opener), he literally forced users to pick up his message and play with it. Both pieces were packaged without a Hornall Anderson label, yet both contained messages that drove the user to a Hornall Anderson URL advertisement displaying the company's ability to build enticing Web sites. Sallquist explains that the inexpensive stunt garnered a substantial amount of new business, but did require a few overtime evenings, hand-stuffing bottles and cans.

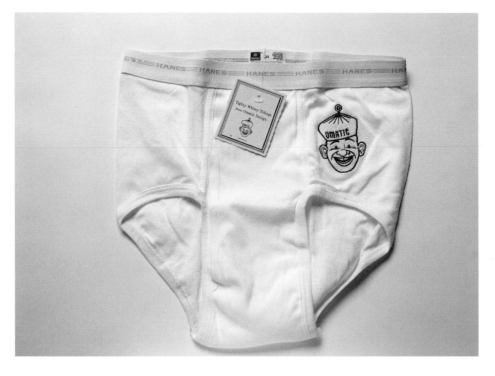

design firm
Omatic Design

designer
Geoffrey Lorenzen

client
Omatic Design
self-promotion

material
embroidery on briefs

Tighty Whitey Tidings

"Aside from a lump of coal, underwear is the ultimate lousy Christmas gift," says Geoffrey Lorenzen of Portland's Omatic Design. Not really a shopper himself, Lorenzen decided it was much easier to create something truly tacky and get a laugh than spend precious hours—and dollars—coming up with the perfect holiday self-promotion.

His ability to forego the art and just have fun led him to the idea of embroidering one of his deliciously retro logos onto Tighty Whitey briefs for men. Lorenzen supplied his embroidery vendor with vector art from Adobe Illustrator to complete this—pardon the pun—short run. He explains that although it may not have won him any business directly, it did get a lot of laughs. "When I went in to one agency we contract for, one of the guys was wearing them over his jeans."

Logo Book

For Dotzero's logo portfolio, Jon Wippich wanted to create a piece with a substantial feel but without the cost of offset printing. "I found the material for the cover at an electronic salvage. I didn't even know what it was until a photographer friend told me it's the stuff they use for circuit boards. I just liked it because when you hold it up to the light it has this great amber look, and a kind of cloth pattern, and the surface is real slick." The contents were laser printed and comb bound. Finally, Wippich says, "I borrowed a corner-rounder and trimmed the covers to give it a more finished look."

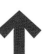

design firm
Dotzero Design

designers
Karen Wippich,
Jon Wippich

client
Dotzero Design
self-promotion

materials
phrenolic circuit board
material, board cover,
plastic comb binding

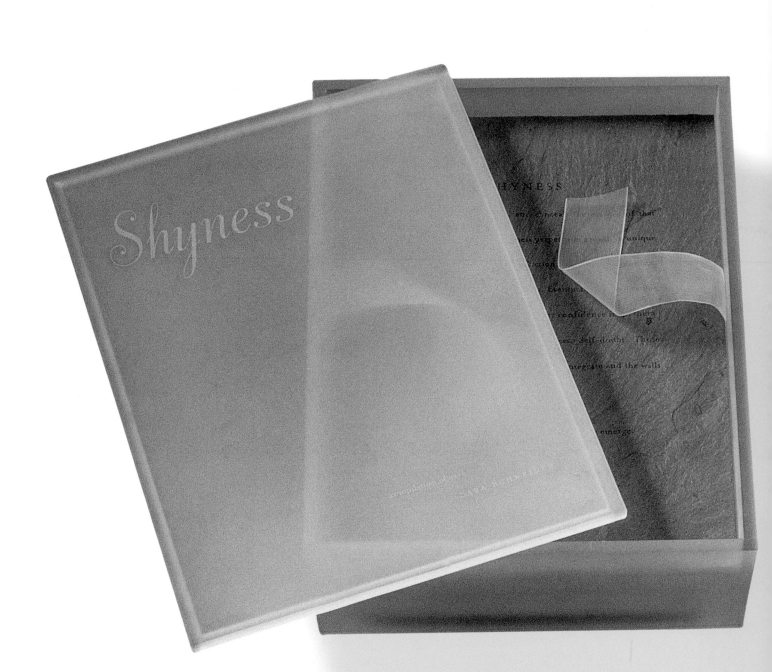

"A tactile piece involves the viewer, it makes them participate in it, and gives another level of perception and communication. Also, it's not often possible to achieve texture in massively produced collateral, so when you can do it, it's attention-getting." : SARA SCHNEIDER

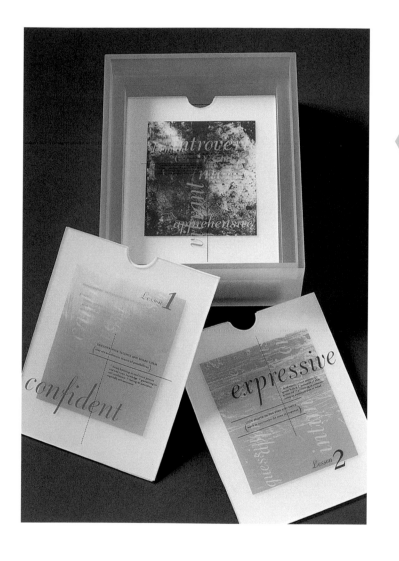

Shyness Portfolio

In graphics, a book is necessarily judged by its cover. Unfortunately for young artists just out of school, the message of that standard black vinyl-and-leather portfolio case can be, "Here comes yet another designer."

Sara Schneider wanted a portfolio that would make an unequivocal statement about herself and her work and so created this radical tactile design based on her personal journey from Shy Child to Mature Designer. "In art school I learned that my introspective nature actually developed qualities in me that I might not have otherwise had, qualities that enhance my ability as a designer. I wanted my portfolio to reveal that."

Schneider commissioned a 7.5" x 9.5" x 4" (19 cm x 24 cm x 10 cm) Plexiglas box, had it sandblasted, and the word "Shyness" engraved on the cover. "When a person is shy, you can't see through the exterior, but you can tell there are beautiful things inside," she says.

Removing the lid, the user is stopped by a panel of solid slate on which is engraved some of Schneider's poetic prose about shyness. Beneath the slate panel are six sandblasted Plexi plates: Schneider silk-screened original photos of walls onto the plates by hand, and each features one word expressing a characteristic hidden within the shy person: "Confident," "Vibrant," "Expressive," etc. Between each of these plates, Schneider placed 4"x 5" (10 cm x 13 cm) mounted transparencies of her work.

A stainless steel block at the bottom of the box, surrounded by crumbled slate, is Schneider's representation of a strong personal core rising out of pulverized obstacles.

designer
Sara Schneider

client
Sara Schneider
self-promotion

materials
Plexiglas, slate,
stainless steel

"Getting the inks to adhere to the sandblasted surface was challenging," Schneider adds. "Also, I had to grind the slate into powder by hand, in a mortar and pestle."

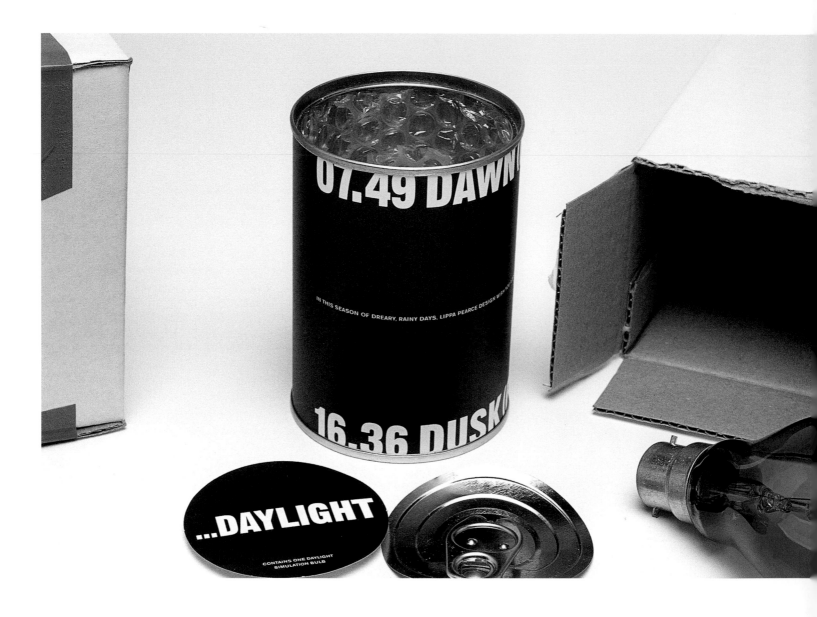

Lightbulb-New Year's Greeting Card

When you pop open this sealed can, the first thing you see is an insert reading, "...DAYLIGHT." And daylight there is, in the form of a daylight simulation lightbulb.

"Our studio is literally on a river," explains designer Harry Pearce. "One day, Domenic and I were walking to get lunch at a little café across the bridge. It was such a dull, miserable afternoon that I said, 'Let's send daylight to our customers.'"

In an ode to the playful works of Marcel Duchamp, Pearce and cofounder Domenic Lippa bought one thousand lightbulbs and found a manufacturer to seal them in aluminum cans. "We had to do dozens of experiments to figure out a safe packing system for the bulbs. Once we figured that out, we sent all the contents to a packaging house and they sent us back the sealed-up tins. Since we spent all our budget on that process, we had to apply the labels by hand."

design firm
Lippa Pearce Design Ltd.

designers
Harry Pearce, Jeremy Roots

art direction
Domenic Lippa, Harry Pearce

client
Lippa Pearce Design Ltd. self-promotion

materials
aluminum can, packing material, paper, paper label, day simulation lightbulb

Holiday Gift Tag Self-Promotion
© Vrontikis Design Office

For Los Angeles designer Petrula Vrontikis, design is about solving problems. Imagining a holiday giveaway that would keep her goodwill message in her clients' hands throughout the year, she focused on an often-overlooked tactile element of the holiday season—gift tags. "The tag that people are putting on a package should be as creative as the bow or the paper," Vrontikis says, adding, "I also wanted to beautify tag packaging, which is usually so crummy looking."

May all your gifts be filled with grace, hope, peace, joy.

And may they be wrapped with fun, creativity, excitement, love.

Vrontikis Design Office

PEACE ON OUR EARTH

design firm
Vrontikis Design Office

creative direction
Petrula Vrontikis

client
Vrontikis Design Office
self-promotion

materials
cardstock, string,
metal can

There was a second problem to solve. "I wanted to give something that wouldn't get thrown away." Concluding that the most valued gifts are the ones that are truly meaningful to the giver, Vrontikis decided that the gift-tag giveaways should also express her commitment to recycling. "I think it's a designer's responsibility to be as aware of the options as possible, and when we can use recyclable material, it's our responsibility to do so."

All the gift tags that Vrontikis has sent out over the years are printed on some form of recycled material: Money Paper made from recycled currency, Beer Paper made from hops and recycled beer labels, and Golf Paper made from golf-course grass clippings. The process that generated the majority of gift tags, however, epitomizes the designer's role in the responsible use of precious resources: "All during the year, as jobs were

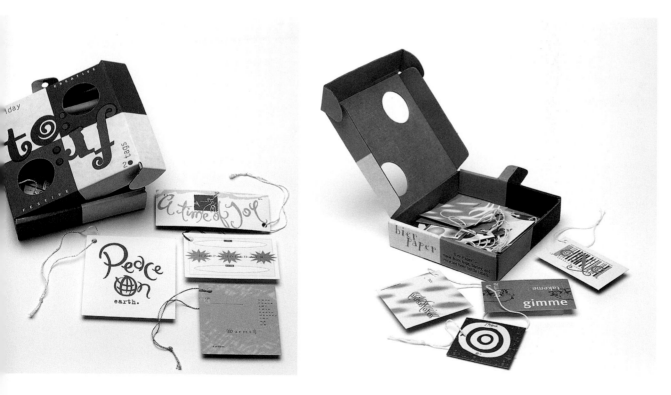

Holiday Gift Tag Self-Promotion [continued]

going to be printed, we would find out if there was extra room on the press sheet," says Vrontikis. "If there was, we would give the printer a file of gift tags that matched the extra room. Then we could just trim the tags off the end of the sheet. We had no control over the kind of paper the tags were printed on, but the printer would usually do it for free, so we could print on paper that would normally be thrown out, and without it costing the clients or us anything."

In November, as the holidays approached, "We would design the packages fast, which we always looked forward to. Everybody in the studio was in on it, even interns, so the tags were always this big creative outburst."

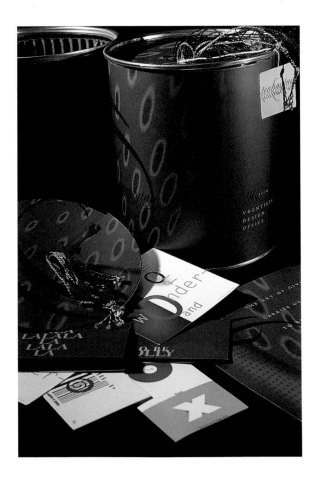

design firm
Felder Grafikdesign

art direction, design, copy
Peter Felder,
Johannes Rauch

client
Felder Grafikdesign
self-promotion

materials
paper, stitched binding,
postage stamp, leaf, film
negative, feather, razor-
blade, lint

auf – gelesen

picked – up

Schwerter zu Pflugscharen:
Über diese Klinge
Ist keiner gesprungen
Niemandes Haar wurde
gekrümmt:
ein guter
Schnitt
für ein Stück Stahl
das üblicherweise
durch Stoppelfelder pflügt
doch niemals
zum Pflug wird

WILKINSON
SWORD

dreifach-veredelt

Auf Gelesen (Picked Up)

Picked-Up is a self-promo celebrating the millennium. With this piece, designer Peter Felder explored "the beauty of unimportant things, things that are actually packed with small stories. Self-ironic, laconic, timeless. Things to touch."

Everyday elements, like a razor blade or a leaf on the right hand pages, are mirrored by spare, poetic text, evoking the more fanciful meanings of the objects. Pasted onto the front cover, a simple circle of paper; on the back cover, the negative space it once inhabited—the eternal suggested by the mundane.

Felder printed three hundred of these enigmatic self-promotion pieces and attached the found objects himself. He and his design partner Johannes Rauch went through four bottles of Calvin Klein's Eternity, spraying the aptly named cologne onto a single sheet inside each book.

2000 Calendar

Lest some of the biggest fans of tactile design be overlooked, we should mention the countless vendors who appreciate the offbeat challenges that tactile design presents. For a five hundred–run of this gift calendar fashioned like a swatch book, Diesel Design approached a manufacturer of ductwork. "The rivets are standard, but the metal had to be folded to spec, so we had to work with them pretty closely," says Diesel's Shane Kendrick. "They really enjoyed doing something different for a change, instead of just ducts and more ducts."

design firm
Diesel Design

designer
Will Yarbrough

artists
Michael Lemme, Walter Lopez, Josh Glenn, Luis Dominguez, Alicia Boelou, Jeffrey Harkness, Jacquie Van Keuren, Emily Cohen, Will Yarbrough, Ned Horton, Amy Bainbridge, David Wilson, Cindy Sweeney

client
Diesel Design
self-promotion

materials
cardstock, aluminum

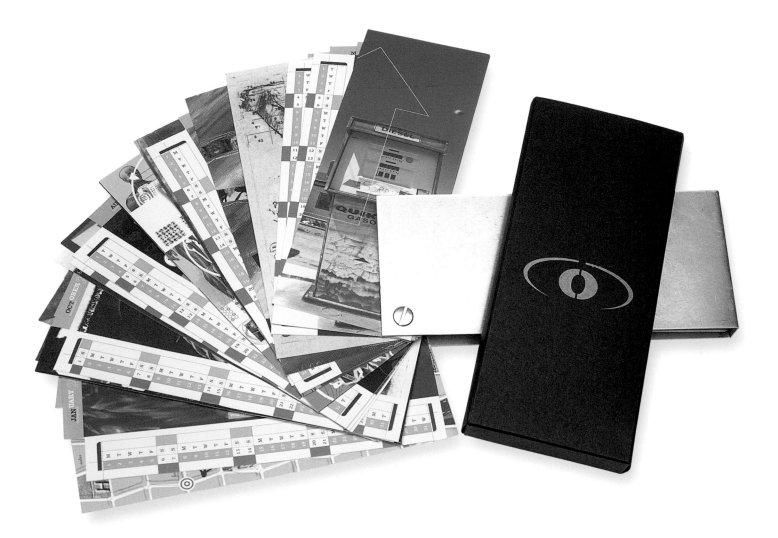

Moving Announcement

"The Fuel to Power Your Ideas", is Diesel Design's motto, and when clients (and potential clients) make the mailing list of the Bay-area firm, they learn to watch the mailbox for a stream of high-octane self-promos.

When Diesel moved shop to a new location, the announcement was printed on this silk-screened shop rag, enclosed in a metallic silver static bag. Although the static bag spoke to the high-tech companies that make up most of Diesel's clientele, it also played a nice counterpoint to the humble rag. "The hardest thing was finding the quantity of rags we needed," says Diesel's Lara Neathery. "We had to run around town to the auto parts houses, buying up all we could find."

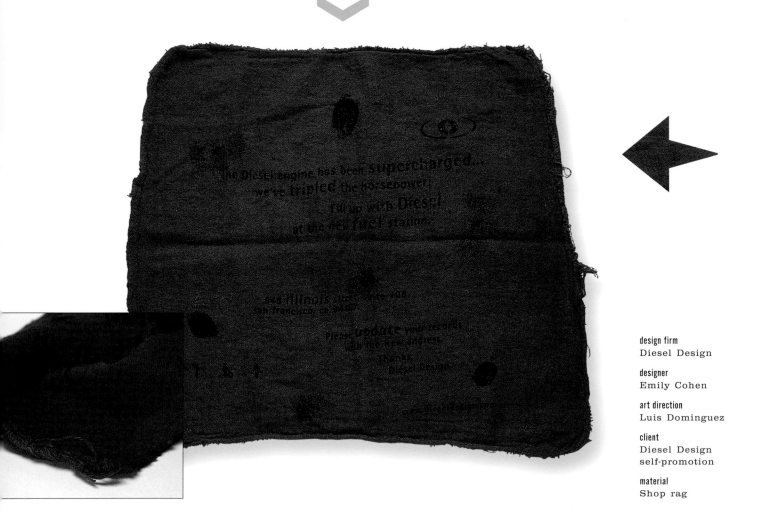

design firm
Diesel Design

designer
Emily Cohen

art direction
Luis Dominguez

client
Diesel Design
self-promotion

material
Shop rag

design firm
Diesel Design

client
Diesel Design
self-promotion

materials
cardstock, metal can,
magnetic hook

1999 Calendar

As a leader in the Bay-area design community, Diesel has showcased the work of other designers since 1994 via giveaway calendars. Searching for inspiration for this piece, the Diesel Design team went to their tried-and-true font of inspiration: materials. "One of the things we do a lot around here is look through industrial-supply magazines," says founder Jeffrey Harkness. "We found the tins first—inexpensive but unique—and they became the initial idea. The question then became, 'How do we turn these into a calendar?'"

Recipients enjoyed the humor and insight in the Hopes and Fears in the New Millennium 1999 calendar, but it was the tactile design of the piece that kept Diesel's presence in hand year-round. "You have to interact with it day by day, rotating the month so that you can bring up the next day. It's fun and people enjoyed playing with it."

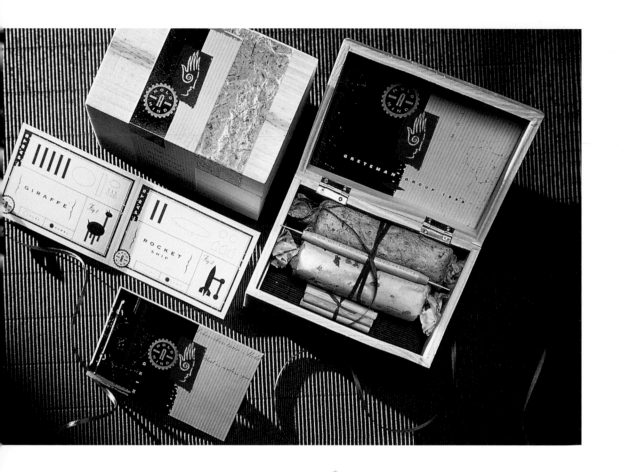

design firm
The Greteman Group

design/illustration
James Strange

art direction
Sonia Greteman

client
The Greteman Group self-
promotion

materials
balsa-wood box, clay,
molding tools,
handmade paper

Mold-a-Mind Gift

Sonia Greteman, president and creative director of the Wichita-based
The Greteman Group, has a holistic philosophy. This is not only evident
in the meditative environment of the company's warehouse space and
Greteman's own Eastern approach to living, but in the firm's self-promo-
tions. Instead of sending holiday cards, for instance, Greteman each year
makes a donation to a nonprofit organization in her clients' names. She
and her staff then get to have fun creating a themed announcement that
ties into that year's charity.

In 1998, the Group donated to an arts-related charity, and came up
with this themed announcement, dubbed Mold-a-Mind. For these
announcements, the designers aimed to not only please the eyes but also
engage the hands, minds, and hearts of their clients. The balsa-wood box
contains two blocks of molding clay and a booklet of whimsical instruc-
tions for making a train, a giraffe, and a rocket ship.

Spark-a-Star Millennium Gift

To celebrate the turning of the millennium, The Greteman Group donated to a charity that offers opportunities to underprivileged students. Sparklers were not only appropriate for the *fin de siecle* celebration but also symbolized the charity, which "puts the spark back in young people's lives."

The cover graphic represents the constellation Orion. It was printed on a sticker and applied to the outside of the silver tube; it also appears on the round, die-cut card holding the ends of the sparklers inside the package.

"We used an old-fashioned letterpress for the printing," Greteman adds. "The cool thing about a letterpress is that you can put gold and silver right on black and it gets pressed into the paper. It's a lost art that gives you a little deboss and almost looks metallic with these inks."

design firm
The Greteman Group

design/art direction
James Strange,
Sonia Greteman

illustration
Garrett Fresh

client
The Greteman Group
self-promotion

materials
aluminum tube,
sparklers, paper

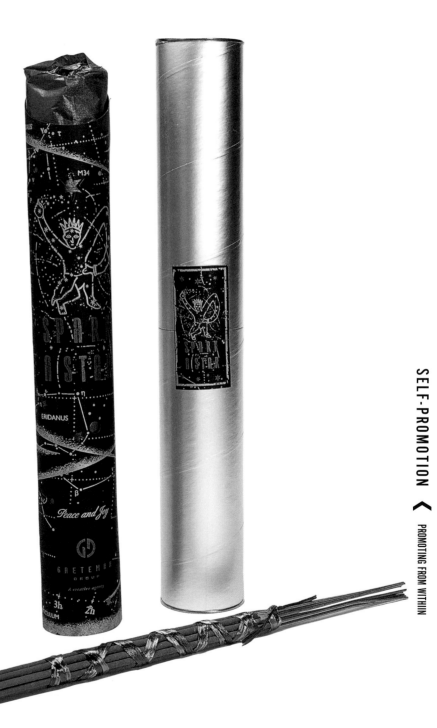

Pocket-Sized Portfolios

 Scale has the ability to imbue the simplest object with must-touch tactility, as artist/designer Mark Allen discovered. Embracing his budget limitations to the nth degree, Allen shrunk his new portfolios to matchbook size and found that potential clients couldn't keep their hands off of them. "They just want to play with them and then put them in their pockets—which is fine with me."

design firm
Mark Allen Design

client
Mark Allen Design
self-promotion

materials
acetate, paper

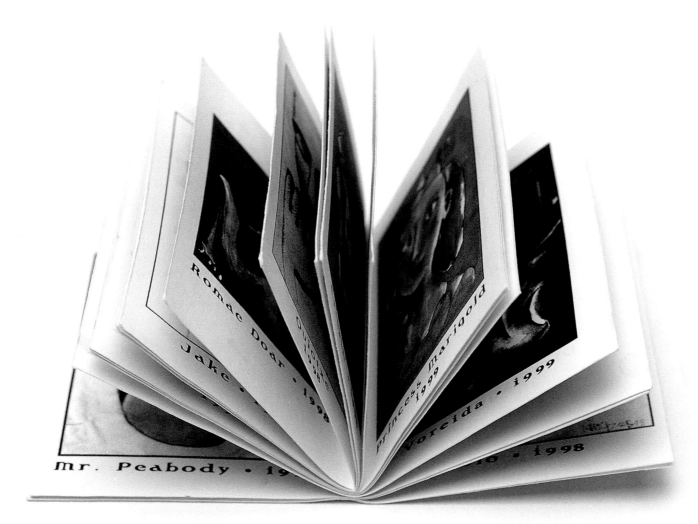

Paper Cut-Out Ornaments

When Darby Scott, a designer who built a name for herself as a "paper engineer", decided to create her own line of promotional giveaways, she returned to one of the most ancient tactile techniques: the cut-out. Perhaps most accurately described as sculpture, Scott's holiday cards have origins dating back to the second century when Chinese artists first began crafting paper. Scott printed these free-standing evergreens and snowflake ornaments on white matte cardstock with the added frosty effect of high-gloss white ink.

Scott designed an ink pattern and two custom pigments to adorn the paper slipcover case and envelope. White space was left on the inside flap of the envelope for customers to add a personalized message to the gift.

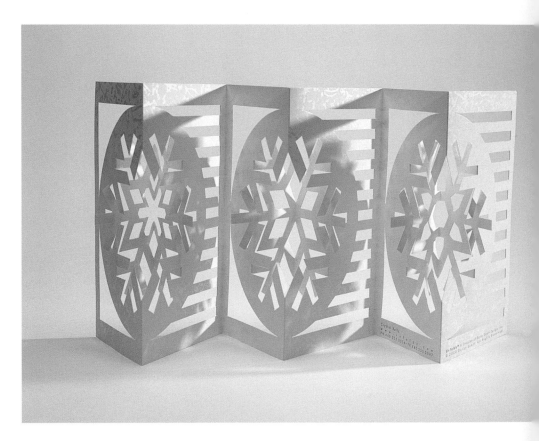

design firm
Unfoldz

designer
Darby Scott

client
Unfoldz self-promotion

material
paper

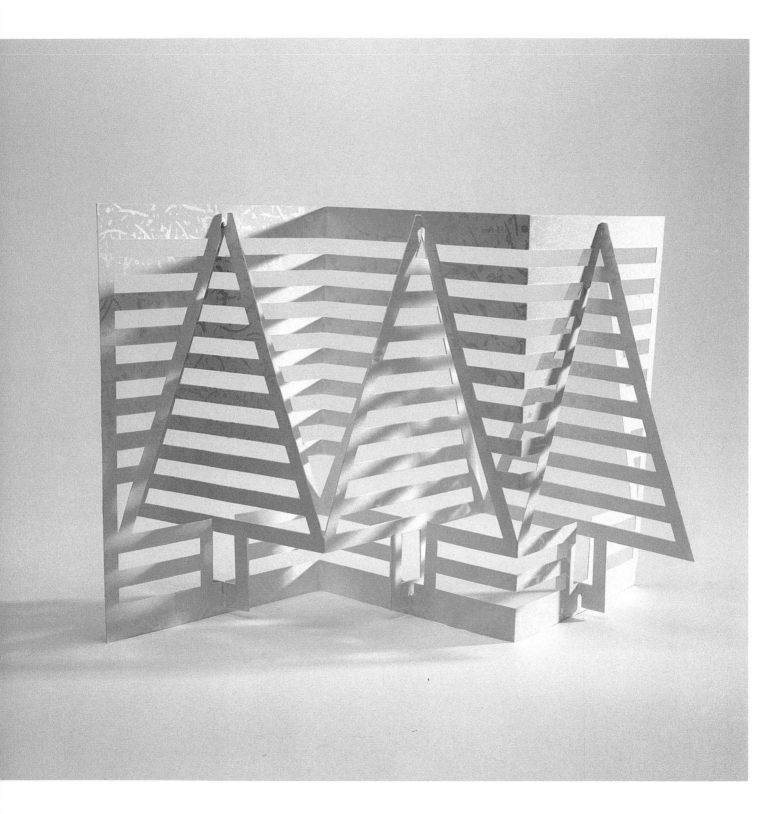

Al U. Minium Postcard

Steven Guarnaccia designed this aluminum postcard for New York's Purgatory Pie Press, a shop with a reputation for uncompromising handmade work. "They were printing artists' postcards using unconventional materials that challenged the Postal Service and their own presses. People could subscribe and get the cards in limited editions, signed and numbered. They're either expensive postcards or inexpensive prints, depending on how you look at it," he says. For Guarnaccia, Purgatory Pie's art retailing experiment was an adventure in tactile graphics and an opportunity to explore his interest in robots.

The cards quickly became collectible according to Guarnaccia, and so the U.S. Postal Service was spared the challenge of delivering Al U. Minium and his moveable jaw. Guarnaccia's potential clients got to play with Mr. Minium, however. "Anytime I do something in quantities, I send it to a select group of people as promotion."

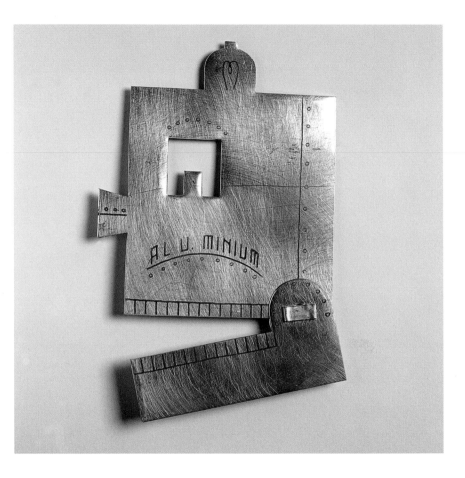

design firm
Studio Guarnaccia

designer
Steven Guarnaccia

construction
Purgatory Pie Press

client
Purgatory Pie Press

material
aluminum

meth*od*ol*o*gy 1999 Calendar

design firm
Chen Design Associates

designers
Joshua Chen,
Kathryn Hoffman,
Leon Yu, Gary Blum

creative director
Joshua Chen

client
Chen Design Associates
self-promotion

materials
matte cardstock,
bookbinding tape,
paper, elastic band

Every calendar is essentially tactile in nature, however some beg for more human attention than others. This Chen Design Associates' 1999 self-promotion strikes a sweet balance between function, sophistication, and touch-ability. There's just something about the clean, gray, matte cover with its black bookbinding tape and elastic band that makes you want to hold it—as if it is a precious text discovered after hours of toil in the Bodleian Library.

"We wanted to showcase different elements of good graphic design and present them in a systematic fashion," says Joshua Chen. "Like a lab experiment encased in a scientific notebook." Entitled meth*od*ol*o*gy, the calendar expresses basic principals such as structure, typography, and contrast in an intriguing layout that is at once retro and futuristic. Inside, and clipped into the metal fastener that holds the pages together, are instructions for turning the cover into an easel for display.

Chen split the cost of production with his printer, using a different paper for each month and allowing his vendor to provide the calendar as a giveaway.

WebAppFactory Identity System

Joshua Chen, head of Chen Design Associates in San Francisco, explains that when he first met with client WebAppFactory, they emphasized their "roll-up-your-sleeves-and-do-everything" philosophy. "As a small start-up they realized the only way to make it was to pitch in and work together," says Chen. "So everyone from the CEO down to the newest person on the block has a factory kind of work ethic."

To conceive their identity system, Chen and designer Max Spector focused on WebAppFactory's made-in-America approach, juxtaposing it with the company's high-tech mission of creating custom database applications for new media.

The initials WAF are laser-cut into the letterhead, envelope, media kit, and business cards in an enlarged dot-matrix-type pattern that implies both the factory feel—almost as if any part of the system could be used as a punchcard—and the digital world in which the company works.

WebAppFactory

JORDAN DEA-MATTSON

President & CEO

jordan_dea-mattson@webappfactory.com
www.webappfactory.com

t 650.623.0283
f 650.623.0290

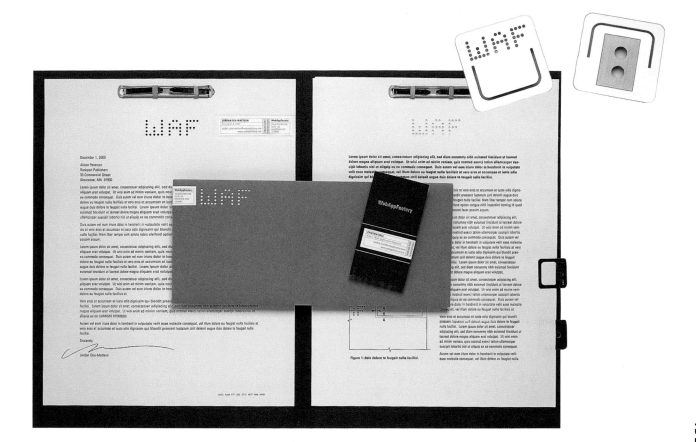

Chen added two budget-conscious elements to this package. First, the business cards and letterhead can be customized through the addition of laser-printed peel-off labels containing employees' contact information. Second, note the quirky paper clips: While working with his metal shop to create the business cards, Chen noticed leftover space on the 20" x 30" (51 cm x 76 cm) sheet set-up. Feeling playful, he filled up every spare inch with paper clips designed in the shape of the company's logo.

design firm
Chen Design Associates

designer
Max Spector

creative/art director
Joshua Chen

client
WebAppFactory

materials
paper, custom
paper clips

design firm
Vrontikis Design Office

client
Playpen

material
cardstock

Playpen Business Cards

Tactile graphics not only invite alternative materials but also the use of traditional materials in new and unexpected ways. When applied to something as ubiquitous as a business card, for instance, the matter-of-fact becomes something truly extraordinary.

A guiding principle of the broadcast graphics company Playpen is that their clients should have as much fun working with the firm as the firm has working on projects. "It was like they were saying to their clients, 'Come play in our sandbox,'" says designer Petrula Vrontikis, who took Playpen's slogan, Design with Fun in Mind both literally and tactile-ly.

Although at a distance they appear to be rather plain, solid-color business cards, in the hand they pop open, revealing themselves to be 3-D playpens. Peering into the tiny peephole, users see the company's motto printed on the inside. This design embodies the spirit of tactile graphics, putting the message in the mind by first putting it in the hand.

"These were expensive," Vrontikis says, "because the client wanted four different colors of the same card, so we did a run of four-over-four, then had them die-cut, then glued." Anticipating that the business cards would need to fit into cardholders, Vrontikis was conscientious about gluing and folding. "One of the things that helps designers with this kind of project is to have a printer's rep who enjoys the creative process," she says. "When they enjoy the process, they take care that things are done properly."

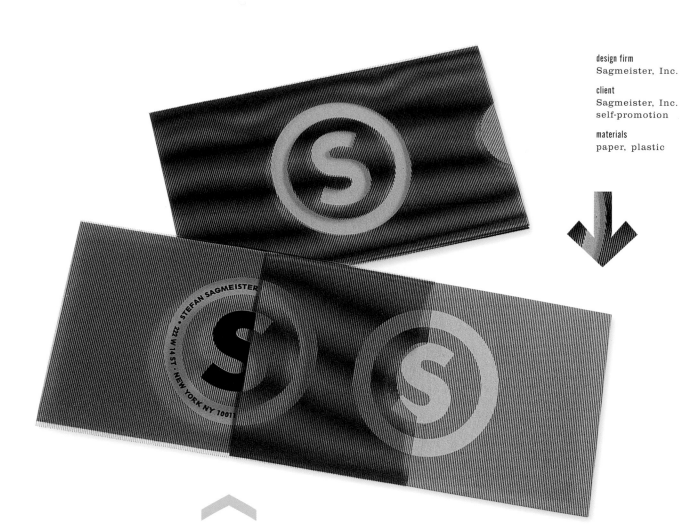

design firm
Sagmeister, Inc.

client
Sagmeister, Inc.
self-promotion

materials
paper, plastic

Moiré Screen Business Card

 The moiré pattern that results from incorrect screen angles can be a problem in color-process printing, but a delight in a tactile graphic such as this business card.

 Putting the science of optics to work for him, Stefan Sagmeister carefully plotted the extremely heavy moiré pattern to distract the eye—until his company's address is revealed by removing the card from its sleeve. "It comes as quite a surprise. As you pull the card out, first you see the S's go in different directions, then the address appears," Sagmeister says. "It proved to be a job-getter for us."

ring
jason
ring 646 242 7371

Anti-Card

"This is my antibusiness card, or noncard," explains New York designer Jason Ring. Inside this transparent envelope, where one expects to find a business card, there's only empty space. Upon receipt of the card, even knowing there is nothing in there, one can't resist opening the flap to check out the interior space. As Ring explains, you can look at his anti-card as an artistic joke or you can enjoy the "pragmatic and surprising experience" of storing something inside. Ring will include little gifts at times—"During the holidays I might put different things inside like pine needles. Sometimes I include really small samples of my work. But mainly I like to hand it out empty."

designer
Jason Ring

client
Jason Ring self-promotion

material
vellum envelope

Chen Design Associates Ephemera

"I hate standard paper clips. They can ruin the whole look of a presentation," says designer Joshua Chen. His company's logo, with its intersecting circles, provided a wonderful opportunity to riff on paper clip design. Throughout this identity system, Chen emphasizes movement and the appeal of contact. "We talk a lot about intersections—intersecting our talents with what our client is looking for. Here, we visually interpreted that using a variety of techniques. The thick, 100 percent cotton paper we chose for our business cards is offset printed in orange, then letterpressed in gray. On the back, the contact information is blind embossed. The objective was to make it all resonate, so that people would want to run their fingers over the surface of the letters. This adds to the whole intersection idea, creating an interaction between the reader and the sender."

Chen says that the additions of a metallic cardholder and the funky circular paper clips tie in thematically with the warehouse environment of his office space.

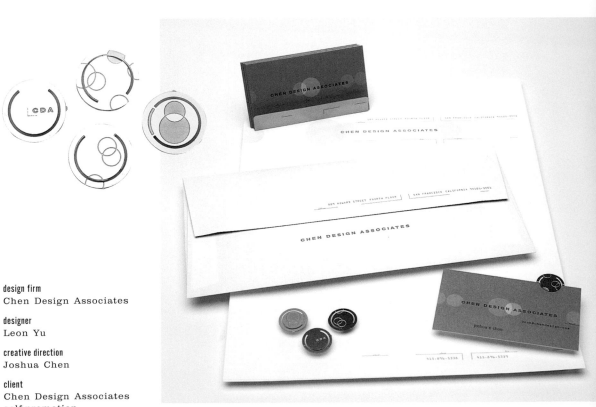

design firm
Chen Design Associates

designer
Leon Yu

creative direction
Joshua Chen

client
Chen Design Associates
self-promotion

materials
paper, custom paper clips,
cardholder

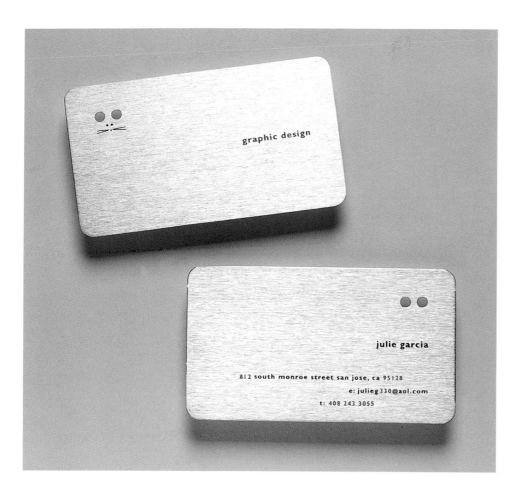

designer
Julie Garcia

client
Julie Garcia
self-promotion

material
die-cut aluminum

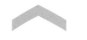

Aluminum Business Cards

This capricious aluminum business card embodies opposites: designer Julie Garcia's bold use of materials and her cute mouse logo. "I like the idea of something so soft on something so hard," she says.

"The small type was a challenge for the metal shop. The screen kept falling apart on the metal, so they had to be very careful. Especially with the mouse whiskers on the back," she says.

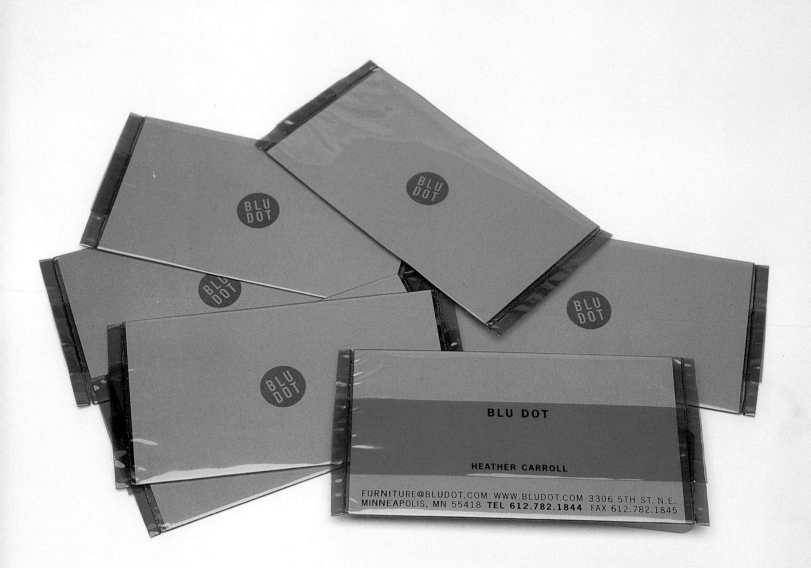

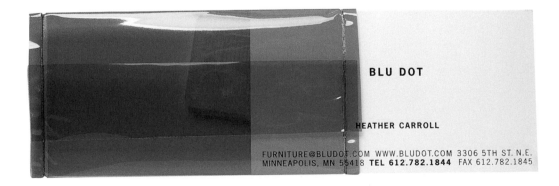

design firm
Fame

designer
Stuart Flake

client
Blue Dot

materials
card, cellophane wrapper

Blue Dot Business Card

"Last year, Blue Dot's trade show booth had a Habitrail with live gerbils. They like to make a strong presence," says designer Stuart Flake.

At trade shows, business cards are as common as coffee breaks. Commissioned to design a business card that wouldn't get tossed, Stuart Flake made what he calls, "The plainest card you could possibly imagine, just type on one side." Then he gave the card tactility by sealing each one in a nifty little transparent blue cellophane envelope. This provided aesthetic weight and a sense of value.

"We did the electrostatic sealing by hand. After a couple hours you've got enough for a trade show," says Flake, adding, "People who get the cards feel like they're being given a gift, which is powerful."

American Exotica/The Cell Treatment Presentation

In Hollywood, everybody's got a movie project to sell, and each week producers hear dozens of pitches from would-be *auteurs*. Given this constant barrage of great ideas, even the most open-minded executive can get a little hard-of-hearing. Gearing up to pitch Tinsel Town, director Tarsem Singh decided he needed a new approach for his pet project, a bold stylistic twist on the psychological thriller genre. At the time, Singh's project was called *American Exotica*, but it would eventually be released as *The Cell*, one of the most visually stunning feature films of 2000.

Singh's quest for a new type of presentation brought him to Los Angeles designer Daniel Tsai. "Tarsem needed a way to make his ideas tangible," says Tsai. "He threw it open to us to do whatever we could to make the movie real to the people he was pitching." Working with designers Staci Mackenzie, Kurt Parker and Daniel Garcia, Tsai found a remarkable tactile graphics solution and in the process literally began a revolution in the way directors sell film projects.

Studying *The Cell's* powerful, dreamlike symbolism, the artists imagined the film as a container filled with objects in unlikely juxtapositions that add up to an emotional whole, something akin to the box constructions of New York surrealist Joseph Cornell (1903–1973). They saw the container as a leave-behind that would underscore the emotional and symbolic power of the script and the director's vision. Tsai describes the conception as "a box of daydreams and memories that the main character took with her when she was growing up."

Inside the elegant hardwood box, a ribbon draws the user through the layered contents like a narrative thread. Photographs, bits of fabric, handwritten letters, even a rare, luminescent butterfly are the tactile remains of what poet W.B. Yeats called the "rag-and-bone shop of the heart."

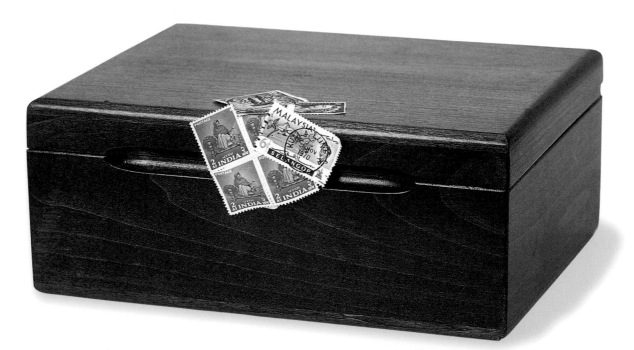

design firm
44 Phases

designers
Daniel H. Tsai, Staci
Mackenzie, Kurt Parker,
Daniel Garcia

client
Tarsem Singh

materials
hardwood box, paper,
photographs, xerography,
fabric, butterfly, fabric
trim, assorted artifacts,
postage stamps

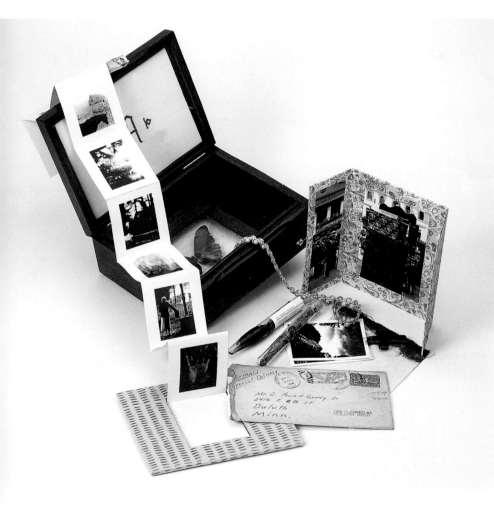

The designers began by writing a sentence to symbolically describe the action of each scripted page, one sentence per page. "Then we each pulled out one sentence and went to work illustrating it." The next step in constructing the package was to mock up a prototype of the box and then commission a carpenter to realize it. The finished piece was completed in ten days and employed over 75 vendors, including printers, color copyists, papermakers, a calligrapher, a seamstress, a hand letterpress typesetter, and a butterfly collector.

The combination of Singh's vision and the irresistible design enabled *The Cell* to eventually find its producer, New Line Cinema. To date, the team that eventually became the Los Angeles-based firm 44 Phases has made dozens of these "treatment presentations" for a growing list of clients.

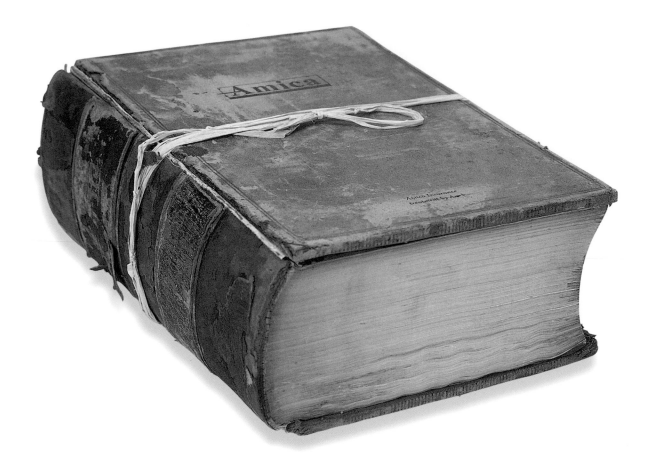

Amica Insurance Treatment Presentation

44 Phases was approached by a commercial director who was pitching a Midwestern insurance company specializing in disaster policies. "The director had an idea but he didn't know how to translate it into a conference call, so he came to us," says designer Daniel Tsai. "Insurance is about foreshadowing events that could happen, and so we tried to make that concept real."

The 44 Phases designers hollowed an oversized antique book to serve as a container. Next, they collected what Tsai describes as, "Memories retrieved after a disaster, which describes what the insurance company does." To the user, these objects read like clues: rusted and burned heirlooms, bits of twisted metal, the scattered details of a life. Most powerful of all is a series of transparencies, which when held up to light, reveal images of looming catastrophe.

Because the container is a book, it suggests that the contents will tell a linear tale, an assumption subverted as soon as the cover is opened. Inside, the user examines successive strata of haunting objects in a non-sequential, emotional archaeology. The sensuality of the Amica treatment presentation communicates an emotional complexity that would have been inexpressible on a 2-D surface.

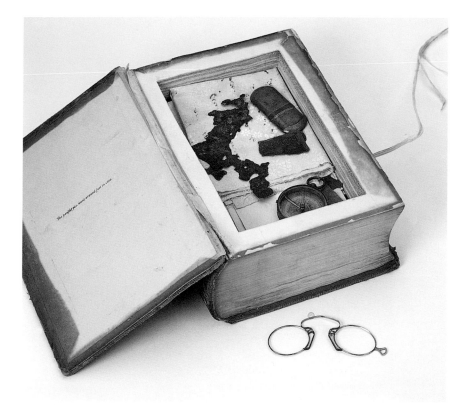

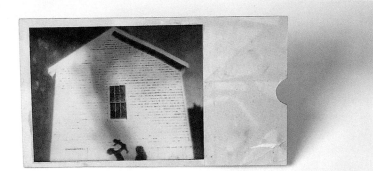

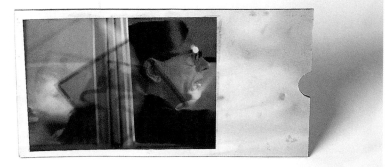

design firm
44 Phases

designers
Daniel H. Tsai,
Karen Orilla

client
Amica Insurance

materials
antique book, paper,
transparencies, fabric,
assorted artifacts

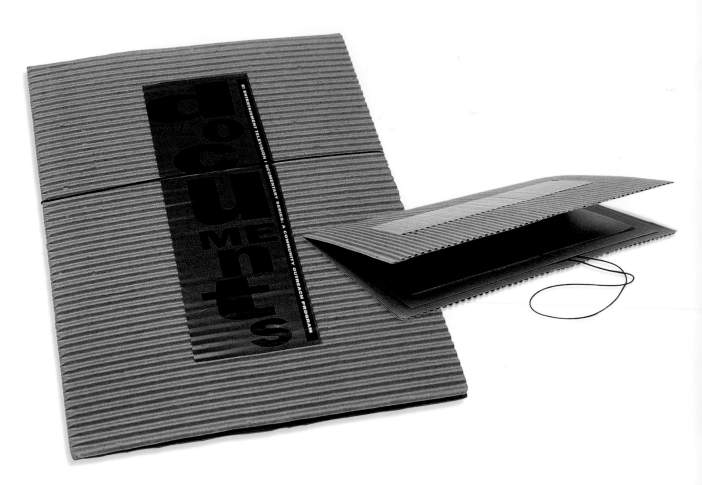

design firm
Vrontikis Design Office

creative direction
Petrula Vrontikis

client
E! Entertainment
Television

materials
e-flute, elastic cord,
paper, chipboard, label

E! Documents Kit

Asked to create an outreach package to promote an E! Channel documentary series to schools and libraries, Petrula Vrontikis saw in the project's budgetary constraints an opportunity to subvert a design trend through the power of tactile graphics. Studying similar media kits in the market, she found a preponderance of slick graphics and chose instead to steer her project against the grain. "I chose the e-flute material because it's inexpensive, and it's also so powerful in its simplicity."

"Generally, I have found that when I have to make only a small quantity of something, it enables me to think about alternative materials," says Vrontikis, a Los Angeles—based designer and Art Center College of Design instructor. "Alternative materials often come out of tight budgets."

The folded e-flute is stabilized with chipboard, providing a gritty, pragmatic feel that parallels and amplifies the real-world nature of the documentary series. The simple elastic cord and its cover label are also integral elements of this economical, elegant package, of which only one thousand were produced. The cord closes the cover with flair rather than pricey fasteners, and the clean lines of the inexpensive label give the overall package a sophisticated look. As Vrontikis describes it, "The whole thing looks much more elaborate than it actually is."

Boeing Business Jets Invitation

It took six vendors to complete this eighty-unit promotional project and a load of creative brainpower on the part of graphic designer Henry Yui and his team at Seattle-based Hornall Anderson Design Works, Inc. Created to promote custom-designed interiors for corporate jets, this exquisite catalog features a leather slip cover, wood laminate back, embossed paper, photos, a velum overlay, and metal etchings.

Says Yui, "The CEO of Boeing wanted a small piece that he could give to *Fortune* 40 CEOs that reflected luxury, usability, and function, but still felt like a work in progress." Thus, the pages of this promotional piece fan out like a swatch paint chip-book, depicting the workmanship and detail available in each section of the aircraft cabin. The use of metal and wood suggest the solidity of the jets. The leather slipcase has the luscious feel of a fine Italian wallet, while the small size lends the piece an heirloom quality.

Although Yui only had a month to take this project from concept to manufacture, he admits it was quite a coup as he was awarded both a substantial budget and extensive creative freedom. Even under such lavish circumstances, he is quick to add, the smallest job can still be one of the toughest. "The pitfall with a project like this," he says, "is to overdesign."

design firm
Hornall Anderson Design Works, Inc.

client
The Boeing Company

materials
wood laminate, leather, paper, vellum, aluminum

The Boeing Business Jet

The Boeing Business Jet ▪ Boeing & General Electric

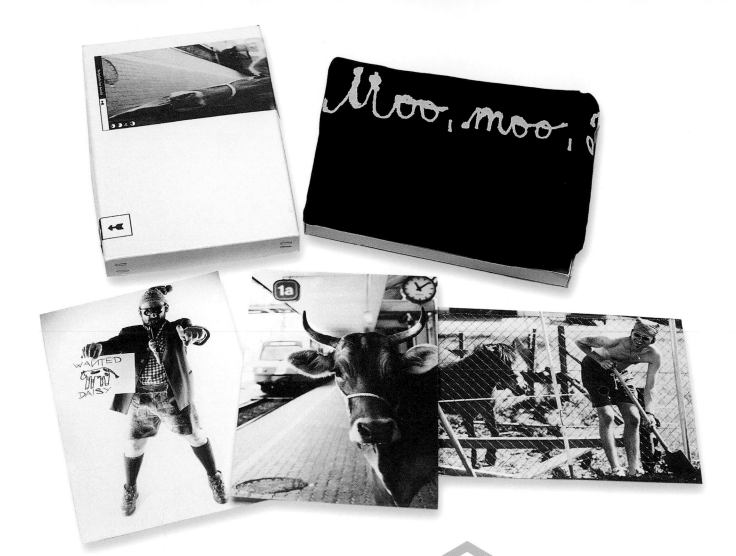

Moo, Moo, Daisy

design firm
Atelier Für Text
Und Gestaltung

design/concept
Hermann Brändle, Kurt
Dornig, Sigi Ramoser,
Sandro Scherling

client
Fotostudio Fotolabor
Paintbox

materials
fabric, cardstock,
cardboard

According to Sigi Ramoser of Germany's Atelier Für Text Und Gestaltung, this whimsical piece was created to attract the eyes—and fingers—of German fashion designers to their client, the elite photo house Fotostudio Fotolabor Paintbox. Instead of a typical portfolio-style brochure, this tactile piece invites recipients into the wonderfully silly adventures of Daisy the Cow, a bovine beauty who "wants to become a model in the big city."

The silky black rayon is printed with Daisy's dairy ... er, diary... entries, describing her adventures in search of supermodel stardom. This *memoir de moo* is shipped in a tidy white box and includes a candid shot of the determined Daisy. (Note the ironic poignancy of her pouting lips and innocent, cow-next-door charm. She'll set the fashion world on its horns.)

Smith Sport Optics Display and Packaging

This point-of-purchase display uses natural material in an unexpected way; first by sandblasting the rock component to leave an embossed image, rather than a debossed one, and second by allowing the fastening tape and metal rivets of the boxes to remain exposed, suggesting forthrightness and honesty.

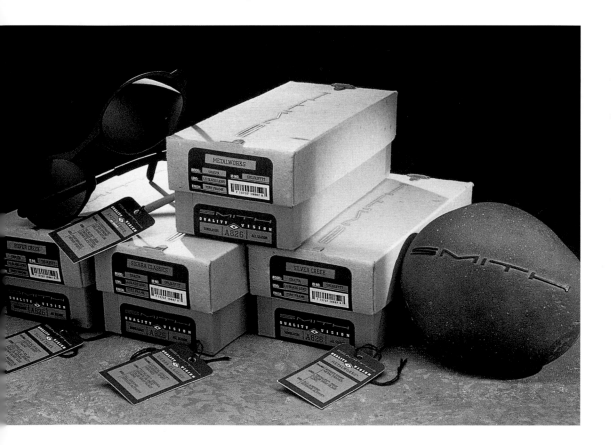

design firm
Hornall Anderson Design
Works, Inc.

designers
Jack Anderson, David
Bates, Cliff Chung

client
Smith Sport Optics

materials
debossed stone, card-
board, rivets

design firm
Felder Grafikdesign

designers
Peter Felder,
Sigi Ramoser

art direction
Peter Felder

client
Schulheim Mader

materials
paper, acetate, jewel case

5 x 5 Jahre Schulheim Mader

Peter Felder says that production was much more difficult than concepting for this beautiful jewel case. The CD was made to celebrate the twenty-fifth anniversary of a hostel for handicapped children, whose singing is featured on the CD.

The jewel case employs a tactile design that prompts the user to remove the liner notes, which creates an elegant, playful illusion. Explains Felder, "If you take out the booklet you see five colors. Putting it back into the sleeve creates twenty-five new colors. Each of the twenty-five colors stands for one year of the Schulheim Mader hostel. The single colors—five on the booklet, five on the CD cover—symbolize the handicapped children and the therapists.

[Working] together, something new can arise in their daily work, play, and caring for each other—new colors, a new fullness of life."

Yet Felder adds that offset printing five colors onto acetate wasn't easy. The colors kept running together, so they were forced to experiment with different materials until they finally discovered an acetate—the type used for overhead projections—with enough absorbency to hold the ink. As it was impossible to cut the plastic by machine, Felder and his team were forced to hand-trim the five hundred inserts.

design firm
Carbone Smolin Agency

creative direction
Ken Carbone

art direction
Justin Peters

client
American Craft Museum

materials
cardstock, foam brick

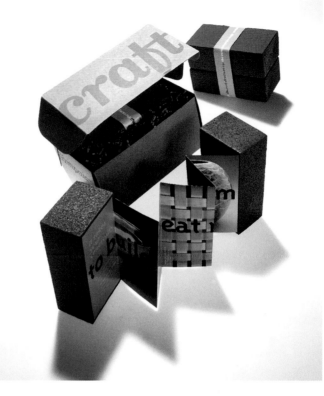

American Craft Museum Direct-Mail Campaign

Evidenced by this elegant fund raising piece, the work featured at the American Craft Museum should be categorized as fine art. Carbone Smolin Agency cofounder Ken Carbone explains that when the museum first pitched the idea of a direct-mail piece to raise funds for the purchase and redesign of its facility, fundraisers had settled on a twenty-five thousand–run, number ten envelope-size brochure. Carbone, however, questioned positioning the museum with a mailer that might not live up to the quality of exhibitions found inside the walls of the facility.

"I asked the director how many people on that list could actually write a one million dollar check? It turns out only about five hundred of them could, so I suggested taking that same budget and putting it into five hundred pieces that would stop people in their tracks. Something with real personal appeal. Something that positioned the organization as a winning investment." The result? A stunning gift box enclosing a design object worthy of display.

Carbone felt that two bricks, encased in the gift box, would speak to the museum's need for physical expansion and serve as the cover for this unique accordion-fold brochure. After finding a foam-brick manufacturer through a movie prop house, Carbone had the bricks custom cut and painted. Adds Carbone, "Since we couldn't control how people might open the brochure, we wrote the text in a circular fashion." If you open the brochure one way it reads, "To build a great museum" on the front and "It takes more than bricks" on the back. If you open the brochure the other way, it reads "It takes more than bricks" on the front, and "To build a great museum" on the back.

Carbone also suggested overrunning the printed brochure and using it as a stand-alone.

designer
Carmen Dunjko

client
Bryce Duffy

materials
cardstock,
black rubber band

BRYCE DUFFY

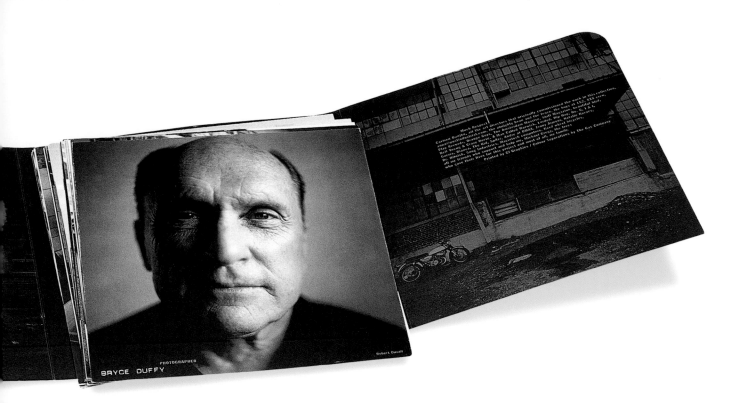

Bryce Duffy Brochure

Photographer Bryce Duffy was making a living as a commercial photographer, but just barely. Kicking his career into overdrive, he knew, would require a high-powered portfolio. Designer Carmen Dunjko found that power in tactility.

"Bryce's work is all about engaging the people that he's photographing," Dunjko says. "He doesn't try to control the situation, but rather attempts to bring out an honest dialogue." She set out to embody that dialogue in a design that would invite interaction.

"I wanted to get as close as possible to the feeling that you're looking at a contact sheet, so that the art director feels that they're in a process, that they're making editorial decisions."

Dunjko wanted art directors to see the portfolio as something *useful*, a practical problem-solving device. Her solution was to leave the photos unbound, so that art directors could order them as needed for a particular pitch. This also served a practical purpose, simplifying what would have otherwise been a printing nightmare. "To do something like this would have been a twelve-color job if it had been bound, but because it was [made up of] individual parts it was easier to change plates and change inks. We came up with a formula where certain sheets were printed in color and some in quadratone. It was complex. The color separator embraced the craft, which was really helpful."

The heavy stock imparts Duffy's straighforward, photojournalistic style, and ditto the black rubber band. "Finding the rubber band was the hardest part," Dunjko says. "We ended up contacting suppliers in the music business. It's a belt for a turntable."

Ben Kelly Design Brochure

When Lippa Pearce Design Ltd. was asked to create a memorable brochure for Ben Kelly's world-renowned interior and installation design studio, the artists decided to focus on the multidisciplinary nature of his work. "Ben Kelly works with all kinds of materials," explains Harry Pearce. "Everything from rough concrete to found objects in the form of chevrons— all kinds of oddities from his wanderings out and about. So our idea for this book was to bring together all kinds of binding processes and paper stocks. Some parts are printed, some are silk-screened, some are lithographed. I think we ended up with six different printing processes, six different materials, and three different folding methods. Together, they sum up how Kelly works."

Of course, Pearce admits, they also drove their printer—as Londoners say—barking mad.

design firm
Lippa Pearce
Design Ltd.

designers
Harry Pearce,
Jeremy Roots

art direction
Harry Pearce

client
Ben Kelly Design

materials
cardboard, plastic,
paper, spiral binding

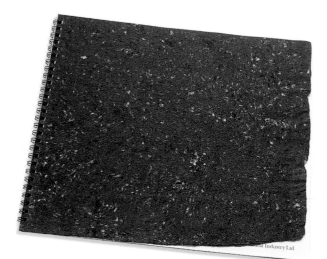

Cultural Industry—Now You See It Programs

For the South Bank Festival of Arts called Now You See It, the Lippa Pearce design team created a program that changed its costume with each performance. Although the contents remained the same for each show, each performance received a cover that spoke to its unique personality. So, the comedian with rough edges had a sandpaper cover, the jazz ensemble was represented by midnight blue plastic, and the ballet dancer was celebrated with a delicate, recycled paper stock. For the audience, these keepsakes became an integral part of the performance, tactilely defining the diverse soul of the festival.

design firm
Lippa Pearce Design Ltd.

designers
Mark Diaper,
Domenic Lippa

art direction
Domenic Lippa

client
South Bank Festival
of Arts *Now You See It*

materials
corrugated cardboard,
various handmade papers,
sandpaper, paper lining
material, paper, plastic

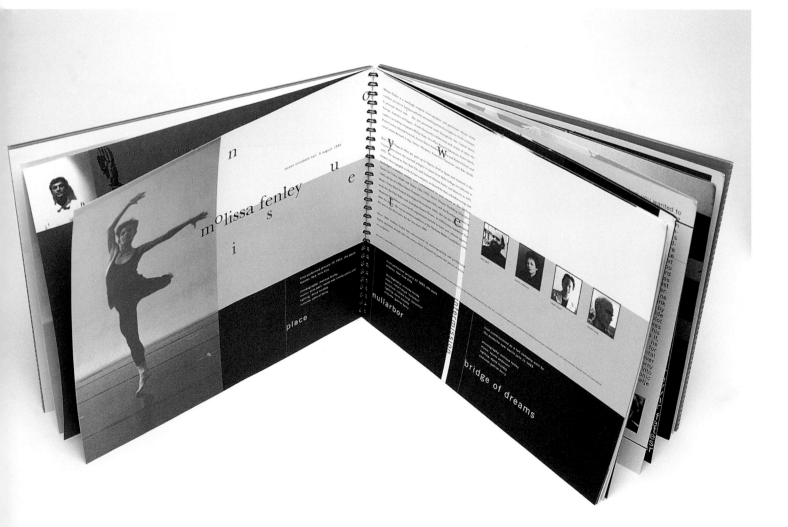

design firm
AGF Funds, Inc.

designers
In-house team

client
AGF Funds, Inc.
self-promotion

materials
duplex paper,
paper, brass rod,
rubber bands

AGF Funds, Inc. Promotional Brochure

If it weren't for the extraordinary craftsmanship of vendors like CJ Graphics in Toronto, Canada, pieces like this exquisitely sophisticated brochure would never make it from concept to completion.

AGF, one of Canada's largest wealth management firms, came to CJ Graphics with a relatively simple idea for this oversized piece, but they needed the printer to complete several tricky elements. The gold lettering, for example, is not only embossed but also foil-stamped. Likewise, the stock is a duplex of matte black and cream. An additional touch of refinement is added by the thin brass rod, which does double duty as a closure element and a binder for the contents.

Finished in printed vellum, the overall look speaks of both the spare elegance of the Far East and the power of Wall Street.

Bridgetown Promotional Calendar

This inventive calendar was designed to keep the Bridgetown Printing Company's name in their clients' hands year-round. "The clients received the metal stand and the first month's calendar in a box with a card explaining that the rest of the calendar would come throughout the year," Dotzero's Jon Wippich explains. "We wanted each month to be a completely different look, and since this was a millennium calendar, we based each month on a decade of the previous century, plus two bonus months that were about the future."

The style of each month is drawn from the decade it represents, so the 1900s are represented by a playful Western style, the teens by flashy Art Deco, the '30s by Art Nouveau, etc. "It was fun finding different ways to approach each piece," Wippich adds. From collage to tinting to painting, Dotzero got to throw the graphics kitchen sink at this project.

For the elegant metal stands, Wippich went back to a familiar vendor. "The same metal cutters who did our Aluminum Man business card holders (see page 53) did the calendar stand," Wippich explains. "They'd never had to bend metal to this severe an angle before and cutting out lettering that small was pretty challenging, too. We had to keep trying till we got it right."

Wippich concludes, "People can always tell when some thought and handwork has gone into something. That gives it value."

design firm
Dotzero Design

design and illustration
Karen Wippich,
Jon Wippich

client
Bridgetown Printing
Company

materials
cardstock,
die-cut aluminum

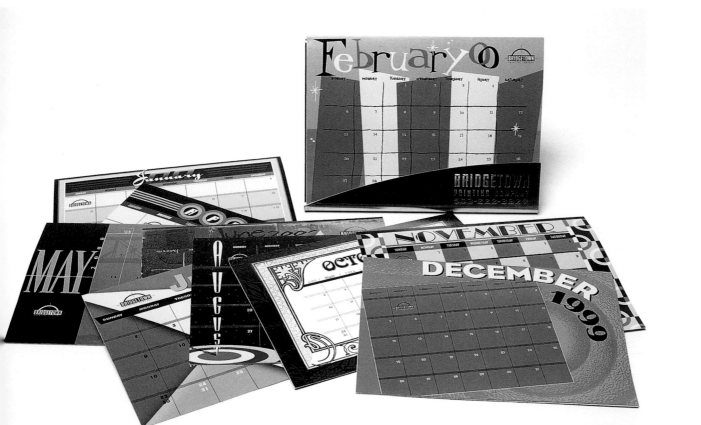

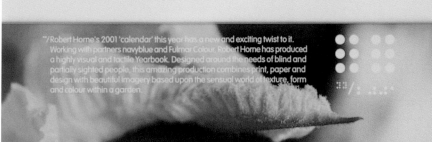

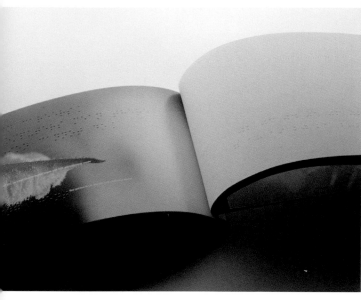

Robert Horne Paper Company Calendar Promotion

To lend impact to paper manufacturer Robert Horne's Design Consultants promotional calendar, the London design firm Navy Blue created a tactile slight of hand.

The overall effect of this piece is a dynamic embodiment of the differences between sighted and nonsighted experiences of the same object. Ostensibly, the calendar tells the story of a garden's changes of season. However, the garden on which the calendar is based is a London sensory awareness park for the disabled. Like the park, the calendar demands tactile interaction.

As the calendar progresses from front to back, blind users find increasing amounts of tactile information in the form of Braille and die-cuts. Conversely, information for sighted persons increases as the calendar is read from back to front. Yet, heat- and light-sensitive inks cause the text to quickly disappear from vision, giving sighted users an experience of the nonsighted world.

The Royal National Institute for the Blind was consulted on the project.

design firm
Navy Blue Design
Consultants

designer
Clare Lundy

creative director
Geoff Nichol

client
Robert Horne
Paper Company

materials
paper, heat-and-light-
sensitive inks

design firm
Margo Chase Design

client
Matteo Linen

materials
embossed cardstock,
metal grommet

Matteo Linen Insert

The luxury linen manufacturer Matteo had a budget problem that
designer Margo Chase solved with an understated, elegant, and practical
tactile design.

"Matteo makes very expensive products, and the problem was that because
they're not doing large quantities, they couldn't justify having a different size
insert for each product." Chase came up with the little silver metal stud, which
she attached to the *outside*, to float the inserts inside packaging of any size.

"It solved the problem, and it also contributed to the feeling of luxury because
it picks up on the silver foil in the printing, and because there's an actual
object there."

Andromeda Brochure

Experimenting with materials can turn even the humblest product pitch into a commanding message. This is even true when the product is a not-so-humble twelve-million-dollar yacht from manufacturer Omega Marine.

To announce the launch of this champagne-and-caviar product, Maximo Escobedo of San Diego–based design firm Miriello Grafico, Inc. was asked to make a one thousand–run promotional piece.

"We wanted to make the brochure as much an experience as the boat," says Escobedo. "So we had the client make the stainless steel binder for us. It's based on a hinge and held together with three Chicago screws." The binder's burnished finish not only catches the light but also the eye. In the hand, it imparts the confidence of precision craftsmanship. "With this design, they had to go out on a limb, but once they saw that we knew what the boat was about and that what we were doing would give them an edge—they trusted us."

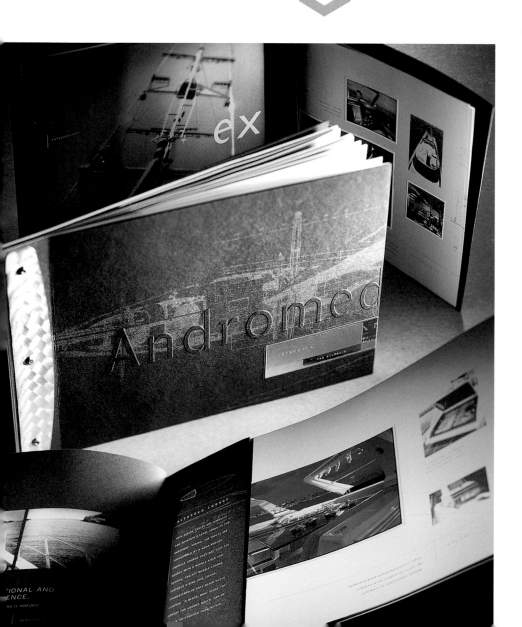

design firm
Miriello Grafico, Inc.

designer
Maximo Escobedo

client
Omega Marine

materials
stainless steel riveted
binder, textured paper

design firm
Miriello Grafico, Inc.

designer
Michelle Aranda

client
Qualcomm

materials
cherrywood cover, 23' (7m)
long accordion-fold paper,
glass inscription window

Dr. Viterbi Retirement Book

When a founder of the wireless communication technology corporation Qualcomm announced his retirement, it fell to Michelle Aranda of Miriello Grafico to design a keepsake that would convey the deep respect of his employees. Aranda's solution was a book with handmade cherrywood covers that folds out, accordion style, to over twenty feet. During production, the paper was printed with photos from the honoree's life and then shipped around the world to be signed by the company's eight thousand employees.

"A plaque would have been too cold, too easy to forget about," says Aranda. "We wanted to design something that Dr. Viterbi would keep out to look at and touch—something of substance, like a piece of furniture."

Te'nere Expedition Announcement

Maps printed on silk were given to
Allied pilots and paratroopers in World War
II. Silk is light, strong, easily concealed, and
the fine weave allows for graphic detail.

Rebeca Méndez designed this map on
a silk scarf while planning her honeymoon
expedition to Niger. Several family mem-
bers and friends joined the expedition, and
the scarf served as a bon voyage gift for all.
The scarf is sprinkled with witty details,
such as, "Adam & Rebeca's Honeymoon,"
and "Augustin's 45th Birthday." Single
words describing extremes of human
experience mark the degrees of longitude
and latitude along the map's edge: Love,
Limitlessness, Despair, etc.

design firm
Rebeca Méndez
Communication Design

manufacturer
Microsoie/Montreal

material
silk

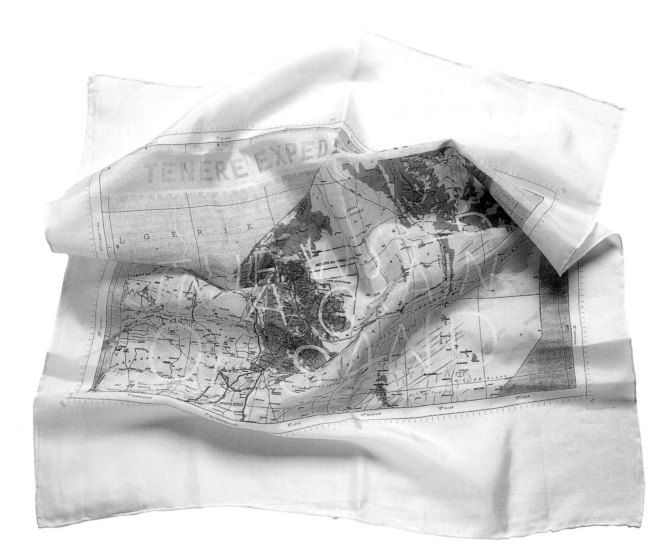

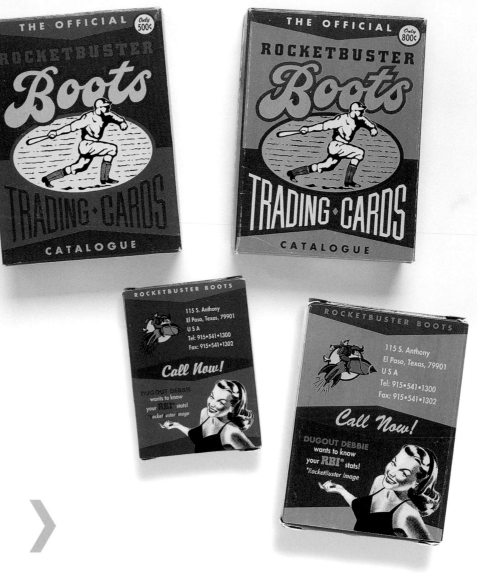

Trading Card/Sticker Catalogs

The folks at El Paso's Rocketbuster Boots don't drop names, but they could if they wanted: Mel, Sly, Billy Bob, Arnold, and Oprah all wear Rocketbuster's handmade western boots. Rocketbuster also holds the Guinness World's Record for Largest Cowboy Boot (almost five feet, or 1.5 meters, high). Nearly everything about this small craft-oriented manufacturer is remarkable, including their tactile catalogs.

Rocketbuster boots are not only collectable, but each pair has a unique thematic story to tell, and co-owner and in-house designer Nevena Christi realized that trading cards could perfectly embody the uniqueness and collectibility of the boots. "You have to make something that people are going to keep," she says, "Because there's just so much junk out there in the world." Christi adds that the catalogs themselves have become collectable, fetching $50 apiece on the on-line trading Web site ebay.com.

"The biggest challenge to making [the trading cards] was color correction, because people expect the product to look like it did in the catalog, and this was printing so many colors at once, and on card-board, which we wanted to use because it will last," Christi says.

Although the playing card catalogs were instantly popular, retailers who circulated them amongst their customers found that cards were disappearing from the decks.

To address this, Christi did a run of trading-cards-as-stickers. Not surprisingly, the stickers were as popular as the cards had been. "But the stores can stick the stickers in a book to show people, so they won't get lost."

Explaining that both the boots and the catalogs were collated and packaged by hand, Christi laughs, "We do things the stupid way here." We should all be so stupid, however: Rocketbuster has a twelve-week waiting list for boots that cost as much as a new Vespa, and its catalogs are in demand even though they cost $12 retail. "If somebody buys a pair of boots, we give them the twelve bucks back," Christi adds.

design firm
Rocketbuster Boots
El Paso, Texas

designer
Nevena Christi

client
Rocketbuster Boots
self-promotion

materials
cardboard, stickers

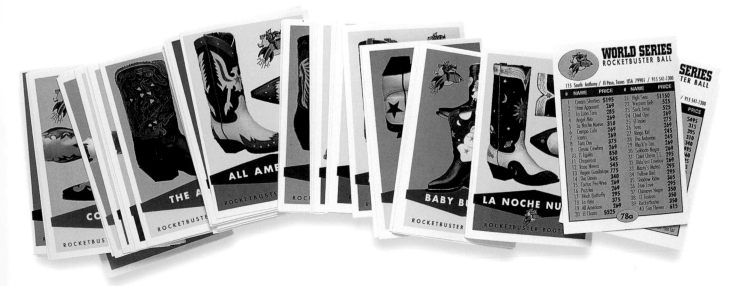

Columbia TriStar Interactive Press Kit

For some designers, tactile graphics is about interactivity and putting the product in a startling new context. That's all well and good of course, but sometimes experimenting with materials comes down to just plain *fun*.

With this press kit for Columbia TriStar Interactive, the eye is first drawn to a bright plastic binder peeking out through the smoke-and-mirrors silk-screened polypropylene bag. Once the binder is reached, it reveals six whimsical dividers that have been printed, punched, perforated, and textured with a range of wonderfully wacky '50s-style children's games. These little marvels range from connect the dots to scratch and sniffs. A bright pair of plastic scissors is provided for paper doll cutouts.

"I like touching things," says designer Winnie Li. "I'm always looking for opportunities to challenge myself with a new material."

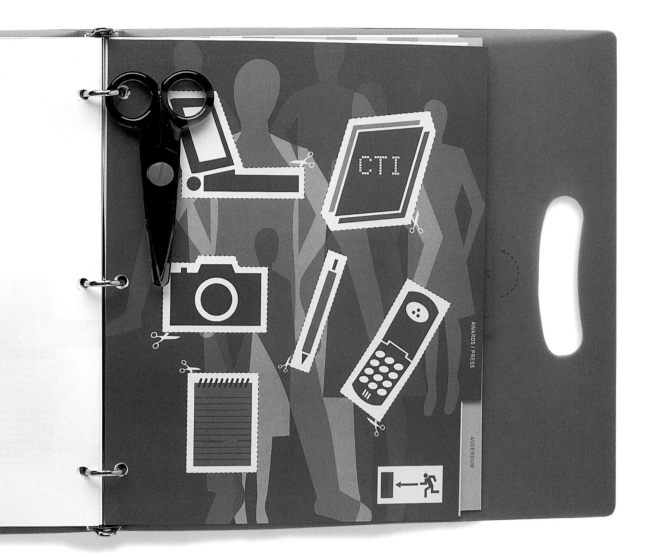

design firm
Winnie Li

designer
Winnie Li

creative direction
Wyndham Chow

photography
Benny Chan

client
Columbia TriStar
Interactive

materials
silk-screened polypropy-
lene binder, paper inserts,
plastic scissors

design firm
Anvil Graphic Design

art director
Laura Bauer

designer
Cathy Chin

concepting
Allan Ratliff

client
San Francisco Museum
of Modern Art

materials
foam picture
frame, Air Box

San Francisco Museum of Modern Art Membership

Anvil Graphic Design spent a lot of time in painstaking research for a high-tech client who needed packaging to ship fragile electronic parts. The designers were thrilled to discover these remarkable Air Boxes, but when the client finally opted for more conventional packaging, the Air Box found its way to Anvil's hold shelf. Not for long, however.

Preparing for a gift membership drive, fund-raisers for the San Francisco Museum of Modern Art approached Anvil to design a freebie that would accompany gift memberships. Two parameters: First, the free gift would be displayed in the museum lobby to advertise the gift membership drive, so the packaging needed to stand on its own as an object worthy of the surroundings; second, the budget was very limited.

"We know lots and lots of vendors, and one was willing to give us a discount on these great frames, so we decided on those first," says Laura Bauer, Anvil's creative director. "Museum literature had to go in the package, so we made a little fold-up piece and slipped it inside the frame."

The final question was how to package and display the frame. "We showed the Air Box to the client, and she just loved it, because it was so new, and also because they could display the whole thing, and it would look great," says Bauer. Best of all, there's no need for environmentally unfriendly packing peanuts as the work provides its own insulation.

Even in the shadow of the greatest artworks of modernity, this design is a standout for its stylistic simplicity and tactile charm.

design firm
Gumption Design

partner/creative director
Evelyn Lontok

client
Gumption Design
self-promotion

materials
compressed sponge

Spring Cleaning Self-Promotion

"I always wanted to do something about spring cleaning," enthuses designer Evelyn Lontok, but it wasn't until her mother returned from a trade-show with several compressed sponge give-aways that she came up with this zany but useful self-promo. "I do a lot of work with a letter press that is willing to run absolutely any material as a test. I brought in an 8.5" x 11" (22 cm x 28 cm) sheet of compressed sponge and it totally worked." The result is a perky useable that invites customers to "get started with brilliant designs." Lontok's fun design got her lots of notice. (And her letterpress vendor is still using the sponge leftovers to clean up around the shop!)

RDG Mondo Self-Promotion Mailer

Every now and again it's nice to reintroduce yourself to a regular client, Ric Riordon believes. "When you get working with a certain market you tend to get type-cast," he says. "We do a lot of packaging in Nashville and Los Angeles, polished stuff. We wanted to show something a little different, something less formal and more playful." Nothing shakes up expectations like a tactile presentation, evidenced by this understated, yet off-center, leave-behind.

There is a nice contrast between the stiff paper covers and the (orange!) Naugahyde, juxtaposed with the deep-embossed silver stamp that emulates the wire binding. The pages inside are the size of CD jewel cases.

The piece expresses sophistication yet embraces the Gen-X spirit of the projects Riordon was targeting. "We had a great response, and it got us the jobs we wanted," he says.

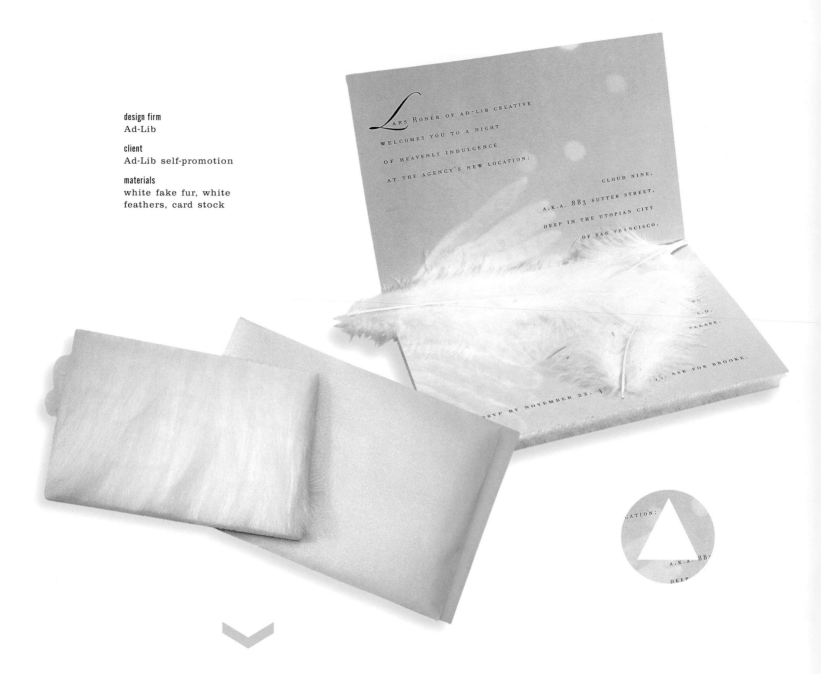

design firm
Ad-Lib

client
Ad-Lib self-promotion

materials
white fake fur, white feathers, card stock

Heavenly Invitation

As Amanda DeHaan of San Francisco's Francisco's Ad-Lib Creative describes it, this piece was designed to "stand out from the glut of invites" that abound during the holiday season. The firm's creative team designed this heavenly invitation to express the angelic treatment they could expect at the party.

The artists had a lot of fun deciding on the perfect material for the outside of the card. Originally they envisioned cotton batting for a white cloud look, but found it wasn"t lush enough. Ultimately they bought white fake fur, which they hand-cut, trimmed and mounted onto the cards. To highlight the beatific feathered wing design inside, the team—which included art director Ksenya Faenova and designer Steven Wasden—added several loose white feathers.

"The party went really well," adds DeHaan. "We had a harpist, and manicurists and a masseuse. We projected *It's A Wonderful Life* on a wall and only served desserts because, of course, there's no real food in heaven."

Fame Self-Promotion

Admit it: the The first time you saw that yellow plastic caution tape on the street, you couldn't couldn't help wondering what it would be like to rip through it. For this marketing piece, the Fame retail branding group decided to invite potential clients to have a go. "What we create needs to do more than simply get the message out there," says designer Stuawart Flake, "It needs to shout the message louder, or be more clever some-how. Communication should have some power behind it." This oversized piece shipped in a silver acetate anti-static bag, but it was its tactile nature that lent impact. "In retail," says Flake, "Scale and excitement mean everything."

design firm
Fame

creative director
Tina Wilcox

client
Fame self-promotion

materials
paper, coverstock,
caution tape,
anti-static bag

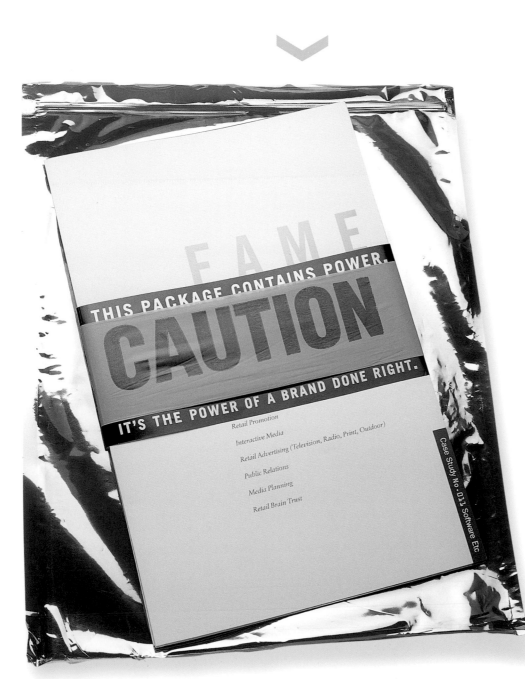

design firm
Wen Oliveri

art direction/design
Jamie Oliveri,
Cinthia Wen

client
Patrick Robinson

materials
leather, metallic paint,
silk ribbon, paper,
cover stock,
bookbinding tape

Patrick Robinson Brand-Positioning Book

When fashion designer Patrick Robinson left Armani to start his own brand, he came to Wen Oliveri for graphics that would manifest his strong personal ethic and design aesthetic. To hear Jamie Oliveri describe it, the lyrical nature of this brand positioning piece was a designer's dream.

> **"It was so nice not to have to distill it down like we would with a corporate project,"** Oliveri sighs. **"We had the luxury of doing tons of research and then just collapsing it all into a book."**

Although the designers were free to be wildly expressive, they nonetheless kept a disciplined, restrained hand. Dipping only occasionally into the tactile palette, each time they did it was to startling effect.

Oliveri relates, "We noticed similarities between the photo of the leaf and the leather that Patrick was using in the collection, so we included bits of the leather. Suddenly, the tactile embellishment brought the photo to life. Also, that little hand-stroke of metallic paint works off the black-and-white shot of the ocean and animates it."

"Patrick's all about not judging a book by its cover," Oliveri says, "So the cover is left unattached, with this beautiful spine exposed." The extra long ribbon is the same fabric as the binding material. The project had a small print run, and handwork gave it a wonderful personalized feel.

"The biggest challenge was the binding," Oliveri says, "Because it had no outside support. It was a labor-intensive project, but it was a labor of love."

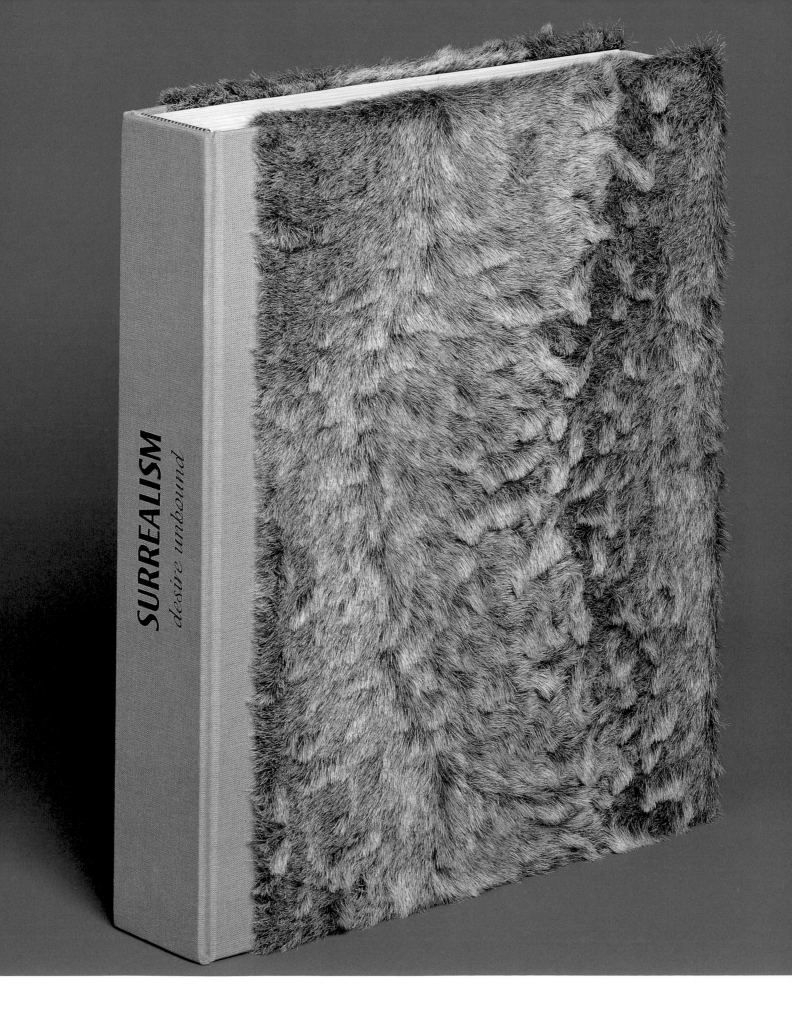

SURREALISM
desire unbound

design firm
Boxer Design

designer
Eileen Boxer

client
Tate Gallery

materials
book, synthetic fur

Book Prototype, *Desire Unbound*

Planning a major show to survey the erotic spirit in art's Surrealist movement, the Tate Gallery in London also wanted a volume to accompany the exhibit. For this they contacted New York designer Eileen Boxer.

"It was a challenge," Boxer says. "[The show] represents a wide range of artists from the movement, and I didn't want to represent one artist over the others on the cover." Boxer solved the problem with a tactile graphic that embraces the sensuality of the exhibition's theme, *Desire Unbound*, while embodying the outrageous vitality that was a Surrealist hallmark. Although the piece doesn't single out one artist, the design is nonetheless a subtle nod to Surrealist Meret Oppenheim's classic sculpture, *Le Dejeuner en Fourrure*, a fur-lined tea cup.

After deciding on the fur, Boxer next turned to color. "The Surrealists used pink a lot, but I wanted one that's slightly dirty-looking, slightly off-pink. They weren't about pretty; their things always made you slightly uncomfortable, and so this combination of the sensuous fur and the pink is slightly 'off.'"

Gumby's Colors
Holly Harman
©2000 Chronicle Books

"The EVA foam for these covers is a wonderful, nontoxic material that gets mixed up like cake batter; you can make it into anything you want," says Kristine Brogno, manager of children's design at Chronicle. Incorporating an actual figurine into the book was the designers' first decision, because, "You gotta have something to play with."

Although inexpensive and easy to mold, the EVA foam has its trade-offs: It's a tricky surface for four-color printing, so the covers had to be screen-printed, which means less control. Also, the figures are duplicated in 2-D on the cover under the foam, and getting the registration right required eagle-eyed supervision.

The figurines have wire armatures sandwiched between two layers of foam and are—á la the original Gumby and Pokey—wonderfully bendable.

Pokey Counts
Holly Harman
©2000 Chronicle Books

Pokey
Counts

by Holly Harman

Bendable
Pokey
pops out!

designer
Michael Mabry

art director
Kristine Brogno

client
Chronicle Books

materials
EVA foam, heavy board

Night Writing: A Journal
©2001 Robie Rogge

In the nineteenth century, the French military used a type of code called Night Writing, which ultimately formed the basis of the Braille alphabet. The term night writing also suggests dream notation, which is decryption of another sort. Designer Alethea Morrison brought these two ideas together in a powerful tactile design for the Chronicle Books Gift Division.

Braille letters are embossed on each of the divider pages, suggesting secrets and the linguistics of the unconscious. Morrison chose the editorial content and graced each divider with a bit of typographic cryptography abstracted from one word of that divider's quote. The padded midnight blue felt fairly whispers of mystery and hidden oracles.

"Night hath a thousand eyes," wrote John Lyly in 1600. Unfortunately, we don't know if Lyly had a dream journal as exquisite as this. (But we're pretty sure he didn't have the neat-o light-up ballpoint pen that comes with this tactile treasure.

designer
Alethea Morrison

client
Chronicle Books

materials
felt cover, embossed cover-stock dividers, pen

design firm
Kelly Tokerud Design

art director
Kristen Nobles

client
Chronicle Books

produced by
Swans Island Books

material
Beluga textured binding

The Truth about Great White Sharks
Mary M. Cerullo
©2000 Chronicle Books

Good photos of Great Whites are hard to come by. Although books about sharks generally sell well, the inaccessibility of the models (and their double rows of sharp teeth) mean that the selection of shark photos is limited. One way to set your shark book apart from the competition, however, is with tactile design.

"We very much wanted the cover to feel as close as possible to shark skin," says Kristine Brogno, describing Chronicle's use of the high-touch Beluga surface from Rexam. "It makes the book stand out in the marketplace, and for older kids, the tactile quality adds to the perceived value of the book."

Black Bread Poetry Anthology

design and binding
Jason Ring

client
Editor, Sianne Ngai

materials
paper, sandwich bag

Jason Ring learned a lot from skateboarding. "When I was a teenager, skateboarding was the only mode of transportation I could find that could be experimental and creative. It's a linear process that gets you from point A to point B, but along the way you also have the opportunity to do something spontaneous and exciting." For Ring, design is similar: creating within a framework, but jazzing along the way.

Ring's approach—and his sense of humor—are witnessed in this wacky and endearing presentation of editor Sianne Ngai's *Black Bread Poetry Anthology*. "Sianne left it up to me to come up with a reason for the name of the anthology. I mean, why is it called *Black Bread*? So I thought maybe the book is a loaf of bread and each page is a slice. So I scanned individual slices of Wonder Bread and placed those images on different pages. Then I thought, let's take it to another level and put end-pieces of bread on the front and back cover. Then I thought, how could I take this further still? So I put it in a Ziplock sandwich bag."

The limited run of less than five hundred was offset printed and then hand-bound by Ring.

"The whole thing about living is experiencing. How do we experience? First and foremost through our senses. If you can combine more than one sense in a design, more than the visual, specifically including the sense of touch, then you double the experience. And if the two parts, the visual and the tactile, work together to reinforce the whole, then you've got something really special. A rare treat."

design firm
Art Center College of Design,
Design Office

design director
Rebeca Méndez

design assistant
Darin Beaman

client
Art Center College of Design

materials
perforated paper
and cardstock, silk ribbon

Art Center College of Design Catalog 1995/96

The impact of new media and technology hit Art Center College of Design in 1993 just as their new catalog was being conceived. "We had to consider that this might be our last printed catalog. This sense of ambivalence...became the vision," says designer Rebeca Méndez. Because the catalog was a tactile embodiment of that ambivalence, the reader's fingers explored questions that only the future could answer.

Opening the catalog, the reader is confronted with a rupture of classical book design. Both covers and all of the pages are horizontally perforated from end to end. Unbroken, the ominous perforations suggest a threat running through image and text, and when the pages inevitably separate, information splits and folds into sudden, unlikely combinations. These breaches and reconfigurations suggest the threshold on which design education stood in 1993, as well as the interdisciplinary mission of Art Center. Similarly, certain portions of the text are blurred or completely obscured.

Slyly, the outside of the design first suggests a rather dull, perfect-bound academic publication missing its cover. The exposed spine's thick ribbon of glue is interrupted by a small fissure revealing a strata of pages and a bright red silk bookmark. (Interestingly, the notch also suggests Art Center's most prominent architectural feature: The main building is a suspension bridge spanning a deep arroyo.)

**UCLA Department of Architecture
and Urban Design Catalog 2000-2001**

Each page of this catalog for the UCLA
Department of Architecture and Urban Design
is laid out with imagery on the left and text
on the right. These two interconnected bodies
of information are kept separate, however,
by the unconventional stitched binding.

Because the catalog's information
can only be unified in the eye—and hand—
of the user, the separation encourages
tactile interplay.

design firm
Rebeca Méndez
Communication Design

designer
Rebeca Méndez

assistant designer
Carolina Trigo

client
UCLA Department
of Architecture and
Urban Design

materials
paper, stitched binding,
translucent plastic cover

design firm
Rebeca Méndez
Communication Design

client
Slowpace

materials
paper, cover stock, heat-sensitive material

Slowspace Book Prototype

Entitled Slowspace, this collection of essays by architects and artists explores the mercurial theme of "matter as a delay," says Rebeca Méndez. "The essays speculate on how to see time in materials, and how matter responds in time. The materials for the book itself were so important." Méndez's tactile cover is made from a heat-sensitive material that puts the book's theme right into the user's hand.

SLOW SPACE

Edited by Michael Bell and Sze Tsung Leong

The Monacelli Press

Daniel J. Martinez

The Things You See When You Don't Have a Grenade!

SMART ART PRESS Santa Monica, 1996

design firm
Shiffman Design

art direction/design
Tracey Shiffman

client
Daniel Martinez

material
peachboard cover

Daniel J. Martinez...Grenade!

"This was a book about the work of a very talented conceptual artist, Daniel Martinez. He brought the project to me, and he was willing to let me guide that journey," says designer Tracey Shiffman.

"A lot of the intrigue in Martinez's work is that his messages are coded. I chose the Morse code to describe that symbolically."

She adds, "I like the fact that the peachboard fur picks up actual lint. At first, the surface is pure and sexy, but the minute you run up against it you wish you hadn't. That's similar to the reaction people have with [Martinez's] work."

DIRECTORY

2GD/2graphicdesignAPS
Wilders Plads 8A
DK-1403 Copenhagen, Denmark
www.2gd.dk

5D Studio
20651 Seaboard Road
Malibu, CA 90265, USA
www.5dstudio.com

44 Phases
8444 Wilshire Boulevard, 5th floor
Beverly Hills, CA 90211, USA
T: 323-655-6944
www.44phases.com

ALR Design
3007 Park Avenue, #1
Richmond, VA 23221, USA
www.alrdesign.com

Addison
20 Exchange Place
New York, NY 10005, USA
www.addison.com

Ad-Lib Creative
883 Sutter Street
San Francisco, CA 94109, USA
T: 415-345-0955
F: 415-345-0960
www.ad-lib.com

After Hours Creative
5444 E. Washington, Suite 3
Phoenix, AZ 85034, USA
www.ahcreative.com

Ames Design
518 Green Lake Way N
Seattle, WA 98103, USA
www.amesdesign.com

Anvil Graphic Design
2611 Broadway
Redwood City, CA 94063, USA
T: 650-261-6090
www.hitanvil.com

Atelier Für Text Und Gestaltung
A-6850 Dornbirn Sägerstrabe 4
Dornbirn, Austria
T: 05572 27480

BBK Studio
648 Monroe Avenue, NW, Suite 212
Grand Rapids, MI 49503, USA
www.bbkstudio.com

Barbara Brown Marketing & Design
2873 Pierpont Boulevard
Ventura, CA 93001, USA
E: bbrown@bbmd-inc.com

Baumann & Baumann, Büro für Gestaltung
Taubentalstrasse 4/1
Schwäbisch Gmünd 73525, Germany
www.baumannandbaumann.com

Beattie Vass Design Pty Ltd.
18 Willis Street
Richmond, Victoria, Australia
www.bvdesign.com.au

Belyea
1809 7th Avenue, Suite 1250
Seattle, WA 98101, USA
www.belyea.com

Bill Wood Illustration
24 Gould Street
Burwood, Victoria 3125, Australia
www.illustration.com.au

Blok Design Inc.
822 Richmond Street West, Suite 301
Toronto, ON M6J 1C9, Canada

Boxer Design
548 State Street
Brooklyn, NY 11217, USA
T: 718-802-9212
E: eboxer@thorn.net

Braue Design
Eiswerkestrasse 8
27572 Bremerhaven, Germany
www.brauedesign.de

Buero fuer Gestaltung
Domstrasse 81
D-63067 Offenbach, Germany
www.bfg-im-netz.de

Cahan and Associates
171 2nd Street, 5th Floor
San Francisco, CA 94105, USA
www.cahanassociates.com

Carbone Smolin Agency
22 W. 19th Street, 10th floor
New York, NY 10011, USA
T: 212-807-0011
F: 212-807-0870
www.carbonesmolin.com

Cato Purnell Partners Pty. Limited
254 Swan Street
Richmond, Victoria 3121, Australia
www.cato.com.au

Chen Design Associates
589 Howard Street, 4th floor
San Francisco, CA 94105-3001, USA
T: 415-896-5338
F: 415-896-5539
www.chendesign.com

Chris Rooney Illustration/Design
639 Castro Street
San Francisco, CA 94114-2506, USA
www.looneyrooney.com

Chronicle Books
85 Second Street, 6th floor
San Francisco, CA 94105, USA
T: 415-537-3730
www.chroniclebooks.com

Color Marketing Group
5904 Richmond Highway, Suite 408
Alexandria, VA 22303, USA
T: 703-329-8500
F: 703-329-0155
E: cmg@colormarketing.org

CPd - Chris Perks Design
333 Flinders Lane, 2nd Floor
Melbourne, Victoria 3000, Australia
www.cpdtotal.com.au

Crawford/Mikus Design Inc
887 W. Marietta Street NW, Suite T-101
Atlanta, GA 30318, USA
www.crawfordmikus.com

Cross Colours
P.O. Box 47098
Parklands, 2121, South Africa
www.crosscolours.co.za

David Lemley Design
8 Boston Street, #11
Seattle, WA 98109, USA
www.lemleydesign.com

Design Forum
7575 Paragon Road
Dayton, OH 45419, USA
www.designforum.com

The Design Group
Cityplaza 3, 6th floor
14 Tai Koo Wan Road
Hong Kong, China

Diesel Design
948 Illinois Street, Suite 108
San Francisco, CA 94107, USA
T: 415-621-4481
www.dieseldesign.com

Dinnick and Howells
298 Markham Street, 2nd floor
Toronto, ON M6J 2GB, Canada
www.dinnickandhowells.com

Dotzero Design
8014 SW 6th Avenue
Portland, OR 97219, USA
T: 503-892-9262
F: 503-245-3791
www.dotzerodesign.com

EAI
887 W. Marietta Street, NW, Suite J-101
Atlanta, GA 30318, USA
www.eai-atl.com

EGBG
Nieuwe Uilenburgerstraat 5
1011 LM Amsterdam, The Netherlands
E: office@egbe.ni

Eiswerkestrasse 8
27572 Bremerhaven, Germany
www.brauedesign.com

EKH Design
30 Boronia Street
Redfern, Sydney NSW 2016, Australia
www.ekhdesign.com.au

Elizabeth Resnick Design
126 Payson Road
Chestnut Hill, MA 02467, USA
elizres@aol.com

Eymer Design, Inc.
25 Dry Dock Avenue
Boston, MA 02210, USA
www.eymer.com

F3 Design
P.O. Box 948
Crystal Lake, IL 60039, USA
www.f3design.com

Falco Hannemann Grafikdesign
Steckelhörn 9
20457 Hamburg , Germany
www.falcoh.de

Fellers Marketing and Advertising
623 Congress Avenue, Suite 800
Austin, TX 78701, USA
www.fellers.com

Fitch
10350 Olentangy River Road
P.O. Box 360
Worthington, OH 43085, USA
www.fitch.com

Stewart Flake
60 S. 6th Street, Suite 2800
Minneapolis, MN 55402, USA
T: 612-342-4150

Format Design
Steckelhörn 9
20457 Hamburg, Germany
E: ettling@format-hh.com

Fossil
2280 N. Greenville Avenue
Richardson, TX 75082, USA
www.fossil.com

Julie Garcia
812 South Monroe Street
San Jose, CA 95128, USA
T: 408-243-3055
E: julieg330@aol.com

Gee + Chung Design
29 Bryant Street, Suite 100
San Francisco, CA 94105, USA
www.geechungdesign.com

Get Smart Design Co.
899 Jackson Street
Dubuque, IA 52001-7014, USA
E: getsmartjeff@mwci.net

Giorgio Davanzo Design
232 Belmont Avenue E, #506
Seattle, WA 98102, USA
www.davanzodesign.com

Grafik Marketing Communications
1199 N. Fairfax Street, Suite 700
Alexandria, VA 22314, USA
www.grafik.com

Graif Design, Inc.
165 E. Highway CC
Nixa, MO 65714, USA
www.graifdesign.com

GraphicType Services
24 Sherwood Lane
Nutley, NJ 07110, USA
www.graphictype.com

Greenfield/Belser Ltd.
1818 N Street NW, Suite 110
Washington, DC 20036, USA
www.gbltd.com

Gregory Thomas Associates
2812 Santa Monica Boulevard, Suite 201
Santa Monica, CA 90404, USA
www.gtabrands.com

The Greteman Group
1425 E. Douglas, Suite 200
Wichita, KS 62711, USA
T: 316-263-1004
F: 316-273-1060
www.gretemangroup.com

Group Baronet
2200 N. Lamar, #201
Dallas, TX 75202, USA
www.groupbaronet.com

Group 55 Marketing
3011 West Grand Boulevard, Suite 329
Detroit, MI 48202, USA
www.group55.com

GSD&M
828 West 6th Street
Austin, TX 78703, USA

Gumption Design
60 E. 13th Street, 2E
New York, NY 10003, USA
T: 212-979-8265
F: 212-477-1113
www.gumptiondesign.com

Gustavo Machado Studio
Rua Itu, 234192
Campinas, SP 13025-340, Brazil
www.gustavo-machado.com/english

HGV
46A Rosebery Avenue
London EC1R 4RP, England, UK
www.hgv.co.uk

Heart Times Coffee Cup Equals Lighting
8538 Hollywood Boulevard
Los Angeles, CA 90069, USA

Hoffmann Angelic Design
317-1675 Martin Drive
Surrey, BC V4A 6E2, Canada
E: Hoffmann_angelic@telus.net

Hornall Anderson Design Works, Inc.
1008 Western Avenue, 6th floor
Seattle WA 98104, USA
T: 206-467-5800
F: 206-467-6411
www.hornallanderson.com

IDEO
700 High Street
Palo Alto, CA 94301, USA
T: 650-289-3409
www.ideo.com

IE Design
1600 Rosecrans Avenue, Building 6B/#200
Manhattan Beach, CA 90266, USA

JOED Design Inc.
533 South Division Street
Elmhurst, IL 60126, USA
www.joeddesign.com

Johnny V Design
2702 Dartmouth Road, Apt. #6
Alexandria, VA 22314, USA
www.funkfoto.com

Julia Tam Design
2216 Via La Brea
Palos Verdes, CA 90274, USA
Taandmm888@earthlink.net

KBDA
2338 Overland Avenue
Los Angeles, CA 90064, USA
www.kbda.com
T: 310-287-2400
F: 310-287-0909
E: kim@kbda.com

Kenzo Izutani Office Corporation
1-24-19 Fukasawa
Setagaya-Ku
Tokyo 158-0081, Japan
home.att.net.jp/orange/izutanix

Kiko Abata and Company
6161 Delmar Boulevard, Suite 200
St. Louis, MO 63112-1203, USA
www.kikuAbata.com

Kirshenbaum Communications
725 Greenwich Street
San Francisco, CA 94133, USA
www.kirshenbaum.com

KROG
Krakovski nasip 22
1000 Ljubljana, Slovenia
E: edi.berk@krog.si

Lawrence and Brooks
12 Sheldon Street
Providence, RI 02906, USA
E: striedman@lawrenceandbrooks.com

Lewis Moberly
33 Gresse Street
London W1T 1QU, UK
www.lewismoberly.com

Lieber Brewster Design
19 West 34th Street, Suite 618
New York, NY 10001, USA
www.lieberbrewster.com

Lippa Pearce Design Ltd.
358a Richmond Road
Twickenham TW12DU, England, UK
T: 4420 8744 2100
www.lippapearcedesign.com

Louis London
6665 Delmar Boulevard, Suite 300
St. Louis, MO 63130, USA

Lowercase, Inc.
213 W. Institute Place, Suite 311
Chicago, IL 60610, USA
www.lowercaseinc.com

Lunar Design Inc.
541 Eighth Street
San Francisco, CA 94102, USA
www.lunar.com

Mad Creative
150 Chestnut Street
Providence, RI 02903, USA
www.madcreative.com

Margo Chase Design
2255 Bancroft Avenue
Los Angeles, CA 90039, USA
T: 323-668-1055
www.margochase.com

Mark Allen Design
2209 Ocean Avenue
Venice, CA 90291, USA
T: 310-396-6471

Mek-Aroonreung/Lefebure
1735 N. Fairfax Drive, No. 13
Arlington, VA 22209, USA
E: pumm@erols.com

Metzler et Associes
5 Rue de Charonne
75011 Paris, France

Michael Doret Graphic Design
6545 Cahuenga Terrace
Hollywood, CA 90068, USA
www.michaeldoret.com

MOD/Michael Osborne Design
444 De Haro Street, #207
San Francisco, CA 94107, USA
www.modsf.com

Migliori Design
392 Rochambeau Avenue
Providence, RI 02906, USA
E: miglioridesign@aol.com

Mike Quon/Designation Inc.
53 Spring Street
New York, NY 10012, USA
www.mikequondesign.com

Mires Design Inc
2345 Kettner Boulevard.
San Diego, CA 92101, USA
www.miresdesign.com

Mirko Ilic Corp.
207 East 32nd Street
New York, NY 10016, USA
T: 212-481-9737

Misha Design Studio
1638 Commonwealth Avenue, Suite 24
Boston, MA 02135, USA
www.mishalenn.com

Mix Pictures Grafik
Weihermatte 5
Ch-6204 Sempach, Switzerland
www.mixpictures.ch

Muller & Company
4739 Belleview
Kansas City, MO 64112, USA
www.mullerco.com

Nancy Cohen Design
25790 Dundee
Royal Oak, MI 48067, USA
E: nancybcohen@home.com

National Broadcasting Company, Inc.
30 Rockefeller Plaza
New York, NY 10112, USA

Navy Blue Design Consultants (London) Ltd.
Third Floor Morelands 17-21 Old Street
London ECIV 9HL, England, UK
T: 44-207-253-0316
www.navyblue.co.uk

Neal Ashby
1330 Connecticut Avenue, NW, Suite 300
Washington, DC 20036, USA
E: nashby@riaa.com

neo design
1048 Potomac Street, NW
Washington, DC 20007, USA
www.neo-design.com

New York City Technical College
300 Jay Street, N325
Brooklyn, NY 11201, USA
T: 718-260-5930

Niklaus Troxler Design
Postpach
CH-6130 Willisau, Switzerland
www.mixpictures.ch

Oh Boy, A Design Company
49 Geary Street, Suite 530
San Francisco, CA 94108, USA
T: 415-834-9063
www.ohboyco.com

Omatic Design
408 SW 2nd Street, Suite 509
Portland, OR 97204, USA
T: 503-225-1866
F: 503-225-1846
www.omaticdesign.com

Palazzolo Design Studio
6410 Knapp
Ada, MI 49301, USA
www.palazzolodesign.com

Parham Sanatana
7 West 18th Street, 7th Floor
New York, NY 10011, USA
www.parhamsantana.com

The Partnership
512 Means Street, #400
Atlanta, GA 30318, USA
E: A-dusenberry@thepartnership.com

Paul Rogers Studio
12 S. Fair Oaks, #208
Pasadena, CA 91109, USA
E: rvhstudio@aol.com

Pepe Gimeno - Proyecto Gráfico
C/ Cadirers, s/n - Pol. d'Obradors
E-46110 Godella
Valencia, Spain
E: gimeno@ctv.es

Plazm Media
P.O. Box 2863
Portland, OR 97208-2853, USA
E: design@plazm.com

The Pushpin Group Inc.
18 East 16th Street, 7th Floor
New York, NY 10003,USA
www.pushpininc.com

R2 Design
Praceta D. Nuno Alvares Pereira 20 5° FQ
4450 Matosinmos, Portugal
R2design@mail.telepac.pt

R.M. Hendrix Design Company
P.O. Box 2128
Chattanooga, TN 37409, USA
www.hendrixdesign.com

Rebeca Méndez Communication Design
2873 N. Mount Curve Avenue
Altadena, CA 91001, USA
T: 626-403-2122
E: balam@earthlink.net

Recording Industry Association of America
1330 Connecticut Ave., NW, Suite 300
Washington, DC 20036, USA
www.riaa.com

Red Canoe
347 Clear Creek Trail
Deer Lodge, TN 37726, USA
www.redcanoe.com

Re-public
Laplandsgade 4
2300 Copenhagen, K, Denmark
www.re-public.com

Jason Ring
200 Bowery, 8E
New York, NY 10012, USA
T: 646-242-7071
F: 718-857-2021

The Riordon Design Group Inc.
131 George Street
Oakville, ON, Canada L6J 3B9
T: 905-339-0750
www.riordondesign.com

Rocketbuster Boots
115 Anthony Street
El Paso, TX 79901-1064, USA
T: 915-541-1300
www.rocketbuster.com

Rullkötter AGD
Kleines Heenfeld 19
D-32278 Kirchlengern, Germany
www.rullkoetter.de

Sagmeister Inc.
222 W 14th Street, #15A,
New York, NY 10011-7226, USA
T: 212-647-1789

Sara Schneider
85 Second Street, 6th floor
San Francisco, CA 94105, USA
T: 415-537-3730

Sayles Graphic Design
3701 Beaver Avenue
Des Moines, IA 50310, USA
E: sayles@saylesdesign.com

Scholz & Volkmer Intermediales Design, GmbH
Schwalbacher Strasse 76
D-65783 Wiesbaden, Germany
www.s-v.de

Segura Inc.
1110 N. Milwaukee Avenue
Chicago, IL 60622, USA
www.segura-inc.com

Selbert Perkins Design Collaborative
2067 Massachusetts Avenue
Cambridge, MA 02138, USA
E: shaddad@spdeast.com

Shields Design
415 E. Olive Avenue
Fresno, CA 93728, USA
www.shieldsdesign.com

Smart Works Pty. Ltd.
113 Ferrars Street
Southbank, Victoria 3006, Australia
www.smartworks.com.au

Sommese Design
481 Glenn Road
State College, PA 16803, USA
E: lxs14@psu.edu

Studio Flux
3515 Aldrich Avenue S, No. 4
Minneapolis, MN 55408, USA
T: 612-824-0308

Studio GT&P
Via Ariosto
5-06034 Foligno, PG, Italy
www.tobanelli.it

Studio Guarnaccia
31 Fairfield Street
Montclair, NJ 07042, USA
T: 973-746-9785

Sunja Park Design
2116 Roselin Place
Los Angeles, CA 90039, USA
www.sunjadesign.com

Supon Gibson Design
1232 31st Street NW
Washington, DC 20007-3402, USA
www.supongibson.com

Tau Diseño S.A.
Felipe IV, 8. 2° izda.
28014 Madrid, Spain
E: spain@taudesign.com

Terrapin Graphics
991 Avenue Road
Toronto, ON M5P 2K9, Canada
www.terrapin-graphics.com

Thumbnail Creative Group
#301 - One Alexander Street
Vancouver, BC, Canada V6A 1B2
E: rik@thumnailcreative.com

Turkel Schwartz & Partners
2871 Oak Avenue
Coconut Grove, FL 33133, USA
www.braindarts.com

Unfoldz
(A Division of Darby Scott Design, Inc.)
8061 Hackberry
Mentor, OH 44060, USA
T: 440-255-3556
F: 440-255-0097
www.unfoldz.com

The Via Group
34 Danforth Street, Suite 309
Portland, ME 04101, USA
www.vianow.com

Viva Dolan Communications and Design Inc.
99 Crown's Lane, 5th Floor
Toronto, ON M5R 3P4, Canada
www.vivadolan.com

Vrontikis Design Office
2707 Westwood Boulevard
Los Angeles, CA 90064-4231, USA
T: 310-446-5446

VSA Partners
1347 South State Street
Chicago, IL 60605, USA
www.vsapartners.com

Wasserman & Partners Advertising Inc.
1020 Mainland Street, Suite 160
Vancouver, BC V6B 2T 4, Canada
www.wasserman-partners.com

Wen Oliveri
479 Tehama Street
San Francisco, CA 94103, USA
T: 415-284-9807
www.wenoliveri.com

The Works Design Communications
401 Richmond Street West, Suite 350
Toronto, ON M5V 3A8, Canada
www.worksdesign.com

WorldSTAR Design & Communications
4401 Shallowford Road, Suite 192/552
Roswell, GA 30075, USA
E: worldstar@mindspring.com

ABOUT THE AUTHORS

Cheryl Dangel Cullen is a marketing and graphic design consultant who writes for several major graphic design publications. Her books include *The Best Annual Report Design, Large Graphics, Small Graphics, The Best of Brochure Design 6, Then Is Now,* and *Promotion Design That Works,* all from Rockport Publishers. She lives outside Chicago.

Leatrice Eiseman is an internationally recognized color specialist who heads the Eiseman Center for Color Information and Training, and she is the executive director of the Pantone Color Institute. She is widely quoted in the media and is the author of several books, including *Color for Your Every Mood* and *Pantone Guide to Communicating with Color.* For more information on Leatrice, visit her website www.colorinstitute.pantone.com.

Ferdinand Lewis has written about the arts and entertainment for *Daily Variety, American Theatre, Animation, Logik, TV Kids,* and *Audio Media* magazines. He is a recipient of an Irvine Fellowship for Arts Journalism, four PBS APAC Awards, the Richard Scott Handley Prize for Creative Writing, the Group Repertory Theatre's New Playwright's Award, and a Durfee Foundation Fellowship.

His plays have been performed on both coasts and in Europe, and his experimental writing has appeared in *Parabasis: The Journal of A.S.K. Theatre Projects.* He is working on a pair of books about ensemble theater, *Ensemble Works: An Anthology* for Theatre Communications Group Publishers, and *Ensemble Works: Traditions, Approaches, Strategies,* which is supported by the Flintridge Foundation.

Margaret E. Richardson is a writer and editor specializing in design and art projects. As editor of *U&lc: the International Journal of Graphic Design and Digital Media,* Richardson worked with an array of prestigious designers and the magazine garnered many design awards. Richardson writes for *Print,* atypi.org and dz3.com, while also teaching a class in the History of Graphic Design at Portland State University.

Rita Street has written about entertainment, entertainment technology, and the graphic arts for various publications in the U.S., U.K., and Asia. She is the former editor of *Animation* and *Film & Video* magazines. Other Rockport titles authored by Street include *Computer Animation: A Whole New World* and *Creative Newsletters & Annual Reports: Designing Information.* She is the founder of the international organization Women In Animation.

Karen Triedman teaches color, applied color, the psychology of color, and design and visual merchandising at Rhode Island School of Design. She has written on design, art, and color for local newspapers and magazines and has also reviewed artists and design books. Karen consults in the areas of visual marketing and color design. Clients have included Swarovski Silver Crystal, New England Development Co., Paramount Cards, Card$mart, and Foxwoods Casino.